# The Art of Captain Cook's Voyages

The publication of *The Art of Captain Cook's Voyages* has been assisted by
The Australian Government
The New Zealand Government
The Australia–New Zealand Foundation
The Royal Society
The Utah Foundation
The Visual Arts Board of the Australia Council

Rüdiger Joppien and
Bernard Smith

# The
# Art of
# Captain Cook's
# Voyages

*Volume Three    Text*

# The Voyage of the *Resolution* and *Discovery* 1776-1780

with a
Descriptive Catalogue
of all known original drawings and
paintings of peoples, places, artefacts
and events and original engravings
associated with the Voyage

Published for the
Paul Mellon Center for Studies
in British Art by
YALE UNIVERSITY PRESS,
New Haven and London, 1988

in association with the
AUSTRALIAN ACADEMY
OF THE HUMANITIES

© Rüdiger Joppien and Bernard Smith
First published 1988

Designed by Derrick I. Stone Design
Typeset by Meredith Typesetting
Printed by Owen King Printers Australia Pty Ltd

Library of Congress catalog card number 84-52812
ISBN 0-300-04105-5 (v.111)

TO THE MEMORY OF

J. C. Beaglehole and R. A. Skelton

# CONTENTS

The Artists

# PREFACE

This third volume of *The Art of Captain Cook's Voyages* describes and illustrates all the known drawings, paintings and engravings that contain first-hand information about the peoples and places encountered by Captain Cook on his third and last voyage to the Pacific. The first part provides an account of the art work as it was produced during the voyage together with a full account of the life and art of John Webber, the official artist of the voyage, and of William Ellis, the surgeon's mate who also left a considerable amount of original work, some of it related to that of Webber. The second part consists of a complete illustrated catalogue of the known work and falls into three broad categories: (1) drawings and paintings executed on the voyage; (2) drawings and paintings by Webber and Ellis relating to the voyage but completed after their return to England; (3) engravings, etchings etc. produced to illustrate the first published accounts of the voyage or published independently by Webber (or others), for example, his *Views in the South Seas*. The catalogue thus seeks to provide a complete illustrated inventory of all the first-hand visual information relating to Cook's third voyage, in so far as it relates to peoples and places.

As was made clear in the first volume, we have not included drawings which relate exclusively to natural history or navigation. These constitute major categories of voyage art and deserve volumes in their own right. Fortunately the Hakluyt Society, in association with the Australian Academy of the Humanities, has undertaken the publication in three volumes of the *Charts and Views of Captain Cook's Voyages*, under the authorship of Lieutenant-Commander A. C. F. David with assistance from the authors of the present volumes. This publication will complement and complete the documentation of the landscapes drawn on Cook's voyages left incomplete in the present volume. It is to be hoped that eventually the natural history drawings relating to Cook's voyages will be published in their entirety in well-illustrated descriptive catalogues. We shall then possess a complete visual record of the three voyages in a manner that is readily available both to the specialist and the general reader.

During the third voyage the illustration of peoples and places, particularly the work of Webber, often tends to combine with the more specialized interests of the natural historian and occasionally with that of the navigator. The trend is more apparent in the third than in the first or second voyages. We have not hesitated therefore to include a number of typical specimens of natural history and coastal views where they help to illustrate the interests and concerns of the artists, Webber and Ellis.

As mentioned in the preface to volume one, all the works catalogued in these volumes, with the exception of a few in Los Angeles and Seattle, have been seen and studied by either one or the other of the co-authors. Most of the originals, and virtually all those in British and Australian collections, have been examined by both authors. This third volume, however, is substantially the work of Dr Rüdiger Joppien. He has been responsible for the preparation of most of the documentation of the catalogue and the provision of the basic draft of part one, which discusses the art work in relation to the voyage, and the life and art of Webber and Ellis. The short section on the Cleveley problem is the product of a decision to publish our broad field of agreement despite some differences of opinion about various aspects of the problem.

For the research and preparation of this volume we are again greatly indebted to several major institutions in many parts of the world, and to their curators, who have so willingly responded to repeated and at times incessant enquiries, and who allowed us to inspect their drawings and catalogue and illustrate them. These include: the British Library, the British Museum, and the National Maritime Museum, in London; the Peabody Museum, Cambridge, Massachusetts; the Bernice P. Bishop Museum, Honolulu; the Alexander Turnbull Library, Wellington; and in Australia, the Mitchell and Dixson Libraries of the State Library of New South Wales, and the National Library of Australia, Canberra. The volume would never have been completed without their continued co-operation. Dr Joppien also wishes to express his

gratitude to the Humanities Research Centre of the Australian National University, Canberra, of which he was a Visiting Fellow for several months in 1975 and 1981-82.

Many colleagues provided us with invaluable advice in their own specialized fields and gave us their time in fruitful discussions that went quite beyond their 'duty'. Several have already been mentioned in the earlier volumes but we are bound to express our thanks again to those who have continued to help us to the end of this, the last and the largest volume. We have deeply appreciated their continued co-operation, as well as the help of others, as we faced new problems peculiar to the third voyage. We regret that our appreciation can only be expressed here, in a volume already swollen in size, within the brief but rugged democracy of the alphabet: Yvonne Boerlin-Brodbeck, Kupferstichkabinet, Kunstmuseum, Basel; Margaret Calder, Mitchell Library, Sydney; Sylvia Carr, National Library of Australia, Canberra; Judith A. Diment, Botanical Library, British Museum (Natural History), London; Ian Donaldson, Humanities Research Centre, Canberra; Antony Griffiths, Department of Prints and Drawings, British Museum, London; Carlos van Hasselt, Fondation Custodia, Institut Néerlandais, Paris; Niall Hobhouse of Hobhouse Ltd, London; Elizabeth Imashev, Mitchell Library, Sydney; Professor W. D. Jackson, University of Tasmania; Robert Langdon, Research School of Pacific Studies, Canberra; Moira M. Long, Alexander Turnbull Library, Wellington; John Maggs of Maggs Bros, London; Andreas Meier, Graphische Sammlung, Kunstmuseum, Bern; Patrick J. Noon, Mellon Center for Studies in British Art, New Haven; Barbara Perry, National Library of Australia, Canberra; Harley Preston and Roger Quarm, National Maritime Museum, London; Marie-Catherine Sahut, Musée du Louvre, Paris; Catherine Santamaria, National Library, Australia, Canberra; Douglas Schoenherr, The Public Archives of Canada, Ottawa; Jeremy Spencer, Canberra; Lindsay Stainton, Department of Prints and Drawings, British Museum, London; Bernard Stokes, Bishop Suter Museum, Nelson; Cynthia Timberlake, Bernice P. Bishop Museum, Honolulu; J. E. Traue, Editor, *The Turnbull Library Record*, Wellington; Thomas Woodcock, Somerset Herald, College of Arms, London.

In 1978 Douglas Cole of the Simon Fraser University, Burnaby, B.C. made available to us his notes on Webber and greatly assisted us to continue our research into the life of the artist. Harald Wäber of Bern, a descendant of the Webber family and himself a professional archivist, provided much helpful information about his forbear and assisted our research. To him we owe new insights into Webber's years in Bern, particularly concerning the financial assistance he received from the Corporation of Merchants when in training to be an artist.

Adrienne Kaeppler, Curator of Oceanic Ethnology at the Smithsonian Museum, Washington has continued to assist us in this as in the earlier volumes, and we thank her for making available parts of the manuscript of her forthcoming book on the Leverian Museum even though it arrived too late for its results to be taken into full consideration within our own text. We are most grateful to Lieutenant-Commander Andrew C. F. David, of the Hydrographic Department of the Admiralty, Taunton, for providing us with a complete transcript of the Sandwich-Banks correspondence relating to the publication of the third voyage when it was still in the archives of the Montagu family at Mapperton, and for help in other ways. We are grateful also to Harold Carter for continued assistance on questions relating to Sir Joseph Banks's correspondence, and we wish to express our thanks to Mrs Francis P. Farquhar of Berkeley, California for her help and hospitality, when cataloguing her collection of Webber drawings.

In London three of our friends and colleagues have taken a special interest in this volume. Emma Hicks was invariably helpful in our pursuit of various lines of enquiry as they arose. We owe much to her unfailing enthusiasm and professional sagacity. Peter Whitehead of the British Museum (Natural History), a Nestor of Cook studies since his splendid book of the fishes collected on Cook's voyages appeared in 1969, has been most helpful in discussions, introducing us to other collections, and providing detailed information from his comprehensive files. Jonathan King of the Museum of Mankind, London, led us to invaluable information concerning artefacts collected on the voyage and to the history of collections. Dr Joppien particularly wishes to express his gratitude to both Jonathan and his wife Finney for their warm and generous hospitality to him on his research visits to London during the past ten years.

We also wish to express our thanks to the Council of the Australian Academy of the Humanities for its initial support of volumes one and two of this publication as one of its official projects undertaken for the Australian Bicentenary. Our gratitude is due also to the staff of Oxford University Press, Melbourne, particularly Louise Sweetland and Ev Beissbarth for their care and attention in seeing the book through the press, to Derrick Stone for the experience, enthusiasm and flair he has brought to the complex design problems presented
xii

by a book of this kind, and finally to Lee White, for her judicious and imperturbable editing of our many and often exasperating drafts of the text.

Projects of this kind do not depend upon the acquisition of information alone. They require continued personal support. So our last and most cherished thanks must go to Kathrin Joppien and Kate Smith for their patience and goodwill during the past ten years when the pressures developed by this project placed exacting demands at times upon our households.

<div align="right">

Rüdiger Joppien
Bernard Smith
December 1986

</div>

# LIST OF PLATES

xviii

# ABBREVIATIONS

*Text*

| | |
|---|---|
| Banks, *Journal* | *The Endeavour Journal of Joseph Banks 1768-1771*, ed J. C. Beaglehole, Sydney, 1962. 2 vols. |
| Cook, *Journals* | *The Journals of Captain James Cook on his Voyages of Discovery.* |
| I | I *The Voyage of the Endeavour, 1768-1771.* |
| II | II *The Voyage of the Resolution and the Adventure, 1772-1775.* |
| III | III *The Voyage of the Resolution and Discovery, 1776-1780.* In two parts. Cambridge University Press. Published for the Hakluyt Society, 1955-68. |

All other abbreviated references to manuscripts, books and articles cite the author's surname only followed by the year of publication. The bibliography should be consulted for a more complete reference.

| | |
|---|---|
| ANU | Australian National University |
| BL | British Library |
| BM | British Museum |
| JWCI | *Journal of the Warburg and Courtauld Institutes* |
| NLA | National Library of Australia |
| PRO | Public Record Office, London |
| RA | Royal Academy |
| fp. | facing page |
| f/piece | frontispiece |
| l.c., l.l., l.r. | lower centre, lower left, lower right |
| u.c., u.l., u.r. | upper centre, upper left, upper right |
| w/m | watermark (watermarks are described from bottom to top) |

*Illustrations*

All references to illustrations in *texts cited* are prefixed by pl. whether designated in the cited text as plate, number or figure. All references to illustrations used in the *introductory text of this volume* are in the form (plate   ). Illustrations in the *catalogue* are referred to by the relevant catalogue number.

# THE VOYAGE OF THE *RESOLUTION* AND *DISCOVERY* 1776-1780

## 1. The Appointment of John Webber

In February 1776, the Admiralty, knowing that Cook was ready and willing to sail again, appointed him to the command of a new voyage of exploration to the Pacific. Like his first voyage, it had been proposed initially by the Royal Society and had for its object the discovery of a northern passage from the Pacific into the Atlantic Ocean. Apart from the advantages that would accrue to science from such a voyage it was realized that a northern passage to the Pacific would bring major economic benefits to British interests, such as the Hudson's Bay company, that held a virtual monopoly on the northern fur trade.

The *Resolution*, which had served Cook well on his second voyage, was refitted at Deptford and a recently-built Whitby collier, the *Diligence*, was renamed the *Discovery*, and also fitted out for the voyage.

Cook's instructions, which he certainly had a personal hand in framing, required him to enter the Pacific once again via the Cape, then search out the islands in the south Indian Ocean in the longitude of Mauritius, that had recently been reported by the French navigators, Kerguelen and Marion de Fresne. After seeking and examining thoroughly a good harbour in those islands he was to proceed to Tahiti (touching if he thought desirable at New Zealand) and there give his ship's company refreshment and rest prior to embarking on the northern leg of his journey. Omai, who had become something of a social lion during his stay in England, was to be taken back on the *Resolution* and settled in the island of his choice in the Society Islands.

Cook was directed to leave Tahiti by February 1777 and sail to the north-west coast of America (Drake's 'New Albion'), and there wood, water and procure refreshments at a suitable harbour. He was then 'very carefully to search for, and to explore, such Rivers or Inlets as may appear to be of a considerable extent and pointing towards Hudsons or Baffins Bays'. Should no such passage be found he should then repair to the port of St Peter and St Paul in Kamchatka and pass the winter there. In the ensuing spring of 1778 he should proceed to the north again and explore the arctic sea in a further search for a north-east or a north-west passage into the North Sea or the Atlantic Ocean. Thereafter

> having discovered such Passage, or failed in the attempt, make the best of your way back to England by such Route as you may think best for the improvement of Geography and Navigation . . .[1]

On the first voyage Banks had established beyond doubt the value of taking artists as invaluable recorders of information on voyages of exploration. William Hodges, on the second voyage, had performed to Cook's complete satisfaction and had been of value to the Admiralty on his return, particularly in the preparation of the plate that accompanied the official account of the voyage. The good sense therefore of taking a competent artist on the new voyage was not in question.

Daniel Carl Solander, the botanist who had accompanied Banks on Cook's first voyage and later became his librarian, found Cook a suitable artist for the new voyage. While visiting the annual exhibition of the Royal Academy in the spring of 1776 shortly after the exhibition opened (it ran from 24 April to 22 May), Solander noticed a portrait that took his fancy. Entitled *Portrait of an artist* it was by John Webber, a young artist of Swiss extraction who had recently returned to England after studying art in Bern and Paris. As Solander discovered when he visited him a few days later Webber was competent not only in portraiture but also in landscape. He was then twenty-four years of age and Solander had no hesitation in introducing him to the Admiralty.[2]

Webber did not however receive his appointment from the Admiralty — for an honorarium of 100 guineas per annum — until 24 June. He joined the *Resolution* at Plymouth on 5 July,[3] and it sailed for the Cape seven days later. He thus had a little more time than

[1] Cook, *Journals* III, 1, ccxxi-ccxxiv.

[2] Cole (1979a), 19-20. For a detailed account of Webber's early life see pp. 171-82.

[3] ibid.

Hodges — three weeks rather than a fortnight — to prepare himself for the voyage; though in both cases they probably knew in advance that they would most likely be appointed. The appointment was couched in terms that were virtually identical to those employed for the appointment of Hodges four years before:

> Whereas we have engaged Mr John Webber Draughtsman and Landskip Painter to proceed in His Majesty's Sloop under your Command on her present intended voyage, in order to make Drawings and Paintings of such places in the Countries you may touch at in the course of the said Voyage as may be proper to give a more perfect Idea thereof than can be formed by written descriptions only; You are hereby required and directed to receive the said Mr John Webber on board giving him all proper assistance, Victualling him as the Sloop's company, and taking care that he does diligently employ himself in making Drawings or Paintings of such places as you may touch at, that may be worthy of notice, in the course of your Voyage, as also such other objects and things as may fall within the compass of His abilities.[4]

[4] Cook, *Journals* III, 2, 1507.

The terms of this commission naturally set the key to Webber's work during the next four years. It was Cook who was to take care of him and see that he diligently employed himself and drew what was 'worthy of notice'. Even more so than on his second voyage, Cook clearly had it in mind on this voyage to publish his own account on his return and it is also clear that he regarded Webber as his visual collaborator in that undertaking from the beginning. This needs to be kept in mind when we consider Webber's work in the Pacific. Webber is frequently on the spot with Cook and often depicts incidents, scenes, or portraits of individuals, mentioned by Cook in his Journal. Webber became very much the 'Captain's artist' though as we shall see he also collaborated with William Anderson, the surgeon on the *Resolution*, who was a keen and knowledgeable naturalist and a splendid diarist. In Webber's drawings with their emphasis upon description, the recording of notable events, and linear accuracy, we may perhaps see something of Cook's guiding hand and the eventual publication that was already in his mind. Webber is both in his own nature and under Cook's guidance more factual, less fanciful and imaginative than Hodges, indulging little in the very free studies and colouristic experiments that frequently graced the work of Hodges. In consequence his total *oeuvre* became a much greater achievement in visual documentation.

# 2. Tenerife:
## 1-4 August 1776

On 12 July 1776 the *Resolution* and *Discovery* sailed out of Plymouth Sound and on 1 August anchored in the road of Santa Cruz, capital of Tenerife. Here the ships lay for three days and short excursions into the town and countryside were arranged. In the afternoon of 2 August, William Anderson, surgeon on the *Resolution* and a talented naturalist, with three companions hired mules to go to Laguna, the second city of Tenerife. No visit to the Pico was arranged, though Anderson would have wished to go there had he known of the ship's stay for three days.

Webber's only known works are a view of the island port (3.1) and a painting developed from it (plate 1; 3.2). Neither include the Pico. The painting, which is signed and dated, could well be the road of Santa Cruz that Cook mentioned in his letter to the Admiralty, written about three months later from Cape Town, in which he refers to 'a painting which he (Webber) made of St Cruz in the Island of Teneriffe I have left with Mr Brand of this place to be forwarded to their Lordships by the first safe opportunity'.[1] It was a practice he had followed on the second voyage with a number of paintings by Hodges.

Webber thus began his voyage with an oil painting. Doubtless Cook was keen to show the Admiralty the value of a professional artist, and views of foreign ports and harbours were valued items of naval intelligence. The painting was developed from the drawing and concentrated on the settlement, the adjacent country and mountain range. Topographical views of harbours and coastal profiles became one of Webber's major concerns during the voyage, but though he converted the first into an oil painting, it was a practice which he did not continue.

[1] PRO Adm. 1/1611, quoted by Beaglehole in Cook, *Journals* III, 2, 1523.

PLATE 1
John Webber, *Tenerife*, 1776. Yale Center for British Art, New Haven. (3.2)

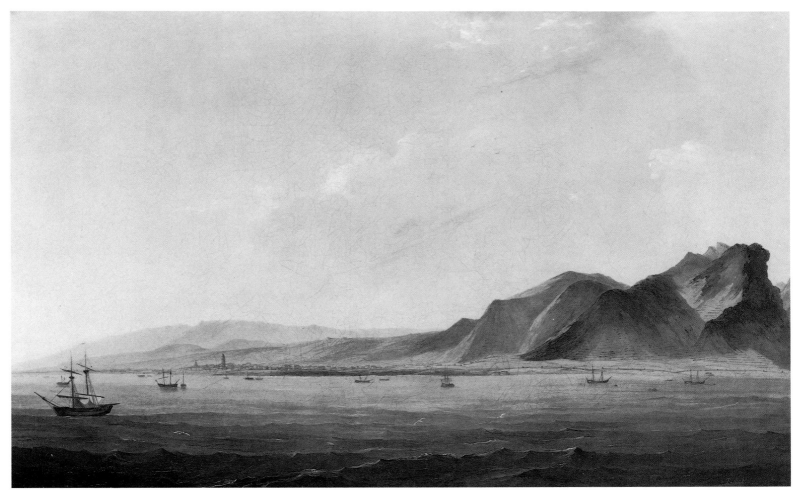

# 3. Cape of Good Hope:
## 18 October-1 December 1776

[1] Read before the Society on 15 January 1777 and published in the *Philosophical Transactions*, LXVIII, (1778) 102-6. See Beaglehole, and therein Anderson's account of the Cape district, in Cook, *Journals* III, 2, 757-8.

PLATE 2
John Webber, *A View of Christmas Harbour*, December 1776-. British Library, London. (3.3)

The Cape of Good Hope was Webber's first encounter with the non-European world. It is not unlikely that during the six weeks there he visited the interior, though we have no evidence of it. A *View of the Harbour*, is listed in the Catalogue he later made of his works submitted to the Admiralty on his return (no. 160), but is otherwise unknown. Moreover as it is listed at the end of the Catalogue it may refer to the harbour of Simon's Bay where the ships anchored on the return home.

Cook and Anderson tell us little of activities on land during the stay, though we do hear of an excursion into the hinterland between 16 and 20 November, by Anderson and five others. In his journal Anderson made extensive comment on the geological make-up of the country, its rocks and soil. A large granite rock known as the Paarl particularly attracted his attention, and he made it the object of a letter to Sir John Pringle (1707-1782), President of the Royal Society.[1] There is no evidence however of Webber having taken part in the expedition.

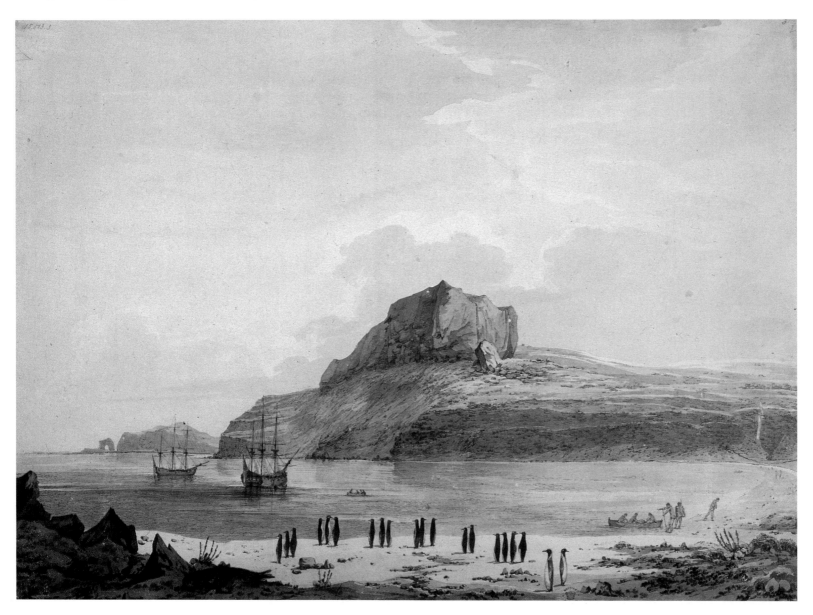

4

# 4. Kerguelen Island:
## 25-30 December 1776

During the ships' stay at Christmas Harbour, Kerguelen Island, in the Southern Ocean, fog and rain prevailed for most of the time. Webber however, took little interest in depicting weather conditions either on this or other occasions. From the beginning of the voyage, it would appear, his aim was to provide illustrations for engraving, and he was reluctant to experiment with oil or water-colour for interpreting the atmosphere or the movement of clouds as Hodges and even Parkinson had done. Webber's *A View of Christmas Harbour* (plate 2; 3.3) is the first of a series of harbour views, in which he represented the ships' anchorage. For the sake of animation he added a flock of penguins and some sailors landing on the shore. The contrast between humans and animals could not more explicitly evoke an atmosphere of desolation. Except for a few tufts of grass, there is nothing but barren slopes and rocks. Anderson had much to say about the geology of the island, and might well have stimulated Webber to focus his view upon Tarpeian Rock, a gigantic cube on the summit of the headland.[1] Beyond it the coastline to the left became steep and rugged receding to a large arched rock. The same view with exactly the same landscape features and identical viewpoint was adopted by the other draughtsman of the voyage, William Ellis, surgeon's mate on the *Discovery*, in his drawing of *Christmas Harbour in the Island of Desolation* (plate 3; 3.5).

Devoid of all traces of human existence, Christmas Harbour constituted a *terra incognita*, and an entirely new experience for Webber. Yet he was not altogether unprepared for it. During the second half of the eighteenth century both scientists and artists were developing an increasing interest in geology, in the structural conformation of landscapes and the nature

[1] Samwell seems to be the only one who has identified this rock by name, see Cook, *Journals* III, 2, 991.

PLATE 3
William Ellis, *Christmas Harbour in the Island of Desolation*, December 1776-. National Library of Australia, Canberra. (3.5)

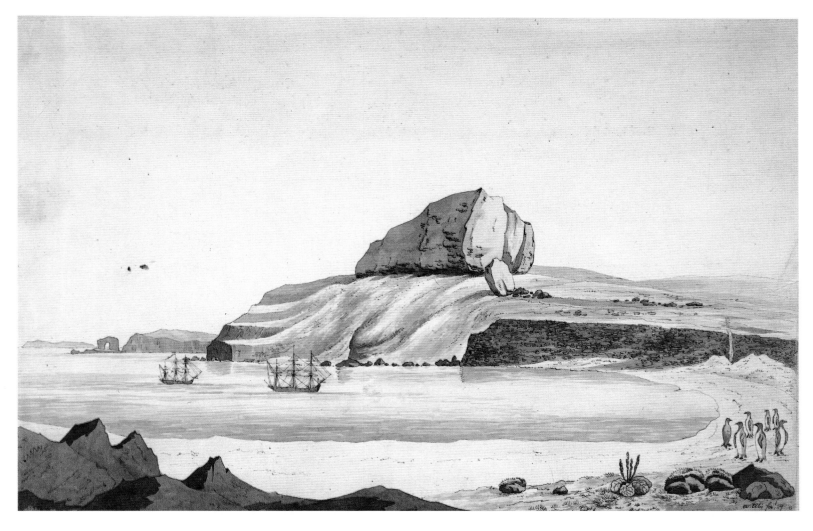

[2] See Stafford, (1977) 89-124.

[3] Stafford, (1977) 100, 121 fn. 83.

[4] Borlase (1754) pl. XI, opp. 166 with the following caption: 'To the Rev.<sup>d</sup> Charles Lyttleton L.L.D. Dean of Exeter. This Tolmen in Constantine Parish in Cornwall is most gratefully inscribed by Wm. Borlase'. This engraving is repeated in the 1769 edition of Borlase's book.

of rocks in particular. Torn between conflicting taste for formed and for unformed nature, artists often depicted rocks as an expression of nature's forces.[2] They embodied the 'mysterious aspect of nature', its propensity for chaos. They thus formed a potential alternative to traditional concepts of order, and had already aroused much interest on the first voyage (I.III-II4, I.I2I, I.I22). Apart from their aesthetic appeal in displaying the grandeur of nature, they 'carried you back, beyond all historical record into the obscurity of a totally unknown period'.[3]

Kerguelen Island, rarely visited by men, had been shaped by natural forces over millions of years. It might well therefore have appealed to the more reflective among Cook's company, to men such as William Anderson, David Samwell (Anderson's assistant and surgeon's second mate on the *Resolution*) and even to Webber himself in the way that wayside dolmens or the monuments of Stonehenge had come to be regarded by antiquarians and artists alike. Subjects with a similar appeal that might have been known to Webber had been recorded in works such as William Borlase's engraving from his *Observations on the Antiquities, Historical and Monumental of the County of Cornwall* (Oxford 1754) (plate 4).[4] Webber's approach in his own drawing of Christmas Harbour is neither imaginative nor romantic. It is addressed to the conveyance of accurate geological information; and yet it was subjects like it, disseminated by thousands of prints in the official accounts of Cook's voyages that helped to bring about a significant change in the aesthetic perception of landscape. Webber's landscape one might say was both informational and up to date. He made no attempt to close the composition by coulisse or repoussoir components; the landscape is seen as a segment of a wider panorama beyond both sides of the frame, a way of composing still to achieve full 'aesthetic' acceptance in the work of Thomas Girtin, (plate 5) some years later. Here it is tempting to see the influence on taste of such navigationally-oriented coastal views, the kind of view Webber was engaged on constantly to assist Cook's surveys. The emotional effect was to open up the composition, and suggest limitless space both laterally and in depth.

Five years after the voyage Webber re-drew the view for engraving (3.4), small changes being made in the vertical scale and figures. Cook and others in their journals had referred to the penguins being so unaccustomed to man that they were readily knocked down. The seal was introduced because the island had been found to be one of their breeding grounds. Both penguin and seal provided blubber that was turned into oil for the ships, so many were killed.

Such representations indicate another aspect of Webber's engagement. Though not a natural-history draughtsman and so not specifically charged with that kind of work he was, nevertheless, expected to record plant and animal life as aspects of the, as we would now say, ecology of a country.

At times he was also called upon to assist with the identification of natural history specimens collected and described by Anderson. At Christmas Harbour, Anderson wrote descriptions of three types of penguin encountered and compared them to specimens which Pierre Sonnerat had already observed and published in his *Voyage à La Nouvelle Guinée* (Paris 1776).

PLATE 4
*Dolmen, Monument in the Parish of Constantine, Cornwall.* Engraving by J. Green after William Borlase. From Borlase's *Observations on the Antiquities, Historical and Monumental of the County of Cornwall.* Oxford 1754, pl. XI (opp. 166)

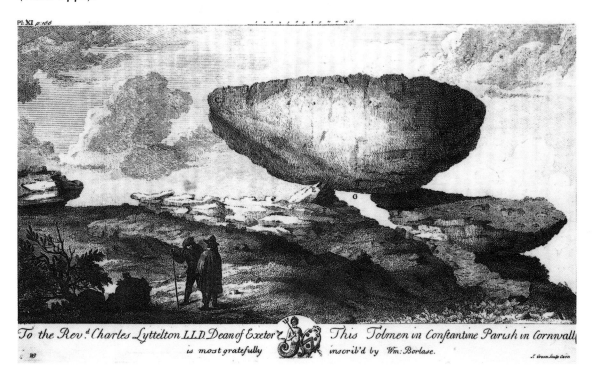

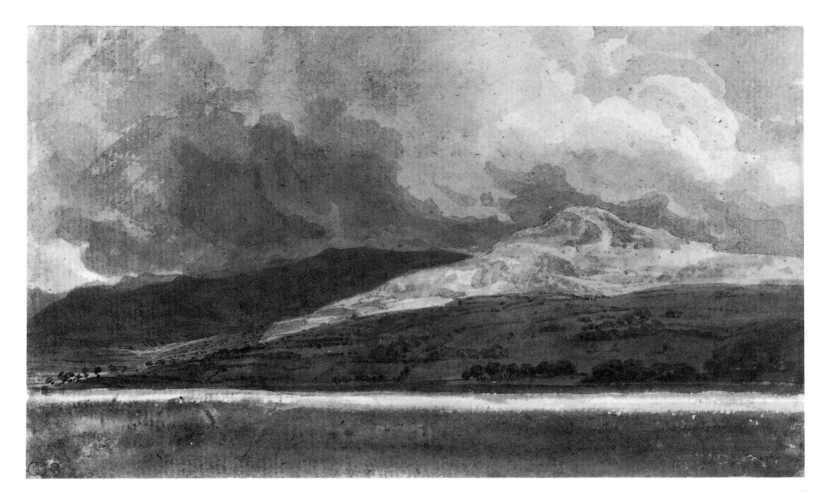

Concerning his first type, which he called 'Amphippus maximus the largest Penguin', Anderson wrote:

PLATE 5
Thomas Girtin, *Hills and Stream*, 1801, water-colour, 5⅞ × 10⅛ : 149 × 256. British Museum, Department of Prints and Drawings, London.

> The upper part of the body and throat are blackish or a leaden grey, the under part white with black feet. It has two broad stripes of fine yellow beginning on the sides of the head and descending by each side of the neck above its breast. The bill is longer than in the other sorts.[5]

This type was what is now known as the King Penguin, *Aptenodytes patagonicus*. This was drawn by Webber (plate 6; 3.431) but in a more accomplished way than had been achieved by Sonnerat (plate 7).

Concerning his third type of penguin, which he called 'Amphippus cristatus or crested Penguin', Anderson wrote:

> The upper part of the body and throat are black; the rest white except the upper part of the head, which has a fine yellow arch looking backwards and ending on each side in long soft feathers which it can erect as two crests.

And he added the comment: 'never seen by any of us before nor do we know that any writer has mentioned it'.[6] In Webber's drawing, Anderson's description is delineated in detail (plate 8; 3.431).[7]

It is clear from his journal that Anderson was preparing books on animals and plants collected on the voyage, and there need be little doubt that he hoped to make use of Webber's drawings to support his identifications and descriptions.

Webber in turn was influenced by Anderson's scientific interests. Although he does not appear to have made a drawing of Anderson's second type of penguin observed on Kerguelen, 'Amphippus australis or southern Penguin' (now known as the Gentoo penguin, *Pygoscelis papua*),[7] and it need not therefore further concern us here, Webber did introduce the two kinds of penguin he drew for Anderson into his *View of Christmas Harbour*, behaving in the manner Anderson described. Anderson had noticed his Amphippus maximus penguins 'keeping by themselves and walking in smaller flocks', whereas the smaller Amphippus cristatus penguins, 'were only found by themselves but in great numbers farther out on the shores of the harbour',[8] and this indeed is the way Webber has shown the two types in his *View* (plate 2).

Anderson's interest in botany on Kerguelen by nature of the place was limited to the cabbage plant as the only plant on an otherwise barren island. This he described in detail and praised for its anti-scorbutic quality. New to botanical science, Anderson named it *Pringlea antiscorbutica* in honour of Sir John Pringle. The medicinal value of the plant recommended

[5] Anderson in Cook, *Journals* III, 2, 773.
[6] ibid, 774, not mentioned in Sonnerat.
[7] For the two penguins drawn by Webber see Lysaght (1959) 341, nos. 123, 124.

[8] Anderson in Cook, *Journals* III, 2, 774.

PLATE 6
John Webber, *King Penguin (Aptenodytes patagonicus)*, December 1776, pen, wash and water-colour, 9⅞ × 6⅛ : 251 × 157. British Museum, Department of Prints and Drawings, London. (3.431)

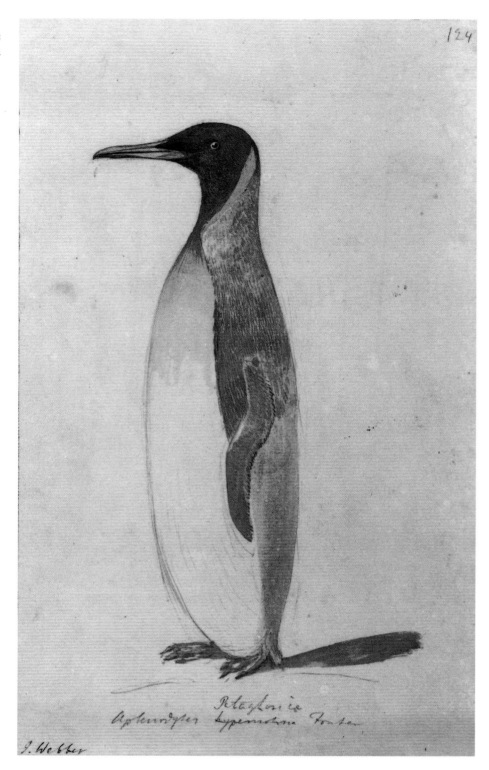

PLATE 7
*Le Manchot de la Nouvelle Guinée.* Engraving by C. Bacquoy after Pierre Sonnerat. From Sonnerat's *Voyage à Nouvelle Guinée*, Paris, 1776, pl. 113

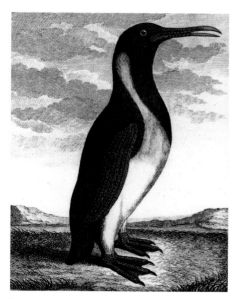

8

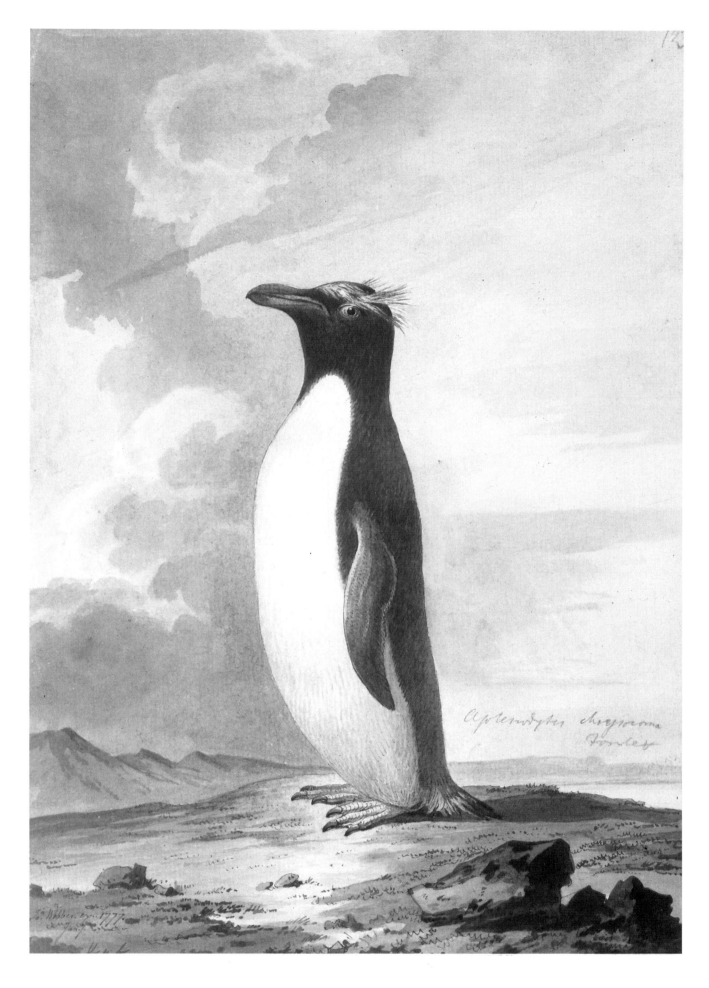

PLATE 8
John Webber, *Crested Penguin (Eudyptes chrysolophus)*, January 1777, pen, wash and water-colour, $10^5/_{16} \times 7^1/_4 : 262 \times 184$. British Museum, Department of Prints and Drawings, London. (3.431)

[9] ibid., 771-2.

it to seamen and Pringle's name drew attention to its use.[9] Webber drew the plant (plate 9; 3.426a) and also introduced it into his *View* at the lower right and left (plate 2).

Webber's *A View of Christmas Harbour* was therefore a kind of little overture for the voyage work to come. It fused several documentary interests. Cook would obviously have been keen on the representation of the island itself and its coastline. Anderson valued the inclusion of accurate representations of the plant and animal life, while Webber himself, by including the ships and some human interest, treated it as an historical event. As later works will reveal, not all such considerations were so well combined as here. But what he certainly did repeat as a kind of *leit-motif*, was the use of a harbour view and the reception of the ships by the local 'inhabitants'.

PLATE 9
John Webber, *Kerguelen Island cabbage (Pringlea antiscorbutica)*, December 1776. British Museum (Natural History), London. (3.426a)

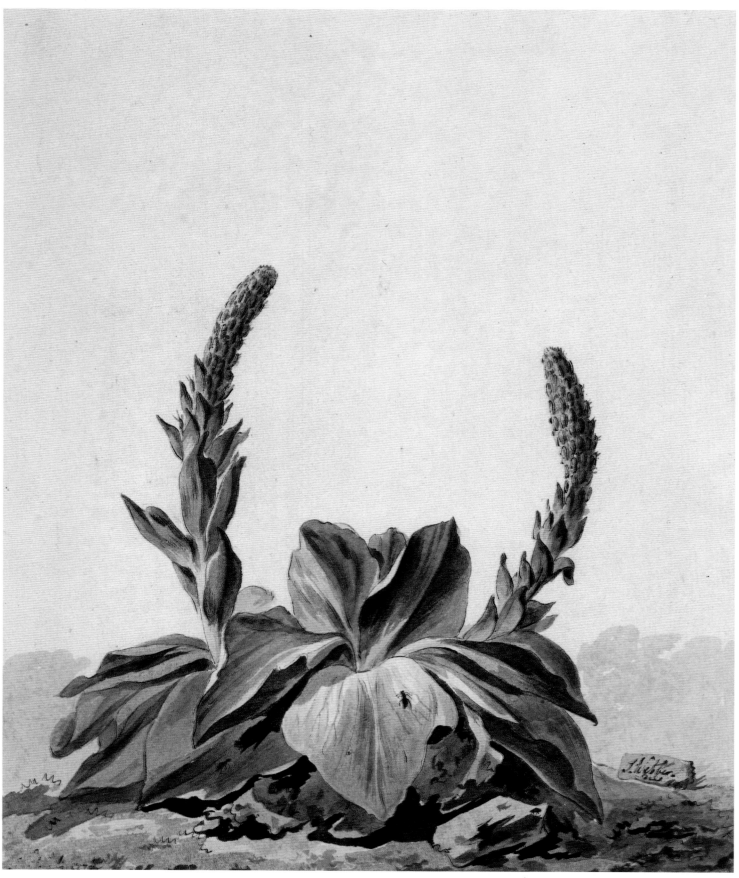

10

## 5. Van Diemen's Land:
## 24-30 January 1777

From 24 January to 30 January the expedition remained in Adventure Bay (Bruny Island), Van Diemen's Land. On approaching land Webber, as became his usual practice, drew a coastal profile for Cook, carefully noting topographical points and indicating the direction of the ship to the coast and its distance. He also drew a comprehensive view of the bay, listing it in his Catalogue (no. 1), but it is otherwise unknown. The land about the bay is mountainous, the hills covered with tall, straight eucalypts. These drew Anderson's attention. No representations of them are known to have been drawn by Webber but the gap is filled by the 'amateur' draughtsman, William Ellis, whose eye for natural history responded to some varied and remarkable aspects of the voyage. Noteworthy in this respect are his two drawings *View of the Fluted Cape, Van Diemen's Land, New Holland* (plate 10; 3.7) and the Tasmanian blue gum (*E. globolus*), in *Study of Trees . . .* (plate 11; 3.427). In the latter he depicted both its adult and juvenile foliage, together with some evidence of its burning by the local inhabitants.

Both Anderson and his assistant, Samwell, noticed the hollow trunks burnt out by the Tasmanians to provide shelter and their rudimentary huts built of sticks. Anderson's comparison of the Tasmanians, living in the inside of trees, to the fauns and satyrs of classical antiquity

PLATE 10
William Ellis, *View of the Fluted Cape, Van Diemen's Land, New Holland,* signed and dated January 1777. La Trobe Library, State Library of Victoria, Melbourne. (3.7)

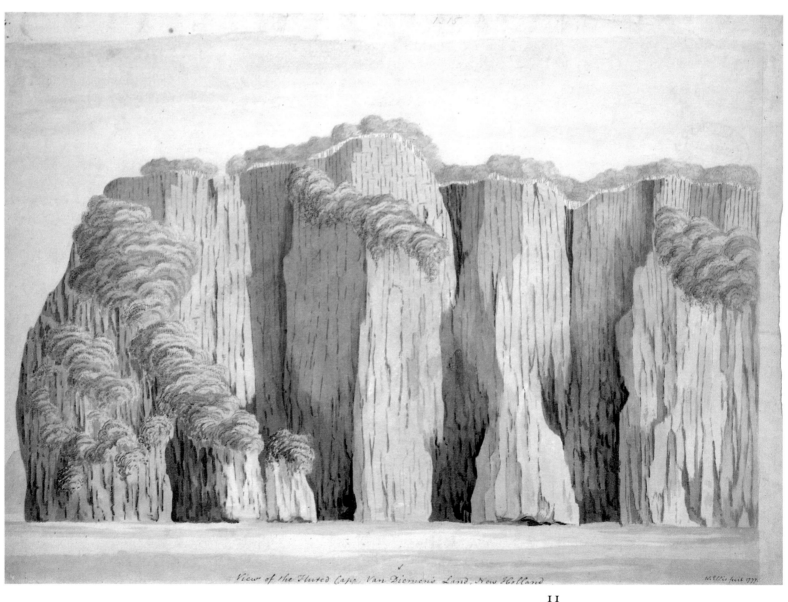

*View of the Fluted Cape, Van Diemen's Land, New Holland*

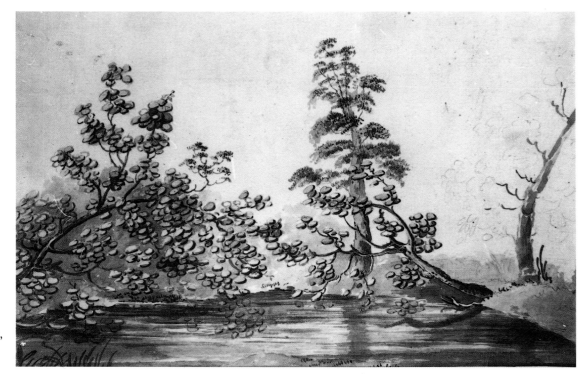

PLATE 11
William Ellis, *Study of Trees by a small
sheet of water in Adventure Bay, Tasmania*,
January 1777. La Trobe Library, State
Library of Victoria, Melbourne. (3.427)

[1] ibid., 786.

might have fired any eighteenth-century artist's imagination.[1] But we do not know whether Webber went into the country or saw such things.

In any case he had other work to do. In *An Interview between Captain Cook and the Natives* (plate 12; 3.12) Webber faced his first major task. He had to depict an event he had witnessed and make a 'history' out of it. It demanded an ability for quick, accurate recording together with a feeling for composition. Webber who had hitherto drawn only unmoving objects (portraits, figure studies, landscapes) found himself acting as a witness of a memorable but transient scene, which required highly specialized skills. Like Velasquez's *The Surrender of Breda* (plate 13) a masterpiece of the genre, such compositions sought to depict the crucial moment of contact, and the range of gestures and expressions of the participants. In drawings throughout the voyage Webber continually drew subjects illustrating Cook's reception by the indigenous peoples with whom he came in contact. Assuming a somewhat detached position Webber sought to document such decisive moments. Unlike Hodges, who depicted similar situations on the second voyage, and occasionally stressed the hostilities associated with them (2.128; 2.134), Webber preferred to show the moment of encounter on land and usually in an atmosphere of peace.

In his *Interview* Webber records an incident that occurred twice (28 and 29 January 1777), but it seems to owe most to the second occasion. Cook steps forward to meet a naked man who, like Cook himself, has separated himself from the rest of his people. On either side the followers of the two protagonists stand and watch the 'ceremony' of cultures meeting. The rowing boat in the foreground, pulled on the shore, provides the momently suspended link with the ships. The landscape, which is only lightly sketched in, seems to be bushy but is not well-defined, for the drawing is obviously unfinished. Yet even so, it is here that we may see, for the first time, Webber's predilection for lean, elongated figures, with small heads, an idiosyncrasy that runs through most of his full-length figure drawings and may best be explained as his manner for endowing nobility. Some modern scholars have criticized Webber for this, not understanding his style and usage.[2] It is mostly in his 'history' paintings that Webber employs such elongated figures, using it far less in his portrayal of individuals in portrait work.

On this occasion Webber also had to portray naked figures. Again his training as a landscape and a portrait painter (it is uncertain whether he had ever attended life-classes) did not stand him in good stead. Of all his known works, the *Interview* is the only one that depicts totally naked figures.

The apparent lack of shame with which the Tasmanians presented themselves gave rise to astonishment. Samwell observed that the men were 'constantly employed in pulling or playing with the prepuce'.[3] Of course, it was an act not normally depicted in either history or portrait painting; and Webber, predictably, did not portray it. And it may be noted also that both his *A Man of New Holland* (plate 14; 3.10) and *A Woman of New Holland* (plate 15; 3.13) are cut off at their hips. But was this entirely Webber's choice?

Following the reception accorded Hawkesworth's account of the first voyage Cook's

[2] This general criticism goes back to Beaglehole's introduction to Cook, *Journals* III, 1, ccxi.

[3] Samwell in Cook, *Journals* III, 2, 993.

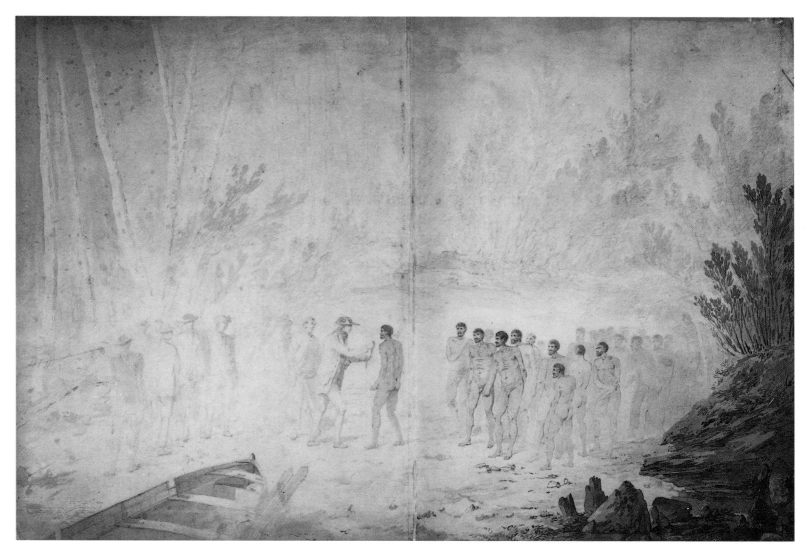

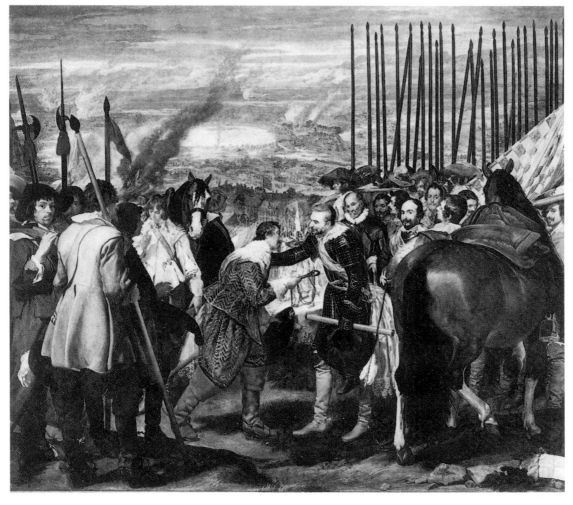

13

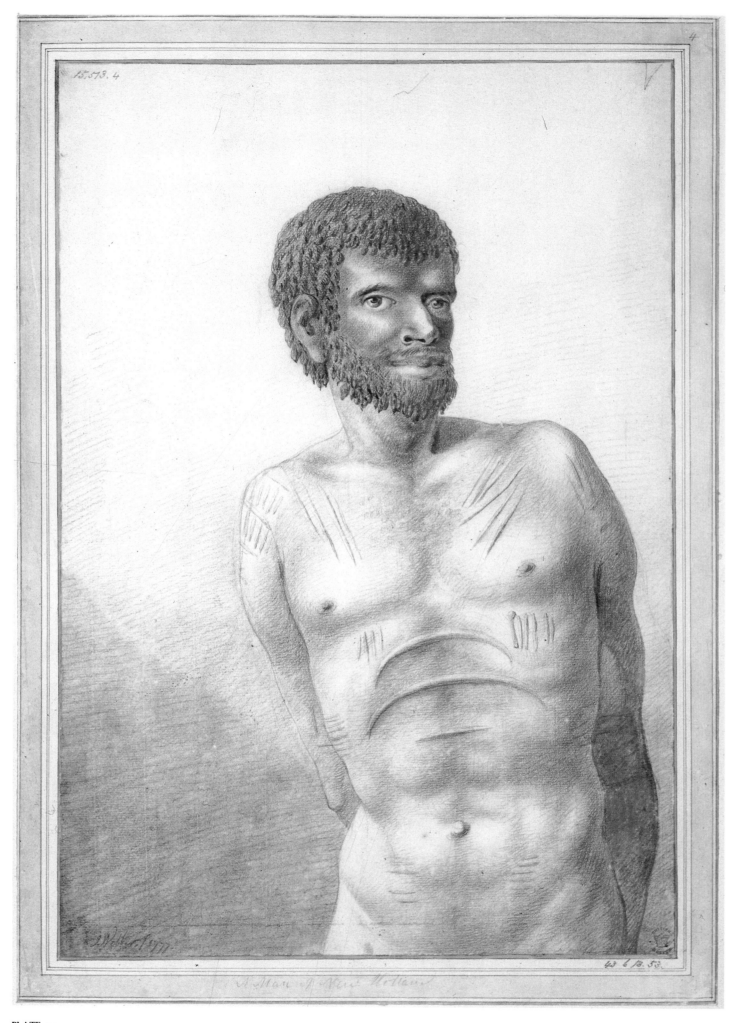

PLATE 14
John Webber, *A Man of New Holland*,
January 1777-. British Library, London. (3.10)

14

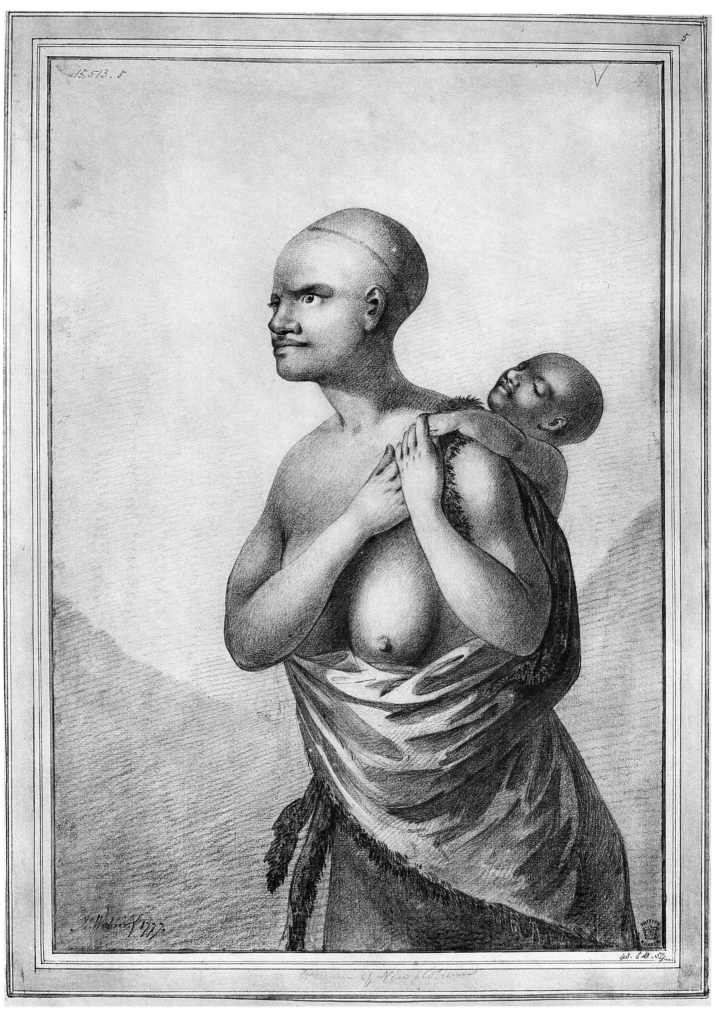

15.513.5

PLATE 15
John Webber, *A Woman of New Holland*,
January 1777-. British Library, London. (3.13)

15

[4] Cook, *Journals* II, cxlvi.

[5] Dutton, (1974) 21-3, 145-7.

[6] Samwell in Cook, *Journals* III, 2, 994.

[7] Anderson in Cook, *Journals* III, 2, 788.
[8] ibid.

[9] Anderson and Samwell respectively in Cook, *Journals* III, 2, 792-3, 991.

editor John Douglas, with Cook's explicit encouragement, ensured that in the official account of the second voyage 'nothing indecent [should] appear in the whole book'.[4] Cook no doubt ensured that the same injunction held for material destined for the account of his third voyage. Some years later, on Baudin's voyage, the young artist, Nicolas-Martin Petit (-1804), was able to take a freer view of such matters, and depicted the Tasmanians in full length, playing in their traditional way with their penises and urinating[5] — all of which had been described in detail by Anderson twenty-five years before.

The people of Van Diemen's Land were the first non-Europeans to come to Webber's attention and he made the first representations of a society and culture that barely a hundred years later was virtually extinct. Three portraits by Webber of Tasmanians exist, and all three correspond fairly closely to the written descriptions of Cook, Anderson and Samwell. They noticed that the men had frizzy and woolly hair which they coloured with red ochre paint. Webber stressed this feature by adding red crayon to his drawing of *A Man of New Holland* (plate 14; 3.10). He also noted the cicatrized incisions on the men and the characteristic posture, the right arm crossed behind the back grasping the left. Webber also drew the portrait of an older, middle-aged man (3.12).

According to Samwell the Tasmanian women 'were altogether the ugliest Creatures that can be imagined in the human Shape'.[6] They wore short kangaroo skins on their shoulders for the sake of their children which they carried slung over their backs. Webber depicts his *A Woman of New Holland* (plate 15; 3.13) thus carrying her child and allowing it apparently 'to hang backwards and sleep expos'd to the heat of the sun',[7] and confirmed visually that 'the breasts of those who had born children were loose and pendulous',[8] a feature modified in the published engraving (3.13A).

In then delineating the first of the peoples who came under his observation Webber maintained a close accord between his visualizations and the verbal descriptions of the journals. But there is also a mild kindness about the portraits that suggests that he did not draw them without experiencing some feelings of sympathy.

Anderson and Samwell were perhaps the most astute observers of natural history aboard the *Resolution* and probably influenced Webber as to his subject-matter, and its accuracy and detail. It was probably due to their influence that he involved himself from the beginning in natural history drawing. In Adventure Bay, Webber completed some bird drawings, also one of an opossum (plate 16; 3.434) and a lizard (3.431);[9] both had been shot and taken aboard. Drawings of this kind could be completed at sea between landfalls when there was little else to record. On such occasions doubtless Webber received advice and instruction from the keen amateur naturalists.

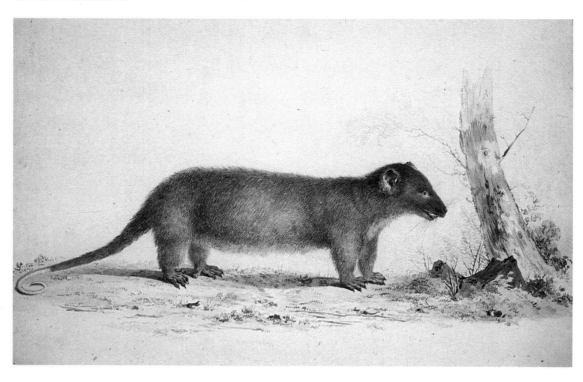

PLATE 16
John Webber, *An Opossum of Van Diemen's Land*, January 1777. Dixson Library, State Library of New South Wales, Sydney. (3.434)

## 6. New Zealand: 12-25 February 1777

In New Zealand the expedition rested for almost a fortnight in Ship Cove, Queen Charlotte Sound. From this time seven drawings and studies have survived, which are all concerned with the Maoris and their way of life. Relations on the whole were friendly, though clouded by the memory of the fatal accident which had occurred in December 1773, when a boat full of people from the *Adventure* under Captain Furneaux was taken and all were killed at Grass Cove.[1] The natives were suspicious that Cook had come back with the idea of revenge, while for their part the British were on their guard, considering the natives warlike and treacherous. The tents and observatory were heavily guarded, and small excursions into the adjacent country were only undertaken in large parties that were armed. Webber's freedom to wander around the location was thus much restricted.

According to Cook, when the ships lay in the Sound the Maoris took up their temporary habitations near them in order to trade. They would come to the ships in their canoes to offer their goods but the British also came on shore. In *Captain Cook in Ship Cove, Queen Charlotte Sound* (plate 17; 3.14) Webber illustrated the first encounter which occurred on 13 or 14 February. Cook, on the right, armed with a sword and accompanied by two of his men, is greeting a Maori chief. Behind him in the jolly boat marines cover his way of retreat. Beyond, in the bay lie the *Resolution* and the *Discovery*. The rest of the picture towards the left is occupied by a group of about twenty Maoris, sitting or standing in front of their huts. Some are occupied grilling fish. Except for a figure on the right who is carrying a *taiaha* over his shoulder, no weapons of these people, famed for their belligerence, can be seen. This impression of peacefulness is reinforced by the inclusion of women and children, suggesting that whole families dwelt in these temporary shelters. In the foreground and the background Maori canoes

[1] Cf. Cook, *Journals* II, 749-52.

PLATE 17
John Webber, *Captain Cook in Ship Cove, Queen Charlotte Sound*, February 1777. National Maritime Museum, London. (3.14)

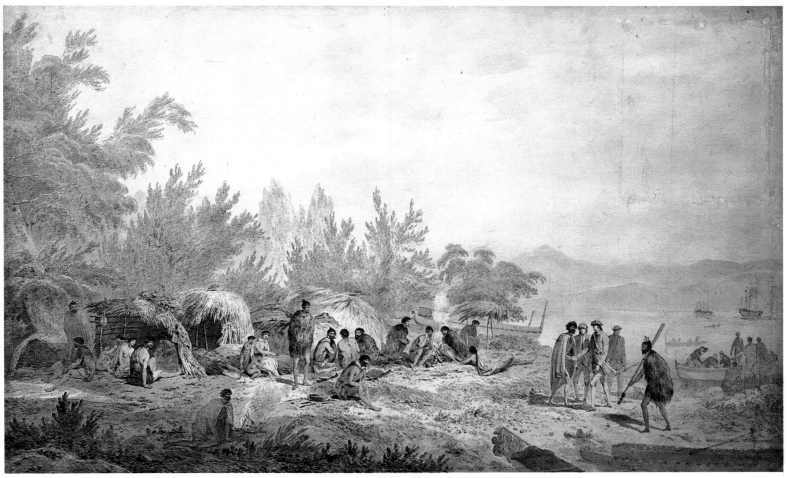

17

lie in the water or are pulled ashore, adding to the liveliness of the scene.

The picture holds a commanding position among Webber's drawings from the voyage largely because of its size and the number of figures represented. It is one of those 'history' drawings that document events of the expedition in a narrative manner. Cook, the peaceful hero, the pacifier of the South Sea nations, has gone on land to establish good relations with those people on whose food supplies the fate of the expedition so much depended. He is shown achieving this end with daring and almost single-handedly, for the ships are at quite a distance. Cook is of the same height as his fellow men, and when he steps on shore he shakes hands. His posture is in no way ennobled, nor are the Maoris represented as heroes. Instead Webber seems to have been at pains to show them in as many natural positions as possible.

Admittedly a few of the figures recall older iconographic conventions. That of the woman with children around her might possibly be based on a Caritas group, or the seated Maoris resting their heads on their hands might remind one of the stoical Indian in West's *Death of General Wolfe* (National Gallery of Canada, Ottawa) but in general the poses are much too indiscriminate to suggest heroic intentions. Webber described the drawing in his Catalogue as 'A Representation of the Natives in their temporary habitations', and it is the housing aspect that is important. Webber's *Maori Huts* (plate 18; 3.15) pursues the same interest, showing the Maoris seated beside their dwellings. Habitations normally constituted a separate section in Cook's own systematic accounts of peoples encountered. The Royal Society had advised him to do so on his first voyage, for housing was an important indicator of the level of civil society. With it went a certain interest in domesticity, such as Maori methods of cooking.

In order to provide a balanced account it was desirable to delineate the Maori's permanent dwellings. These are shown in Webber's drawings made at a Maori *pa* (plate 19; 3.16); probably the fortified village on the island of Motuara, visited by Cook on 15 February and by Anderson on 20 February. Cook had already been there in January 1770 when he found it deserted, and Furneaux had established his winter quarters there on the second voyage, when it was also used as William Bayly's observatory, and a garden was planted. When Cook returned in February 1777 he found the *pa* had been built again, but again was uninhabited. This gave Webber an opportunity of executing drawings inside the *pa*. His two preserved sketches (3.18, 3.19) are pencil outlines obviously intended for development. One shows a panoramic view with four houses and palisades in front; the other features a palisade and larger house which rather fits Anderson's description about their being 'built exactly in the manner

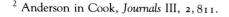

[2] Anderson in Cook, *Journals* III, 2, 811.

of our country barns'.[2] The house Anderson described was as distinguished by size and

PLATE 18
John Webber, *Maori Huts*, February 1777. Knatchbull Collection, Kent. (3.15)

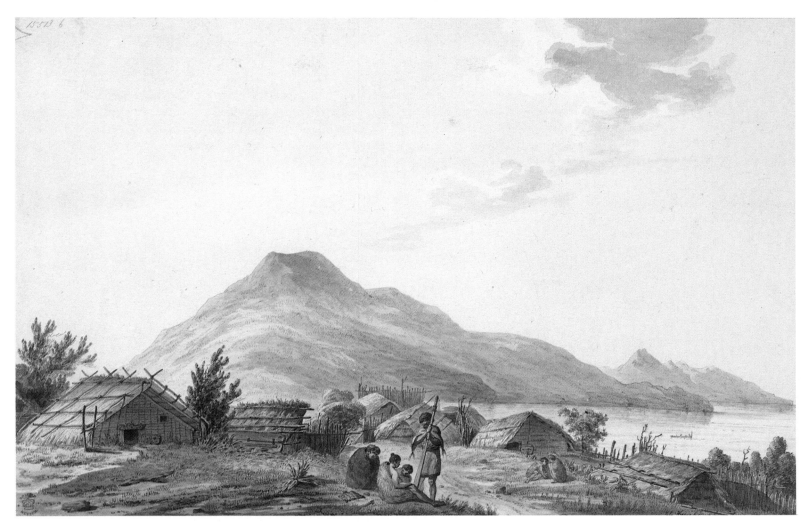

construction from the rest of the smaller houses, as is Webber's example, and the fact that he sketched it on its own could suggest that he was aware of its importance.

PLATE 19
John Webber, *The Hippah*, February 1777-. British Library, London. (3.16)

Webber's later and more accomplished drawing of the scene (plate 19; 3.16) provides a most comprehensive view of the *pa* and relates it to the landscape overlooking the sound. Though Cook and Anderson both tell us that the *pa* was uninhabited, Webber introduces a man leaning on a staff into the foreground, with three figures seated on the ground nearby. For Webber the scene provided an opportunity to depict Maori weapons, and flaxen garments (*pake pake*). Yet the group as a whole is presented so as to strike a humane and deliberately pensive note, one which would appeal to current European sentiment. European painters were not yet ready to renounce staffage elements from their landscapes: rural figures innocently conversing, playing the flute or quietly tending their cattle. Even when they were called upon to depict a different culture, the activity of such figures was still provided as a keynote to the mood of the picture.

Webber also completed a fine pen and wash drawing, a portrait of a Maori chieftain Kahura (plate 20; 3.22) during the stay at Queen Charlotte Sound. He is dressed in a *pake pake* and wears ear pendants of green stone, his hair is combed in the topknot fashion and he shows tattoo marks on the left side of his face. Kahura was a powerful chief who was responsible for the massacre of the *Adventure* crew in 1774. Though he was quickly established as the main aggressor, Cook showed clemency towards him and permitted him to come on board the *Resolution*. 'I must confess', Cook wrote 'I admired his courage and was not a little pleased at the confidence he put in me.'[3] It was at Kahura's visit on 25 February that Webber took his portrait. This circumstance was thus described:

> After his [Kahura's] first fears were over he was so far from showing any uneasiness that on seeing a Portrait of one of his country-men hanging up in the Cabbin, he desired to be drawn, and sat till M<sup>r</sup> Webber had finished without the least restraint.[4]

Cook's remark is important in two ways. For once, it establishes — with some considerable certainty — the identity of the sitter, for on the whole Webber was not in the habit of taking note of the sitter's name. In the majority of cases his subjects are therefore unidentifiable. Only in a few instances, where Cook faced figures of great importance, such as Paulaho or Tu do we know their names. Drawings of people were not annotated as specifically as coastal views. Portraits were not considered to represent individuals but examples of type

[3] Cook, *Journals* III, 2, 69.

[4] ibid.

specimens, representatives of their country or island. As to what mode of selection was used we do not know. It was not always the chieftains who were singled out as proper subjects. As in Kahura's case the incentive to be portrayed did not come from Cook or Webber, but from Kahura himself.

What is particularly interesting in this regard is that Cook had a portrait of a Maori hanging in his cabin. Whether it was the work of Hodges from the previous voyage or one by Webber, we do not know. Cook possessed an admiration for the work of both artists and he may well have decided in any case to display portraits of chieftains and others in his cabin as a means of cultivating friendship.

PLATE 20
John Webber, *A Portrait of the Chief Kahura [Kahoura]*, February 1777. Dixson Library, State Library of New South Wales, Sydney. (3.22)

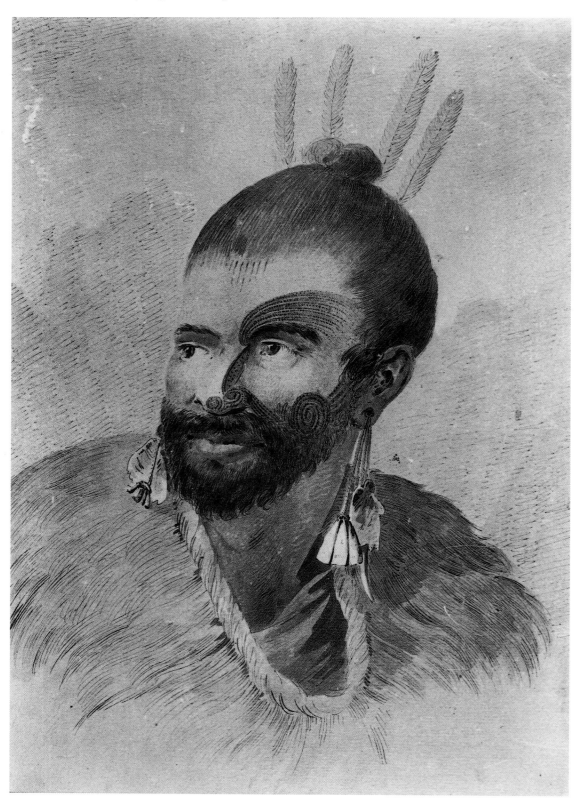

# 7. Mangaia, Cook Islands: 29-30 March 1777

On 25 February Cook's ships left Queen Charlotte Sound. On 29 March the island of Mangaia was sighted. Because of the reef that surrounded the island, no landing was effected and the expedition continued its course the following day. Some information, however, was gained about the place and its people. On 30 March a canoe with two paddlers came out to meet the ships. Anderson says it was the only canoe they saw (3.27).[1] He provides a descriptive account of it:

> The fore part had a board fasten'd over it to prevent the sea getting in on plunging, and the stern post was a thin board about five feet high fork'd at the upper part. The lower part of the boat was of white wood but the upper black . . .[2]

As to the appearance of the canoeists we learn they were dressed with only a girdle between their legs (the *maro*), that they wore beads, knotted their hair on the crown of their head and held it together with a string of cloth. Webber's drawing of the canoe corresponds to all these points except for the corpulence of the Mangaians on which Anderson also remarked.[3]

Before it was sufficiently clear that the ships would not stay, Cook had ordered a boat from each ship to sound the reef. The boats came sufficiently near the shore to observe the crowd of people and their dwellings. But no corresponding drawing is known to exist.

While Cook's boat approached the island it was visited by a Mangaian who had formerly occupied the canoe that Webber drew. He was later induced to come on board the *Resolution* where, through Omai's services, he was questioned about his island. He was called Mou'rooa (also Mourua and Kavoro). Anderson made an indirect reference to him when he described the ear-lobes of the Mangaians, noting that they were 'pierc'd or rather slit, in which one of them stuck a knife'.[4] Webber's drawing *A Man of Mangaia* (plate 21; 3.31), with a knife through his right ear probably depicts Mou'rooa. The knife was probably a trade knife that he had gained earlier in the day by trading, one of those twenty-four dozen common knives from Matthew Boulton of Birmingham that Cook had ordered through the Admiralty, with other provisions, 'in order to exchange for refreshments; with the Natives of such unfrequented Countries as (they) may touch at'.[5] What is particularly well observed in the drawing is the scar, which both Cook and Anderson mention, on Mou'rooa's forehead. Clearly visible in the drawing it was lost in engraving.

[1] Anderson in Cook, *Journals* III, 2, 828.

[2] ibid.

[3] Anderson in Cook, *Journals* III, 2, 829.

[4] ibid., 827.

[5] Cook, *Journals* III, 2, 1492.

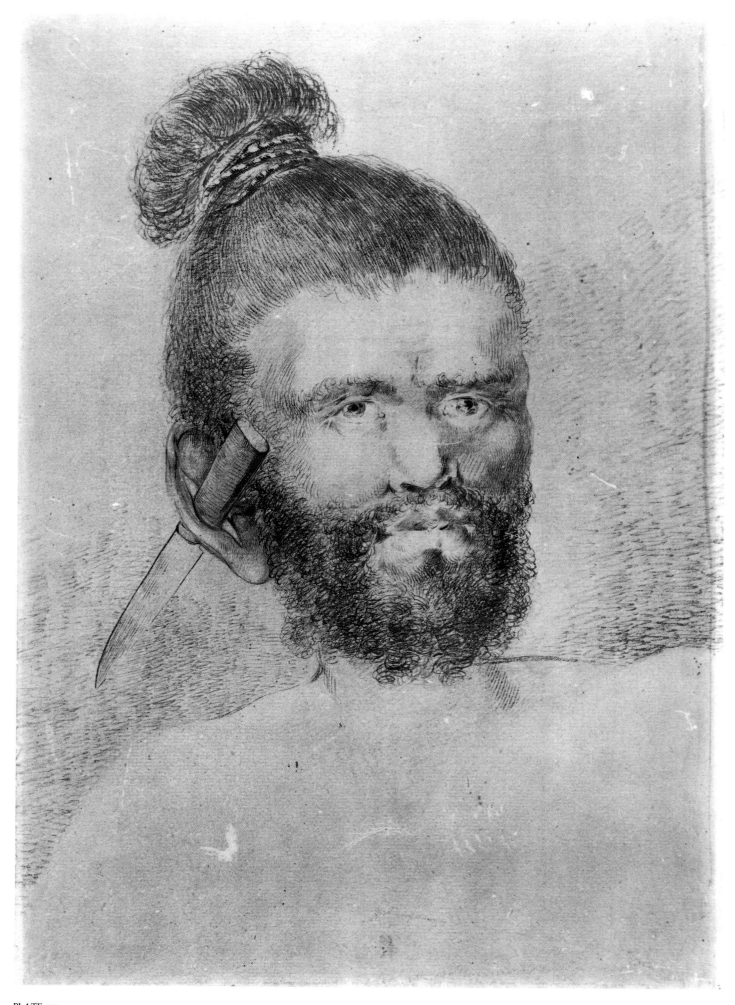

PLATE 21
John Webber, *A Man of Mangaia*, March
1777. Dixson Library, State Library of
New South Wales, Sydney. (3.31)

22

## 8. Atiu (Wateeo), Cook Islands:
   2-3 April 1777

Two days later, on 2 April Cook again saw land, this time the island of Atiu. The ships were soon visited by canoes which Cook described as

> small, long and narrow and support[ed] by outriggers . . . The stern is elevated about 3 or 4 feet something like a ships stern post, the head is flat above, but prow-like below and turns down at the extremity like the end of a fidle.[1]

[1] Cook, *Journals* III, I, 87-8.

And not to leave us in any doubt, Cook adds: 'The drawing which Mr. Webber made of these Canoes will convey the best idea of them'.[2] Webber listed a canoe of Atiu in his Catalogue (no. 63), but the drawing appears not to have survived. Unfortunately Webber was not able to do more drawings of the island and its inhabitants. Burney, Gore, Anderson and Omai were the only ones who visited Atiu, attempting to procure fresh food for the cattle. Though they were detained by the natives for a day, their trip was meant to be a short one. That Webber was not among the men who visited the island, throws a light upon his practice as travelling artist. Unlike any modern reporter who takes pride in venturing to areas of crisis and who would use any opportunity to provide himself with information, the travelling artist of the eighteenth century seems to have enjoyed a much more 'official' status. This is important to remember throughout the description of the voyage. Webber was not a front-line man and seems to have been protected from dangerous enterprises. He appears to have gone on land either as a companion of his commander or when a secure landing had been accomplished.

[2] ibid., 88.

# 9. Manuae, Cook Islands:
## 6 April 1777

The last of the populated islands of the Cook group to be visited was Manuae, the larger of the two Hervey Islands already discovered and so named on Cook's second voyage, but at that time considered uninhabited. Cook made no landing, but several boats came out to meet the ships. One was a double canoe, which contained six natives, naked except for their girdles. Webber made a drawing of it (plate 22; 3.37). Its shape accords exactly with Cook's description of it.[1] In point of composition the drawing is similar to the one of Mangaia, in that the canoe is placed in front of the coastline.

[1] Cook, *Journals* III, 1, 90. Cook added 'see the drawing'.

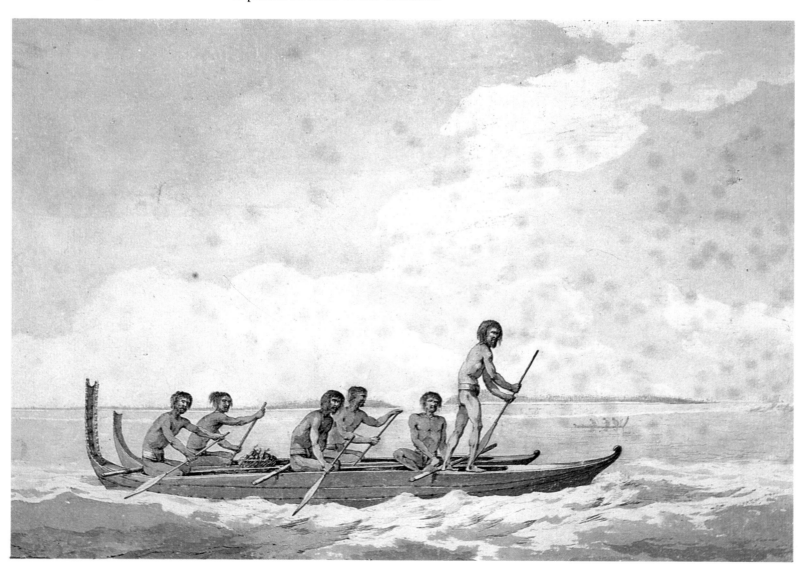

PLATE 22
John Webber, *Six men in a canoe off Manuae*, April 1777. Dixson Library, State Library of New South Wales, Sydney. (3.37)

# 10. Palmerston Island, Cook Islands: 14-15 April 1777

No drawings by Webber of this island are known — except of a fish among Webber's album of natural history drawings in the British Museum (plate 23; 3.431). The specimen may well have been collected and brought on board, as was customary on such occasions, and there is some likelihood that Webber drew and coloured it for Anderson. It was here that Anderson watched a natural spectacle, which must have taken his breath:

> At one part of the reef which looks into or bounds the lake that is within, there was a large bed of Coral almost even with the surface, which afforded perhaps one of the most enchanting prospects that nature has any where produc'd . . . the sun shining bright expos'd the various sorts of coral in the most beautiful order . . . all which were greatly heightened by spangles of the richest colours that glowd from a number of large clams which were every where interspers'd and now half open. But the appearance of these was still inferior to the number of fishes that glided gently along, playing their gambols amongst the little caverns form'd by the Corals . . . The colours of the different sorts were the most beautiful that can be imagin'd, the yellow, blue, red black & far exceeding any thing art can produce and indeed they seem'd to borrow a fresh lustre from the bright sun shine & stillness of the water. Their various forms also contributed to increase the richness of this submarine Grotto in such a manner that the Eye could never tire but view every spot with fresh transport, and wonder for what purpose Nature

PLATE 23
John Webber, A *fish of Palmerston Isles*, April 1777, pen, wash and water-colour, 7⅝ × 10⁷/₁₆ : 193 × 265. British Museum, Department of Prints and Drawings, London. (3.431)

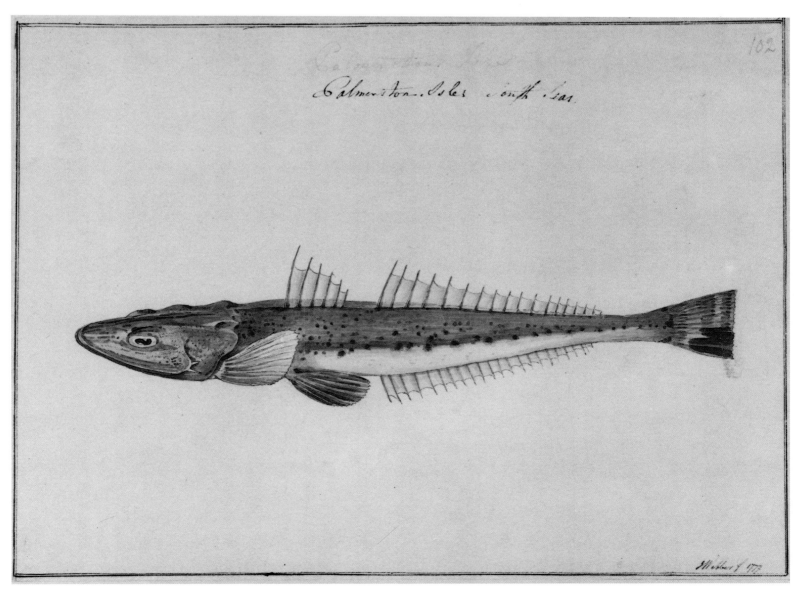

[1] Anderson in Cook, *Journals* III, 2, 851.

should want to conceal a work so elegant in a place where mankind could seldom have an opportunity by enjoying it of rendering the just praise due to her wonderfull operations.[1]

We have often had occasion to draw upon Anderson's precise information and perceptive remarks. Intellectually, he seems to have been one of the most brilliant persons on the expedition, combining both rational and systematic observation with a vivid, emotional response to natural beauty. His remarks about natural phenomena and his mode of description reminds us at times of the interpretative and philosophical approach of the young Forster of the second voyage. His description in the above quotation of the richness and vivacity of the tropical colours, the stillness of the water and the lustrous reflection from the bright sun, animated by the fishes 'playing their gambols' and the complex structure of the little coral caverns, combines into a kind of landscape hitherto not experienced.

Wonder about the smallest of living creatures and the overwhelming richness of their appearance is very much an experience that developed from the eighteenth century passion for natural history and from the Cook voyages in particular.

But we must not assume that William Anderson came to the Pacific unprepared for the beauty of coral. One of Solander's oldest friends, the well-known naturalist, John Ellis

PLATE 24

*Groups of different Corallines growing on Shells, supposed to make this Appearance on the Retreat of the Sea at a very Low Ebbtide.* Engraving by A. Walker after a drawing by [Charles] Brooking. From John Ellis, *An Essay towards a Natural History of the Corallines*, London, 1755, frontispiece.

(1710?-1776), had published his highly influential *Essay towards the Natural History of the Corallines* in 1755, and we may assume that Anderson knew of it, even if he did not take a copy with him on the voyage. It would appear that John Ellis first proposed the construction of artificial marine landscapes of coral for their aesthetic beauty (plate 24).

In art as in science this shift towards an aesthetic appreciation of natural objects, from a conceptional to a more personalized approach evolved slowly. While Parkinson, for example, as a natural history artist was well accustomed to render his drawings of plants and fish in brilliant colours as a means of information, his drawings of landscape and figures were in pencil and sepia wash. Until the late eighteenth century techniques of drawing were largely confined to line and greyish tones, with coloured chalks limited to highlights. Colour was usually reserved for painting, and here too colour palettes rested largely upon the conventions of the old masters. Colour in drawings could only be developed when artists were prepared to appreciate colour as an autonomous means of personal impression and reflection. Hodges seems to have been aware of this possibility during Cook's second voyage, as even his drawings from the Antarctic and his water-colours from Dusky Bay seem to express. For Webber, however, colour had not yet attained that kind of autonomous importance. His response to the colours of the South Seas was slow, and though it is true that some of his drawings are brilliantly coloured, he seems not to have responded to the kind of emotional excitement that we meet in Anderson's descriptions. Webber's attitude to colour was largely conventional and traditional, and he used it as an auxiliary to drawings for shading light and giving a uniform colour-tone to a scene. It cannot be denied that with his greater experience of the Pacific Webber also increasingly became susceptible to the brilliance of tropical light. It finds expression in his water-colours, but as yet it did not radically alter the character of his art. He does not seem to have drawn any profound conclusions from his shipmate Anderson, for when on the homeward voyage he executed smaller versions of the originals for the engravers, his colours are mostly standardized, notwithstanding their delicacy in execution.

# 11. Nomuka (Annamooka), Tonga or Friendly Isles: 1-14 May 1777

On 2 May 1777 the expedition reached Nomuka and anchored in the harbour on the north side of the island, which Cook had already used in June 1774. Both ships were in want of refreshments. A camp was erected on shore both as a trading post and a workshop for repairs. Watering, cutting wood and above all bartering for food became the main occupation during the next days. In Webber's drawing of *The Harbour of Annamooka* (plate 25; 3.38) the building of relationships and trafficking with the Nomukans are embraced within a broad panorama of documented history.

The ships however, are in this case too far out at sea to be included in the picture, though — as before — their presence is hinted at by the ships' boats in the harbour. Some are loaded with water barrels, others are being used for transport of food, which is piled up on shore. In the left foreground a native outrigger is being pulled on to the shore, surrounded by Tongans who lift or carry away fruit. They are moving towards the right, where, between a large hut and a group of coconut palms a large clearing has been made for a group of Nomukans, sitting cross-legged in a circle. In the middle of this hogs, yams, plantains etc, are collected and the marines within the circle are probably engaged in transporting goods received. The presence of the marines is underlined by a pyramid of rifles. They were stationed there 'for the protection of the horses and the waterers'. Two horses may be seen to the right of the hut resting under the shade of a large breadfruit tree. A few yards in front of the tree stands a native hut with open sides and a thatched roof, built on poles. Several Nomukans sit within.

The picture is a narrative of typical incidents such as accompanied a landing: the watering of the ships, the trading, the collecting and transporting of food. There is a complexity of action and movement which only unfolds itself on close examination. Many studies were necessary to build up a comprehensive scene like this. With the exception of a page probably from Webber's sketchbook, showing the coastline of the bay and the hut at right (plate 27; 3.42), these are no longer known. Not only at Tonga, but at all major ports of call, in Nootka Sound as much as in Kealakekua Bay, Webber observed similar scenes, vignettes of daily life. Though he may not have drawn these regularly at all stations, the fact that occasionally they are encapsulated in his pictures shows he was aware of them. By them, Webber reflected the

PLATE 25
John Webber, *The Harbour of Annamooka.* May 1777-, British Library London. (3.38)

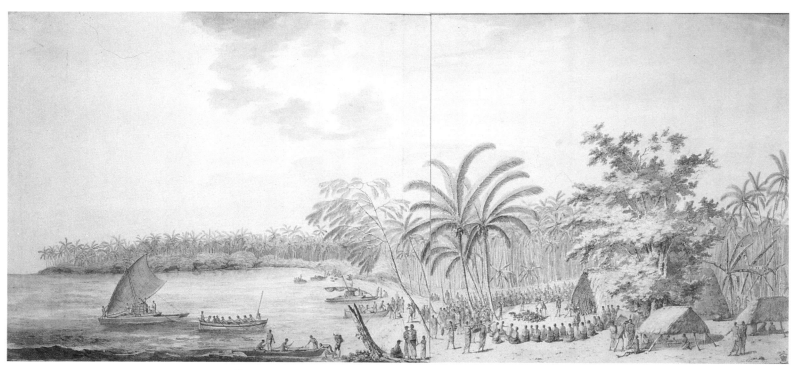

28

PLATE 26
Jan Brueghel the Elder, *Market on a River*, 1611, oil on panel, 16⁵⁄₁₆ × 23¾ : 415 × 605. Rheinisches Landesmuseum, Bonn.

expedition as a history-making event in itself. To have noticed and understood this is a new element among the body of visual representations from Cook's voyages. Neither Parkinson nor Hodges made the maintenance of the ships a proper subject of their art. Furthermore each incident depicted is given much the same weight in Webber's drawings, indeed his presentation is so impartial that we cannot be sure which of the two British officers near the hut in the foreground is Cook. Webber's tendency to demonstrate the complexity of action is historical in an eventful and documentary sense but it is also anti-heroic. The artistic roots for such an approach are located in Dutch and Flemish seventeenth century painting, such as Jan Brueghel's *Market on a River* (plate 26) in which the reportage of events is raised to the level of art.

Webber's feeling for space and his understanding of perspective must also be remarked upon in this instance. Both are notable in all his voyage landscapes: making the space and the extension of the landscape explicit, yet treating the background with the same clarity as the foreground. There is little if any chiaroscuro in his drawings, he seeks instead to provide a total view, giving sharp attention to detail. He delimits the natural boundaries of the drawing while clearly defining the focus of action. In the case of the present picture, a glimpse of the ocean is still provided. As the bay swings round to form a sheltered harbour, human habitations with signs of cultivation begin to 'zoom' in, such as the palisaded fence behind the circle of people.

PLATE 27
John Webber, *Three Nomukan sketches*, May 1777. The Public Archives of Canada, Ottawa. (3.42)

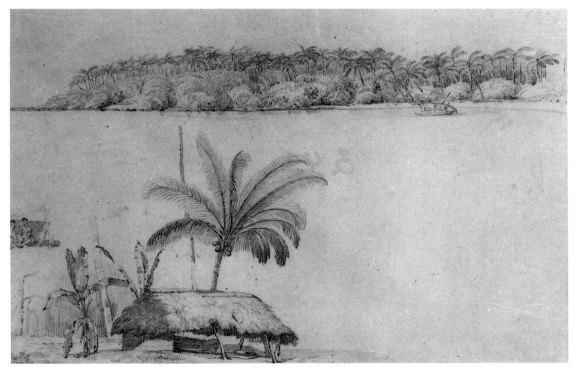

# 12. Lifuka (Ha'apai), Tonga: 17-29 May 1777

Cook left Nomuka on 14 May for the Ha'apai group of islands of northern Tonga. On 17 May he landed at Lifuka, an island which Anderson found in several respects superior to Annamooka.

No. 22 in Webber's Catalogue is a drawing termed 'The manner of receiving, entertaining and making Captain Cook a present of the productions of the Island, on his arrival at the Happi'. The drawing to which this refers is in the British Library *The Reception of Captain Cook at Hapaee* (plate 28; 3.45) and a smaller version in the Dixson Library (3.46). They depict an incident which took place on 18 May 1777. In terms of both composition and comprehensiveness this must qualify as one of Webber's most successful drawings.

The centre of the picture is dominated by a large circle of people seen from above; Webber possibly observed the occasion from some elevated position or simply adopted the bird's eye perspective as a useful device. Cook is seated between two chieftains inside a hut. People on all sides, either laden with fruit, or simply as spectators, are flocking to the ring. Others are attempting to get a better view from the trees. Cook is thus made the object of an honorary act, by which friendship between the Tongans and their foreign visitors was demonstrably cemented. Cook gives an extensive description of the scene, which explains the meaning of the two piles erected on either side of the ring consising of food (yams, breadfruit, plantain, coconuts, sugar cane etc.), and were later given to Cook as a present from the chiefs. After the victuals had been deposited, boxers and fighters with clubs entered the arena successively. In Webber's drawing two pairs of contestants are to be seen engaged with each other, and though their fighting did not lack vigour, their prime purpose was to entertain the watching crowd.

A similar event took place in Tongatapu a month later, on 18 June when Cook was again presented with victuals. During the afternoon boxing was again demonstrated which Anderson described:

> The boxers advance side ways changing the side at every pace, with one arm stretchd fully out before, the other behind, and holding a piece of cord in one hand which they wrap firmly about it when they find an antagonist, or else have done so before they enter, which I imagine is done to prevent a dislocation of the hand or fingers.[1]

Webber's drawing of this event brings the descriptions to life (plate 29; 3.47). Both boxers are naked to the waist and wear long skirts that reach down over their knees. Their hands are bandaged with cord, their arms and legs at places punctured with tattoo marks. Standing with legs apart they have both lifted their left arms, while their right arms are held behind their bodies, just as Anderson had observed. The drawing is remarkable for being one of the few in Webber's *oeuvre* of the voyage in which individuals are represented in special postures. His success here lay in rendering correctly the fighters' movements, and in contrast to his usual manner, he concentrated on the anatomy of the half-naked body in order to provide a convincing representation of the physical energy expended in the sport.

The drawing is of particular interest as it provides us with the rare chance of seeing Webber using a particular source or model. Both boxers bear considerable resemblance to two plates in Bernardino Genga's *Anatomia per uso et intelligenza del disegno* (1691), a book which, from a remark that Samwell makes regarding the boxers of Hawaii,[2] we know was on board the *Resolution*. The plates in question represent the Borghese gladiator, seen in six different representations. Seen from the profile, the gladiator pushes his right arm forward, while the left forms a counterpoise towards the back. In contrast to the movement of the arms, the left leg is striding forward, while the right stands back in support, allowing the right side of the body to stretch out in a diagonal, energetic thrust. Though Webber in his drawing reverses the choreography of the pushing arms and striding legs, his whole conception of the boxers must be regarded as following closely plates XXX and XXXIV of Genga's work (plates 30,31). That Webber should know this collection of forty-two engravings (there is no text except for captions) need not surprise us. The translation of the title page (from the English edition of

[1] Anderson in Cook, *Journals* III, 2, 900.

[2] Samwell in Cook, *Journals* III, 2, 1174; see also below, Hawaii fn. 4. A copy of the original edition of Genga's *Anatomia* is kept in the British Library, London.

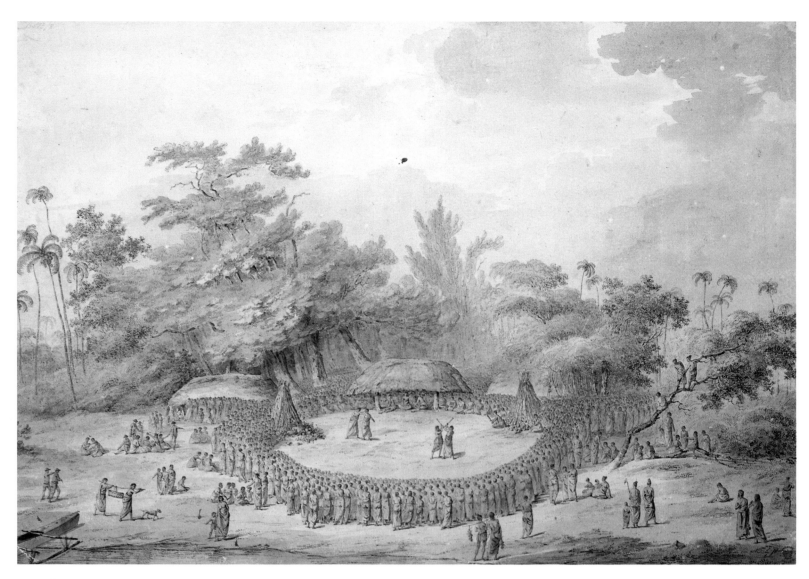

PLATE 28
John Webber, *The Reception of Captain Cook at Hapaee*, May 1777-. British Library, London. (3.45)

1723)[3] makes several interesting points: the work was not meant to be of medical use, its *raison d'être* was to instruct 'painters, sculptors, statuaries and all other studious in the noble art of designing'; moreover, it received its models 'of the bones and muscles of the human body' not only from scientific observation and dissections, but 'from the most celebrated antique statues in Rome' — of which, of course, the Borghese gladiator was one. The book's primary interest was to be of use for designing, or rather drawing the human body, and it thus seems quite logical that it was 'intended originally for yᵉ Use of the Royal French Academy of Painting and Sculpture and carried on under the care and inspection of Charles Errard, Director of the same in Rome'. If one considers the French Academy in Rome as an outstation of the Académie Royale in Paris, it is possible that Webber knew this book during his five years' stay in Paris as a student of that institution. We know that Webber, basically a landscapist and portraitist, struggled with the figure. Might we not assume that he took the book with him for instruction and assistance when drawing the human figure became inevitable? And he may have used Genga's prints to express the idea that the Tongan combatants like the boxers of antiquity, deserved to be depicted in a noble manner. In his later work on the voyage Webber did not often revert to such virile images, but it is interesting to note that at least in some examples there are neo-classical undercurrents in his work.

Among the highlights of the stay at Tonga were the night dances, or *heivas*. The first one was presented by Finau (Feenough), a powerful local chieftain, on 20 May. The entertainment consisted of dances by men and women supported by a band of eighteen musicians. Among them were 'four or five' who 'had pieces of large Bamboo from three to five or six feet long, with the close end of which the[y] kept constantly beating the ground'.[4]

The first to enter the circle of spectators were the women. Their heads were adorned with garlands of the hibiscus flower. During their carefully choreographed dance they encircled the chorus of musicians a number of times while moving their hands and bodies rhythmically to the music. Describing the latter stage of the dance Anderson reported:

They then turnd their faces to the assembly, sung some time, and retreated slowly in a body

[3] Bernardino Genga (1723). A copy is in the Wellcome Library, London.
[4] Cook, *Journals* III, 2, 875.

31

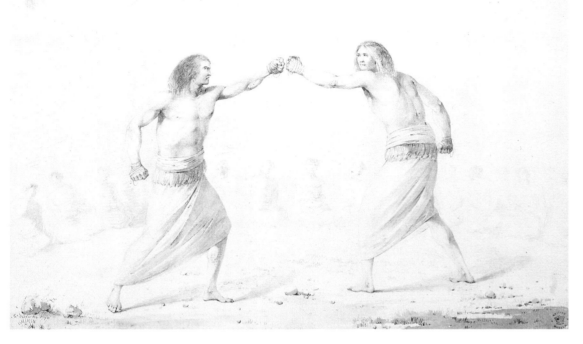

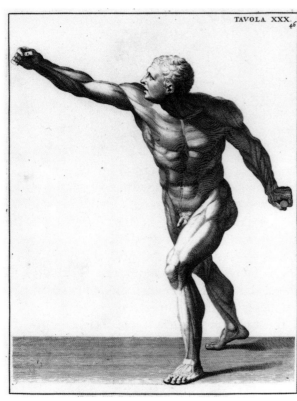

PLATE 30
*The Borghese Gladiator.* Engraving from Bernardino Genga, *Anatomia per uso et intelligenza del disegno.* Rome 1691, pl. XXX.

PLATE 31
*The Borghese Gladiator.* Engraving from Bernardino Genga, *Anatomia per uso et intelligenza del disegno.* Rome 1691. pl. XXXIV.

[5] ibid.

to one part of the circle which was opposite to where some of the principal people sat as spectators in a small hut. One then advanc'd from each side, met and pass'd each other at the front walking round till they came to the rest, on which two advanc'd from each side two of whom pass'd each other and return'd as the former, but the other two remaind & to these came one from each side by intervals till they had again made a circle about the chorus.[5]

Of this performance two drawings by Webber exist (3.48 and 3.49). Though it is difficult to define exactly the moment which Anderson describes — if only for reasons that complex patterns of movement were not easy to relate and even more difficult to represent as 'frozen' moments — Webber's drawings provide an excellent idea of the occasion. Performing by the light of flares and encircled by a multitude of people, the women have arranged themselves in rows of three and four, dancing around the musicians. The two groups, on either side, seem to be responding to each other. All are moving in accord. Webber's drawing in the British Library (plate 32; 3.48) concentrates on the chorus and performers. The drawing is unfinished and the figures in the foreground are only faintly sketched in. The version in the

Dixson Library (plate 33; 3.49) shows a more developed state, with a dozen Tongans and four Europeans sitting in the front row. Their dark backs contrast with the light of the 'stage' and give this drawing a notable theatrical effect.

A similar composition was adopted for the ensuing dance of the men (plate 34; 3.50). By contrast to the women, the two male groups did not move towards each other but divided on either side of the chorus. Anderson again illustrated the moment:

> They sometimes sung slowly in conjunction with the chorus during which they made several very fine motions with their hands but different from those of the women, at the same time, inclining the body to either side alternately by raising one leg which was stretch'd outwards and resting on the other, the arm of the same side being also stretch'd fully upwards.[6]

[6] ibid., 876.

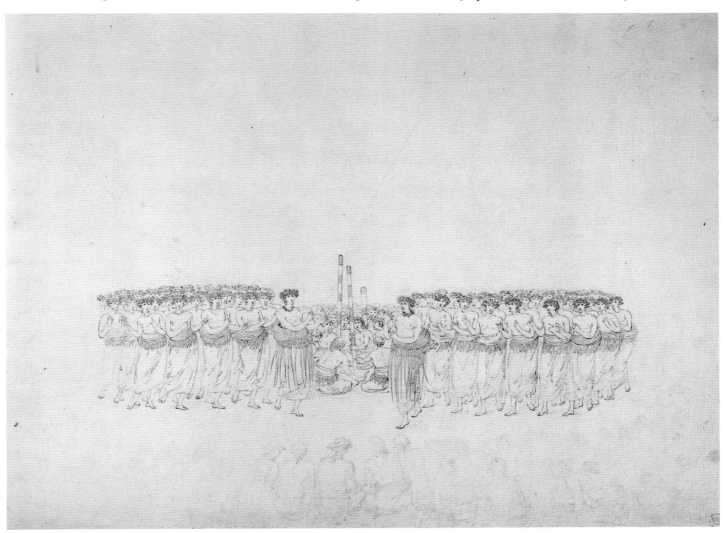

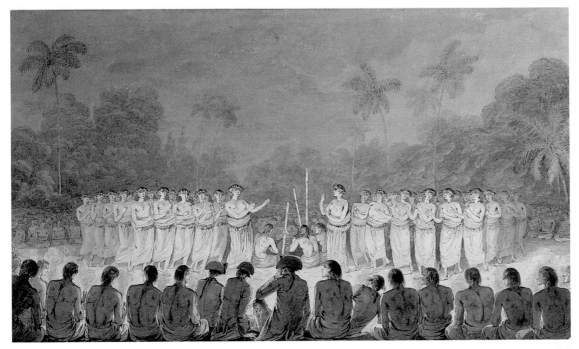

PLATE 32
John Webber, *A Night Dance by Women in Hapaee*, May 1777-. British Library, London. (3.48)

PLATE 33
John Webber, *A Night Dance by Women in Hapaee*, c. 1781-83. Dixson Library, State Library of New South Wales, Sydney. (3.49)

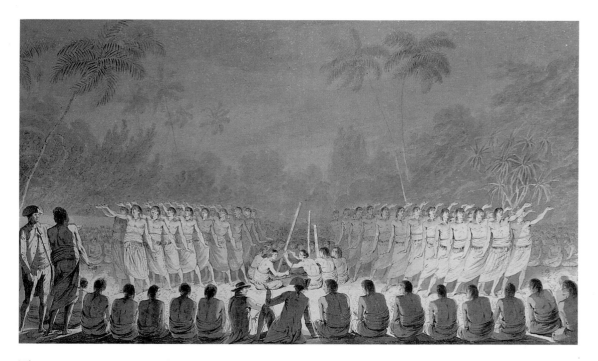

This very moment is caught in Webber's drawing and almost identically treated in the secondary version made for the engraver (3.51 and3.51A).

Among the many entertainments experienced in Tonga the *heiva* was one of the most impressive. The long descriptions by Cook, Anderson, Samwell and others find their visual complement in Webber's drawings. It is perhaps not so surprising that Webber paid so much attention to these elaborate entertainments for dancing had become one of the most popular subjects for eighteenth century painters, and they seemed to hold a special appeal for Webber. Some years later he chose to illustrate Sterne's *Sentimental Journey* (plate 35) with a peasant dance. But the *heiva* was likely to excite far greater interest than any European dance. Exotic dances had attracted attention from the very beginnings of European contact with non-European societies, and it is worth noting in this context that two of the earliest artists to travel well beyond the confines of Europe, John White in the sixteenth century (plate 36) and Albert Eckhout in the seventeenth century (plate 37) both portrayed the dance forms

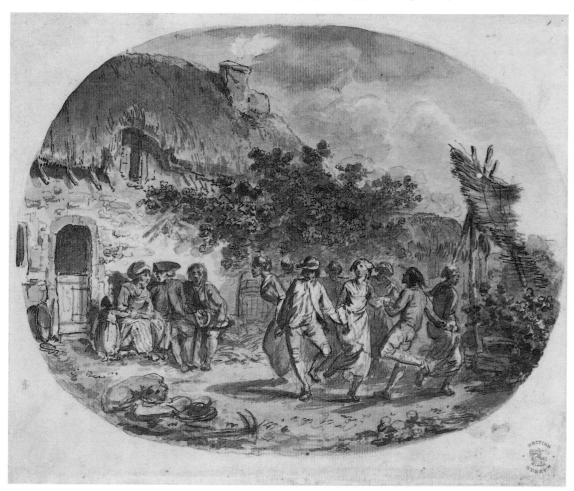

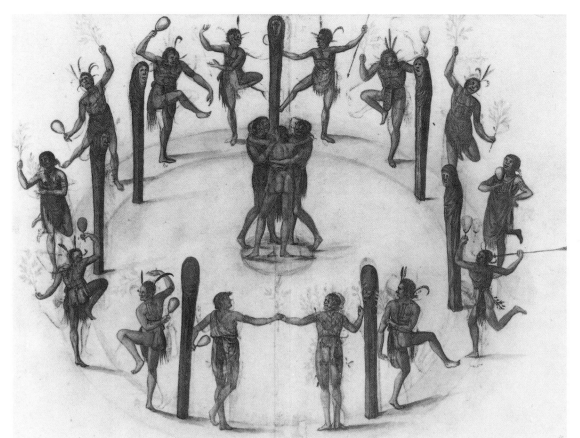

PLATE 36
John White, *Indians dancing around a circle of posts*, 1585, pencil, pen, wash and water-colour, 10¾ ×14 : 274 × 356. British Museum, Department of Prints and Drawings, London.

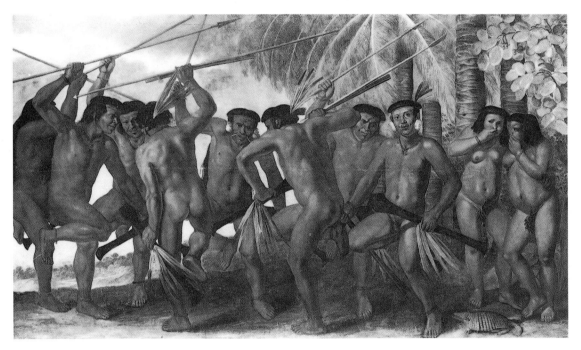

PLATE 37
Albert Eckhout, *Dance of the Tarairiu (Tapuya)*, 1641-43, oil on canvas, 66⅛ × 115¾ : 1680 × 2940. National Museum of Denmark, Department of Ethnography, Copenhagen.

they encountered,[7] for the dance could be appreciated as an expression of common humanity among all people of all times. What made it legitimate, particularly in the eyes of the cultivated classes of Europe, and raised it above the levels of mere dissipation was its status in classical antiquity. Johann Schönfeld's, *The Temple of Diana* (c.1635) (plate 38) showing three young women dancing in a sacred grove below a tempietto reaches to the heart of Webber's drawing. For here the dance, far from being a sportive relaxation indulged in by young half-naked women, is presented as a serious religious rite. The light that falls on the sequestered scene and the unrestrained movements, create an allegory of the Golden Age.[8] Could Tonga be seen in similar terms?

Webber had probably no knowledge of Schönfeld's picture, yet in both cases a similar situation led to a comparable composition. In each case the dancing area is confined in the front by seated figures who turn their backs to the viewer. Webber however augments their number forming them into a row, thus creating a visual foil to the action. The device admirably reflected the actual situation. The officers of the ships are included in the subject; in the act of watching they become participants in an historical moment. Similar devices may be found

[7] Hulton/Quinn, (1964) no. 42A, pl. 38, and Thomsen, (1938) fig. 3.

[8] On this painting see Pée, (1971) cat. no. 14, as well as Galerie Arnoldi-Livie, (1982) no. 2.

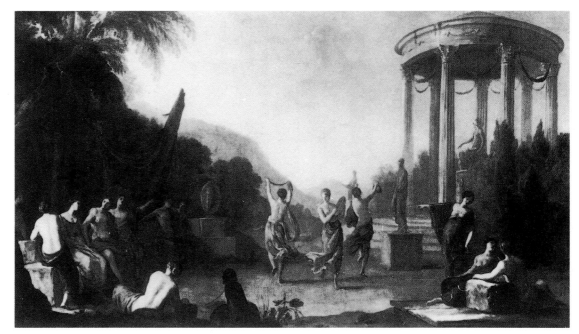

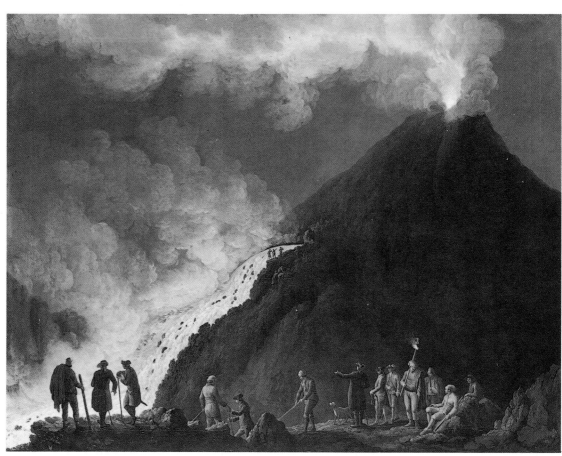

9 See Krönig, (1968a) 51-60.

10 On Wright of Derby see Nicolson, (1968). One may refer particularly to pl. 54 and pl. 58, the latter being the well-known *Experiment on a Bird in the Air Pump*, c. 1767-68, in the Tate Gallery, London.

in many eighteenth century paintings. Sometimes an artist would introduce himself into his work, as Richard Wilson did in his *View of Tivoli over the Campagna* (Vol. 2, plate 10). In such cases the view itself gains the additional viewpoint of a mediating figure or figures. Webber exploited the principle in his dance drawings even to the point of creating different zones of light; showing the front row of spectators as dark silhouettes against a brightly lit middle ground. The device of course was not new. A contemporary example was Philipp Hackert's *The Eruption of Vesuvius* (plate 39) in which darkly silhouetted forms stand against a bright stream of yellow-red lava as it pours down a hill.[9] Such works by both Webber and Hackert draw attention to another pictorial device of great interest to many artists working in the second half of the eighteenth century; the diverse uses of light in pictorial construction. It was much used by Joseph Wright of Derby, who was in the habit of structuring his pictures according to different registers of light, often beginning with a dark foreground, framing a strongly lit middle ground which then in turn merged into a dark background.[10] As a dramatic element binding the composition throughout, light became an increasingly indispensable presence in the art of painting.

## 13. Tongatapu, Tonga:
## 10 June-10 July 1777

Another *heiva* was witnessed at Tongatapu, about four weeks later. Cook had left Lifuka on 29 May 1777 and steered to the largest island of the Tongan group: Amsterdam or Tongatapu. On this occasion the *heiva* was presented by the chieftain Maealiuaki (Mariwaggy) on 17 June. It started with dancing and singing at 11 o'clock in the morning and continued into the night. Cook, it seems, was impressed and intoxicated by the graceful motions of the dancers and the order which prevailed throughout the spectacle:

> The whole of this entertainment was conducted with far better order than could be expected in so large assembly, for at this time there were not less than ten or twelve thousand people in our neighbourhood, that is within the Compass of a quarter of a mile.[1]

Anderson informs us that the dances performed that night were very much of the same character as those watched in Hapaee. Their sequential order and choreography were described by Cook, Anderson and others as extensively as could be grasped but they revealed, naturally enough, their own inability to understand the deeper meaning of the dance. Or as Cook wrote:

> These dances vary perhaps much more than we were able to discover, however, there appeared a sort of sameness throughout the whole, and so would, I apprehend the most of our Country dances to people as unacquainted with them as we are with theirs. The drawings which Mr. Webber has made of these performances will give a very good idea of the order in which they range themselves but neither pen nor pencil can describe the numerous actions and motions they observe, which as I have observed are easy and gracefull and many of them extremely so.[2]

Another interesting local ceremony which Cook and his men witnessed was the drinking of kava at the village of Mu'a (Moa). Webber's drawing of this event is kept in the Dixson Library (plate 40; 3.55) but is probably the second state of an earlier version described in

[1] Cook, *Journals* III, 1, 131.

[2] ibid.

PLATE 40
John Webber, *Poulaho, King of the Friendly Islands, drinking Kava*, c. 1781-83. Dixson Library, State Library of New South Wales, Sydney. (3.55)

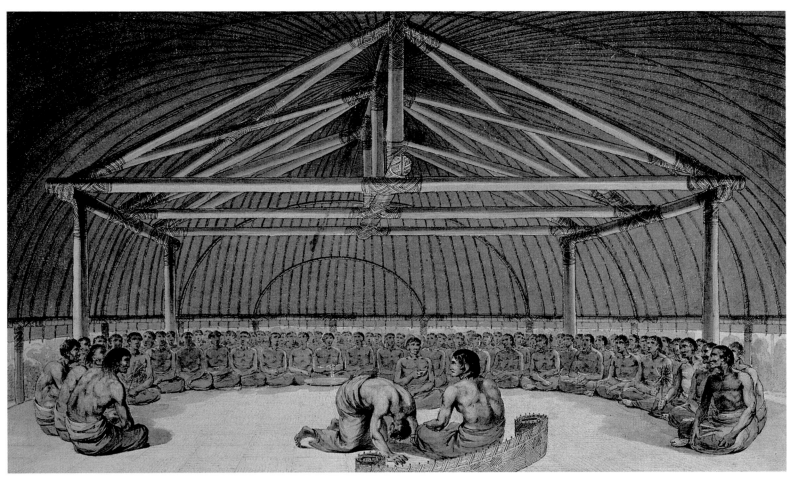

Webber's Catalogue as 'King Pawlehow (Paulaho) drinking his Cava, and attended by the Principal Chiefs of the Island' (no. 15). Paulaho is seen sitting in the foreground his back almost wholly turned to the spectator. He faces a man in front of him who has fallen prostrate to kiss his feet. A kind of matted fence has been placed behind Paulaho's back, illustrating, as observed in the journals, that nobody was allowed to sit behind him. A large group of Tongans, sitting cross-legged and bare-chested, surround the king in a semicircle. For the actual ceremony we must turn to Anderson, who describes the ceremony following the preparation of the kava:

> They then begin to distribute it in little cups made of a bit of plantane leaf tied at each end, but where the company is large & respectable as our present one was the person who distributes it calls out to know who the servants shall carry it to, and is commonly directed by one person belonging to the chief who gives the Kava.[3]

[3] Anderson in Cook, *Journals* III, 2, 908.

Accordingly, the man with the dish is the distributor of the kava, while another one sitting nearer to Paulaho in the middle of the circle, could be regarded a servant, holding a bowl in his hand. The fact that no other cup is seen indicates the Tongan custom of offering the first cup to the king himself. The scene is set in a large and spacious hut, resting on four posts and covered by a tunnel-like roof, rounded at the ends and covered with reeds. The construction of the supporting posts and rafter-work correspond to a hut that Anderson described in great detail:

> It [the house] is supported by strong posts plac'd commonly at equal distances a little within the edge, with others laid along upon their tops and some laid across from these, which again have perpendicular ones rising from their middle to support the top ridge. These are firmly lash'd together with a cord made of Cocoa nut fibres, in which they indicate their taste for variety by mixing white and black so as always to represent som[e] regular figure. The frame on which the thatching is supported consists of well made laths laid in a very regular manner from top to bottom, with others running across in the same manner without them & fastend with the Cocoa cord. The thatch is chiefly of Cocoa & other leaves laid over these laths in such a way, by being doubled under them & intercepted by the next, that they need little fastening and to a thickness which makes them proof against the rain or wind.[4]

[4] ibid., 935.

A comparison between the text and drawing reveals the uncommon pains which Webber took to make the structure intelligible, concentrating on the joining of the beams and paying attention to the different colours of the cord by which they were lashed together. Both Anderson's and Webber's accounts correspond so closely with each other, that it seems likely they studied the hut together. Depiction of the interiors of houses in the South Pacific islands are extremely rare among Webber's works and there are very few similar scenes from the first and second voyages. For this reason in particular Webber's drawing is of the utmost importance for our knowledge of contemporary Tongan building techniques.

The most unusual and extraordinary ceremony observed during the ships' stay at Tongatapu was the *Inasi*, which took place at Mua from 8 to 9 July. Its meaning was not fully understood, and the descriptions that Cook and Anderson have left us do not help to make it any less mysterious. It was centred upon the son of Fatafehi Paulaho, who was Tu'i Tonga, the sacred King of Tonga, and was probably performed in honour of his coming of age. Cook recorded that the 'occasion of this ceremony was him [Paulaho] and his Son eating together, a thing that had never yet been done'.[5] Whatever the meaning of the ceremony, food, particularly in the form of yams, played a significant part. Several thousand people were involved, most of whom entered the performing area with sticks about four feet long to which smaller sticks were tied representing symbolic yams. In a long trail either in pairs or individually with the sticks over their shoulders, they approached a shelter or small hut, in which Paulaho, his son and other people of distinction were seated. Anderson termed it the 'royal Canopy'.[6] It was set against the background of the king's mount of the dead with a single *fa'itoka* on the mount. Cook has a similar description of the place of action.[7]

[5] Cook, *Journals* III, 1, 146.

[6] Anderson in Cook, *Journals* III, 2, 915.

[7] Cook, *Journals* III, 1, 146 ff.

The Inasi ceremony is illustrated in an engraving of the official account as: *The Natche, a Ceremony in Honour of the King's son, in Tongataboo* (plate 41; 3.61A) The drawing for it is no longer known, but it was included in Webber's Catalogue: 'The Annache, or Ceremony of Inauguration of the Heriditary Prince at Amsterdam' (no. 29). It is interesting that Webber should call the ceremony *annache*, so similar to the term *natche* which Anderson picked up.[8] The similarity of names, though slight, is significant, indicating that Anderson and Webber on this occasion also collaborated in the details of the representation. On the other hand Cook had no name for the ceremony.

[8] Anderson in Cook, *Journals* III, 2, 916.

After the first night of the ceremony Anderson returned to the place the following morning, with the intention of gaining some more 'information on their religious and political

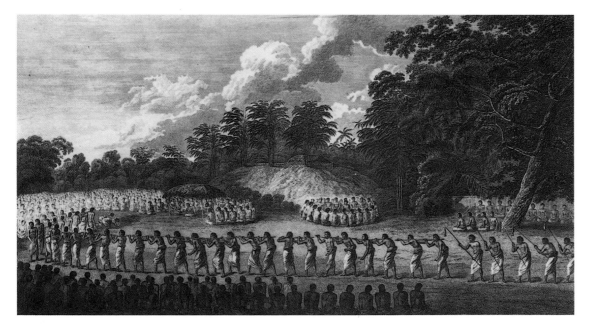

PLATE 41
*The Natche, a Ceremony in Honour of the King's Son, in Tongataboo.* Engraving by Hall and Middiman after Webber. (3.61A)

opinions'.[9] In this he was frustrated for the second part of the event 'did not begin till the afternoon'.[10] It is likely that during this morning excursion, Anderson was accompanied by Webber, for only then Webber could have made his drawing of the venue of the ceremony devoid of people. His wash drawing (plate 42; 3.61) shows a mount with the *fa'itoka*, or burying ground, with the King's temporary shelter, or royal canopy, erected in front of it. To judge from the engraving mentioned above, the drawing served as a study for a more extensive representation of the ceremony. It is loose in structure, spirited in the toning and calligraphic quality of the brush work, and a splendid example of Webber's fieldwork style — even if the wash was added a little later on board the ship.

A companion drawing of the *fa'itoka*, also made on Tongatapu, and close in style, suggests a similar date of execution (3.60). Unfortunately, none of the journals entirely correspond to this view. Cook had commented upon a *fa'itoka* belonging to the king as 'a Wall of stone [that] inclosed three seperate Mounts and on each of these Mounts stood a house'.[11] Anderson saw a burying ground on Lifuka 'which was a mount two or three feet high coverd with gravel and had four or five small huts on it, in which they said the bodies of some of their principle people were interrd'.[12] Though Anderson's description seems to answer Webber's view, its title, listed in Webber's Catalogue as 'The Burying place for a family of a chief at Amsterdam' (no. 26) and the title of the engraving of the official account (3.59A) refer to Amsterdam (Tongatapu). The drawing may well represent a view which Webber came upon while walking the island. Anderson had praised the 'neat prospects about the cultivated grounds and dwelling places, but more especially about the Fyatokkas or burying grounds, where sometimes art, sometimes nature has done much to please the eye'.[13] Webber's drawing provides a delightful glimpse of a park-like setting populated by coconut palms and Puko trees. This is particularly born out in the more accomplished version in pen, wash and water-colour in the British Library (plate 43; 3.58). It retains the tonal pattern of the wash drawing but makes changes in detail, altering the density of the vegetation and introducing a number of figures. Webber may have had in mind a similar representation of an 'Afia-too-ca' by Hodges, which, in an engraving by Byrne is illustrated in the official account of the second voyage (2.89B). The duplication of elements is striking: the charnel house(s) on the mount, a small hut with thatched roof and figures relaxing in its shade, a fence and trees, even a figure carrying yams on a pole over his shoulder. The components are so close that it becomes an intriguing question whether Webber has not here purposefully repeated and reinterpreted Hodges's earlier view in a different arrangement. Did he have, by any chance, a similar interest in necropolitan subjects?

For Webber the *fa'itoka* was his first encounter with exotic burial customs. The subject might well exercise a powerful appeal on any artist's mind particularly during the later eighteenth century — a time when ancient funerary customs were being revealed continuously by archaeological excavations in Herculaneum and elsewhere. Burial customs offered clues about the religion of hitherto unknown peoples and contained important information on their material culture. Nor was there only the scientific side to consider. In that age of sentimentality, when a preoccupation with the funeral became a European cult of some proportion, the imagery of death aroused feelings both of contemplation and edification. The idea of death and its

[9] ibid.
[10] ibid.

[11] Cook, *Journals* III, 1, 138.

[12] Anderson in Cook, *Journals* III, 2, 873.

[13] ibid., 920.

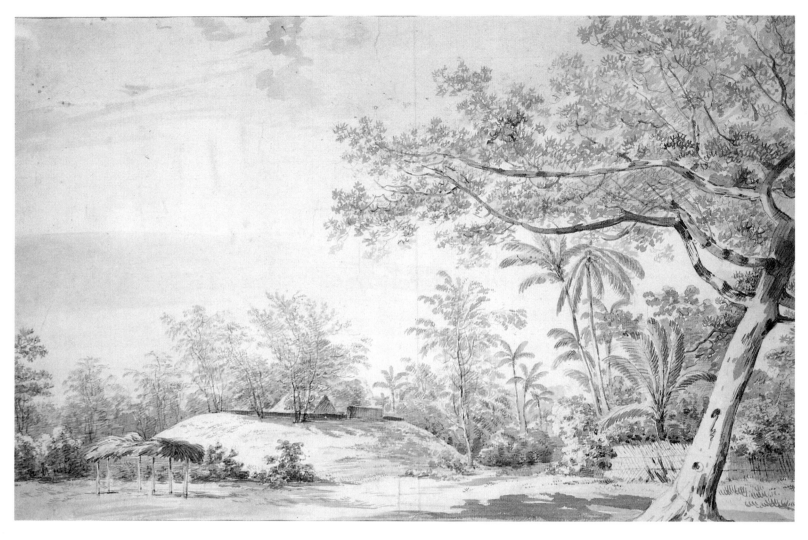

[14] As an introduction to this theme see Matsche-von Wicht, (1979) 45-56.

[15] Hirschfeld, vol. 2 (1780), with a section on parks and trees: 'Vom Baumwerk' (58). Opposite this illustration is a picture of Rousseau's grave at Ermenonville.

[16] On Harper and his drawing see Geissler, (1985) 44.

[17] Panofsky, (1970) 340-67. The author draws attention to several examples of the eighteenth century preoccupation with the motif of the tomb in the landscape, such as in the work of G. B. Cipriani and G. W. Kolbe.

presence expressed in symbolic form was actively encouraged particularly in the art of landscape gardening.[14] Chr. C. L. Hirschfeld's *Theorie der Gartenkunst* (1779-80)[15] shows a park scene with an urn on a mount, evoking the omnipresence of death (plate 44). Adolf Friedrich Harper's drawing of a *Landscape with a Monument* (c. 1750) (plate 45) with its rectangular sarcophagus in a small clearing between trees,[16] affords a closer parallel to Webber's *fa'itoka* drawing. Both drawings associate images of death with an ideal vision of nature; both follow the mood of Nicolas Poussin's *Et in Arcadia Ego* in the Louvre, a painting of great influence in the eighteenth century.[17] In the case of Webber's drawing the link with Poussin is even more poignant than in Harper's for Tonga certainly was an arcadian dream. But it was also

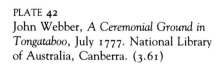

PLATE 42
John Webber, A *Ceremonial Ground in Tongataboo,* July 1777. National Library of Australia, Canberra. (3.61)

PLATE 43
John Webber, A *View of a fa'itoka, or Burying Ground,* 1778. Dixson Library, State Library of New South Wales, Sydney. (3.58)

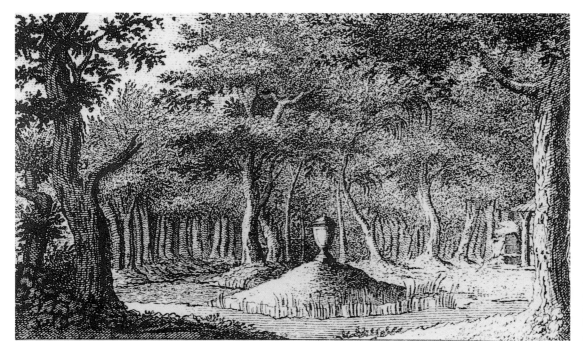

PLATE 44
*Parkscene with an urn.* Engraving by Liebe after Johann Heinrich Brandt. From Chr. C. L. Hirschfeld, *Theorie der Gartenkunst*, Leipzig, 1779-80, vol 2, 58.

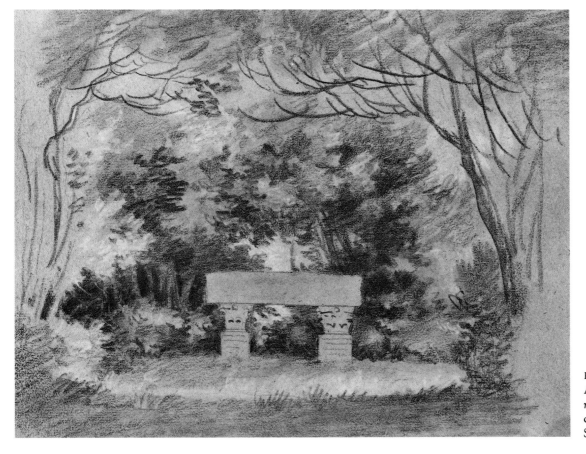

PLATE 45
Adolf Friedrich Harper, *Landscape with a monument*, c. 1750, monochrome crayon, 7¾ × 10⁷/16 : 197 × 265. Staatsgalerie, Stuttgart.

for Cook and his small company of ship's officers an 'Elysian Field', and like those fields it was associated with death.

During the stay at Tonga of over two months, extended excursions were made on Nomuka, Lifuka and Tongatapu which provided many pleasant, even paradisal views. According to Anderson, these islands:

> are entirely cloath'd with trees amongst which are many Cocoa palms, and each forms a prospect like a beautiful garden plac'd in the sea, to heighten which the serene weather we now had contributed very much & the whole might supply the imagination with an idea of some fairy land realiz'd.[18]

Such comments recall the arcadian landscapes, favoured by the English landscape gardeners of the time inspired by the paintings of Claude. Clearly, it was the classical landscape that Tonga invoked in the minds of the most sensitive of the voyagers. As Samwell put it:

> Such enchanting Prospects does this little Isle afford that it may be said to realize the poetical

[18] Anderson in Cook, *Journals* III, 2, 869-70.

41

[19] Samwell in Cook, *Journals* III, 2, 1014.

Descriptions of the Elysian Fields in ancient Writers, it is certainly as beautiful a Spot as Immagination can paint.[19]

Webber's response to Tonga was neither as imaginative nor as elevated as those of Anderson and Samwell. It was more matter of fact, more picturesque, more domestic even. His idea of the pleasures which Tonga provided is encapsulated in the drawing he described as a 'Conversation' in his Catalogue (no. 16) otherwise known as *A View in Annamooka* (plate 46; 3.43). The scene is one of idyllic repose; a woman, seated under a hut, is playing the nose-flute (*fangu-fangu*) in the manner of her country. The way of playing the instrument was described precisely by Anderson.[20] Webber seeks here to record a cherished moment of Tongan leisure, a time for conversation and music.

[20] Anderson in Cook, *Journals* III, 2, 940, and also Samwell in ibid., 1038-9.

The drawing is interesting in other respects. Firstly, it can be connected with a study of a hut (plate 27; 3.42), which is believed to derive from Webber's sketchbook. Secondly, the scene is unconnected with any event recorded in the voyage journals, and this is something of an exception. The informality of the scene, its genre-like quality seems to suggest that on this occasion Webber created it entirely for his own pleasure, in the pastoral mode, which was popular at the time of Webber's training in Paris, and many examples of it by Boucher, Fragonard, de Loutherbourg and others come to mind (plate 47).

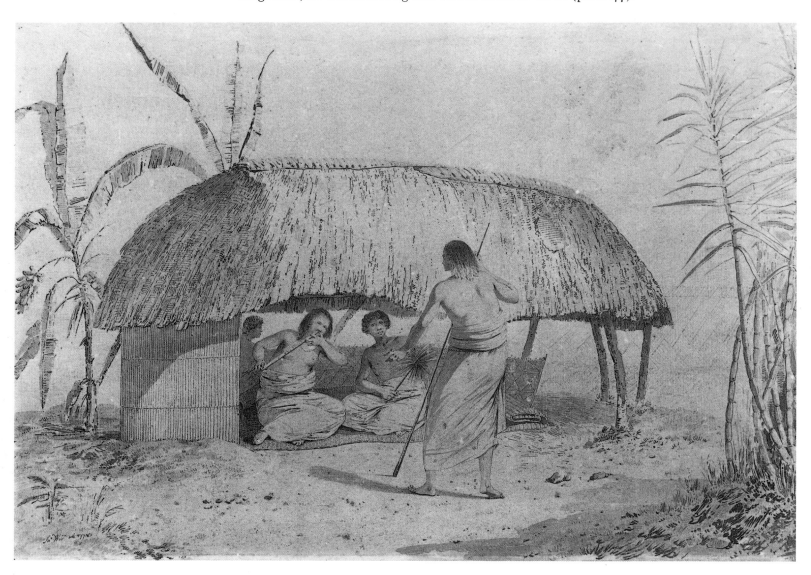

PLATE 46
John Webber, *A View in Annamooka*, 1778. Dixson Library, State Library of New South Wales, Sydney. (3.43)

[21] Anderson in Cook, *Journals* III, 2, 865.

One of Webber's most demanding tasks was the production of portraits. On Tonga, the two most important men who assisted the British, were the chieftain Finau and Paulaho, the Tu'i Tonga (or 'King'). Meetings with Finau were held on Nomuka and Lifuka. Anderson described him as 'a tall man about 30 but rather thin, and has more of the European features than any we have yet seen here'.[21] Webber's portrait of him in oil is listed in his Catalogue (oils, no. 2) but unfortunately is no longer known. A man of quite different appearance and of more consequence was Paulaho, the 'King' of Tonga. He came to visit the ships at Lifuka and accompanied Cook to Tongatapu, entertaining him and his men for the rest of their stay. Anderson provides us with an idea of Paulaho's size and portliness:

If weight of body could give weight in rank or power Poulahao was certainly the most eminent

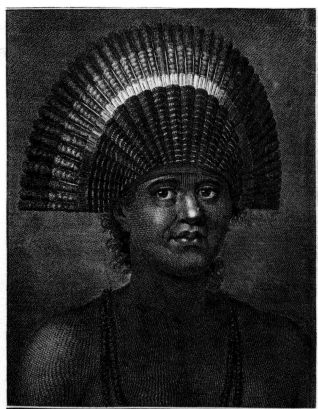

PLATE 47
*Repose of the Shepherds.* Engraving by
Pierre Laurent after Philippe Jacques de
Loutherbourg, c. 1765.

PLATE 48
*Poulaho, King of the Friendly Islands.*
Engraving by Hall after Webber.
(3.52A)

man in that respect we had seen, for though not very tall he was of a monstrous size with fat which render'd him very unwieldy and almost shapeless.[22]

Apart from the representation of Paulaho in the drawing of the kava drinking ceremony (3.55), Webber painted an oil portrait of the 'King' and recorded it in his Catalogue as 'Powlehow King of the Friendly Islands wearing a Cap of Ceremony' (no. 1). Cook had referred to it: 'a painting which Mr Webber has made of Fattafee Polaho dressed in one of these bonnets will convey the best idea'.[23] Though the painting is now lost, we have some idea of it from Hall's engraving *Poulaho, King of the Friendly Islands*; (plate 48; 3.52A). Paulaho is adorned with a necklace and a large, radiant head-dress. He is fleshy, with strong, full cheek-bones and a broad, fattish nose. However, the representation is far from confirming Anderson's characterization. Cook, too, had called Paulaho 'the most corperate plump fellow we had met with'.[24] Webber's portrait does not support this description. Perhaps he here idealized in his own way an important personage. That Paulaho's corpulence was not merely lost in the process of engraving, but omitted on purpose is supported too, by Webber's drawing of the kava ceremony (plate 40). Here too, Paulaho is not presented as fat and unwieldy, but muscular rather. In fact none of the natives in the ceremony confirm the report of a plump and fattish people. Nowhere in Webber's drawings do we get a clear idea of the Tongan physique, and the same negative result applies to the people of the Society and Hawaiian Islands. Webber was in fact adverse to the portrayal of individual characteristics, particularly deformities. No drawings of fat or deformed persons feature in his work during the course of the voyage, though many such people were met with. As we have already noted above, Webber's figures are usually lean and rather tall. There is a general tendency towards elongation. To this stereotype he remained more or less faithful throughout the voyage.

The bonnet Paulaho wears was of a kind which was fabricated of feathers from Tonga as well as from Fiji. Indeed there are several remarks in the journals about the Parroquet of Fiji as a trading commodity which was avidly sought by the islanders. Since feathers played an important role as ornament, it is interesting that Webber made three drawings of birds, the 'Tropic Bird', the 'Goula Parroquet of Fidgee' and the 'Parrot of Amsterdam', all listed in his Catalogue (nos. 17, 20, 21). These might have been suggested by Anderson, who took a great interest in the birds of the Pacific. Among the literature of discovery, with which Anderson was familiar as we noted above, was Pierre Sonnerat's *Voyage à la Nouvelle Guinée*, published in 1776, shortly before the departure of Cook's ships.[25] Anderson refers at times to engravings relating to natural history subjects in Sonnerat's book, including those which suggested comparison with the birds of Tonga. Anderson might well have planned a similar publication to be written after the voyage. If that were so it would have been natural enough for him to encourage Webber to draw birds to illustrate the book.

[22] ibid., 880.
[23] Cook, *Journals* III, 1, 117.
[24] ibid., 115.
[25] Of the 120 engravings illustrating Sonnerat's *Voyage à Nouvelle Guinée* 79 show birds. Chapters VI, VIII and XII especially deal with birds observed and described during the voyage. On Sonnerat see Ly-Tio-Fane (1976).

# 14. Eua, (Middleburg), Tonga: 12-17 July 1777

[1] Cook, *Journals* III, 1, 157, fn. 1.

On 12 July the ships anchored at Eua or Middleburg, one of the islands of the Tongan group. In the afternoon of the 13th a party guided by Cook made an excursion 'to the highest part of the island', passing through deep valleys and chasms on the way. Thomas Edgar, Master of the *Discovery*, who kept a journal of the voyage, wrote of the island, that it 'affords some of the most Romantick & beautiful Valleys in the World . . . there is great abundance of every thing for it's inhabitants the Walks are enchanting and the whole Island is a little Paradise'.[1]

No drawing of Euan landscape by Webber has survived. That he made some is indicated by the one listed in his Catalogue: 'A View of the Island Middleburg' (no. 28). Since this is listed as of 'roll' size, it probably contained a broad, panoramic view and was probably developed from sketches.

On 16 July the ships' companies were entertained with boxing and women wrestling, but no drawings of these occasions have survived either. Webber did, however, complete a pencil and wash drawing of a young woman with long hair, bare breasts and a double necklace composed of pearls or berries (plate 49; 3.64). The drawing is mentioned in Webber's Catalogue and identified in the title of the engraving as *A Woman of Eaoo* (3.64A). That Eua was represented by a woman may have been due to the fact that so far in the 'official' programme a portrait of a woman of Tonga was lacking. The beauty of the women was often commented upon and Clerke stated that 'these people . . . surpass in beauty every Nation I ever yet met with'.[2] But why not Tongatapu, why Eua? For Samwell was not at all enthusiastic when he compared the natives of Eua with those of Tongatapu:

[2] Clerke in Cook, *Journals* III, 2, 1308.

> Considering the small Distance between this Island and Tongataboo the difference between the Natives is remarkable, these being a small sized mean-looking People in comparison with the others & the women in general are not so handsome.[3]

[3] Samwell in Cook, *Journals* III, 2, 1050-1.

PLATE 49
John Webber, *A Woman of Eua*, July 1777-. British Library, London. (3.64)

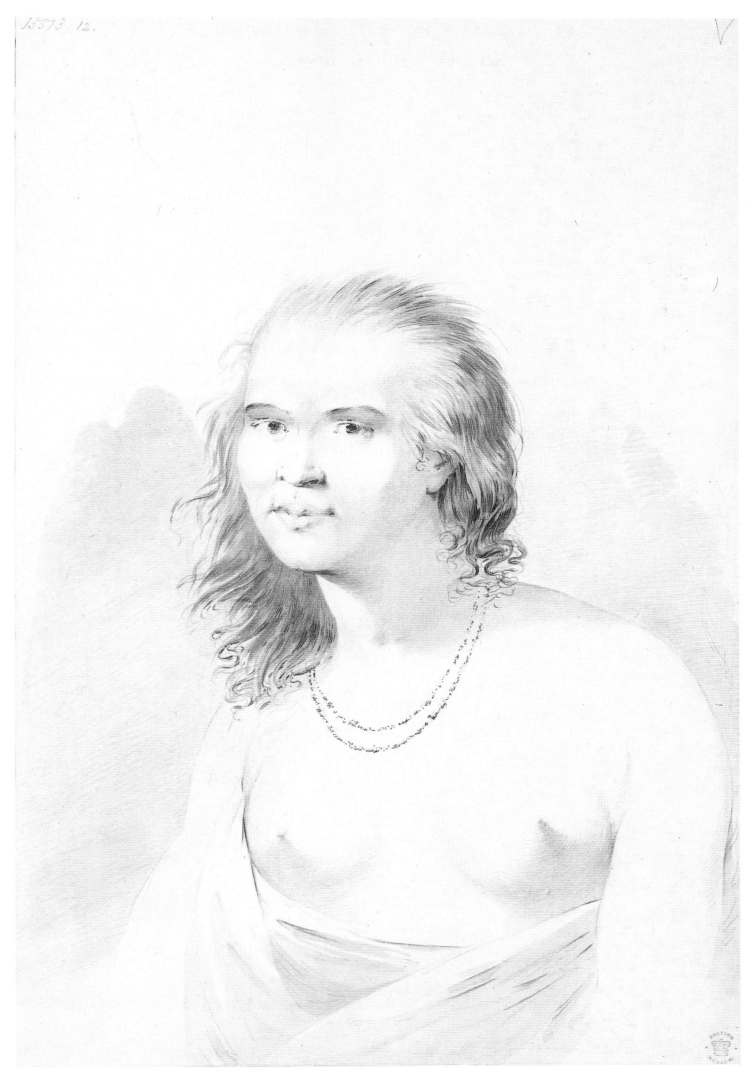

45

# 15. Vaitepiha Bay, Tahiti, Society Islands: 12-23 August 1777

On 12 August 1777 Cook sailed into Vaitepiha Bay, staying until the 24th of that month. During those twelve days Webber made his first contact with Tahitian scenery, and we may imagine him reconnoitring about the bay and making excursions into nearby valleys. It was here in the Society Islands that Webber seized the opportunity of working within pure landscape conventions as distinct from topographical views, a genre in which he attained increasingly happy results.

His first was a water-colour of *A View in Vaitepiha Bay* with Tautira valley in the background (plate 50; 3.81). The flat beach in the front is sharply contrasted with the overwhelming prospect of steep, pyramidal mountains. Small figures of Tahitians, either conversing on land or occupied with their boats, are introduced into the foreground and add a happy, carefree note. The scene is set: though the topographical element is still the determining factor it is 'softened' by picturesque elements and human staffage. *A View in Vaitepiha Valley* (plate 51; 3.86), Webber's second Tahitian landscape, is a surprisingly mature work and among his finest from the voyage. Rendered in delicate pen and water-colour, the viewpoint is now further inland, showing the Vaitepiha River, meandering through a mountainous countryside. As in the previous drawing the human element — the Tahitians by the river and their habitations among the trees and coconut groves — is contrasted against the high peaks. Mountains and hills, shore-line and river, overgrown by vivid vegetation, have been drawn together into a close and balanced view. A melancholy sweetness prevails here between man and his environment — a vision at once arcadian and sublime — and by no means exclusively exotic. A similar composition by Philipp Hackert was created only five years later (plate 52).[1] The comparison reveals how closely Webber remained, even in Tahiti, to the landscape taste of his time.

[1] For Hackert's view see Krönig, (1971) 175-204, the drawing of *Cava de' Tirreni*, pl. 131.

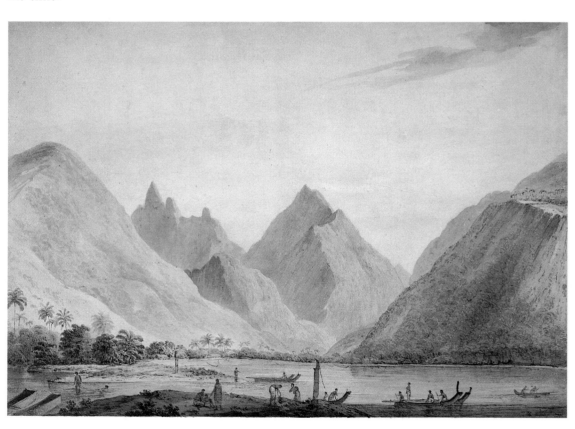

PLATE 50
John Webber, *A View in Vaitepiha Bay*, August 1777-. Peabody Museum, Salem. (3.81)

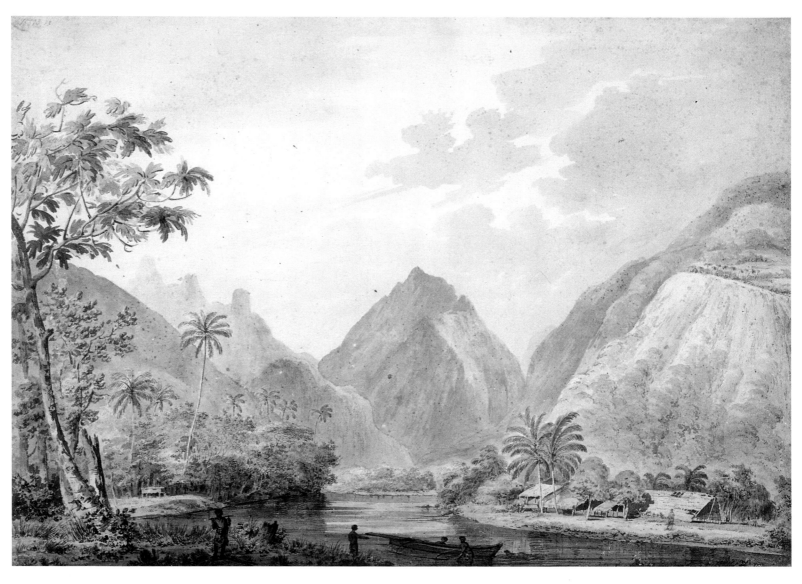

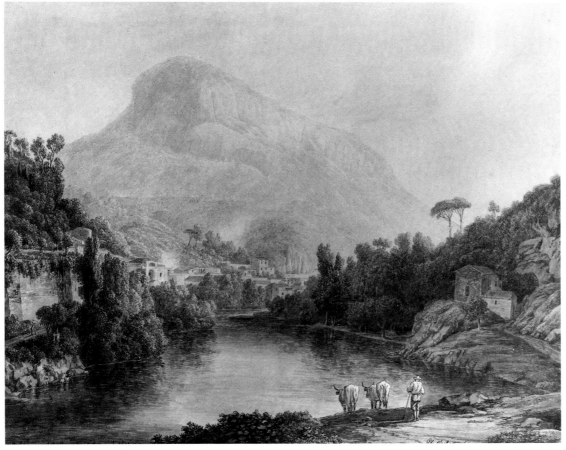

47

# 16. Matavai Bay, Tahiti, Society Islands: 24 August - 30 September 1777

Matavai Bay, by 1777, was the most famous place in the South Seas, already visited on several occasions and made better known by engravings after Parkinson (1.29C) and Hodges (2.108A). We know that Webber sketched there too, for 'A View of Matavy Bay from Point Venus' is listed in his Catalogue (no. 51), but the drawing has disappeared. The only record of it now available is Ellis's view (plate 53; 3.97), for here no doubt, as in so many other cases, we must assume that Ellis either drew from precisely the same spot as Webber, or copied his work later. Ellis's drawing, for all its pleasant *naïveté* and topographical simplifications, can yet provide some idea of Webber's lost composition.

How did Webber work in Tahiti, the island about which so much had been written and of which so many drawings already existed? Did he attend upon Cook, accompanying him on his travels to meet Tu and other chieftains? Did he keep Anderson company and draw objects of interest to the naturalist? Or did he explore the countryside making sketches on his own initiative? To none of these questions, unfortunately, is it possible to provide a clear answer.

A week after their arrival at Matavai Bay a major incident was witnessed and depicted, a human sacrifice at Utuaimahurau, one of the most important *marae* in all Tahiti, and the preferred location for rites associated with Oro, the god of war and death (plate 54; 3.99). The occasion of the sacrifice arose from the smouldering dispute between Mahine of Moorea and a number of Tahitian chieftains, including Tu and To'ofa. The latter was also known as Towha and called 'the admiral of the fleet' by Cook during his previous visit. When it became known that some of Tu's friends in Moorea had been forced to flee into the mountains of Moorea Tu decided, after a lengthy debate at Tu's house which Cook attended, to send an avenging force. To'ofa, always a fiery and forceful man, irritated by Tu's characteristic hesitations, had not attended the debate but acting independently, had killed a man (a *tou-tou*, or slave) by knocking him on the back of the head with a stone, partly to precipitate action and partly to propitiate and encourage the war-god Oro. He then demanded the presence of Tu, who was by virtue of his lineage one of the most respected and influential chieftains of Tahiti, at the sacrificial ceremony.

Cook who had refused to take any part in the warfare with Moorea was nevertheless keen to see 'something of this extraordinary and Barbarous custom'.[1] Tu agreed to this, and as the *marae* of Utuaimahurau was on the south-eastern side of the island Cook decided to go there in the pinnace, taking Tu, Potatau (see 2.55), Anderson and Webber with him. Omai followed in a canoe.

The ritual which they witnessed was an extremely complex and lengthy affair extending over two days and it presented Webber with a classic problem in representation, not only because of its duration but also because several aspects of the ritual were enacted more or less simultaneously. How he went about the task we do not know for none of the field studies which he must have made on location have survived, with the exception of a small water-colour sketch of a part of the setting (3.101). For the composition itself however he chose the interrelated sequences of action that took place towards the end of the afternoon of 1 September. Both Cook and Anderson described the whole course of the ritual in admirable detail, but Webber chose to depict only one small part of the total enactment; the section that seemed to capture the high point of the melancholy drama. But whether Webber used the verbal descriptions of Cook and/or Anderson to assist him when he came to compose his drawing or whether, on the other hand, Cook and/or Anderson had access to Webber's lost field studies to assist their memories when writing up their descriptions, is a beguiling question to which we shall probably never know the answer. One thing however is certain, that Webber's drawing accords fairly closely with the related section of the ritual described by both Cook and Anderson. Here is Cook's account:

They now took the bundles of the feathers and the Sacrifice to the great Morai, the two first

[1] Cook, *Journals* III, 1, 199.

48

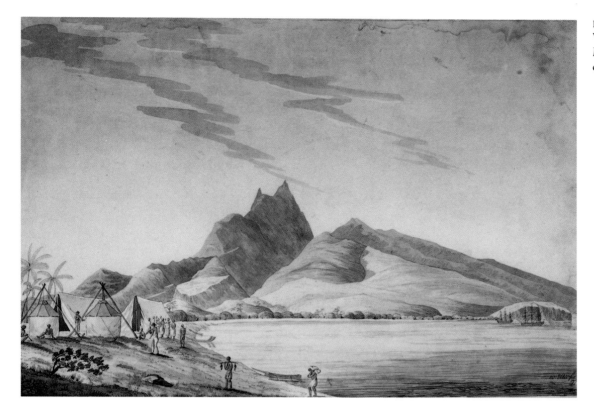

PLATE 53
William Ellis, *View of Matavai-Bay, in the Island [of] Otaheite*, 1777. Private collection, Australia. (3.97)

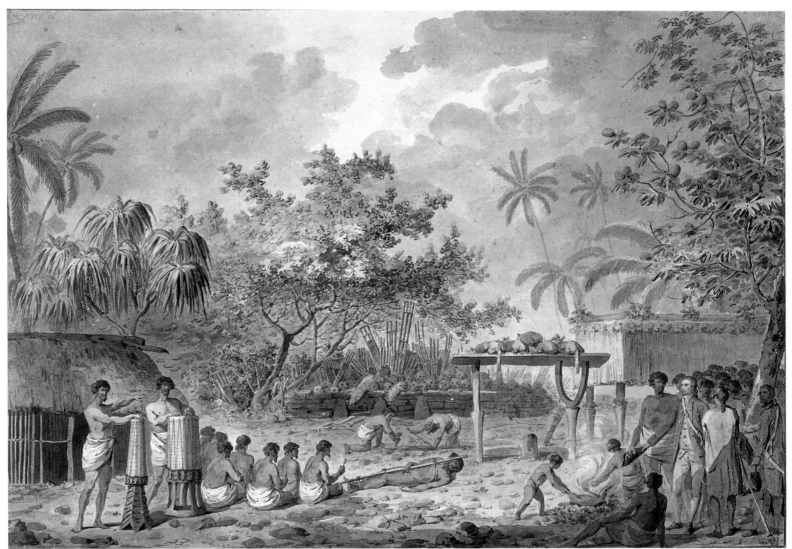

were laid against the pile of Stones, and at the foot of them the latter was placed round which the Priests Seated themselves and began their prayers, while some of their attendants dug a hole at the foot of the Morai in which they burryed the Victim. As it was puting into the Grave a boy squeaked out aloud, Omai said it was the Eatua. In the Mean time a fire was made, the Dog . . . produced and killed, the hair was got off by holding over the fire, the entrails taken out and thrown into the fire where they were left to consume; the hart liver

PLATE 54
John Webber, *A Human Sacrifice at Otaheite*, September 1777. British Library, London. (3.99)

49

kidnies etc were laid on the hot stones for a few Minutes and the blood was collected into a Cocoanut shell and afterward rubed over the dog which was held over the fire for about a Minute, then it together with the heart kidnies &c were carried and laid down before the Priests who were seting round the foot of the grave praying, and which they continued over the dog for some time, while two men beat at times on two drums very loud, and a boy squeeked out as before in a long shrill voice thrice, this as we were told was to call the Eatua to eat what they had prepared for him.[2]

[2] ibid., 201-2.

The rituals described above constitute but a small part of Cook's detailed and admirably ethnographic account of the whole ceremony. And though it was the section that Webber chose to represent as the crux of a ceremony they all so little understood, it is clear that he could only represent a part even of that small section to stand for the still larger whole. In other words the best he could do was represent the visual interaction of several parallel sequences of action within the rite, not within a single moment of time, but within a comparatively small duration of the time taken for the whole ceremony.[3] Webber used this segment of time to present a dramatic impression of the scene: the seated priests clutching their feathers and praying before the corpse to Oro, the two grave diggers, and the dog held over the fire. These parallel sequences are framed on the left by the two men beating the to'ere, the large drums beaten only during such a sacrifice to Oro, and on the right Cook who is speaking to a tall Tahitian, obviously intended as Tu, whom George Forster described as the tallest man they had met in Tahiti (see 2.54) and who here bears a marked resemblance to Webber's portrait of him in the Alexander Turnbull Library (plate 69; 3.113).

[3] On this point see Gombrich, (1964) 293-306.

Webber here faced an endemic problem in the visual representation of narrative even more complicated than that of representing the complex movements of Tongan dancing; problems of a kind he had never had to face as a student of Aberli or Wille.

It is interesting to note that he did not reduce the complexity of the rite to a unified temporal event occurring over two days; that is to say that he did not portray within one frame a succession of events, as a medieval artist such as Sassetta might have done, or Masaccio did do so brilliantly in *The Tribute Money*. He seems to have known that he could not depict the rite as a unified activity. For one thing he did not know enough about it. On the other hand he did not attempt to follow Lessing's advice and seek out 'only one single moment of the action and . . . choose the most pregnant, from which what precedes and what follows will be easily apprehended'.[4]

[4] *Laocoon*, Everyman edn (1930) 55. It is of course possible that Webber was aware of Lessing's argument though perhaps unlikely. But the point is irrelevant since sculptors and painters had been making use of Lessing's 'solution' to the problem since classical times.

Webber's solution to his problem is somewhat similar to, though not identical with, that which Diderot/d'Alembert used to illustrate the complex processes of craft production in the engravings of the *Encyclopédie*. In the illustration of silversmith work (orfèvre grossier) (1771) (plate 55) the several productive processes involved are represented as if proceeding in one room: the metal being cast, then tempered and chased into the shapes required. Such activities would in fact occur in different rooms, at times simultaneously at times differentially, according to the division of labour. Such engravings are both conventionalized and conceptualized representations of a complex productive activity, aided by appropriate verbal keys; a syntactical reconstruction that Diderot had considered a 'déroulement'.[5] Webber's approach is similar in that he represents segments of more or less parallel temporal activities which were all part of one complex ceremony, and from which no one moment has been chosen as 'pregnant' to the whole. But he differs from Diderot by containing his 'déroulement' by the relatively static 'witness' figures who stand to either side, the drummers to the left, whose drums beat out the solemnity of the occasion during the whole ceremony and, to the right, Cook, Tu and their friends. It was, in the end, the visual presence of Cook as the friend of Tu that gave the drawing its deeper resonance for the European audience to which it was addressed. It is not the nature of the rite, so much, that Webber is here representing but rather the apparent complicity of his commander in the rite. And as a result Webber's drawing, reproduced as an engraving, became the most deeply remembered, and the most representative image of Pacific island life for nineteenth-century Europe, an enduring image that never failed to arouse missionary fervour. In seeking to solve a difficult problem of time and movement in visual art Webber had, quite unwittingly, created an ever-recurring topos that assured civilized Europeans that the islanders of the Pacific were savages.

[5] See Bassy, (1980) 206-33, particularly 221.

Both Cook and Anderson had been deeply shocked by the ceremony. 'During the ceremony we were silent but as soon as it was over we made no scruple in giving our sent[i]ments very freely upon it and of Course condemned it.'[6] Webber's drawing represented a dark blot on Tahitian custom, which in many other ways they had found so agreeable. The sacrifice was a total contrast to the noble bearing, grace and generosity, which had so far characterized the natives in the eyes of their visitors and Webber's drawing was tangible evidence of the

[6] Cook, *Journals* III, 1, 205.

PLATE 55
*Silversmithing (Orfèvre grossier)*.
Engraving by Laucotte from D. Diderot/
J. d'Alembert, *Encyclopédie ou
Dictionaire raisonné des sciences, des arts
et des métiers*. Paris, 1771.

lurking barbarity of the peoples of the South Seas. Seen in such categories it had a disastrous effect.[7] In Beaglehole's words, the engraving after Webber's drawing 'became a sort of classic of Pacific illustration'[8] throughout the late eighteenth and nineteenth centuries, but this was a classic in the negative. Together with Webber's representation of the murder of Cook (plate 153; 3.304) it was regarded as final proof of the natives' assumed brutality, their callous and treacherous behaviour, in short their godless state of existence.

    Another structure which evoked the imagery of death, but in quite a different way, was the *tupapau*, an elevated platform used as a resting place for the dead. They had predictably attracted attention on the first and second voyage (1.45; 2.51; 2.52, etc). Webber featured them in his drawings of *Waheiadooa, Chief of Oheitepeha lying in State* (plate 56; 3.93) and *The Body of Tee, a Chief, as Preserved after Death in Otaheite* (plate 57; 3.109).

    The corpse of Waheiadooa (Waheatua) was wrapped in white cloth, lying beneath a shade, in a small palisaded area; the body attended by two men who kept watch, dressing and undressing the corpse at various times. A similar scene was observed in Pare where, as Cook had been told, the body of Tee rested. Cook had known him from his previous voyage, and it was at his desire that the shroud that covered the body was removed and the corpse exposed. Webber's drawing offers him to full sight. Tee had been dead for more than four months and, despite the humid climate, his body had been successfully preserved by embalming. Was not this an amazing fact that reminded one of the burial practices of antiquity? An appropriate drawing was obviously called for.

    In Webber's drawing Tee looks as if he is still alive. The impression is reinforced in Webber's second drawing of the same subject, in which Tee is shown apparently being waited upon by the attendant figure (plate 58; 3.110). The figure reclining on his death bed distinctly recalls Nicolas Poussin's famous painting *The Death of Germanicus*, a painting already well-known during the second half of the eighteenth century and the prototype of numerous similar compositions, particularly by Greuze (plate 59).[9] In such paintings the dying hero or expiring *pater familias* is set against a background of domestic draperies. In Webber's drawing however Tee is already dead and no longer the subject of mourning. That is to say, in the presentation of such exotic rites there was both a continuity and a discontinuity. Yet Webber here was working well within the conventions of European art. As an art student he had copied old-master prints. As a young painter in London he had composed some mythological scenes. There need be no doubt that he possessed a rudimentary knowledge of the visual vocabulary of history painting and its formal rhetoric.

    And he employed it once again in his *A Toopapaoo (tupapau) for a Chief, with a Priest Making his Offering to the Morai* (plate 60; 3.143), a scene witnessed in Huahine. The site is again a sacred, sequestered spot in the tropical wilderness, where the *fare no atua*, or house of the god, stands. A *marae* and *whatta* add to the atmosphere of sanctity. The seated figure is both worshipper and mourner. Webber, in this case, appears to be drawing upon an

[7] See Smith, (1960) 243-5, pl. 152-4.
[8] Beaglehole's note in Cook, *Journals* III, 1, 202, fn. 2.

[9] On the subject of death and mourning in the transformation from baroque to late eighteenth century art see Rosenblum, (1967) ch. 1. On Greuze, in particular in this context, see the contribution by Munhall in Sahut/Volle, (1984) 217-67.

51

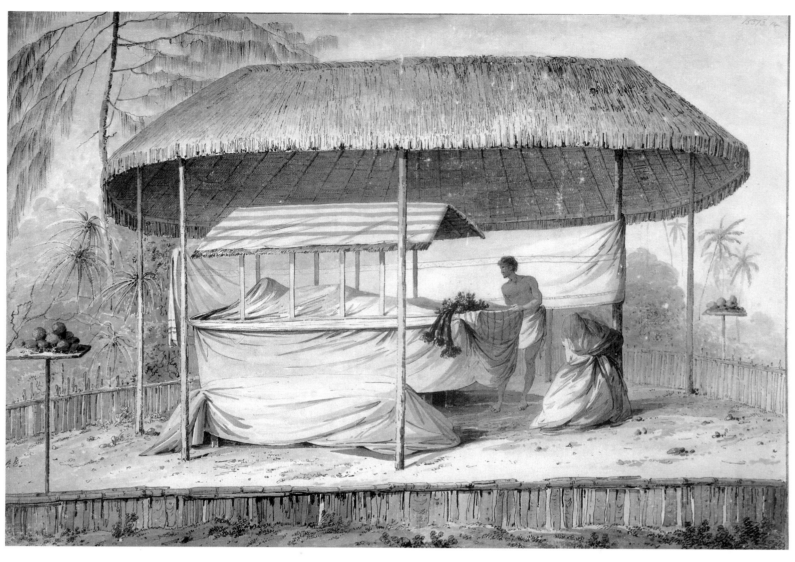

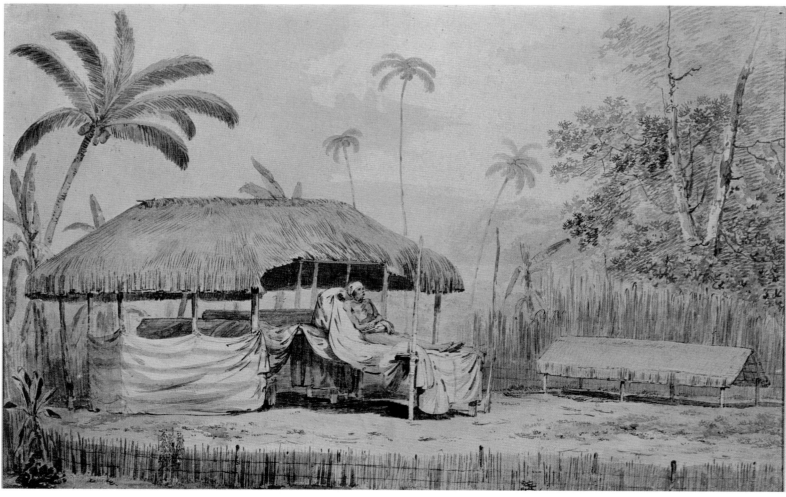

52

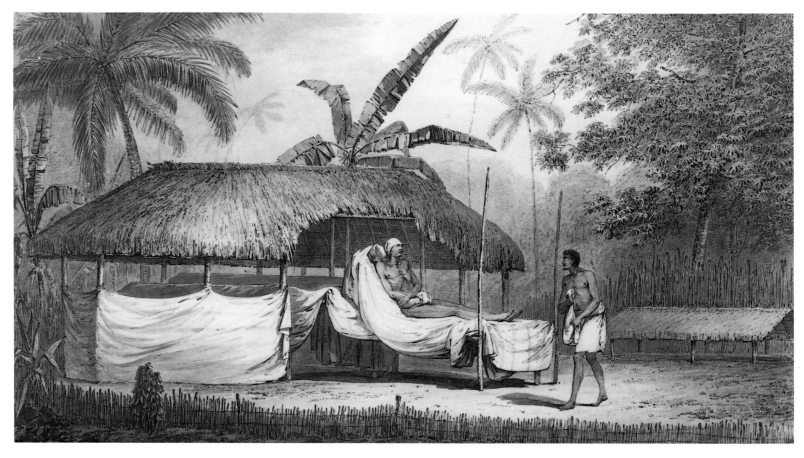

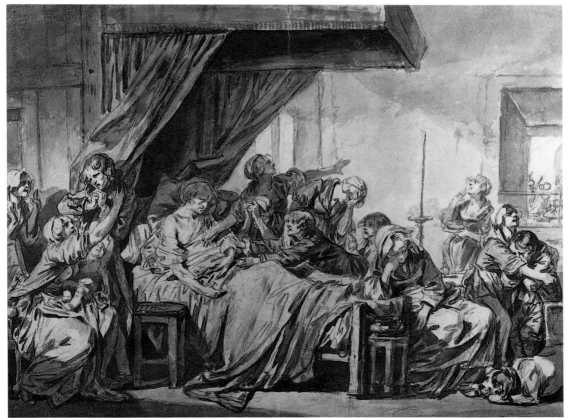

PLATE 58 (above)
John Webber, *The Body of Tee, a Chief,
as Preserved after Death in Otaheite*,
c. 1781-83. Dixson Library, State Library
of New South Wales, Sydney. (3.110)

PLATE 59
Jean-Baptiste Greuze, *The death of a
father, mourned by his children*, 1769,
brush and sepia wash with chalk, 18⅞ ×
26 : 480 × 660. Private collection,
France.

*facing page:*

PLATE 56 (top)
John Webber, *Waheiadooa, chief of
Oheitepeha, lying in state*, August 1777-.
British Library, London. (3.93)

PLATE 57 (bottom)
John Webber, *The Body of Tee, a Chief,
as Preserved after Death in Otaheite*,
September 1777-. Dixson Library, State
Library of New South Wales, Sydney.
(3.109)

iconographical topos of the seventeenth century, as represented in Poussin's *St John on Patmos*
(plate 61), in which the stress is also placed on a solitary figure deep in reflection. In Poussin's
case it is the apostle meditating among the ruins of the ancient world. Over a century later
de Loutherbourg painted an illustration to Young's *Night Thoughts* (plate 62), in which the
solitary figure, this time in a cemetery, muses over an open grave containing a skeleton.[10]
In composition de Loutherbourg's painting could not be more different than Webber's
drawing, yet both are seeking to evoke a mood of melancholic sublimity.

In depicting the *fare atua* Webber followed Parkinson and Spöring (1.69-1.71) and
there is no doubt that Parkinson's work was known to him, if only through the engravings

[10] Cf. Joppien, (1976b) 294-301, fig.
44.

53

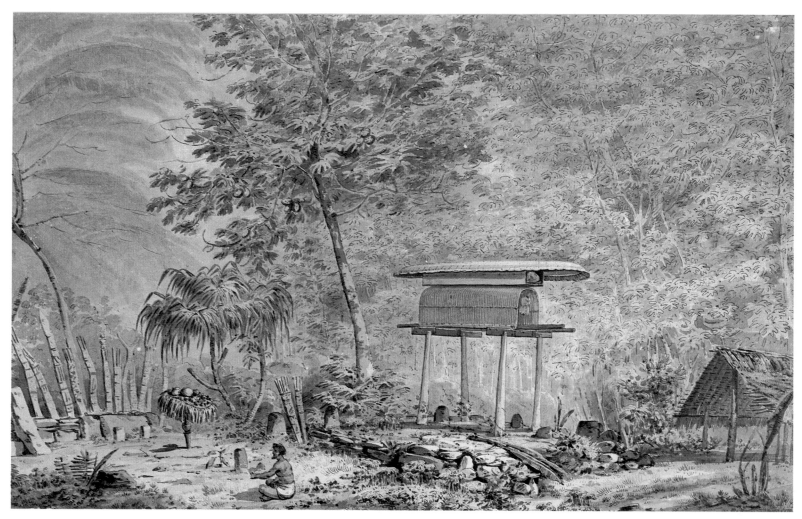

in Hawkesworth (1.70B) and Parkinson's own *Journal* (1.70C). Parkinson's drawing had also been executed in Huahine, and Webber may have drawn the same structure. Cook does not comment on it so that Webber may have chosen to depict it on his own initiative. In Webber's drawing more prominence is given to significant cult detail, the stones and steps of the *marae* and its carved boards, and the stone enclosure around the sacred structure. Webber stresses, as Parkinson did, the solemnity of the place, but here with an enclosure of high trees. Webber,

54

PLATE 62
Illustration to Young's *Night Thoughts.*
Engraving by Ridé and Patron after
Philippe Jacques de Loutherbourg.

we might say, was building visually on what Parkinson had begun. By the time Webber arrived in Tahiti, 'south sea' imagery of this kind had become familiar, almost required, material from the hands of the visiting artist.

But so too had the brighter aspects of Pacific island life, epitomized, as we have noted above, in the dance, and to it Webber also gave his concentrated attention. The carefully finished drawings *A Dance at Otaheite* (plate 63; 3.102) and *A Dancing Girl of Otaheite* (plate 66; 3.104), and *A Young Woman of Otaheite, bringing a Present* (plate 67; 3.106), all provide striking foils to his more solemn, funerary scenes. Here too was an opportunity to distinguish the Tahitian dance from the more formalized dancing of Tonga. Whereas they seem to have called to mind the more formal dances of antiquity, the Tahitian dancing aroused memories of peasant and of folk dancing.

The imagery of the country dance, in its most elegant and artificial formulations, had reached a peak in the work of the French artists, Watteau, Lancret and Boucher of the generations prior to that of Webber, and their work must have been well known to him (plate 64). Scenes of peasants dancing belonged to an older visual tradition. In the 1760s it gained new vigour from the scenes of Russian folk life portrayed by Jean-Baptiste Le Prince. Le Prince had accompanied the Abbé Jean Chappe d'Auteroche on his travels through Russia and observed the social life of the peoples of the steppes.[11] His paintings from his Russian journey were exhibited at the Paris Salon from 1765 onwards, among them dancing scenes and musical entertainments (plate 65).[12] Still closer to Webber's purpose were the Tahitian dances depicted on Cook's first voyage by Parkinson (1.83-1.87). They had provided the source for Cipriani's composition, *A View of the Inside of a house in the Island of Ulietea (Raiatea), with the representation of a dance to the music of that country*, which was engraved by Bartolozzi (1.87B) for Hawkesworth's *Voyages.*

Webber's *A Dance at Otaheite* (plate 63; 3.102) repeats some of the elements of Cipriani's composition, the drummers, the girls dancing in long gowns, with highly puckered ruffs of tapa attached to the back of the waist and feathery pompons covering the breasts. Similar too are the head-dresses made from plaited hair and ornamented with blossoms of the Cape jasmin (see also 2.72). A mat of rushes has been laid to dance upon. Eight years before, when Parkinson described a Tahitian dance in his journal, he noted: 'In the interval, between the several parts of the drama, some men came forward, who seemed to act the part of drolls.'[13] The two men portrayed here seem to be playing a similar role. Why then, we might ask, was Webber's scene so similar to Cipriani's earlier version, included in the official account of the third voyage? The question becomes more pertinent when considered in relation to Webber's

[11] See Chappe d'Auteroche, (1768); Réau, (1921), I, 147-65.

[12] See Adhémar/Seznec, (1960) III, 30-2; (1967) IV, 32-3, 247.

[13] Parkinson, (1773) 74.

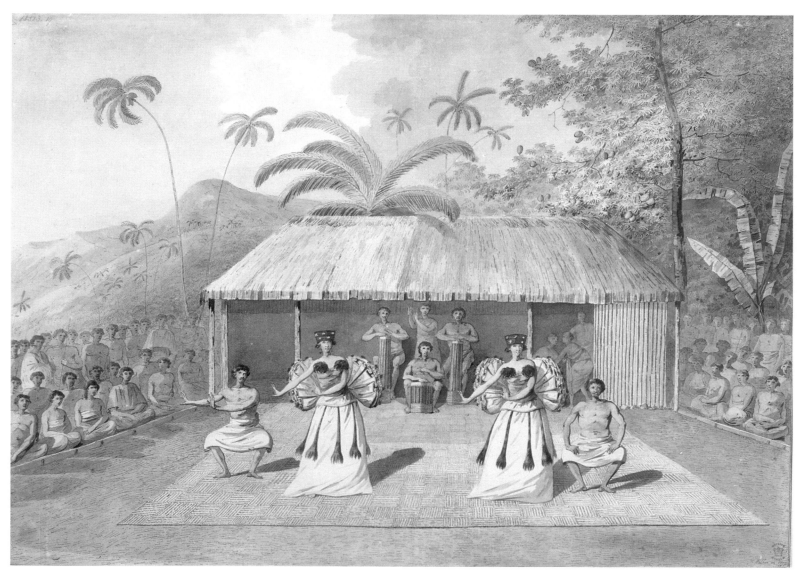

PLATE 63
John Webber, *A Dance at Otaheite*,
September 1777-. British Library,
London. (3.102)

PLATE 64
Antoine Watteau, *The Shepherds*, 1716-
17, oil on canvas, 22 × 31⅞ : 560 ×
810. Staatliche Schlösser und Gärten,
Schloss Charlottenburg, West Berlin.

PLATE 65
Jean-Baptise Le Prince, *The dance (La
danse)*, c. 1770. Part of *La Tenture des
Jeux Russiens*, Manufacture Royale de
Beauvais, Basse-Lisse, wool and silk,
Musée Jacquemart-André, Paris.

56

representation of the *heiva* girl (plate 66; 3.104), which is but a repetition of one of the figures in 3.103. Possibly the dance, or play (both Cook and Anderson called it a *heeva*) represented a particular occasion of some importance. Cook relates that he was twice entertained by plays in which Tu's sisters were the principal performers. Were then the dancers depicting a kind of portraiture? The other reason for their inclusion in the official account could have been simply to provide a balance as a foil to the horror of the *Human Sacrifice*. When Anderson described the *heivas* he found words such as 'their dress on this occasion was truly picturesque and elegant'[14] or 'the women at intervals [were] singing in a softer manner than I ever heard at their other diversions';[15] 'the assembly . . . [was] absorbd in the pleasure the music gave them'[16] etc. Such remarks afforded the greatest contrast imaginable to the ritual manslaughter that had been experienced a few days ago, and it would thus appear conceivable that out of faithfulness to the text of the journals, an alternative, happier scene of Tahitian life was added to the engravings.

Webber's *A Young Woman of Otaheite, bringing a Present* (plate 67; 3.106), struck a similar note. In the engraving by Bartolozzi it became a favourite subject of Cook's third voyage. The girl wears a 'dress' consisting of a prodigious quantity of *tapa* cloth bound about her waist. This and the two feather gorgets, or breast plates, fastened to the 'hoop' of her skirt, were intended as presents to the two captains. This exchange of presents as a ritual gesture for establishing friendly relationships is a recurring theme in Webber's work, particularly in his large compositions. Cook informs us that there were in fact two girls, who 'were conducted on board the Ship with Several Hogs and a quantity of fruit'.[17] Others came behind carrying presents.

The depiction thus reduces an event to one characteristic figure only. It recalls, oddly enough, those pictures of the *Cries* of itinerant trades that enjoyed great popularity in Europe in Webber's time, and earlier. Watteau, Boucher, Moreau, Le Prince in France; Paul Sandby and Francis Wheatley in England all dealt with the subject at one time or another.[18] And Wheatley's *Young Woman carrying a Sheaf of Corn* (1771) (plate 68), is in the tradition of the *Cries*.[19] It provides a useful comparison to Webber's *A Young Woman of Otaheite*, even though one is a local peasant girl familiar to all and the other a Tahitian exotic. Such subjects attest the growing interest in the naturalistic genre during the later eighteenth century, and an increasing awareness of roles, and the division of labour. The *Cries* introduced individuals and roles that were still barely visible upon the aesthetic rim of civil society. In order to become a subject proper to art their appearance had to be modified to accord with the accepted pictorial conventions, made picturesque and invested with a rudimentary elegance. This Webber achieved in a new, stimulating and exotic setting. His young Tahitian is endowed with a mien of classical reflection, but her feet suggest a measure of playful elegance.

Although the expedition remained in Tahiti for more than five weeks, Webber produced only a small number of portraits there. His Catalogue mentions three portraits in oil: 'Otoo King of Otaheite' (no. 3), 'Terreree Sister of King Otoo' (no. 4), 'Oediddee a Native', though a fourth of 'a Native' (no. 7) listed by Webber under Society Islands may have been painted in Tahiti.

'Otoo King of Otaheite' is probably identical with the *Portrait of Tu* (plate 69; 3.113), now in the Alexander Turnbull Library. Compared with Hodges's portrait of Tu (2.54), drawn four years before, Tu now lacks his great mop of frizzled hair and looks, if anything, even more self-conscious. Tu's 'timid' look had certainly not passed unnoticed, though George Forster had praised his 'majestic and intelligent air'.[20] The portrait is possibly a preliminary sketch, or an earlier version of another more finished one, now lost.

It was on the occasion of Webber painting Tu that the latter asked for a portrait of Cook for himself in return. The wish was granted and a portrait of Cook painted and given to him. Later European visitors to Tahiti commented upon the esteem in which Tu held it. But owing probably to climatic conditions it appears not to have survived (see 3.454).

Webber's Tahitian landscapes are few in number but they include two highly-finished and beautiful works. The first, his *A View in Vaitepiha Bay* (plate 50; 3.81) we have already discussed. The second, *A View in the Valley of Matavai Bay (Tuauru Valley)* (plate 70; 3.119), is memorable for the grandeur of the landscape, with its small habitations tucked away among palm trees and majestic mountains. Everywhere a wealth of lush vegetation is to be seen, except on the topmost peaks. Cascades fall down the hills and return as rivulets running through the valley. It would seem that it was not the sensuous and erotic life of Tahiti that stimulated Webber but the exhilarating beauty of the landscape itself. Ellis repeated Webber's view in a delicately coloured drawing which, however, lacks the subtlety and density of the exuberant tropical landscape (plate 71; 3.121).

[14] Anderson in Cook, *Journals* III, 2, 986.
[15] ibid., 985.
[16] ibid.

[17] Cook, *Journals* III, 1, 207-8.

[18] On the *Cries* see Steinitz, (1971); Beall, (1975); Massin, (1978).
[19] See Webster, (1970) fig. 88; herein several examples of Wheatley's *Cries*, also of his series *The Itinerant Traders of London. 1793-97*. A similar composition in this vein is Jean-Baptiste Huet's *La Laitière* in the Musée Cognacq-Jay, Paris, cf. Adhémar/Seznec, (1967) IV, pl. 20.

[20] Forster, (1777) I, 326-7.

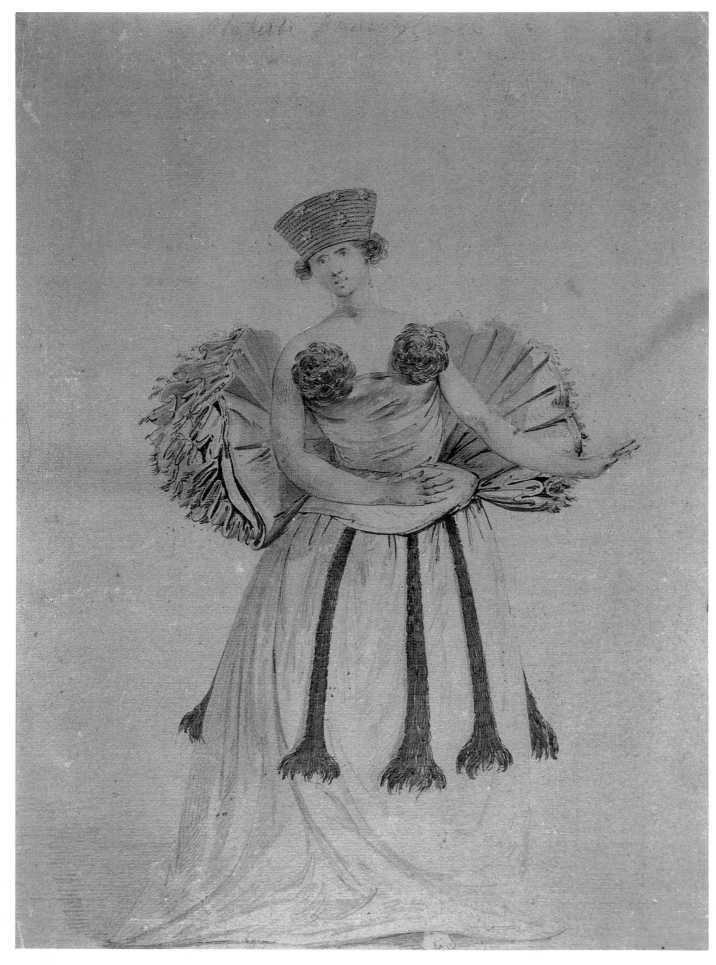

PLATE 66
John Webber, *A Dancing Girl of Otaheite*,
September 1777. Dixson Library, State
Library of New South Wales, Sydney.
(3.104)

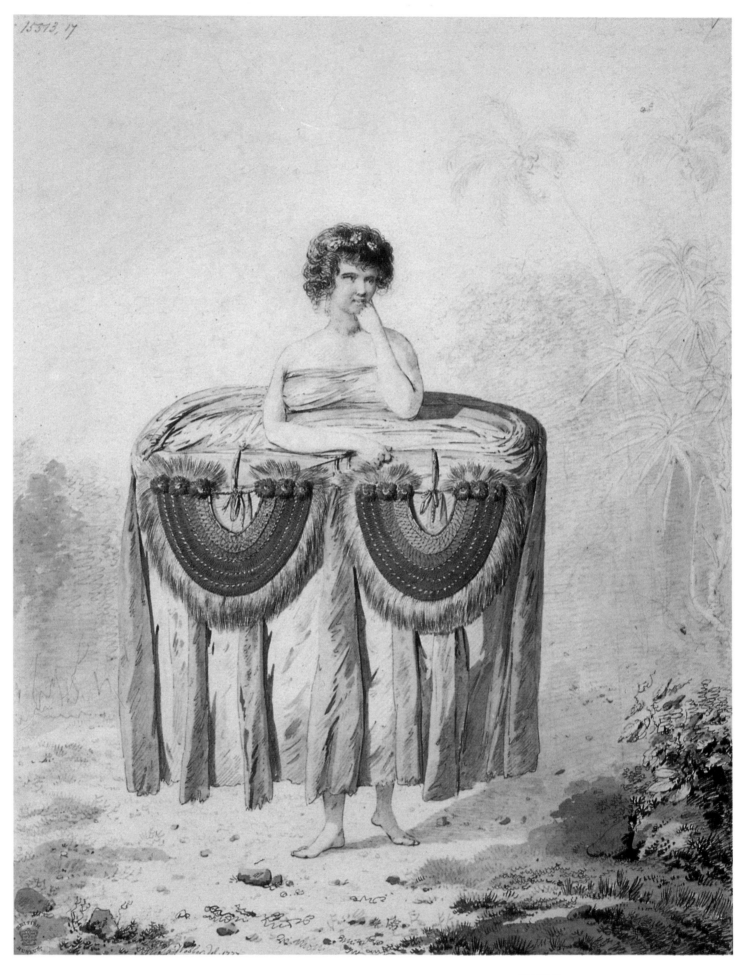

PLATE 67
John Webber, *A young Woman of Otaheite, bringing a Present*, September 1777-. British Library, London, (3.106)

PLATE 68
Francis Wheatley, *Young Woman carrying a Sheaf of Corn*, 1771, pencil and grey wash, 14 × 10 : 356 × 254. Private collection, England.

[21] See Conisbee, (1976) Cat. no. 69.

In Tahiti Webber also was able to undertake work of a more informal kind. A *View of Oparee (Pare)* (3.122), though quite well-finished seems to be a work of this kind, and his *View in Otaheite* (plate 72; 3.123) is a free study, with some brilliant touches of colour, depicting bathers in shallow water. It was a theme, oddly enough, that the artists who travelled with Cook, rarely turned to. Hodges, certainly, introduced bathers into two of his most colourful Tahitian paintings (2.42; 2.43), but Webber appears to have been even more cautious, depicting bathers in only one other drawing, and then quite minutely. Yet the sight of Tahitians bathing would have been a constant and daily experience. There were numerous precedents of course in European painting had he been tempted to a serious composition, including successful recent examples such as Claude-Joseph Vernet's *Landscape with Bathers* (plate 73), that Webber might have seen in Paris in the Salon of 1771.[21] But the subject obviously did not appeal to him greatly, or perhaps to Cook either.

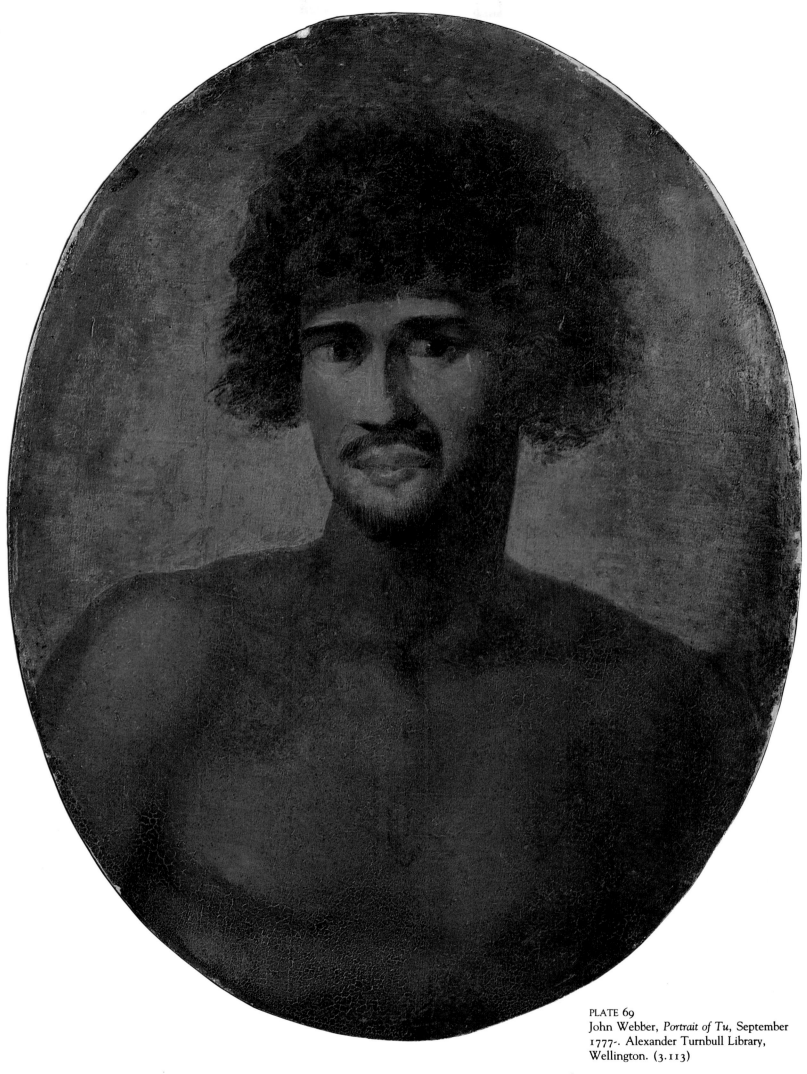

PLATE 69
John Webber, *Portrait of Tu*, September
1777. Alexander Turnbull Library,
Wellington. (3.113)

61

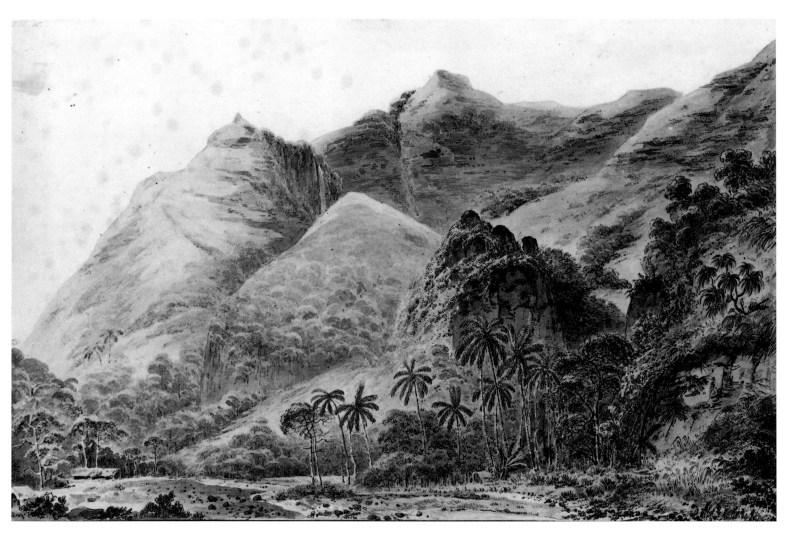

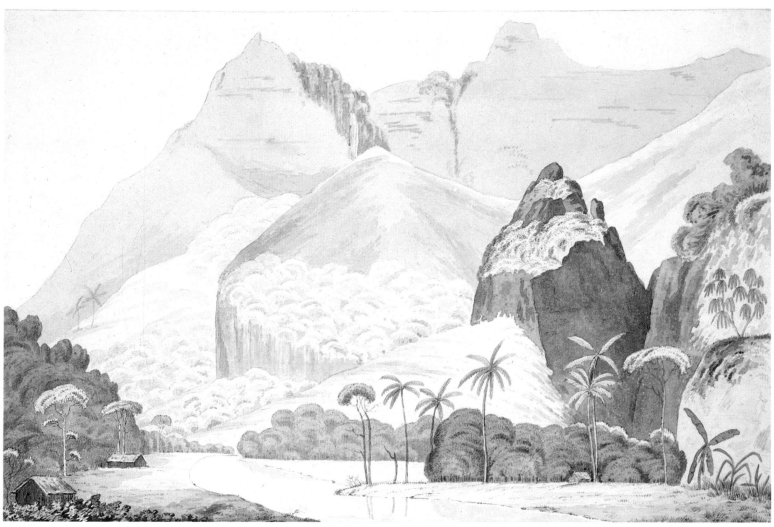

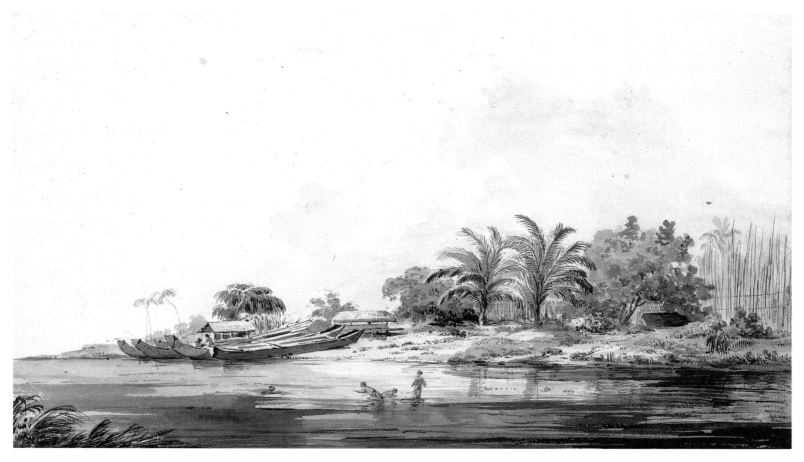

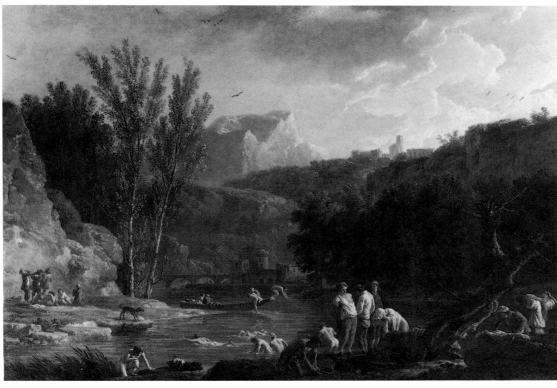

# 17. Moorea (Aimeo), Society Islands: 30 September-11 October 1777

During the stay at Moorea, Webber's interest in landscape found further nourishment in the sketching that resulted in his magnificent panoramic *A View of Aimeo Harbour (Papetoai Bay)* (plate 74; 3.135). It looks towards the island's dramatic volcanic cones, with the two ships at the far end of Papetoai Bay dwarfed by the height and breadth of the scenery.

A second view of the same harbour (plate 75; 3.139) must have been taken from a rising point on land looking back towards the bay and the ships. The drawing is rather exceptional in Webber's *oeuvre* for its composition and point of view. Similar land views had been undertaken by Parkinson and Hodges on the previous voyages (1.29; 2.140; 2.140c), but what makes Webber's drawing unusual is its special feeling here for topographical survey, resulting in an 'inversion' of views. The device was practised among the vedutists on the Continent in their depiction of significant places and may have been known to Webber. Consider, for example, Philipp Hackert's *Cavern called the 'Ear of Dionisius'*, a pair of drawings representing the interior and exterior of a cave near Syracuse (plates 76, 77).[1] Such drawings usually came in pairs, or pendants, but still more views could be added to complete, if needed, the four points of view of the four quarters of the compass. Webber was not a vedutist in a narrow sense, but his training under Wille would have brought him in contact with their devices. Hackert himself had been a student of Wille during the 1760s.

[1] Krönig, (1968b) 253-74.

PLATE 74
John Webber, *A View of Aimeo Harbour (Papetoai Bay)*, October 1777. British Library, London. (3.135)

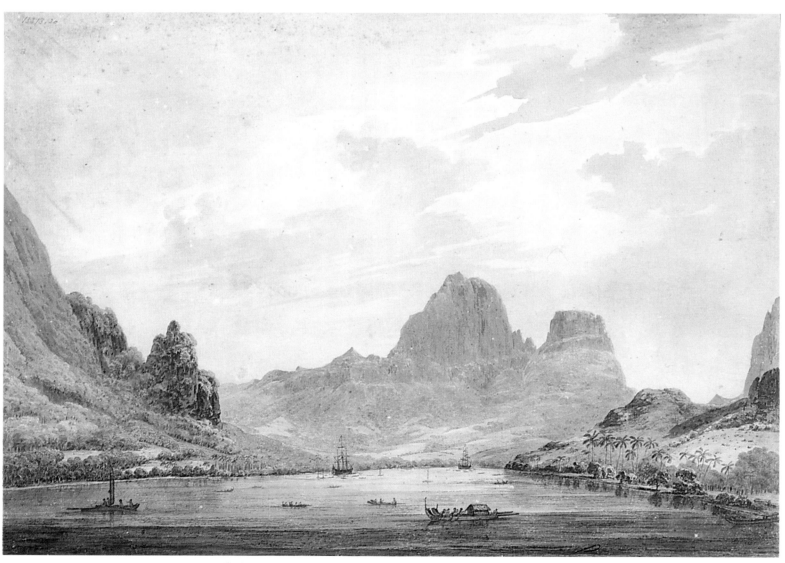

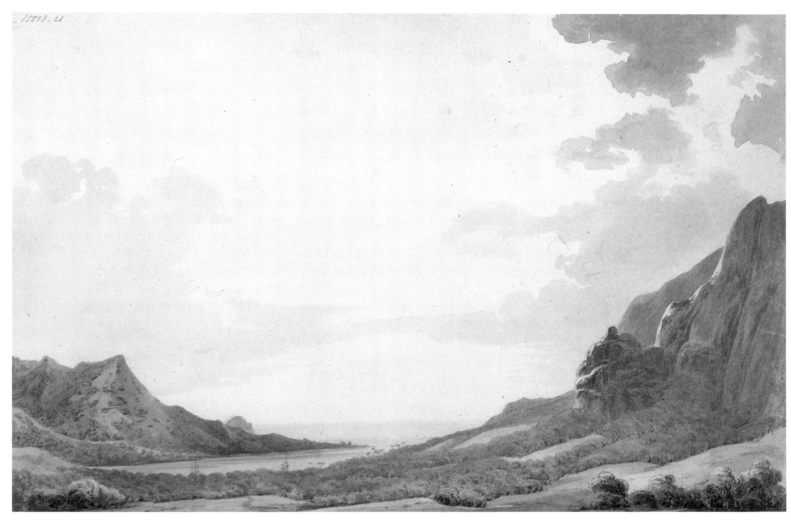

# 18. Fare, Huahine, Society Islands: 12 October-2 November 1777

[1] Cook, *Journals* III, 1, 235.

Webber's A *View of the Harbour of Huaheine* (plate 78; 3.140) would have been of special interest to Cook for it depicts the site of Omai's new home. To leave Omai in the Society Islands, at the island of his choice, was one of Cook's written instructions for his third voyage. In consequence Cook negotiated with the chieftains of the island for a suitable piece of land for Omai to settle upon and then had his carpenters build a timber house for him, in European style. A garden was also laid out, in which, Cook tells us 'Shaddocks, Vines, Pineapples, Millons and several other articles' were planted 'all of which were in a flourishing state before we left the island'.[1]

To most of the potential readers of Cook's third voyage Omai's name was familiar and there was a good deal of sentimental interest in his fate. An illustration of his new house would therefore have been most appropriate, but nothing of that kind has survived. Only with the help of a magnifying glass, can Omai's house, the observatories and the tents be made out in the very depth of the bay, in Webber's drawing. The aquatint after John Cleveley (plate 205) provides some idea perhaps of Omai's house and a reconstruction of the associated activities on shore, though whether it was based on a drawing made 'on the spot' by John Cleveley's brother James (a carpenter on the *Resolution*), as was claimed at the time, is, to say the least, not certain.

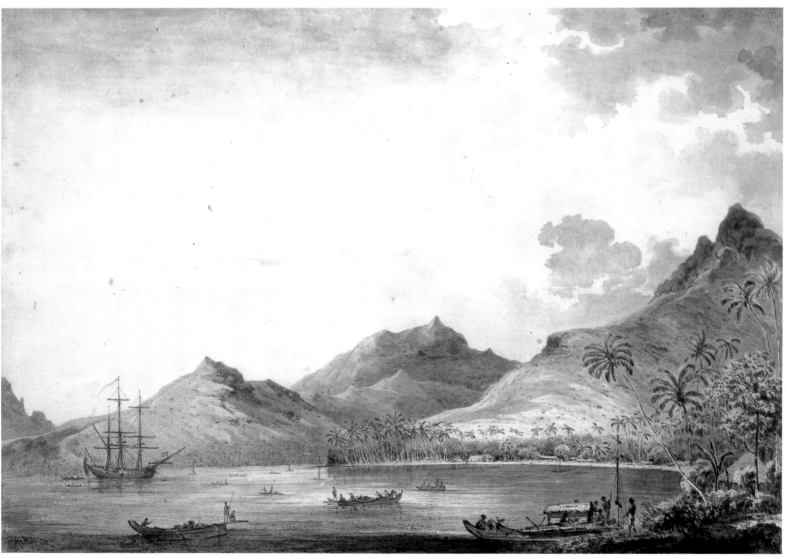

# 19. Raiatea (Ulietea), Society Islands: 3 November-7 December 1777

During Cook's stay of five weeks at Raiatea few new drawings seem to have been undertaken by Webber. Not much field work was done either, nor do we hear of further ceremonies and amusements attended. Perhaps Webber occupied himself completing the work he had begun in the south Pacific, prior to the beginning of the northern leg of the voyage. On 18 November Cook acquainted Captain Clerke of the *Discovery* with the instructions for this section of the voyage: to explore the possible existence of a north-west passage from the Pacific to the Atlantic. Assuming Raiatea to be the last stay in the Pacific islands, the ships were repaired and provisions taken aboard. In the face of a future which looked bleak with ice, snow and continual hardship, the idea of deserting the voyage became a tempting one for some members of the crew; the beauty and availability of the Raiatean women doubtless increased the temptation.

Cook had his own way for retaking deserters. When Alexander Mouat, a midshipman on the *Discovery* and Thomas Shaw, the gunner's mate, deserted to remain on the island, Cook and Clerke decided to take three prominent Raiateans hostage and exchange them only at the return of the men. The hostages taken were Teura and Poetua, son and daughter of the chieftain Oreo, and Moetua, the husband of Poetua. All three were locked up in Clerke's cabin on the *Discovery* from 26 to 29 November. It must have been during this time that Webber painted Poetua's portrait (plate 79; 3.149).

Webber, on the basis of his known *oeuvre*, executed few portraits of Tahitian women. He was a bachelor to the end of his life. Yet the women were a very visible feature in the daily environment during the stay in the Society Islands. They provided many of the seamen with an unfettered enjoyment beyond their dreams and for several months were constantly on the decks of the ships; physically present all the time. Even the dry, sober Cook, if John Williamson, third lieutenant on the *Resolution*, is to be believed, fell victim, in a modest way, to their charms:

> Capt$^n$ Cook is so very partial to y$^e$ Society Isles, that y$^e$ two or three portraits that have been made, are of women (one in particular), that if y$^e$ most diligent search was made over all y$^e$ islands, such another could not be found.[1]

The 'one in particular' seems to have been Poetua, already known to Cook from his second voyage in September 1773, when Cook was sensitive to her unusual beauty, calling her 'a pretty brown girl at whose shrine . . . many pretty things were offered by her numerous Votarists'.[2] Edgar described her as a 'young Princess',[3] and David Samwell who saw her crying in her captivity called her 'the beautiful Poiedooa who was not to be pacified'.

In his portrait Webber presented the girl against a highly generalized background of sultry sky and distant mountains, and the lush foliage of the plantain. Whatever the likeness may have been she was obviously intended also to depict a typical romantic beauty of the south seas. A mood of sensuous eroticism, unusual in Webber's work, prevails. While her right arm follows the fine contours of her body, holding a fan, the left rests across her ample hips. The face is framed by the long black curls, in which she wears the blossoms of the Cape jasmine, and her breasts are framed by her arms but not hidden by them. Webber gave her a dreamy smile, as if submitting to her captivity.[4]

The canoes of Polynesia were one of the main subjects of interest for all the artists who travelled with Cook on his three voyages. In the drawing *A Canoe of Ulietea* (plate 80; 3.152), and the several versions which followed, Webber occupied himself with a subject in which Parkinson and Hodges had also revealed a keen interest. For the construction, maintenance and sailing of the canoes raised the whole question, for the more reflective members of Cook's voyages, of the origins and dispersion of Polynesian society in the Pacific. The version of the drawing in the National Library of Australia (plate 81; 3.154) depicts a young man elegantly posed in a white tapa cloth robe standing in the front of the deck-house. He looks towards

[1] Williamson in Cook, *Journals* III, 1, 247, fn. 1.

[2] Cook, *Journals* II, 421.
[3] Cook, *Journals* III, 248, fn. 3.

[4] See also Smith (1960) 93, fig. 70.

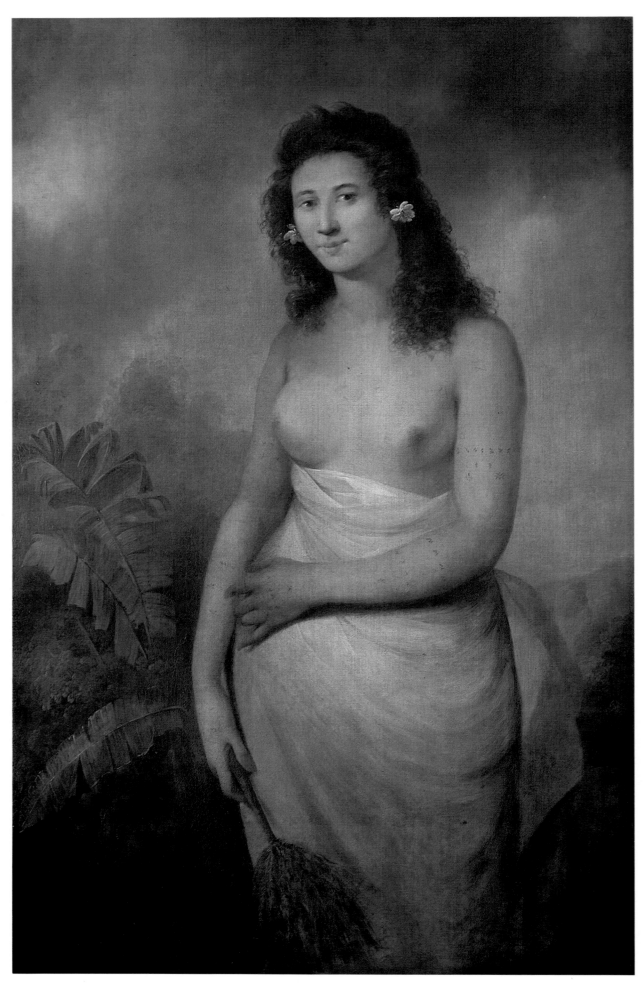

PLATE 79
John Webber, *A Portrait of Peodua*
(*Poetua, Poedooa*), November 1777-.
National Maritime Museum, London.
(3.149)

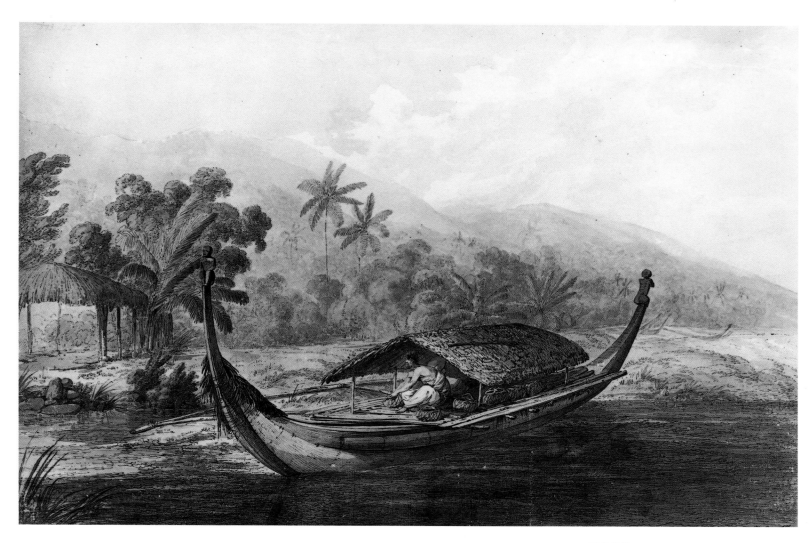

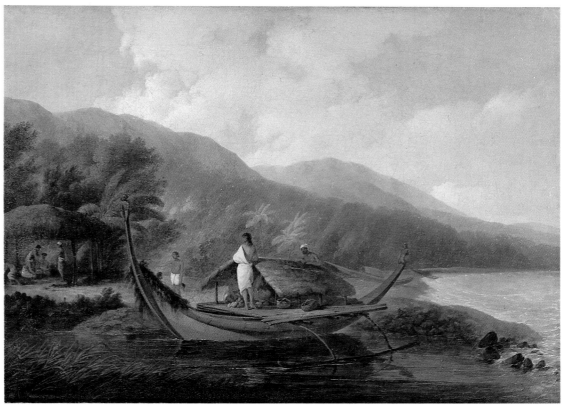

the shore, his glance directed towards another who in turn points to a shed to the left where figures are squatting and apparently conversing. At the other end of the canoe, leaning on the deck-house an older man, who may be in charge, seems to be waiting. Provisions are being taken on board in preparation for sailing.

The narrative element present here was developed in such later versions, whereas the earliest drawing (plate 80; 3.152) depicts no more than one figure in the canoe, an empty

[5] See Robels, (1983) no. 241, 143.

[6] See examples in Joppien, (1973) no. 33 (repr.); Conisbee, (1976) no. 41, 78, 82; Webster, (1970) no. 15, Butlin/Joll, (1977) pls. 57, 103, 103.

shed and in the distance empty canoes. It would seem that Webber became increasingly aware of the intrinsic 'drama', the element of suspense in such departures. The capacity of Polynesian canoes to undertake voyages of considerable length was a topic of great interest on Cook's ships. The theme itself struck a responsive chord in a European audience whose trade and wealth still depended so much upon the arrival and departure of ships. As European commerce expanded, the busy life of the ports became a popular iconographic motif in all European countries. Building on Dutch precedents of the seventeenth century, such as the Herman Saftleven drawing of *River landscape with barges* (plate 82)[5] artists like Vernet or Wheatley in the eighteenth century and Turner or Clarkson Stanfield in the nineteenth, combine landscape feeling with the realism of daily life around the ports they depicted.[6] Webber's *A View in Ulietea* (plate 81; 3.154), once it is mentally dislocated from its exotic setting, provides us with yet another example of this long-established and popular pictorial topos.

On the other hand, and quite apart from this hidden traditional appeal of the subject, Webber's series of drawings of canoes provided quite practical information as to the nature of Polynesian nautical craftsmanship and navigation. To the seafaring English the different types of canoes found in the Society Islands and elsewhere in Polynesia aroused great curiosity. It is not surprising therefore that Webber incorporated many canoes into his compositions on his return home, particularly into his *Views in the South Seas*.

PLATE 82
Herman Saftleven, *River landscape with barges*, brush and brown wash with charcoal, 4¾ × 7⅜ : 123 × 187. Wallraf-Richartz Museum, Cologne.

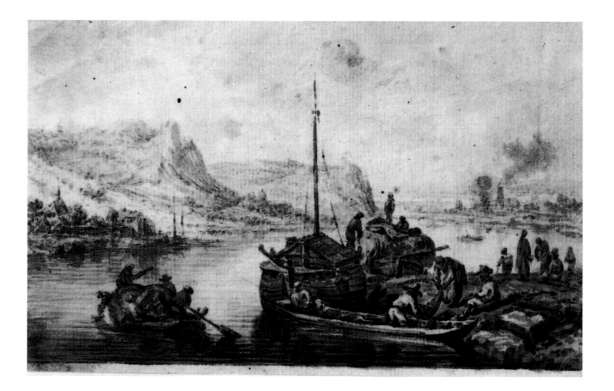

## 20. Borabora (Bolabola), Society Islands: 8-9 December 1777

Cook's stay at this island was restricted for he had no other intention in going there but to procure an anchor which Bougainville on his voyage around the world had lost in Tahiti. On landing he and his party were introduced to Puni (Opoony), the local chief, with whom Cook exchanged presents. Webber's portrait sketch (3.161) of a man of elevated rank and the ensuing finished drawing (plate 83; 3.160) were probably executed on this occasion. No other drawings relating to Borabora are known.

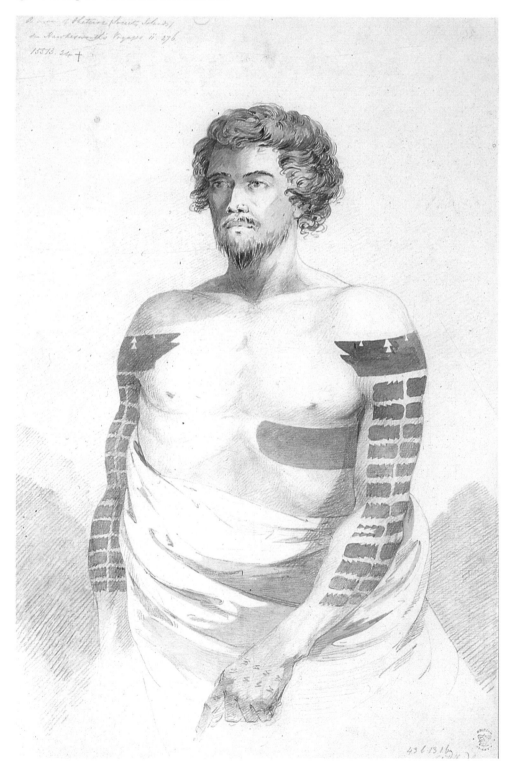

PLATE 83
John Webber, *A Portrait of a Chief of Oparapora (Borabora)*, December 1777·. British Library, London. (3.160)

71

# 21. Hawaiian Islands (Sandwich Islands), Kauai (Atooi): first visit: 19-23 January 1778
# Niihau: first visit: 30 January-2 February 1778

[1] Cook, *Journals* III, 1, 269.

[2] King in Cook, *Journals* III, 1, 283, fn. 2.

[3] Cook, *Journals* III, 1, 283.

[4] ibid., 272.

[5] Samwell in Cook, *Journals* III, 2, 1083.

PLATE 84
John Webber, *An Inland View at Waimea [Atooi]*, January 1778-. British Library, London. (3.165)

When Cook sighted the coast of Kauai in the morning of 19 January 1778, he might not have realized he was on the point of making yet another European discovery of a major group of Pacific islands. No further land had been expected between the Society Islands and the American coast. Canoes soon came alongside the ships and began to trade. Villages could be observed from the ships, and plantations, but few trees.

After the ships had anchored in Waimea Bay on 20 January, Cook went on shore and was greeted by the people with all the signs of veneration: 'The very instant I leaped ashore, they all fell flat on their faces, and remained in that humble posture till I made signs to them to rise.'[1] For the Hawaiians from the beginning, Cook was something more than mortal. The following day he went ashore again, this time accompanied by Webber. One of the drawings which resulted from the visit was Webber's *An Inland View at Waimea [Atooi]* (plate 84; 3.165). It depicts a market scene and illustrates, once again, an encounter between the voyagers and the local inhabitants. King noted that the dwellings 'instead of being scatterd as at the other Islands, are here connect'd into Villages'[2] and something of this is revealed in Webber's drawing, as indeed is Cook's comparison of the houses with 'oblong corn stacks'.[3] Trading was exceptionally good. Cook believed that 'no people could trade with more honisty than these people, never once attempting to cheat us'.[4] The various groups of people as depicted by Webber does suggest a feeling of relaxation and trust. Barrels of water are being rolled about without fuss or molestation, and in the centre a woman converses with a marine. It may be an allusion to the readiness of the Hawaiian girls to offer themselves to the sailors. Samwell remarked that the 'young Women, who were in general exceedingly beautiful, used all their arts to entice our people into their Houses'.[5] And Webber shows a couple of young women in front of a hut on the extreme right in order perhaps to endorse the statement.

Three studies for the scene (3.168-170) enable us to follow the development of the picture from the first sketch of the houses (plate 85; 3.169) to the composition at large. A later sketch (plate 86; 3.168) animated the scene with figures. With the exception of the native carrying a bunch of sugar-canes these are retained in the final work. A study has also survived for the left side of the view (plate 87; 3.170). It illustrates the open arrangement of the houses and provides a vivid impression of the countryside under the heat of the tropical sun.

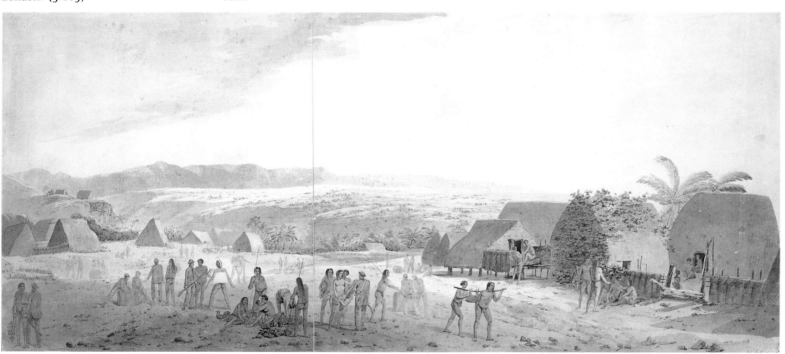

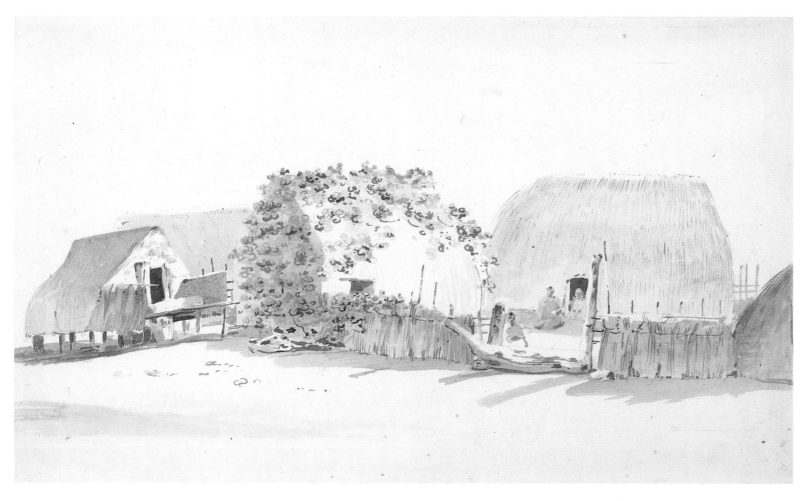

PLATE 85
John Webber, *Native Habitations at Waimea*, January 1778. British Library, London. (3.169)

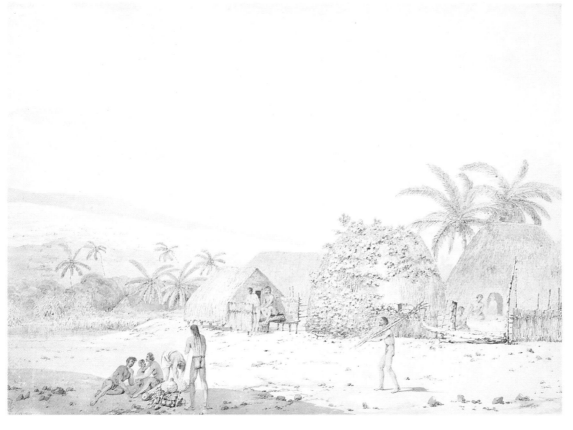

PLATE 86
John Webber, *Habitations of the Natives at Waimea*, January 1778-. British Library, London. (3.168)

The importance of these sketches cannot be overestimated, precisely because they do not reveal any remarkable differences from the finished work. Against them the fidelity of Webber's developed drawings may be tested. The sketches were obviously executed on the spot, and the topographical situation, which they captured, remained fixed in the later work. Although the human elements may be exchanged, the general framework remained the same. Thus from the point of procedure, in planning and reconsidering Webber's works contain little surprises. On the other hand, this matter of fact approach was an indispensible component

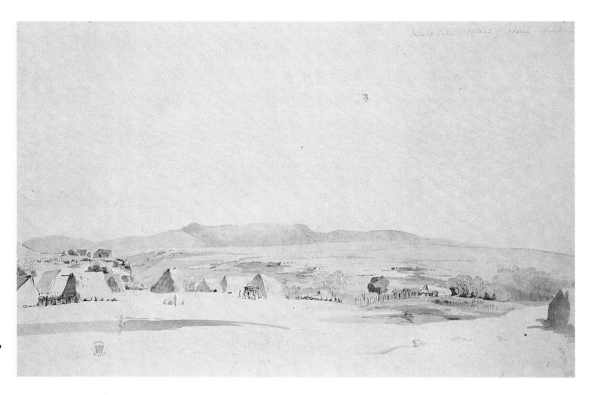

PLATE 87
John Webber, *An Inland View at Waimea*,
January 1778. British Library, London.
(3.170)

[6] Cook, *Journals* III, 1, 269.

[7] On Pars see Wilton, (1971) xxi-xlv;
on the drawings of Chatelet,
Clerisseau and Desprez see Bacou *et
al.*, (1977).

[8] Cook, *Journals* III, 1, 270.

[9] ibid., 271.

[10] ibid., 280, with Beaglehole's
comment, fn. 3.

PLATE 88
John Webber, *A 'Morai' at Atooi*, January
1778-. British Library, London. (3.171)

PLATE 89
John Webber, *An Inside of a House
showing their Idols*, January 1778-. British
Library, London. (3.175)

of his art. He was not there to invent but to document. Webber's reliability cannot be better demonstrated than through his sketches.

On the same day (21 January 1778) Cook, Anderson and Webber undertook 'a walk up the Vally',[6] 'in the course of which they came to a *heiau*, an equivalent of the Tahitian *marae*. It is represented in a couple of Webber's drawings.

Both A *'Morai' at Atooi* (plate 88; 3.171) and *An Inside of a House showing their Idols* (plate 89; 3.175) were engraved for the official account, so stressing the importance of places of cult and worship as a major research interest of the voyage. The representation of the temple area as an archaeological site is underlined by the walled enclosure and the stony ground. During Webber's lifetime artists like Claude-Louis Chatelet, J.L. Clerisseau, Louis-Jean Desprez or William Pars, to mention but a few, worked in Italy, Greece and Asia Minor on specific commissions to record classical ruins and excavations (plate 90).[7]

Their task was little different from Webber's. They worked with the prospect in mind of their drawings being published, and had to be accurate to avoid possible criticism. Most of them worked for patrons, who gave them directions and discussed their work with them. In Hawaii, in January 1778, the situation was similar. Cook made notes about the *heiau's* oracle tower, the 'rude carved boards'[8] and the carved figures of the gods inside the temple house, and then concluded:

> After having seen everything that was to be seen about this Morai and Mr Webber had taken a drawing of it, we returned to the beach by a different rout to the one we came.[9]

Of the people which Webber portrayed in the Hawaiian Islands, three men and one woman can with some probability, be identified as natives of Kauai. Some of his best work went into these portrayals. All are of head-and-shoulder type. There was as yet no suggestion that the ships might return, so Webber had to make his records immediately. Lack of time doubtless demanded sketches first, to be developed later aboard the ship. The two that have survived help us to understand Webber's methods in catching a likeness; the first hasty rendering of the head, hair, beard, and tattoo marks by broad and swift pencil lines (plates 91, 93; 3.180; 3.186).

In the subsequent finished drawing some significant changes have been made (plate 92; 3.179). More of the body is drawn, showing the contours of the shoulders and the upper arms, the expression of the face is refined. The head, now placed more vertically, is drawn in more detail and also looks younger and more elegant. Some more detail has gone into the sitter's hair-style, showing much more clearly the crest of hair across the top of the head. Also the tattooing in zigzag lines, is now executed with more precision and tattoo marks have been added to the right arm and the chest. Their curvilinear pattern echo Cook's interesting observation that 'many had the figure of the *Taame* or brea[s]tplate of Otahiete'.[10]

A *Portrait of a Man of Atooi*, in the British Library (plate 94; 3.183) is more developed than the ones discussed above, but it may possibly be a drawing, despite its lack of tattooing,

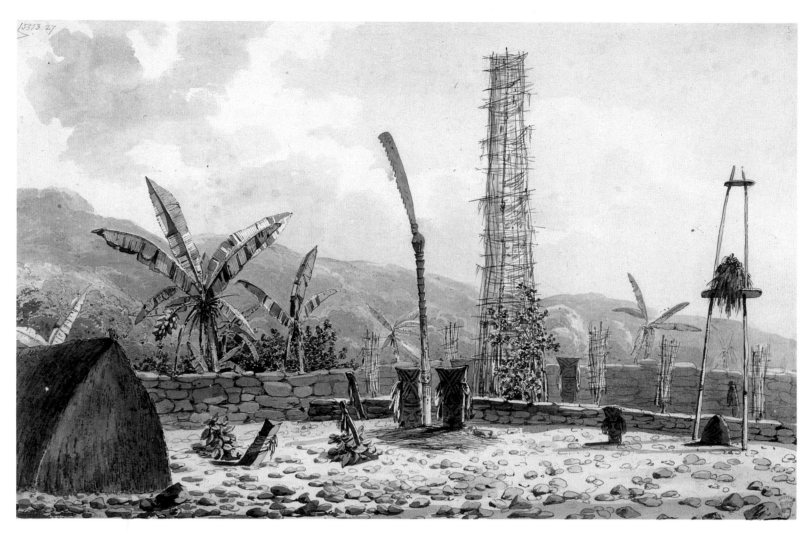

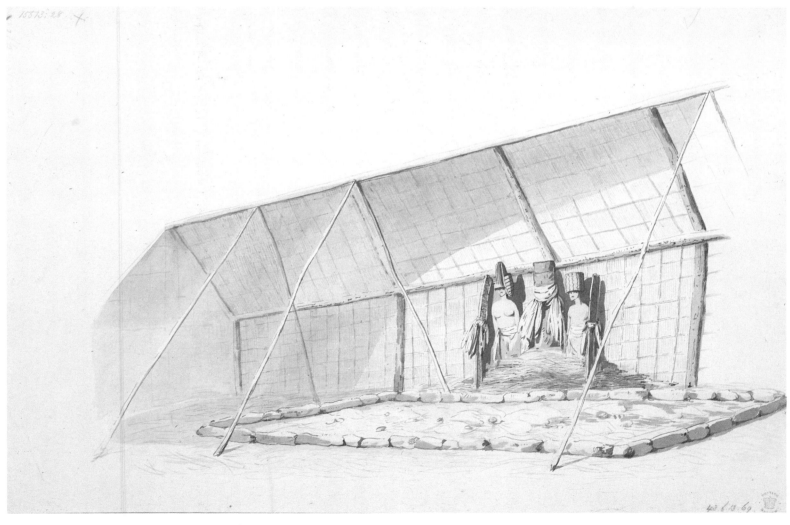

75

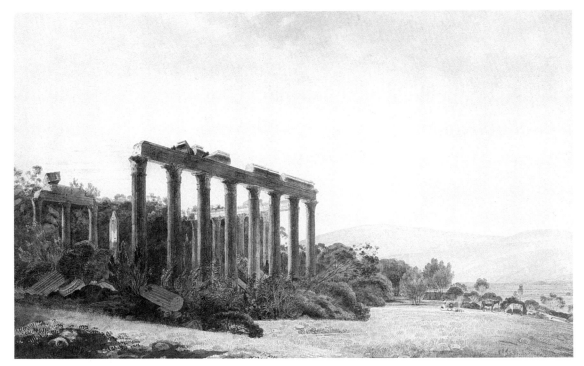

PLATE 90
William Pars, *The Temple at Iakli*, 1765,
pen, grey ink and water-colour, 11¾ ×
18¹¹⁄₁₆ : 299 × 475. British
Museum, Department of Prints and
Drawings, London.

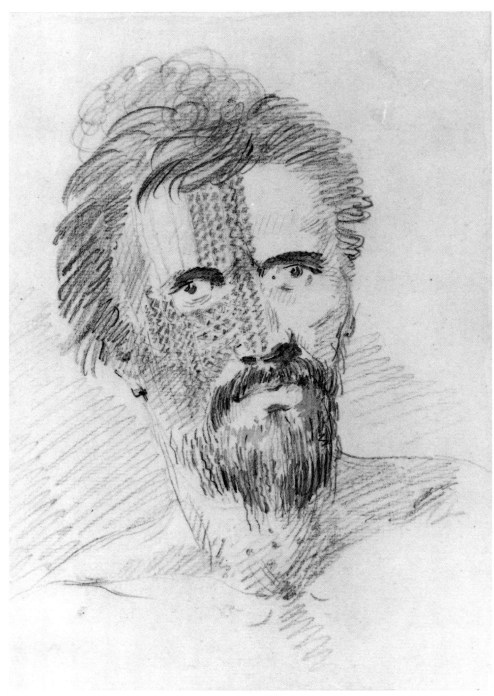

PLATE 91
John Webber, *A Native of Atooi*, January
1778. Farquhar collection, Berkeley.
(3.180)

PLATE 92
John Webber, *Portrait of a Man of Atooi*,
January 1778-. Bishop Museum,
Honolulu. (3.179)

76

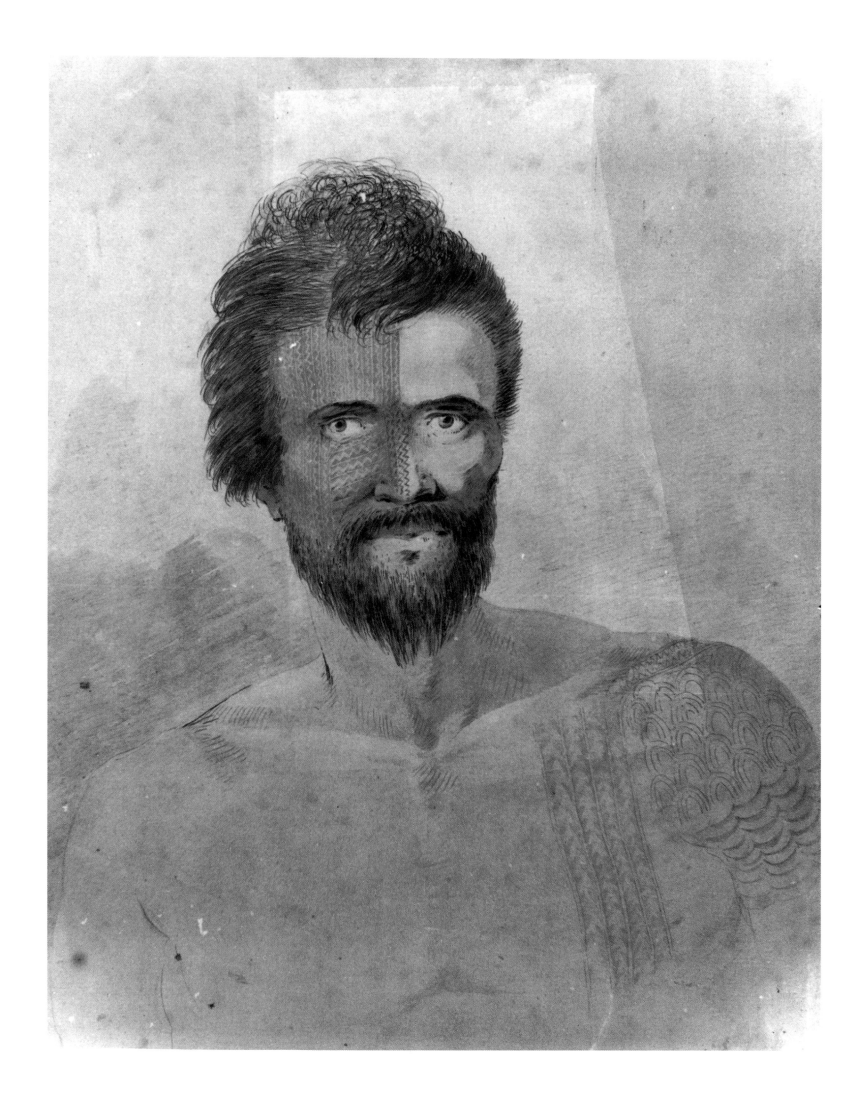

77

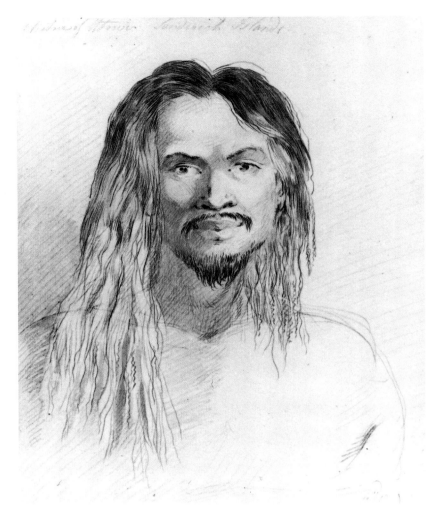

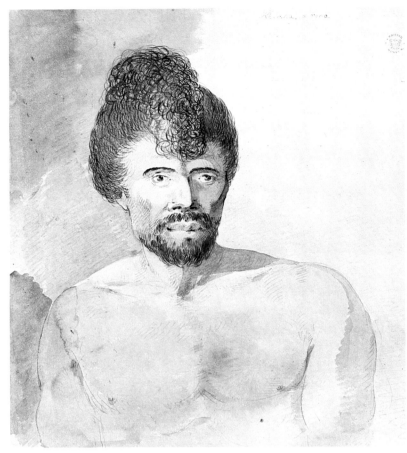

PLATE 93
John Webber, *A Native of Atooi*, January
1778. Farquhar collection, Berkeley.
(3.186)

PLATE 94
John Webber, *A Portrait of a Man of
Atooi*[?], January 1778. British Library,
London. (3.183)

[11] Kaeppler, (1978a) 72, 73 (figs. 91,
92), 75.

of the same man. This drawing in turn was obviously used to depict the man in the feather cape, in the Bishop Museum (plate 95; 3.184). The length of the beard and the cast of the eyes suggest that Webber repeated the portrait, adding features of clothing gained in trading. Two headbands similar to the one around the cap were collected during the first or second stay at Kauai. They later found their way into the Museum of Anthropology and Ethnology at Leningrad.[11] All this points to the fact that in his finished portraits Webber did not confine himself to precisely what the subject was wearing at the time he made his sketches. Where necessary he manipulated details to provide significant ethnographical information.

Because of stormy weather Cook left Kauai and sailed over to the neighbouring island of Niihau, arriving on 29 January when a landing was made to obtain provision. Cook went on shore on 1 February. A drawing by Webber *Sailing Canoes off Niihau* (3.188) may derive from this stay.

PLATE 95
John Webber, *A Warrior of Atooi or of
Niihau*, January 1778-. Bishop Museum,
Honolulu. (3.184)

78

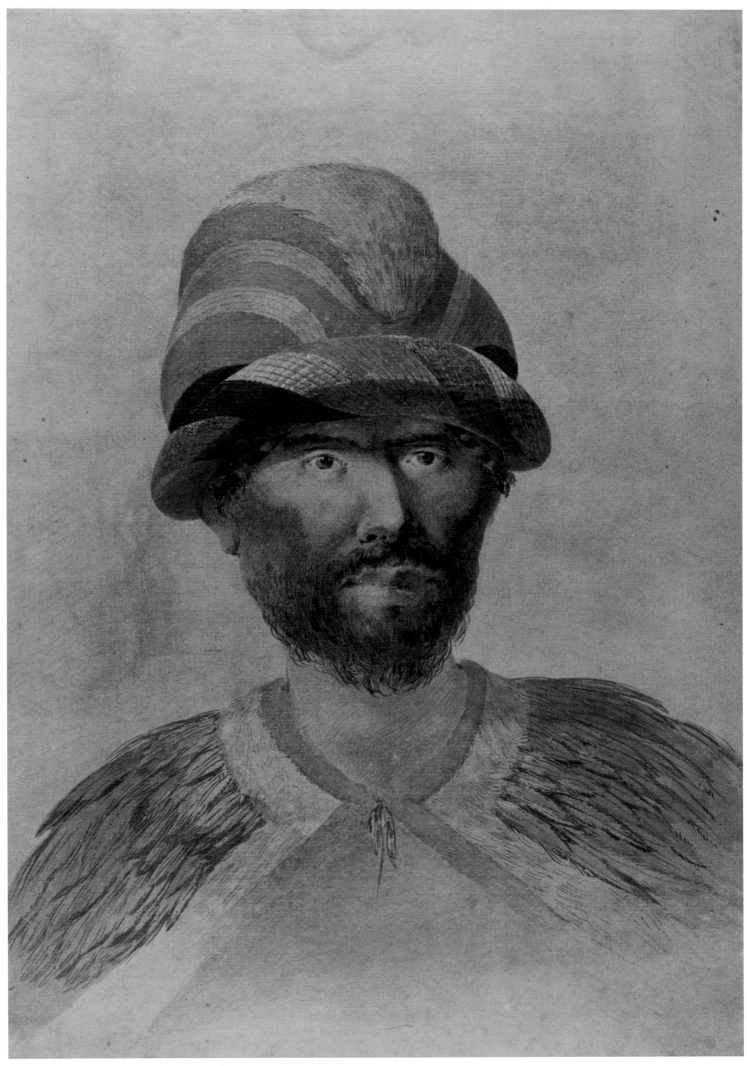

79

## 22. Nootka Sound (King George's Sound), Vancouver Island, north-west coast of America: 29 March - 26 April 1778

During Cook's stay in Ship Cove (Resolution Cove) Webber produced many sketches of great documentary value. Of the four weeks there, eleven days brought severe showers of rain, during which the artist was probably confined to the ship. Several views, such as *A View in Ship Cove* (3.190 and 3.191) seem to have been drawn on board the *Resolution*, the ship itself being included later. The best idea of the surrounding landscape is given in *The Resolution and Discovery moored in Ship Cove* (plate 96; 3.189) which is also his largest work concerned with the voyage. It shows the cove from the western shore as if taken by a modern wide-angle lens. The drawing, besides depicting the two ships inside the cove, includes the usual activities of the crew, wooding, watering and trading. On the beach sailors are occupied rolling barrels to a landing stage, and a couple of blacksmiths are forging fittings for the mast. In the central background, guarded by a sentry, the two astronomers' tents have been erected and observations are being made. The ships, which are here drawn unusually large in scale, are encircled by Nootkans in canoes, who trade and converse with the members of the crews. A painting, or rather a series of paintings, which comes to mind in this context, is Claude-Joseph Vernet's *Ports of France*, a sequence of marine views well-known in France during Webber's student days (plate 97).[1] Vernet exhibited them in the Salon and engravings had made them readily available. In his *Ports* Vernet combined the topographical with a narrative element. Nautical life and street scenes by the ports, showing the bustling life of the embankments illustrated the commercial concourse of the town and its region. In each painting a convincing viewpoint had to be chosen to represent the town's skyline and provide characteristic vignettes of daily occupations. Though basically vedutist and topographical in character, Vernet's paintings aimed at a kind of history piece. Topography was used as foil, against which a richer, and more complex pattern of human activity was depicted.

The link here with Webber's large drawing is obvious. Webber too aimed at a more ambitious composition than a topographical survey. In his carefully composed picture the geographical and commercial components of both the land and sea are drawn together into a hub of human activity.

The drawing represents a time at low tide, as is revealed by other drawings which show Astronomer's Rock surrounded and partly submerged by water (3.195). The time was well chosen for it allowed Webber to depict the bay to advantage, with its rough, irregular shoreline. The east side is shown broken into sections of rock, overgrown by moss, small trees and shrubs; above the beach, a thick apparently impenetrable forest, with many trees felled by the heavy coastal gales. What he saw seems to have been a visual challenge. He was certainly not unacquainted with the empirical demands set by strange landscapes, but the varied activities, the astronomical observations, the watering of the ships, and the activities involved in repairing the masts of the *Resolution*, when seen altogether was quite novel to him.

The character of the landscape, on the other hand, must have recalled his family's homeland, though retaining its sense of strangeness. Of those who kept journals on the voyage, each reacted differently. Clerke approached it in quite a pragmatic, practical manner:

> The Land about this Sound makes in very high Hills, the declivities of which slope into the Sea, where the Shores are very steep & rocky: the Soil in general is rocky, which is apparent in many places, even upon the Tops of the Hills; but it is so well cloathed with Earth, as to produce vast abundance of excellent Timber; indeed, the whole face of the Country is cover'd with it, both Hills & Dales. The wood in general is Fir, there are different kinds of it, and such a variety of Sizes, that in going a very inconsiderable distance, you may cut Sticks of every gradation, from a Main Mast for your Ship, to one for your Jolly Boat.[2]

King's reaction was much more personal:

> The land round the Sound is very much broken into high precipices & deep Chasms; all parts of which are wooded, & continue so down to the water side, where the shore is steep & rocky . . . the whole has a *melancholy* appearance; not even the noise or mark of Animals or birds

[1] Conisbee, (1976). On the *Ports of France* see introduction (no page nos.), for the picture here reproduced see cat. no. 77; also Sahüt/Volle (1984) no. 118.

[2] Clerke in Cook, *Journals* III, 2, 1323.

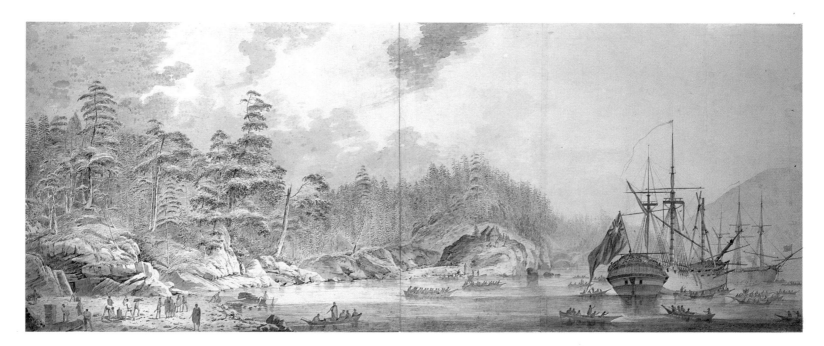

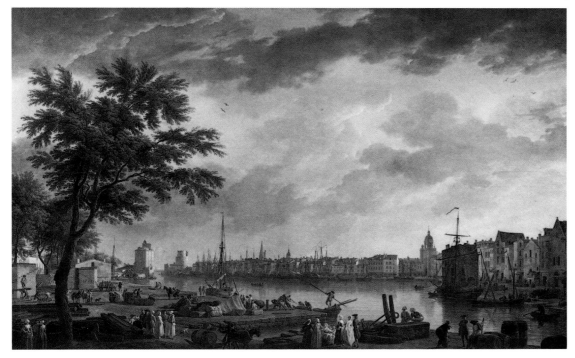

PLATE 96
John Webber, *The Resolution and Discovery in Ship Cove*, April 1778-. National Maritime Museum, London. (3.189)

PLATE 97
Claude-Joseph Vernet, *The Port of La Rochelle*, 1762, oil on canvas, 65 × 103½ : 1650 × 2630. Musée de la Marine, Paris.

are here either to be seen or heard to give some little animation to the woods of King Georges Sound. The high mountains which rise on the back & far inland are many of them bare, & serve to heighten & finish the Picture of as *wild* & *savage* a Country [our italics] as one can well draw in so temperate a climate.[3]

Indeed the landscape around Nootka Sound could well be seen as an epitome of the sublime, and the pervading silence contributed to sensations of gloom and melancholy. Later voyages also commented upon the silence of the forests. The lack of animation led Vancouver to remark, when he returned to Nootka with his own expedition in 1792, 'our residence here was truely forlorn'.[4]

James King (1750-1784) was Webber's contemporary by one year, but their response to Nootka was different. King was groping after a personal experience of landscape through words. Webber had to respond with visual imagery. A similar situation, as we have already noted, had presented itself on Palmerston Island, where Anderson's description of a coral reef found no echo in Webber's art. Parkinson, it may be recalled (vol. 1, p. 30) responded with precision to the varied colours of the water in the lagoons of the Tuamotus, but the response could find no equivalent in his art. Webber likewise, we must conclude, was not able to transform the landscape of Nootka Sound into a personal vision. His drawings from the ship (plate 98; 3.190) are rather conventional in composition in a Dutch manner. But that may have been simply the result of his need to discharge his documentary and topographical responsibilities as voyage artist.

[3] King in Cook, *Journals* III, 2, 1402.

[4] Quoted in Cole/Tippett, (1974) 5, and Tippett/Cole (1977) ch. 1: 'Early Views: Eighteenth Century Exploration', 15-27.

81

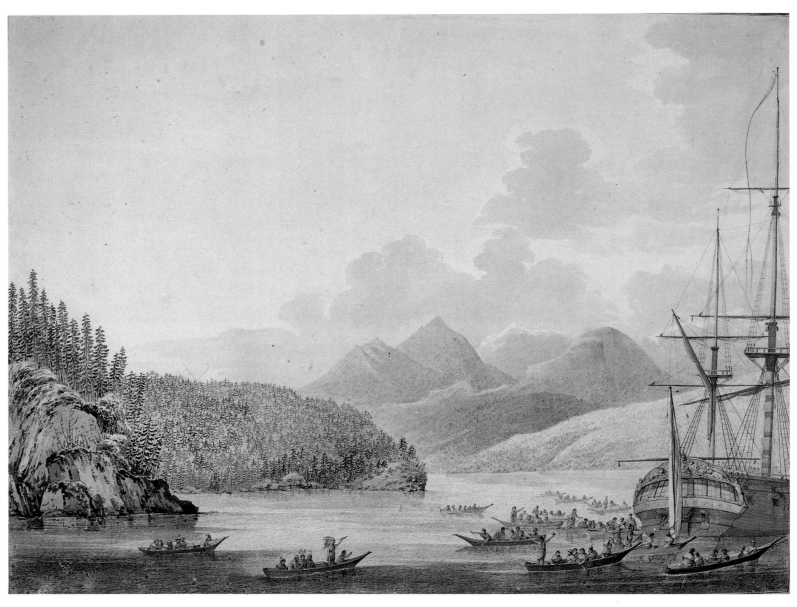

Yet there is variety in his work at Nootka. Webber's *A View in King George's Sound* (plate 99; 3.212), gives quite a different aspect of the area, and does not relate directly to any known episode of the voyage. The curious relation of the rock masses and the many broken stems of the trees attracted his attention, and recalls a comment by Clerke:

> The woods bespeak there being sometimes very turbulent Weather here; there are many Trees blown down, and a vast number of others confoundedly mutilated by the rough Gales that have different times attacked them.[5]

[5] Clerke in Cook, *Journals* III, 2, 1329.

Webber's response to this northern region of the Pacific is to be found in his increasing interest in rock structure and characteristic vegetation, which here he draws in loving detail. The work that went into *A View in King George's Sound* and *The Resolution and Discovery moored in Ship Cove* was obviously assisted by preliminary sketches. Fortunately two have survived (3.209; 3.210).

Webber's sketches of rocks, grasses and trees was an interest shared by his fellow-artist William Ellis, whose *A Rock and a distant View in King George's Sound* (plate 100; 3.206) and *View in King George's Sound* (plate 101; 3.207) are quite striking presentations of the rocky outcrops along the bay; and probably the most sensitive and personal drawings made by Ellis on the voyage.

Some of Webber's drawings can be dated precisely to 22 April, when he accompanied Cook to the village of Yuquot, where 'every thing that was curious both within and without doors'[6] was drawn. Both Webber's *Habitations in Nootka Sound* (plate 102; 3.198) and his *An Inside View of the Natives' Habitations* (plate 103; 3.201) have become popular images of the voyage. A field sketch of the exterior view has been preserved in the National Gallery of Scotland (3.200), which by comparison to the finished drawing (3.198) reveals how well Webber kept to the topographical features of the scene. Only a few subtle changes were made, such as the gradation of the houses on the left, and the heightening of the embankment, by

[6] Cook, *Journals* III, 1, 306.

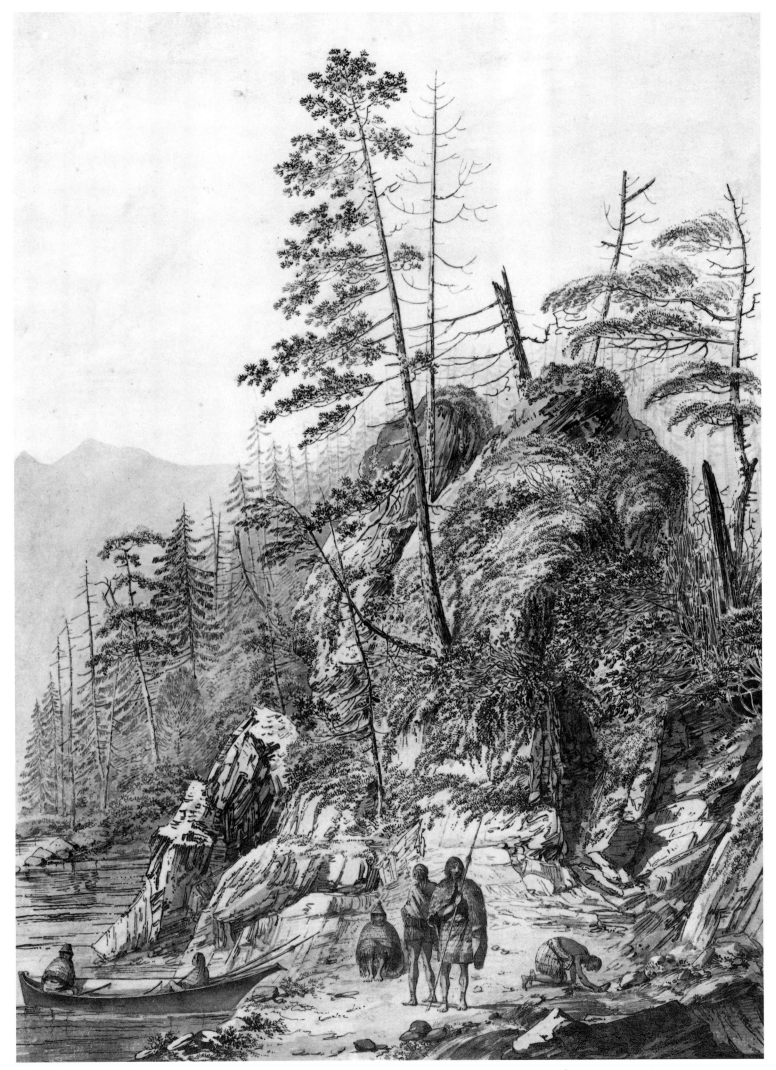

83

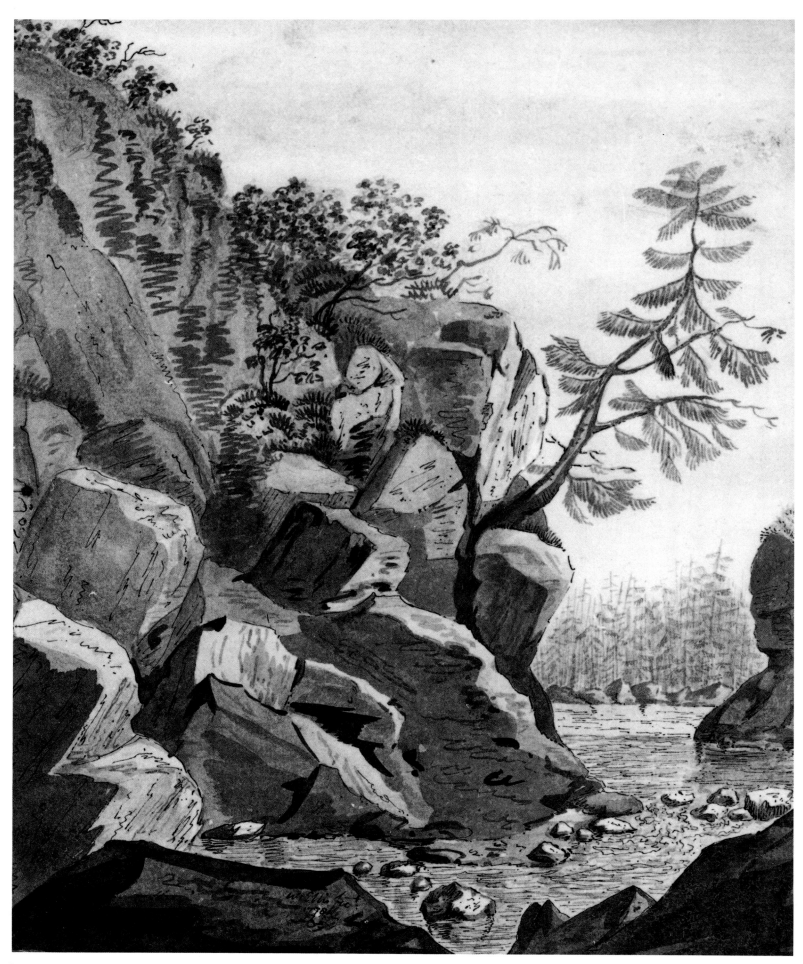

PLATE 100
William Ellis, *A Rock and a distant View
in King George's Sound*, April 1778.
National Library of Australia, Canberra.
(3.206)

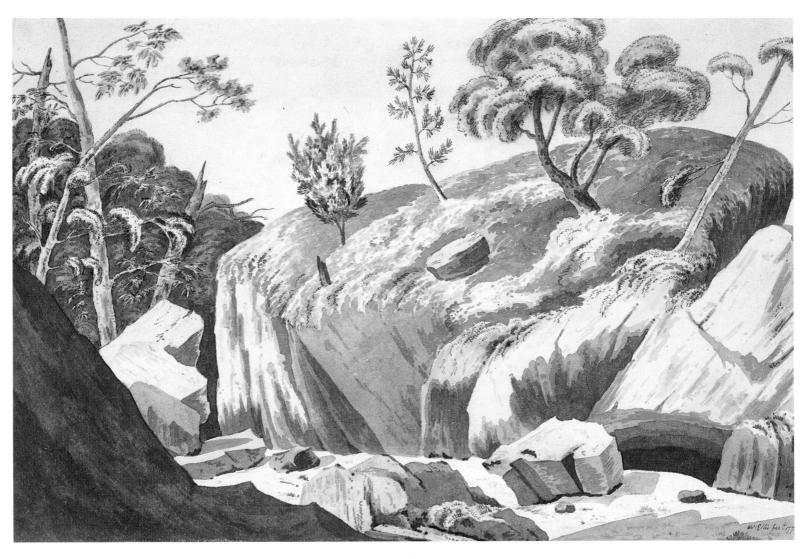

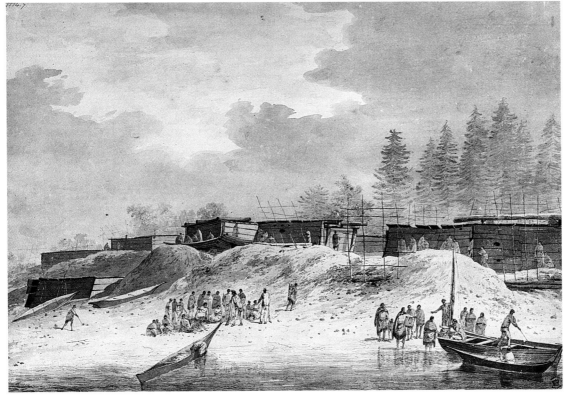

which the houses are separated from the figures on the beach and gain a more towering position. These changes, minimal but decisive, bring the picture to life.

Cook and his party entered one of the houses and Webber completed an interior view. Such work held an element both of adventure and risk. This manifested itself when he began to sketch two 'idols' or carved house-posts (plate 104; 3.203). Webber later recalled the circumstances in a letter to John Douglas, the editor of Cook's third voyage:

> While I was employ'd a man approach'd me with a large knife in one hand semingly displeas'd when he observ'd I notic'd two representations of human figures which were plac'd at one end of the appartment carv'd on a plank, and of a Gigantic proportion: and painted after their custom. However I proceeded, & took as little notice of him as possible, which to prevent he soon provided himself with a Mat, and plac'd it in such a manner as to hinder my having any further a sight of them. Being certain of no further oppertunity to finish my Drawing & the object too interresting for leaving unfinish'd, I considered a little bribery might have some effect, and accordingly made an offer of a button from my coat, which when of metal they are much pleas'd with, this instantly producd the desird effect, for the mat was remov'd and I left at liberty to proceed as before. scarcely had I seated myself and made a beginning, but he return'd & renew'd his former practice, till I had disposd of my buttons, after which time I found no opposition in my further employment.[7]

Interiors had always been of interest in the recording of indigenous people, but rarely

[7] Quoted from Beaglehole, Cook, *Journals* III, 1, 319-20. On the wider consequences of travelling artists meeting indigenous people, see Smith (1984).

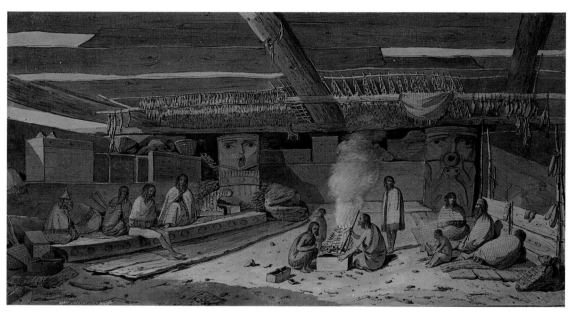

PLATE 103
John Webber, *An Inside View of the Natives' Habitations*, April 1778-. Peabody Museum, Harvard University, Cambridge, Mass. (3.201)

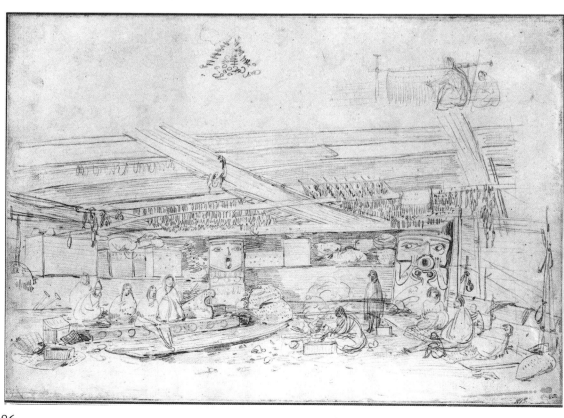

PLATE 104
John Webber, *The Inside of a House in Nootka Sound*, April 1778. National Gallery of Scotland, Edinburgh. (3.203)

had it been possible to base them on reliable evidence. To make good the deficiency interiors were often 'invented' according to prevailing European taste, as was the case with Bernard Picart's drawing *North American Indians in a hut* which served as an illustration for the author's eleven volume survey of *Les Cérémonies et coutumes religieuses de tous les peuples du monde* (Amsterdam 1723) (plate 105).[8] Only in the second half of the eighteenth century do we begin to obtain accurate images of such interiors. To depict them faithfully professional skill and a sufficient element of trust between the indigenous and the European was essential. Alexander Buchan's field-sketch of the *Inhabitants of the Island of Terra del Fuego in their Hut*, (1.6) if it can be called an interior, was redrawn by Cipriani, who placed it in a picturesque setting and endowed the figures with the elegance of classicism yet the hut itself and the positioning of the figures remained almost unchanged.

With Webber's interior a new stage of realism is attained. In contrast to the Buchan/

[8] Picart, (1723) vol. 1, fp. 98.

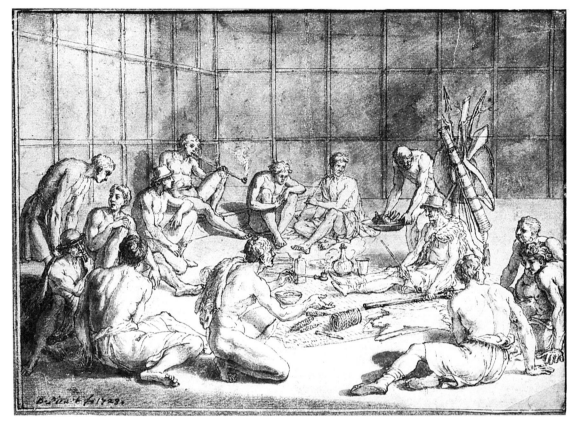

PLATE 105
Bernard Picart, *North American Indians i a hut*, 1723, pen and wash, 5⅞ × 8¼ 150 × 210. National Library of Australia, Canberra.

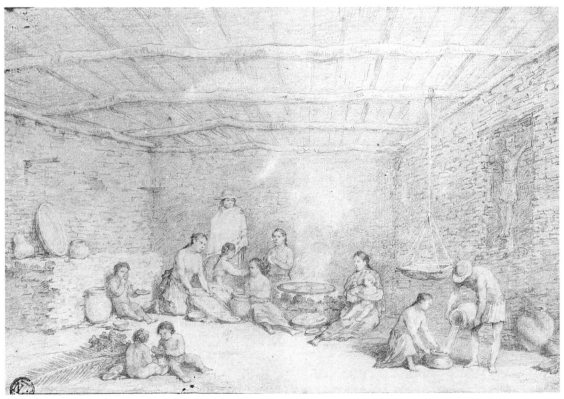

PLATE 106
Alexandre-Jean Noël, *Interior of a habitation in Mexico*, 1769, chalk, 6¼ × 9¼ : 159 × 236. Inv. no. 31476. Cabinet des Dessins, Louvre, Paris.

Cipriani composition we find no substantial change from the early field-sketch to the engraving in the official account.

Webber's interior accords with several verbal descriptions by Cook and his companions: the natives' method of cooking, the rows of smoked salmon under the ceiling, the opening of the roof for the entry of light, the Indians seated on mats, their occupation at weaving, and the 'idols' at the back of the room.

Some nine years earlier, the Frenchman Alexandre-Jean Noël while accompanying the Abbé Chappe d' Auteroche to Mexico also made two drawings of interiors, in which he showed people cooking, eating and music-making (plate 106).[9] From the ethno-historical point of view both drawings are comparable to Webber's views, though it is obvious that Noël attempts to harmonize the scene. This is suggested by the depiction of the naked children, like putti, playing on the ground. Webber, on the other hand, is less compromising and more realistic in his treatment of the scene, stressing the austerity of the abode. In fact, Cook had rightly assumed that these huts were only temporary habitations for the Indians, when they lived on the coast.

Webber's realism here is not surprising. It is rooted in his training as an artist in Paris, when in the company of Jean-Georges Wille he used to go on sketching tours into the country. Many huts, cottages or sheds were drawn on these occasions, in fact, the rustic dwelling was then becoming a popular theme. Unlike the rococo hut or tent, which was a component of the *locus amoenus*, of artificial pleasure and happiness, Wille's new realism interpreted the hut as a physical necessity, as a symbol of human survival. It was not just the rustic side of it that was so appealing. Connected with it was the experience of poverty and simple living. Only a few miles away from the metropolis, in search of simplicity and nature, Wille's artists discovered an 'ethnographic' world of its own, and a suggestive alternative to urban life. The same could be said about Le Prince and his interior views which he brought back from Russia.

Though no interior view by Webber is known from that period, we know from the works of others in Wille's entourage that cottages were visited and drawn. Such scenes have survived from Webber's fellow-students Freudenberger and Guttenberg (plate 107)[10] but the

[9] Benisovich, (1954) 138-44.

[10] See Boerlin-Brodbeck, (1979) 41-3 (Freudenberger) and 23-4 (Guttenberg).

PLATE 107
Carl-Gottlieb Guttenberg, *Interior of a peasant's Hut*, 1770, red chalk, 8½ × 12½ : 215 × 318. Kupferstichkabinett, Kunstmuseum, Basel.

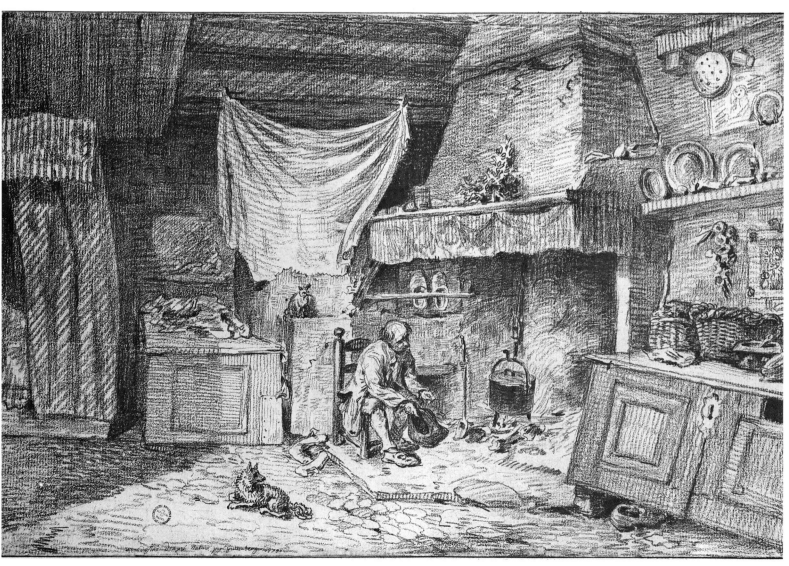

new way of seeing was tested against the models of the past. Similar cottage rooms could be found among the drawings and engravings of such Dutch masters as Abraham Bloemaert, David Teniers or Adriaen van Ostade (plate 108). In France Wille's predilection for rustic household scenes was shared with such distinguished artists as Jean-Baptiste Greuze, Nicolas-Bernard Lépicié and Jean Baptiste Le Prince. Another artist working in this vein was Noël Hallé, whose oil sketch, *The education of the poor* (plate 109) combined a primitive interior with a family group on one side and a working scene on the other.[11] It is noticed here because indoor occupations and parental love were common subjects in French *genre* painting throughout the 1760s and 1770s.

[11] Sahut/Volle, (1984) 272-3.

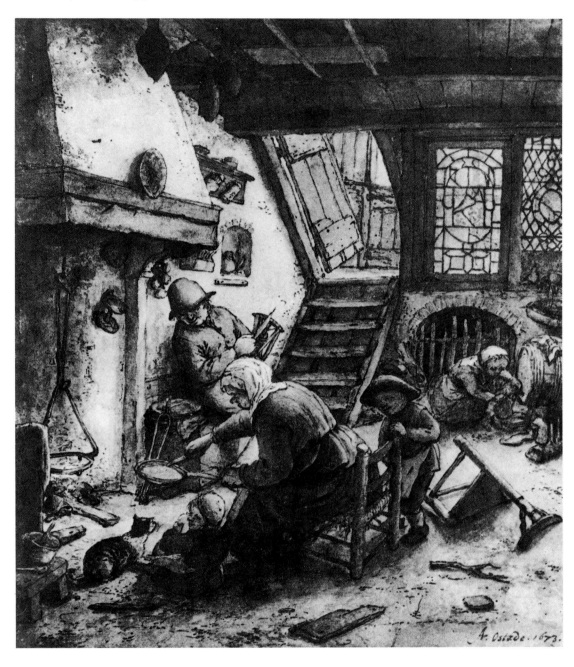

PLATE 108
Adriaen van Ostade, *The underground kitchen*, 1673, pen and brown ink, 7⅝ × 6⅜ : 194 × 162. Institut Néerlandais, Fondation Custodia (Frits Lugt collection), Paris.

In this same context it is interesting to find that Webber treated a similar situation in his drawing *A Family Group in a Communal House at Nootka Sound* (plate 110; 3.205). King had observed that while the ships stayed at Nootka Sound 'all regular labour & occupations' of the Indians had come to a standstill and 'time is given up to dissipation', 'we therefore seldom can see them at their daily toil, & here again we had less opportunity by being coopd up in a cove, far remov'd from the Village'.[12] Nevertheless, he and Cook had noticed some women weaving and Cook in particular had paid attention to their method of doing it. Considering that he was the commander and described all major issues of importance, his descriptions of the manipulation of the different threads is a pleasant and touching piece of observation.[13] In the sketch of the house interior (plate 104; 3.203), Webber made a rough pencil annotation of two women weaving, whereas in the drawing of the family, he gave the subject more prominence. In Webber's *oeuvre* the drawing is not only exceptional for its subject matter. It would be interesting to know whether this was an isolated case, or whether he

[12] King in Cook, *Journals* III, 2, 1412.

[13] Cook, *Journals* III, 1, 313.

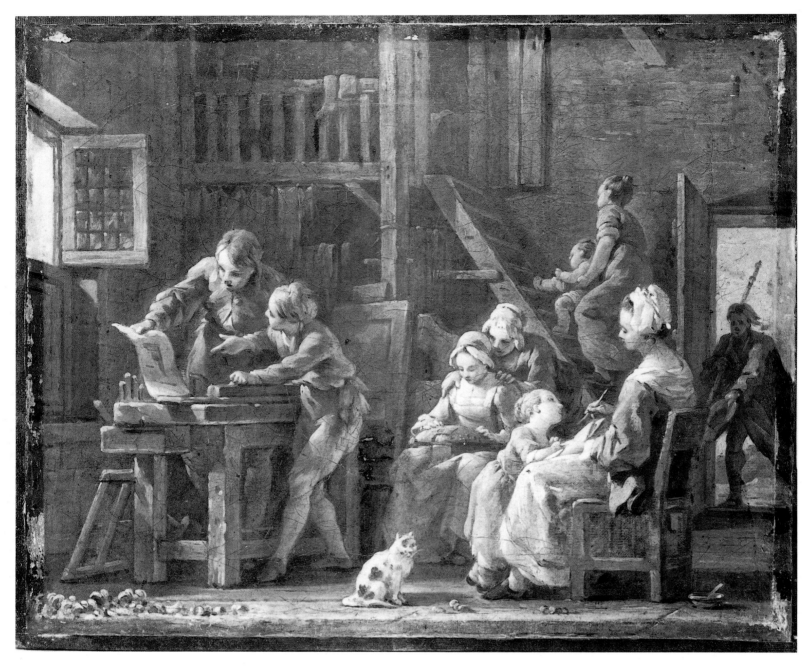

might have covered other 'labours & occupations'. Equally revealing would be his interest in those aspects of social bondage and family relationship, that became so important in the work of the next generation of travelling artists. At present we do not know of any other such drawings by Webber in which a family group is singled out for depiction. That Webber was not insensitive towards the subject is indicated by his depictions of such scenes not only at Nootka but also at Unalaska (3.256 and 3.257).

It was noted above that Webber, in representing indigenous people, tended to see the ethnic type rather than the individual. Yet, none of his portraits are stereotypes. His portraits of the Nootka in particular attest to his sense of specific differences among individuals. Even when Webber drew types, they are distinguished by a wealth of neatly observed traits of personal appearance.

Webber's drawings of the Nootka include both the full-length and the head-and-shoulder portrait. His drawing of *A Native prepared for Hunting* (plate 111; 3.215) is an uncommonly fine one. The title seems to have been invented by the artist, and already spelt out in his Catalogue (no. 65), disagreeing with the fact that little or no hunting occurred during the ships' stay. The arrows and quiver carried by the Indian however, may have given that impression. Of special interest is the basketry hat with a bulbous top decorated with a whaling scene. Hats of this kind were worn by chieftains when whaling. Webber repeated the figure a couple of times and even introduced it into later drawings made after the voyage (3.214).

Webber also used the bulb-top hat for the portrait of *A Woman of Nootka Sound* (plate 112; 3.224). The original sketch had shown her wearing a hat with a flattened top (plate 113; 3.225). But in the engraving the woman is shown in the hat with whaling scenes, Webber

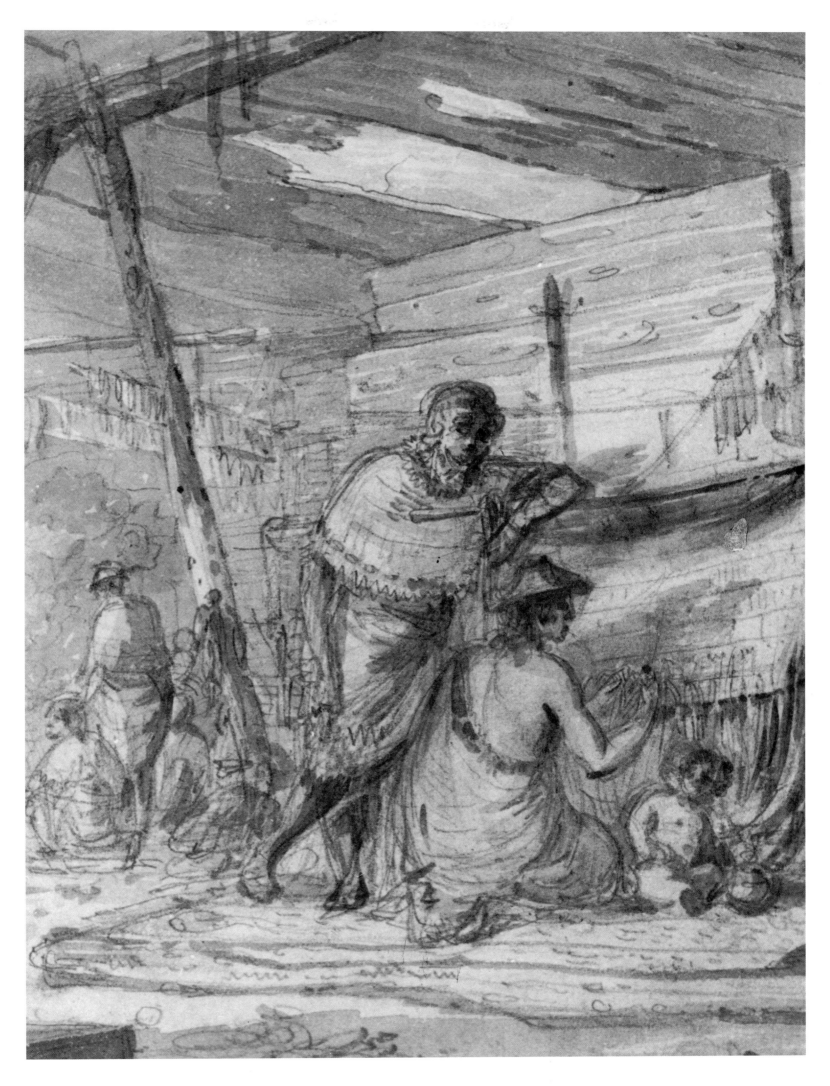

91

[14] King, (1981) 82.

not knowing 'that only chiefs wore these hats'.[14] This is the more ironic, since it was the ethnographic element that constituted the *raison d'être* for the engraved portraits. But the hat was not only a spectacular object, it was also an excellent example of Indian craft. In order to do justice to their skills, it was included, as was the circular cedarbark rain cape, adorned with a fur collar.

The women and men of Nootka shared the art of daubing or 'powdering' their faces. The men in general were more particular about it, as may be seen in Webber's *A Man of Nootka Sound* (plate 114; 3.218). He has a criss-cross pattern on his forehead and wears some leather and copper ornaments suspended from his ears. In terms of physiognomy the drawing answers the verbal description of the men that King gives of them, remarking on their 'high cheek bones; their Noses small, neither flat or Prominent; little mouths, small black Eyes void of fire, & . . . an unusual flatness towards the forehead'.[15] To give this portrait more 'truth' Webber added red water-colour to the face. In another portrait of a different man, whose forehead was painted with wavy lines, Webber used black and red chalk effectively (plate 115; 3.222).

[15] King in Cook, *Journals* III, 2, 1405.

The facial ornamentation of the girls was not apparently as artful as those of the men. 'They were sati[s]fy'd with simple grease & dirt.'[16]

[16] ibid., 1406.

[17] Samwell in Cook, *Journals* III, 2, 1095.
[18] ibid.

Samwell tells how a couple of girls, coming on board to offer themselves to the sailors, had taken 'particular pains to daub their Hair and faces well with red oaker'.[17] However, all their facial art was washed off by their lovers, in the process of which it was discovered that the girls had 'no bad faces'.[18] This incident may illuminate the fact that Webber does not depict the girl of plate 113 with daubing or smearing on her face. In fact, her face is clean and bright and it would not be unlikely that the sitter is one of the ladies that came on board and received a smart washing.

[19] ibid., 1098.

Not only did the Indians show great variety in the ornamentation of their faces, their visitors seldom saw one man wear the same countenance two days together.[19] They were an artful people, and it was expressed as much in their dress as in their canoes and weapons. Particularly noteworthy to Cook and his men were the masks of the Nootka, many of which resembled birds' heads (plate 116; 3.230). Cook found 'most of them both well designed and executed',[20] and consequently many of them were traded. Several of the journals refer to them as something extraordinary, both on account of their carving and colouring. The fact that they could be seen in use and seemed to be associated with their ceremonial songs and dances, increased the interest.

[20] Cook, *Journals* III, 1, 314.

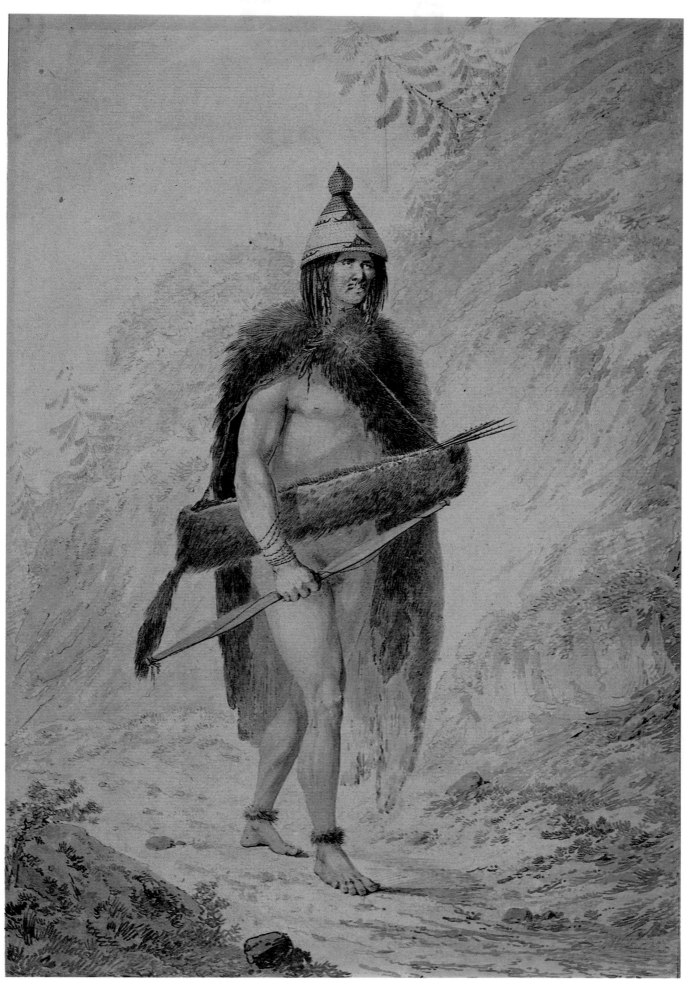

PLATE 111
John Webber, *A Native prepared for*
*Hunting*, April 1778-. Peabody Museum,
Harvard University, Cambridge, Mass.
(3.215)

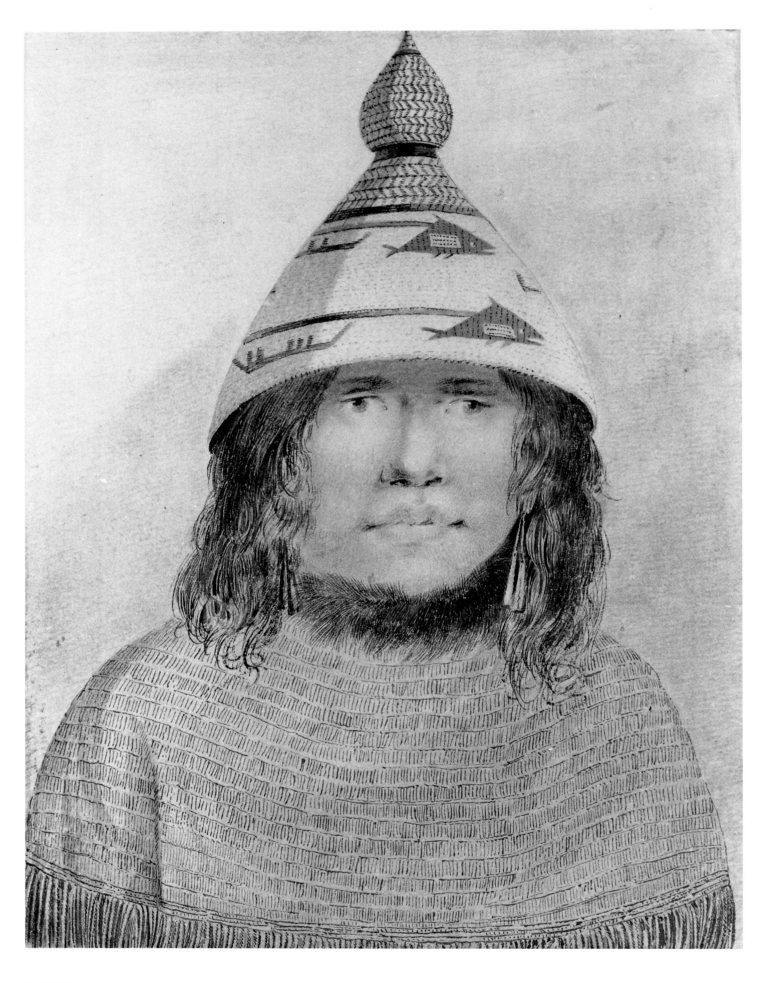

PLATE 112
John Webber, *A Woman of Nootka
Sound*, c. 1781-83. Dixson Library, State
Library of New South Wales, Sydney.
(3.224)

PLATE 113
John Webber, *A Woman of Nootka
Sound*, April 1778. Farquhar collection,
Berkeley. (3.225)

94

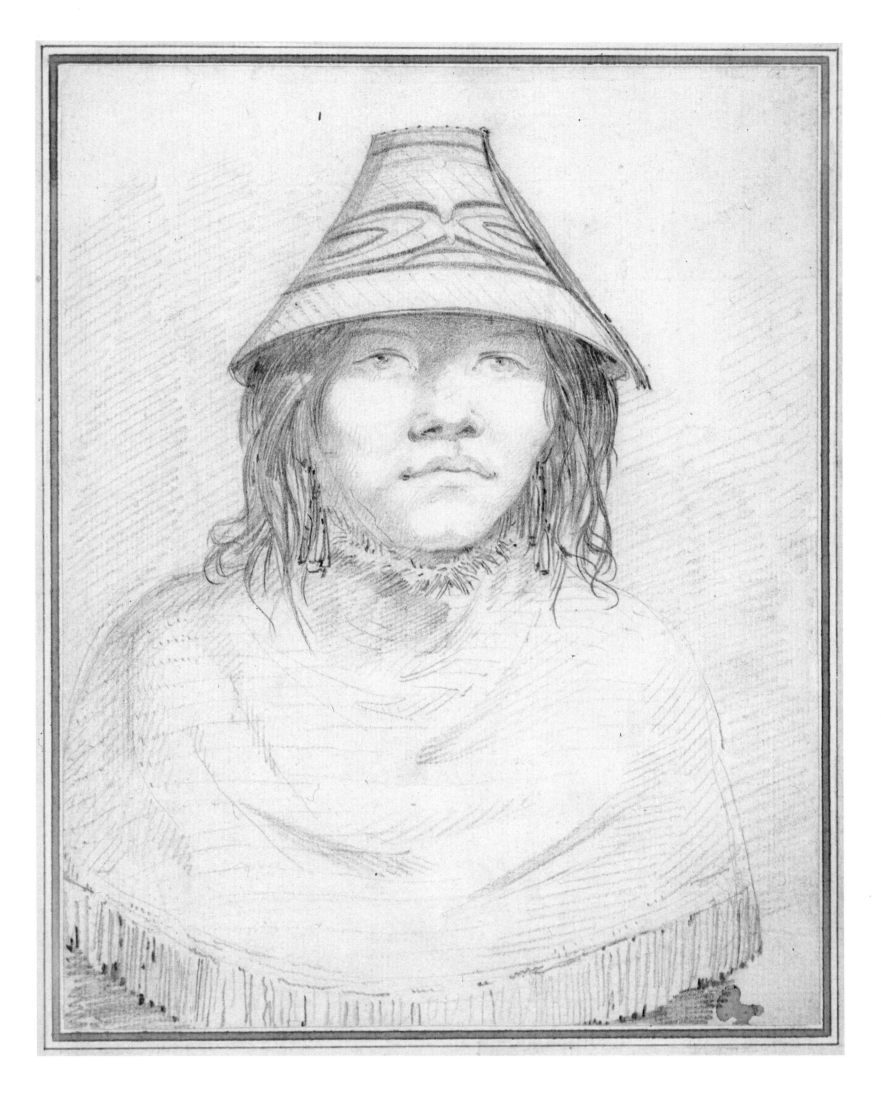

95

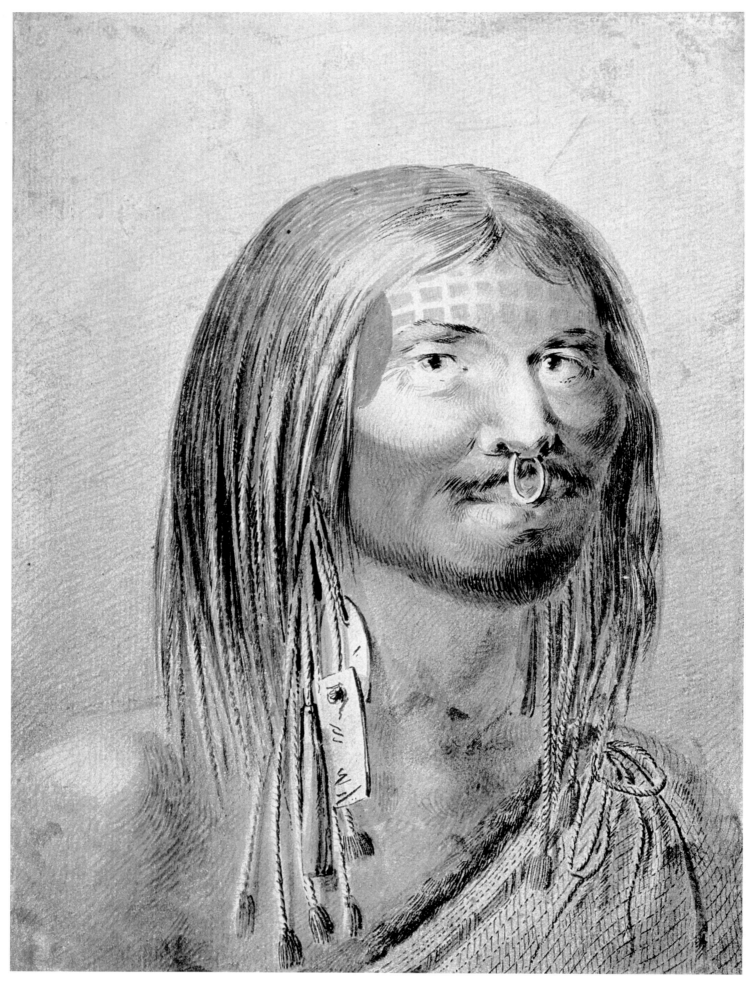

PLATE 114
John Webber, *A Man of Nootka Sound*,
c. 1781-83. Dixson Library, State
Library of New South Wales, Sydney.
(3.218)

96

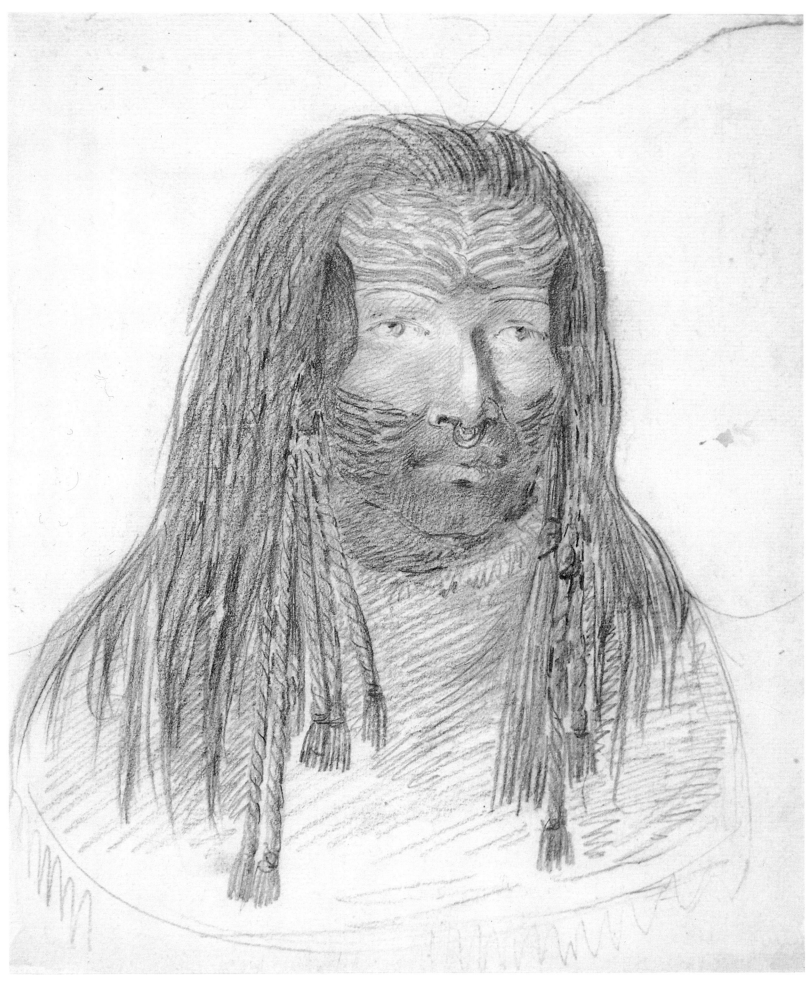

PLATE 115
John Webber, *A Man of Nootka Sound*,
April 1778. Farquhar collection,
Berkeley. (3.222)

97

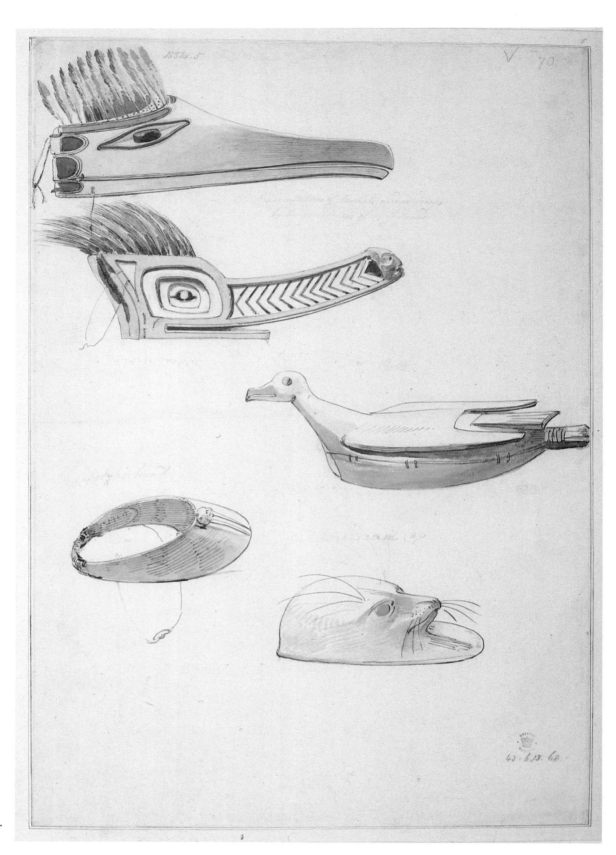

PLATE 116
John Webber, *Representations of Animals used as Decoys*, April 1778-.
British Library, London. (3.230)

## 23. Prince William Sound (Sandwich Sound), Alaska: 12-20 May 1778

After Cook had followed the north-west American coast for about two and half weeks, Cape Hinchinbrook, the entrance to Prince William Sound, was reached on 12 May. Thick and foggy weather prevailed, and also the countryside was found to be rather inhospitable: 'The Country all round having a very desolate & dreary appearance being almost entirely covered with Snow we did not expect to find it inhabited'[1] Samwell wrote. However, as soon as the ships arrived, two large canoes with about twenty Indians in each of them, appeared and made signs of a peaceful reception. As was customary with them, they got up in their boats and spread their arms, which Cook understood as a sign of friendship.

[1] Samwell in Cook, *Journals* III, 2, 1106.

Webber made a small sketch of the scene (3.233) which was later developed into the larger *A View in Prince William Sound* (plate 117; 3.232) with better defined figure work and greater depth in the recession of the country. Like all other landscapes from Prince William Sound, the drawing indirectly reflects the miserable weather experienced during most days of the stay. Rain, fog and gales allowed little time to view the surrounding country. Pen work and grey sepia wash became the appropriate media, reflecting the grey light of the north Pacific coast.

PLATE 117
John Webber, *A View in Prince William Sound*, May 1778-. British Library, London. (3.232)

Webber's *A View of Snug Corner Cove* (plate 118; 3.240) is such a drawing, showing

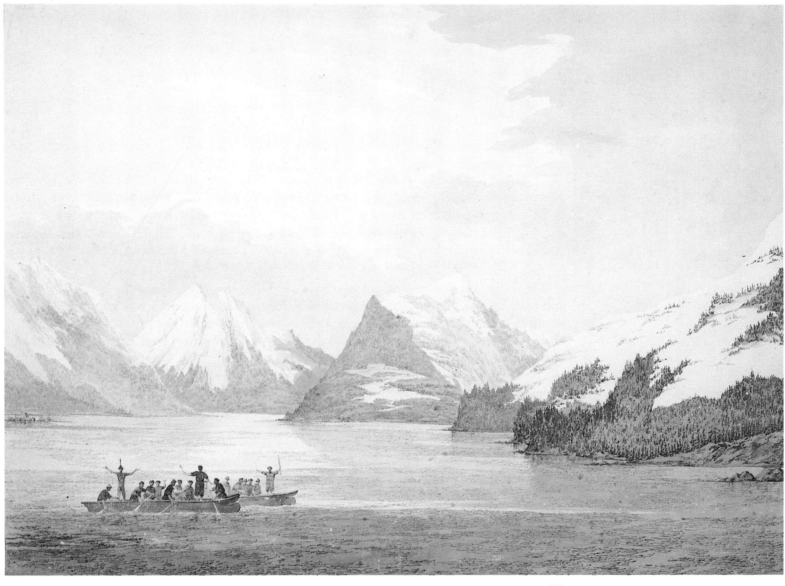

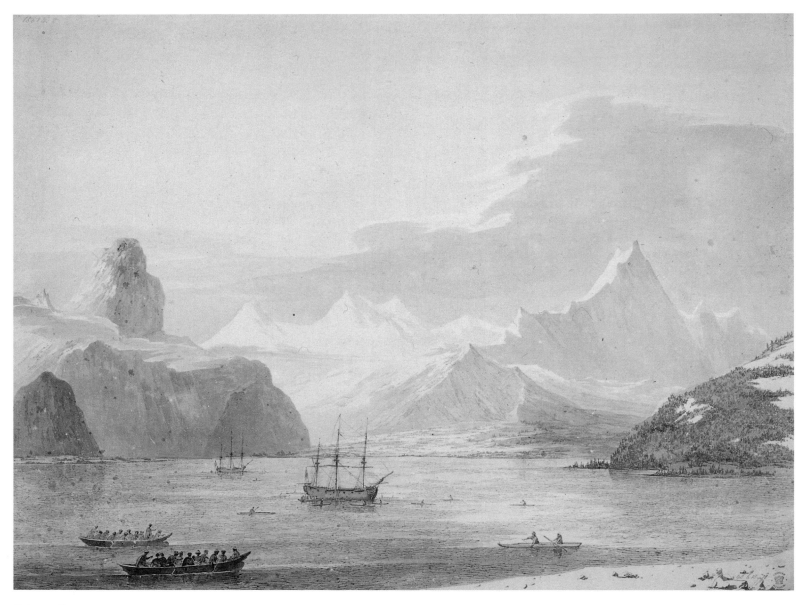

PLATE 118
John Webber, A *View of Snug Corner
Cove*, May 1778-. British Library,
London. (3.240)

[2] Cook, *Journals* III, 1, 351.

[3] King in Cook, *Journals* III, 2, 1417.

[4] Cook, *Journals* III, 1, 360.

[5] For similar views by Cozens of the
Swiss Alps, painted in the 1770s, see
Hawcroft, (1971) in particular: 1, 4,
5, 9.

[6] See Henry, (1984) pl. 12.

the two ships with Indian canoes around them. In Webber's second version (plate 119; 3.241)
the ships are pushed back into the distance and are quite small against the gigantic snow-
covered mountain chain.

On the whole, the drawing corresponds to the journals, as when Cook speaks of the
summits of the neighbouring hills being covered with wood and 'those farther inland seemed
to be naked rocks burried in snow'.[2] King's entry in his journal is even more to the point:

> The bad weather by the Afternoon was followed by light Airs, clear & fair W$^r$. The transition
> was made striking by its giving us a prospect of snowy Mountains & deep bays to the
> NW that had hitherto been hid from our sight.[3]

Mountain peaks rising out of clouds were seen frequently along the north-west coast,
and were represented as such in several of Webber's coastal views. Cook mentions a similar
occasion with regard to Cape Douglas, where 'the elevated summit . . . was seen above the
clouds'.[4] Webber's drawing is built upon the dramatic contrast between the forbidding grandeur
of the mountains and the minute ships.

Following the discovery of the Alps and their glaciers, increasingly mountain peaks
had begun to excite the imagination of travelling artists. John Robert Cozen's *View in the Isle
of Elba* (plate 120) drawn at about the same period presents a similar vision of the mountainous
sublime.[5] Webber, whose origins and training were Swiss, responded deeply to similar subject
matter, while Ellis offered a more schematized version of the same viewpoint but without
figures and ships (plate 122; 3.243).

Eight years later, the Frenchman, Gaspard Duché de Vancy, executed a drawing of
a similar mountainous terrain, his *View of the 'Port des Francais'* (plate 121).[6] Duché was
draughtsman on La Pérouse's fatal expedition and was aware of Webber's work at least through
reproduction, for Cook's voyages were models for the French expedition. So Duché might
have intended his drawing to be both a parallel and a contrast to Webber's. In Duché too,
the white snowy mountains attain almost fantastic proportions, dwarfing the ships. But Duché

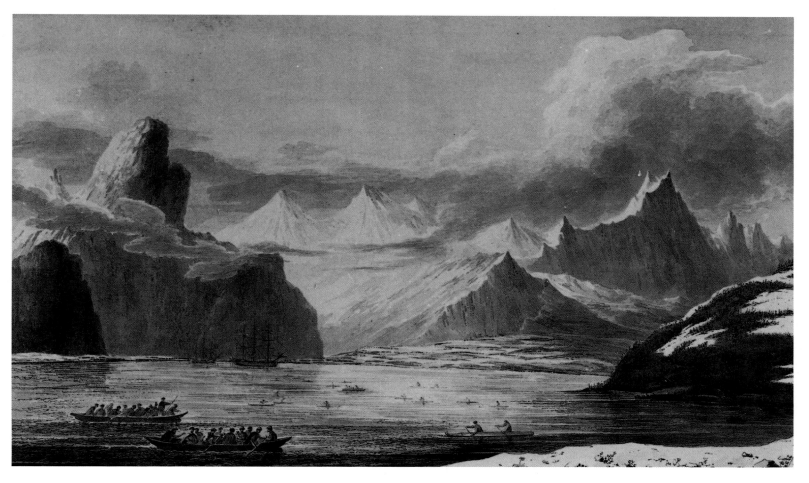

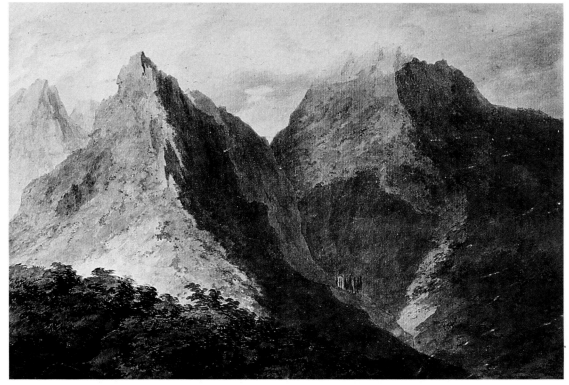

PLATE 119
John Webber, A *View of Snug Corner
Cove*, c. 1781-83. Dixson Library, State
Library of New South Wales, Sydney.
(3.241)

PLATE 120
John Robert Cozens, *View in the Isle of
Elba*, 1780, water-colour, 14½ × 21¼ :
368 × 536. Victoria and Albert
Museum, London.

employs a bird's-eye view, as if to augment the sense of danger by enclosure in the icy scene.

In Prince William Sound, Webber also made a free sketch of local Indians in a canoe (3.242) and portraits of a man and woman of the Sound (plates 123, 124; 3.236; 3.244). Doubtless they were drawn on board, and he was careful to depict their distinctive dress and ornamentation: their 'foul weather frocks', with hoods from the intestines of the whale, and their custom of slitting or piercing their underlip to fasten pieces of bone.

PLATE 121
Gaspard Duché de Vancy, *View of the
'Port des Français'*, 1786, pen and grey
wash, 14³/₁₆ × 19³/₁₆ : 361 ×
494. Service Historique de la Marine,
Château de Vincennes, Paris.

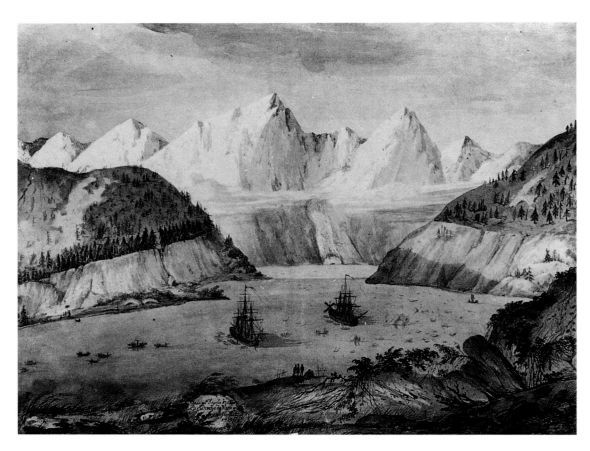

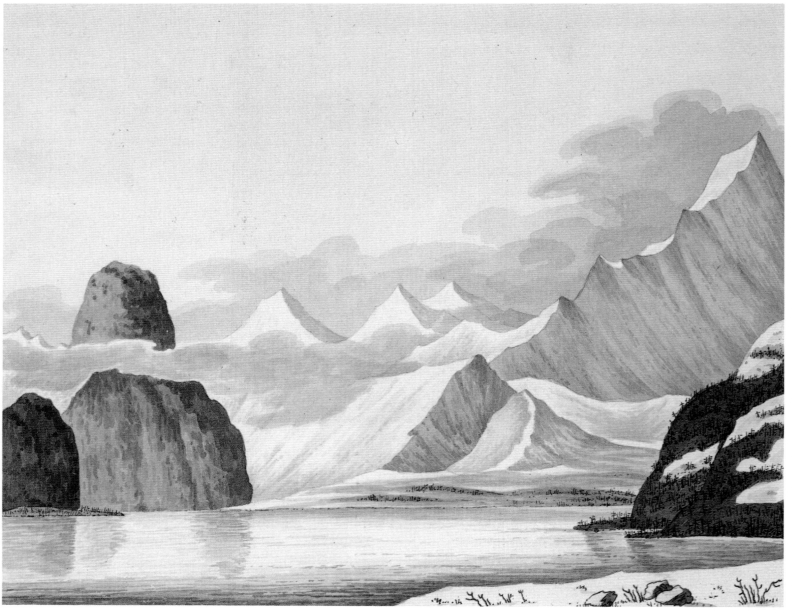

102

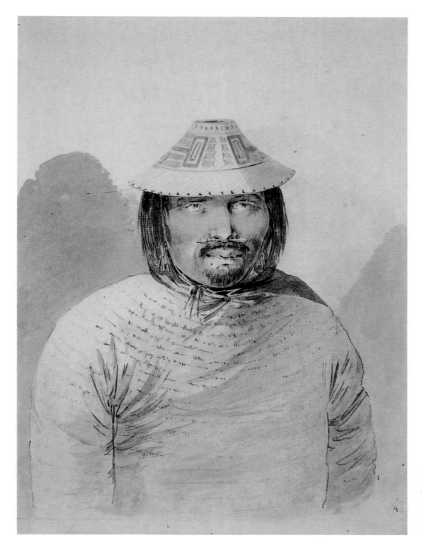

PLATE 123
John Webber, *A Man of Prince William Sound*, May 1778-. Peabody Museum, Harvard University, Cambridge, Mass. (3.236)

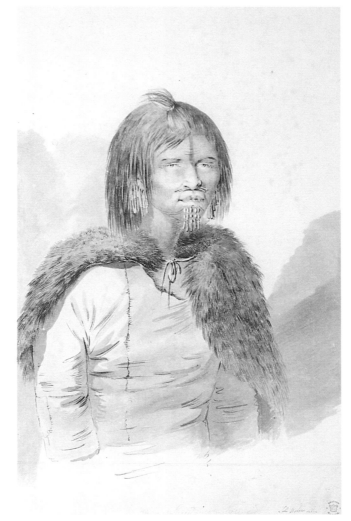

PLATE 124
John Webber, *A Woman of Prince William Sound*, May 1778-. British Library, London. (3.244)

# 24. Cook Inlet, Turnagain Arm, Alaska: 25 May - 6 June 1778

Hoping that Cook Inlet was part of the long sought-after passage, Cook sailed northwards, only to realize that Turnagain Arm and Knik Arm were dead ends. Despite the several days during which the ships stayed at Cook Inlet, Webber does not seem to have made any drawings there. On 1 June James King, second lieutenant of the *Resolution*, John Law, the surgeon of the *Discovery* and William Bayly, the astronomer, formed a small party and took possession of the country around the entry of Turnagain Arm. They met with a group of Indians and established peaceful relations. Webber does not seem to have been on the spot, for no drawing of the occasion is known; neither is there a drawing of the place of the claiming of the land. According to King a bottle containing a document of the act, was buried 'under some rocks by the Side of a Stuntd tree'.[1]

Trading with the natives was brisk at Cook Inlet. One of the objects acquired was a quiver, with some arrows in it, which Webber later turned into a very beautiful drawing (plate 125; 3.248).

No picture of the Alaskan Coast would have been complete without a drawing of the kayaks or sealskin canoes of the Aleut Eskimos who lived along this coast. Cook and others commented on them frequently, with admiration for their light build and their waterproofing. In his drawing of two different types of kayaks from Prince William Sound/Cook Inlet and the Alaskan coast (plate 126; 3.249), Webber carefully depicted their structure and the Aleut

[1] Cook, *Journals* III, 2, 1421.

PLATE 125
John Webber, *A Quiver and Arrows from Turnagain Arm*, May 1778-. British Library, London. (3.248)

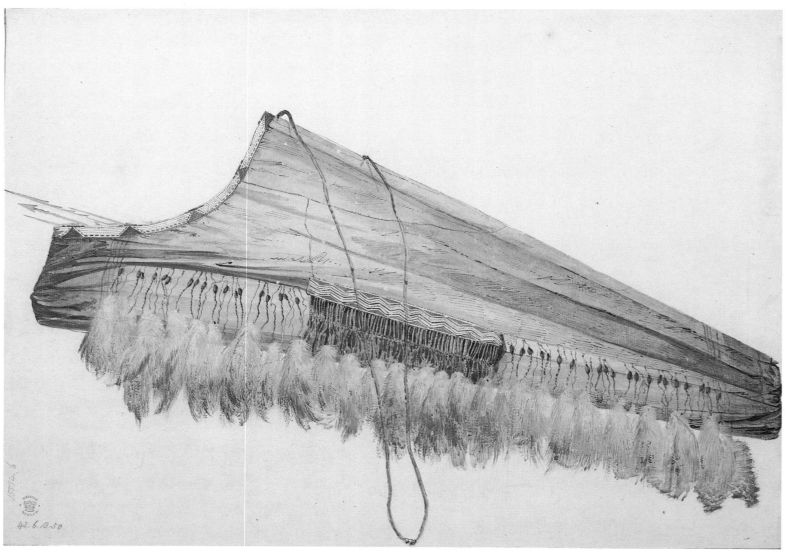

method used for keeping out the water, by means of a skin-hoop fastened to their frocks. The upper two paddlers probably derive from Prince William Sound, the lower one may tentatively be identified as one observed on 21 June off the Alaskan coast, on whom Samwell commented.[2] Both canoes were drawn for a didactic purpose and as such were illustrated in the official account.

[2] Samwell in Cook, *Journals* III, 2, 1119.

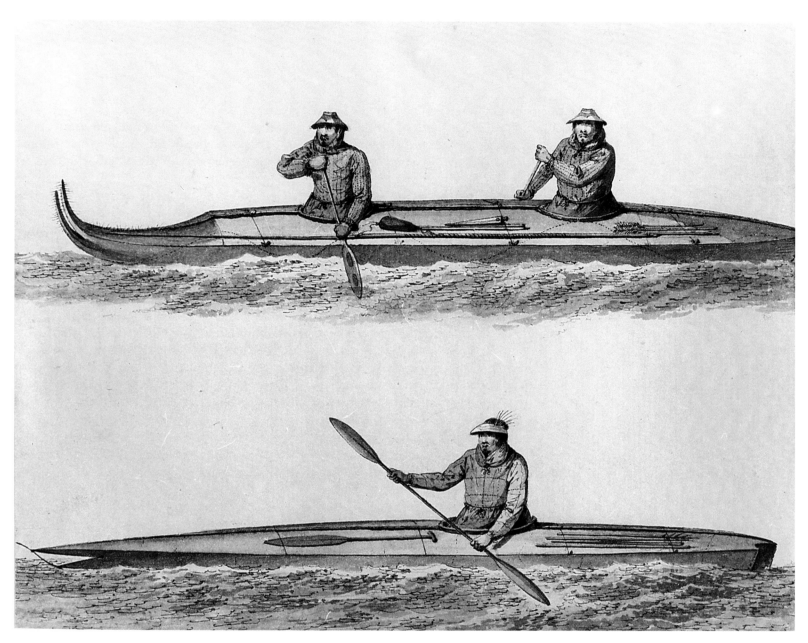

PLATE 126
John Webber, *Kayaks of Prince William Sound and Unalaska*, c. 1781-83. Dixson Library, State Library of New South Wales, Sydney. (3.249)

# 25. Samgoonoodha, (English Bay), Unalaska: first visit: 28 June - 2 July 1778

PLATE 127
John Webber, *Natives of Unalaska and their habitations*, July 1778-. Peabody Museum, Harvard University, Cambridge, Mass. (3.251)

[1] ibid., 1122.

[2] ibid., 1124.

[3] ibid., 1123.

PLATE 128
John Webber, *Natives of Oonalaska and their habitations*, July 1778. National Library of Australia, Canberra. (3.253)

[4] Pinhault, (1984) 25.

[5] Samwell in Cook, *Journals* III, 2, 1124.

After passing along the coast of the Alaska peninsula, Cook reached the eastern Aleutian islands and saw the island of Unalaska on 27 June 1778. After a dangerous passage through the Unalga pass he stood in for the harbour of Samgoonoodha or English Bay on 28 June. Eager not to lose time because of the advanced season, he stopped only briefly there for water, and to wait for a better tide to carry him out into the Bering Sea.

The stay proved worthwhile. The people encountered were ready to trade and invited the English into their houses. The countryside provided many herbs such as wild peas or celery and plenty of fowl. The lower parts of the country were free of snow, and showed budding, even flowering shrubs. This changing face of the countryside is encapsulated in Webber's drawing of the *Natives of Unalaska and their habitations* (plate 127; 3.251), in the foreground of which wild grass, heath and bell-flowers grow profusely.

Owing to Samwell's explicit description of an excursion into the countryside, in which Gore, Samwell and Webber took part, the circumstances of Webber's drawings made on the occasion may be traced. About two miles from the ships, 'in a low Valley close to the Water Side' an 'Indian Town'[1] was discovered into which the men were invited by the natives. Their houses were in the shape of earth mounts, built partly underground, with an entry at the top by means of a wooden beam functioning as a ladder. During the party's stay, which lasted for two hours, Webber made sketches outside and inside the houses (plate 128, 3.253; 3.254; plate 129, 3.256) as well as of 'other curious Objects which presented themselves'.[2]

In his interior, Webber shows a rectangular 'room', or as Samwell explains, a common passage with different apartments for various families lined up at either side. People in the central area converse with others sitting inside the apartments. The framing of the straw-covered roof and the upper storey above the ground floor, where skins and guts were stored, were noted both by Samwell and Webber. They also explain the function of the mats 'which they let down occasionally like Curtains to skreen them from the View of the Common Passage'.[3]

The houses of the Alaskans varied in size according to the rank of the owner. The more important persons lived in smaller houses of their own, whereas the common folk habitated rather large huts. The place which Webber depicts is such a family hut, a feature indicated by the presence of children, who apparently belong to two different families. Webber thus depicted a social aspect of native life, which also held an emotional appeal, for both the baby in the cot, tended by its mother, and the young child next to her kneeling mother add a warm human note to the scene. The arched and well strutted roof presented Webber with a problem in representation: how to depict the interior as widely as possible, showing a kind of panorama of the room, and solving the room's perspective at the same time. In his first drawing taken on the spot or from a field-sketch now lost Webber adopted his viewpoint from as far back as possible inside the hut, but as a result had to cut off the edges of the roof creating a kind of cross-sectional view. This problem arose again, in Webber's drawing of the interior of a balagan in Kamchatka (3.363).

The cross-section was not at all unfamiliar at that time, particularly in drawings for scientific purposes. They were used generously in the Diderot/d'Alembert *Encyclopédie* and were quite common in drawings and engravings of a didactic nature during the second half of the eighteenth century. See, for example, an anonymous drawing of the observatory of the military school in Paris, of about 1768 to 1769 (plate 130).[4] It is worth noting that in Webber's later version of the scene, drawn for the ensuing engraving (3.257) the cross-sectioned house is eliminated in favour of a wholly internal view section, giving the drawing a more pictorial, less technical appeal.

For Webber the trip to the Indian village was of further use, for on his way back to the ship, he and his party met with an Aleut woman, who was willing to be sketched. Not only was she 'prettily dressed'[5] and good natured enough to comply with the directions of the

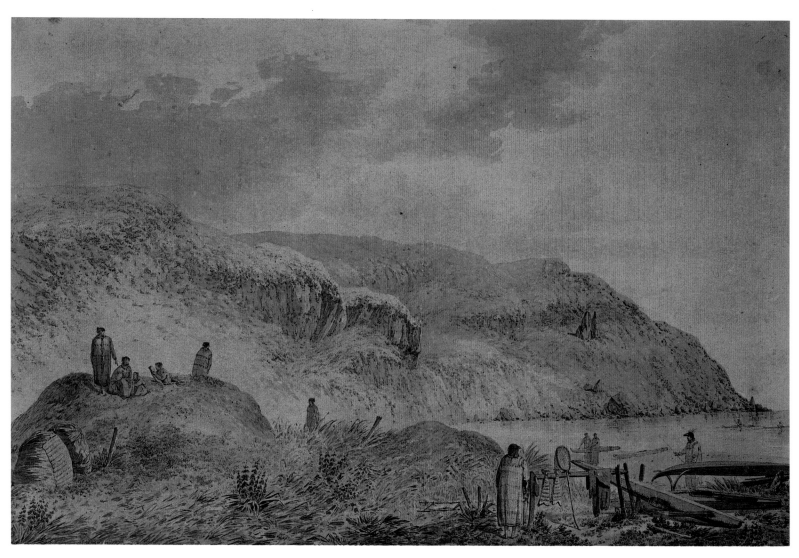

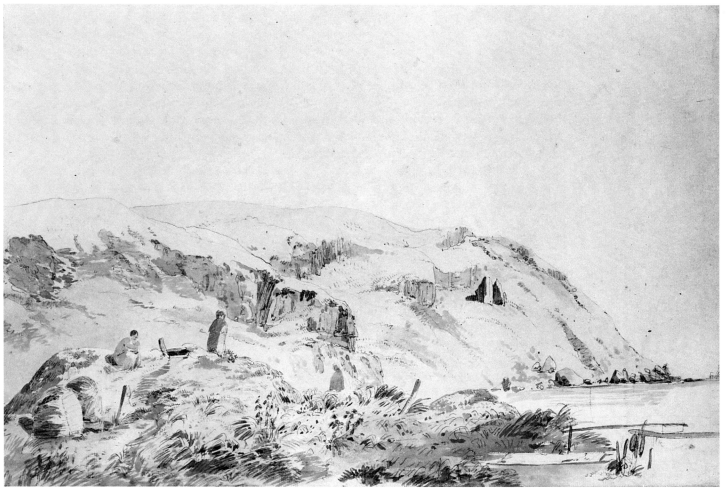

107

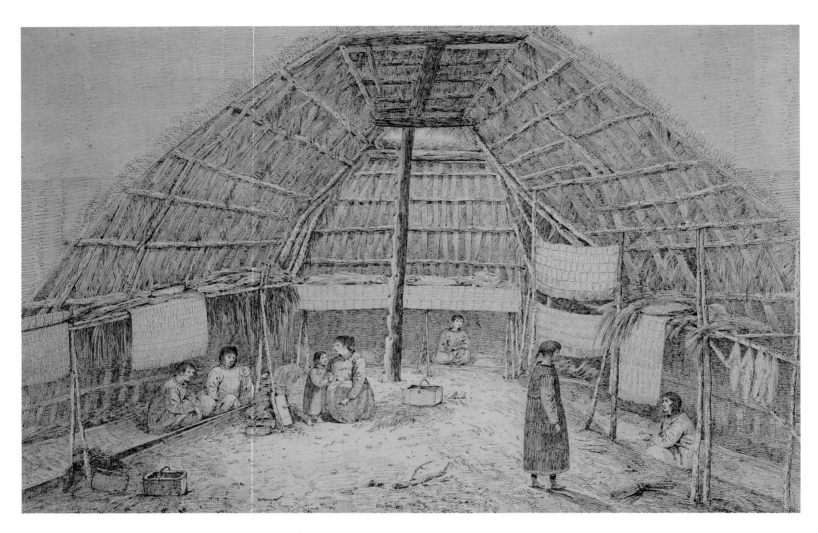

PLATE 129
John Webber, *Inside of a House in Unalaska*, July 1778-. Peabody Museum, Harvard University, Cambridge, Mass. (3.256)

artist: 'she stood up or sat down according as she was desired, seeming very much pleased in having an opportunity to oblige us'.[6] Webber's full-length study of her is now in the National Maritime Museum, London (plate 131; 3.264), from which the artist developed a charming water-colour drawing, now in the British Library (plate 132; 3.263). In the background two dwellings remind us of the Alaskan village they had just visited. Although Samwell recorded that the day was foggy, Webber shows a light blue sky. The hilly panorama and the mounts are of light blue and yellow-green and the drawing is uncommonly fresh and alive. Not many full-length representations of native people are known from Webber's hand, he preferred the half-length or the head and shoulder portrait. However, the friendliness of the woman offering herself as model and the tedium of the voyage may have persuaded Webber to deal with the subject more extensively than was his custom.

At this or a different occasion Webber also drew a whole-length study of a man (plate 133; 3.260), which he began to develop into a more refined drawing, but which seems unfinished (plate 134; 3.259). The identity of the sitter is not known. It may be the Aleut, Yermusk, who on 28 June was taken on board the *Resolution* and spent almost a day there. On the other hand, the fact that the figure is of similar conception to that of the woman could mean that he was her husband, even though Samwell only mentions her as having been drawn by Webber. Whoever was represented, the two drawings are impressive examples of Webber's increasing freedom in portraiture. A pencil line suffices to set out the contours of the subject while grey wash and touches of water-colour give volume to the figure. Webber's technique with the brush now seems so mature that it can delineate precisely even sensitive areas such as the face.

Among the portrait sketches that Webber did at this time one other drawing may be singled out for its competent draughtsmanship, showing the head of a man of Unalaska in Webber's best style (plate 135; 3.262). He is wearing a bird-skin frock, and a piece of bone at his underlip. Here Webber concentrated on the physiognomy, the broad cheek bones and slanting eyes, bringing out some of the facial characteristics of Mongolian people. By the asymmetrical presentation of the shoulders and the sharp turn of the head, Webber intensified the character of his subject; the drawing thus reveals Webber's sense of the individual within the ethnic type.

Most of Webber's field drawings of Alaskan subject matter can be dated to Cook's first

[6] ibid.

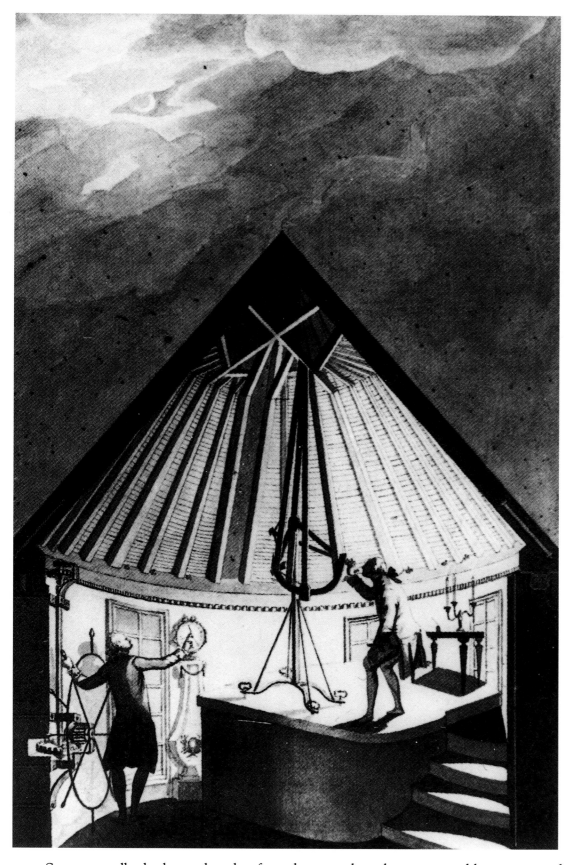

PLATE 130
Anonymous, *Roof of the observatory of the military school in Paris*, 1768-69, pen, black wash and water-colour, 19⅝ × 12½ : 498 × 318. Conservatoire National des Arts et Métiers, Musée National des Téchniques, Paris.

stay at Samgoonoodha harbour, though a few others may have been executed between 3 and 26 October 1778, after the ships returned from their arctic voyage.

From Samgoonoodha the ships went up into Bristol Bay, sailed around Cape Newenham, then still further north towards Bering Strait. Except for a few canoes met with near Cape Newenham (3.268) no contact was made with local people, until on 10 August Cook approached the East Siberian coast and made a landing in the Bay of St Lawrence at Chukotski peninsula.

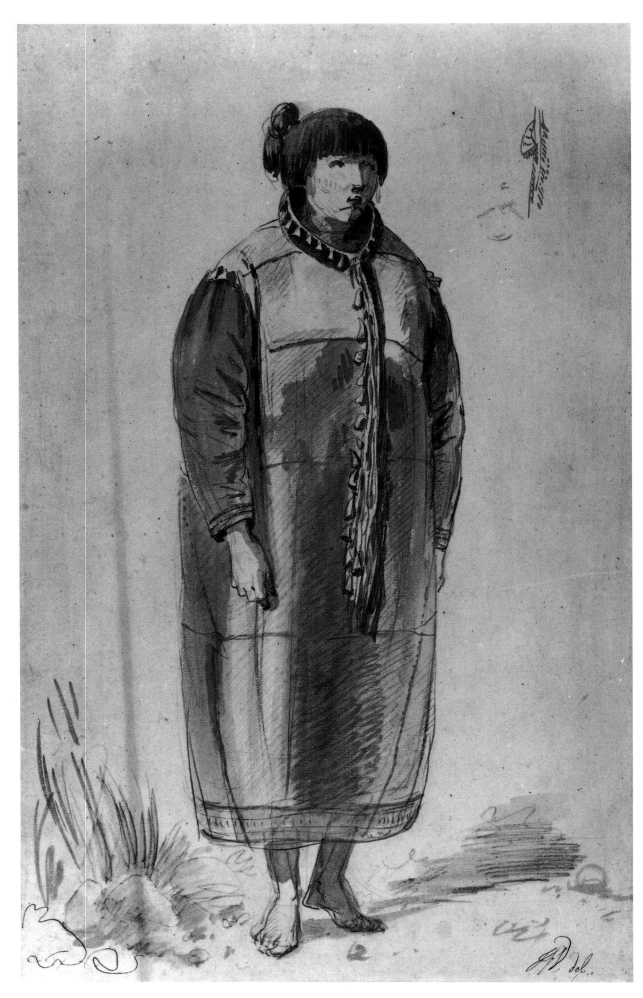

PLATE 131
John Webber, *A Woman of Unalaska*,
July 1778. National Maritime Museum,
London. (3.264)

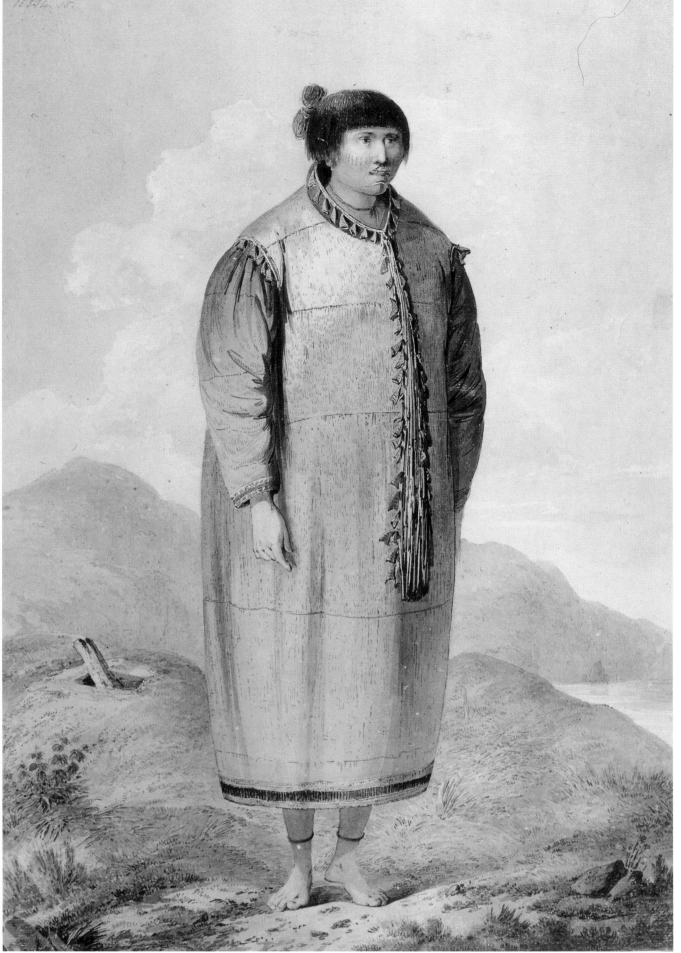

PLATE 132
John Webber, *A Woman of Unalaska*,
July 1778-. British Library, London.
(3.263).

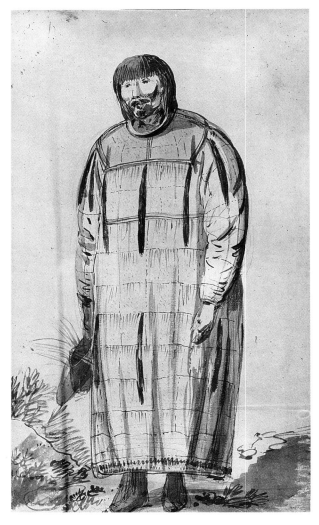

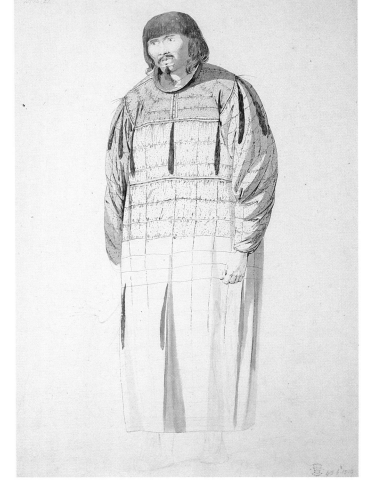

PLATE 133
John Webber, *A Man of Unalaska*, July 1778. National Maritime Museum, London. (3.260)

PLATE 134
John Webber, *A Native of Unalaska*, 1778. British Library, London. (3.259)

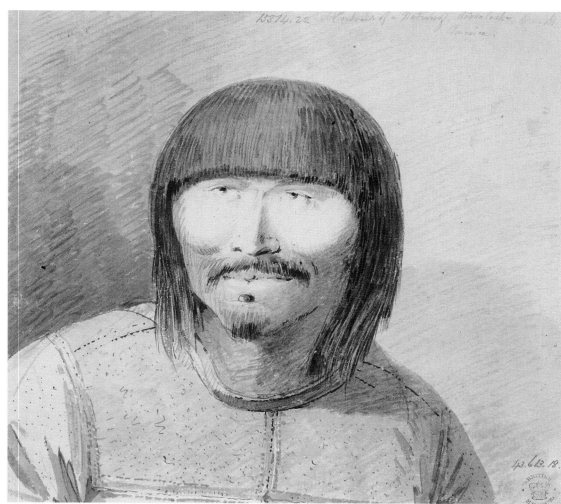

PLATE 135
John Webber, *A Portrait of a Native of Unalaska*, 1778-. British Library, London. (3.262)

## 26. Chukotski Peninsula, Siberia: 10 August 1778

From Webber's point of view, Cook's visit to the natives of Cape Chukotski was an unqualified success. Webber was in one of the three boats that accompanied the commander to the shore. After a first and careful approach by Cook himself to meet a group of the local Chukchi apprehensions were soon overcome by trading knives, beads and tobacco against clothes, gloves and arrows. In honour of their visitors the men performed a dance which they accompanied by the playing of drums. Webber recorded it in a fine pen and wash drawing (plate 136; 3.269). The dance was performed in a semicircle, allowing the artist to distinguish several aspects of the scene. Five Europeans are seated on the ground, bearing upon Cook's observation that 'for greater security [the Chukchi] desired us to sit down'.[1] Into his representation Webber carefully blended some other elements which illustrate the location: the skin-made tents of the natives, their dogs and a view of the desolate countryside. No doubt, several sketches were needed to form this picture, which in terms of rendering the ethnic character and temperament of the Chukchi and the informality of the scene must be rated among Webber's most accomplished compositions.

Two of Webber's sketches made at the time have survived (plate 137; 3.272, and 3.273). These were the basis of another drawing, showing the Chukchi in front of their tents (plate 138; 3.271).

Contrary to Cook's opinion that the Chukchi were careful about their own security, Samwell related that 'many of our people mixed among them without any Reserve'.[2] But this

[1] Cook, *Journals* III, 1, 411.
[2] Samwell in Cook, *Journals* III, 2, 1132.

PLATE 136
John Webber, *Captain Cook's meeting with the Chukchi at St Lawrence Bay*, August 1778-. National Maritime Museum, London. (3.269)

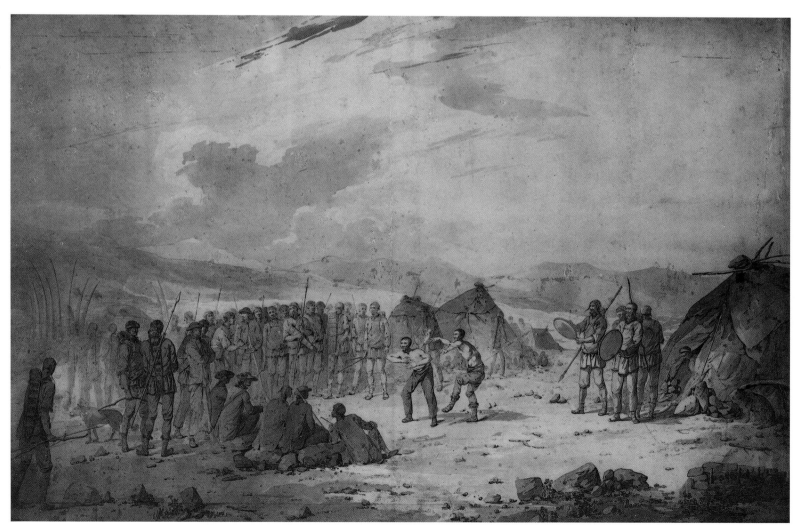

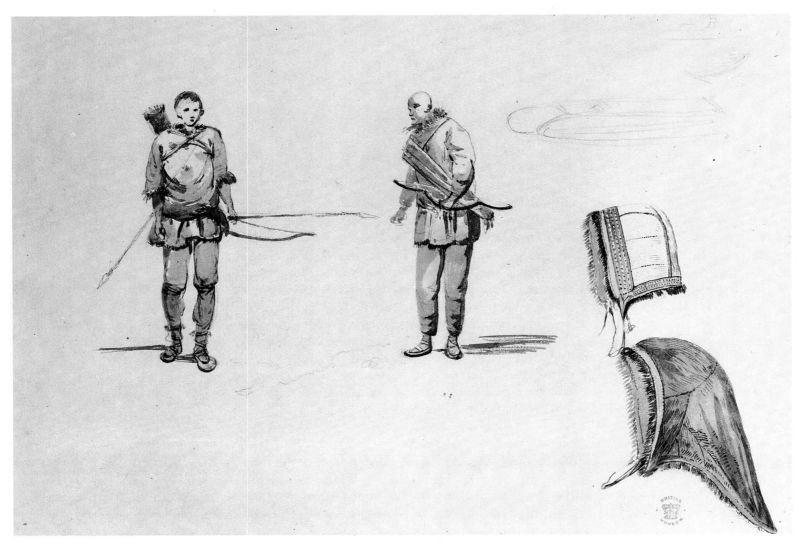

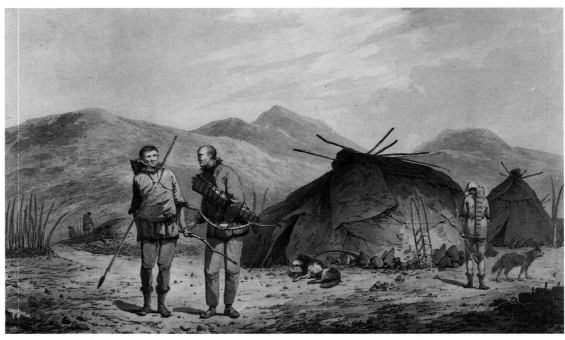

may only have been so after the dance. Needless to say, Webber greatly profited from the situation. His pencil, pen and water-colour drawing of two Chukchi men (plate 137; 3.272) is a splendid little field-sketch depicting the people in full hunting dress. He also drew their caps. It is this kind of sheet filled with random observations gathered at various instances that is so rare in Webber's *oeuvre*. Such situations not only demanded a quick perception and dexterity of drawing, it also required an amicable relationship between the artist and his subjects. Given the length of time that Cook and Webber stayed among the Chukchi (about two or three hours) the resulting drawings are strong evidence of Webber's increasing professionalism.

114

# 27. Arctic Sea:
## 11 August - 3 September 1778

After it had become clear that no north-west passage was available through the American continent itself, it became Cook's intention to find a passage around the northern limits of America. Penetrating into the Artic Sea on 18 August the ships reached their furthest northerly point in latitude 70° 41', to the north of Icy Cape. Here the ice prevented further progress, forcing them to return.

Webber's drawings of *The Resolution and the Discovery among the Ice* (plate 139; 3.275; 3.277) depict the critical situation and the futility of proceeding further north. It is not clear whether the drawings relate to 18 August 1778 or to a later situation on 23 July 1779 when, on a second attempt to find a passage, the ships were again imperilled by enclosing ice.

In spite of the dangerous situation Webber's treatment of the scene is surprisingly calm. It lacks that element of terror apparent in the drawings of Hodges and George Forster of the *Resolution* and the *Adventure* in the Antarctic of five years before (2.7; 2.8; 2.10). The drawings lack any attempt to evoke a sense of imminent danger. They are rather like John Cleveley's *The Racehorse and Carcass forcing their way through the Ice* (plate 140).[1] They are both in a sense 'history' pieces documenting an event of significance, rather than an illustration seeking to arouse emotions. But Webber at least was there; whereas Cleveley developed his work from sketches on the spot by a midshipman, Philippe d'Auvergne.[2]

In contrast Webber developed a sense of drama in *Shooting Sea Horses* (plate 141; 3.278),

[1] Stainton, (1985) cat. no. 49, pl. 35.
[2] See Savours, (1983), 301-3.

PLATE 139
John Webber, *The Resolution and Discovery among the Ice*, August 1778-. Peabody Museum, Harvard University, Cambridge, Mass. (3.275)

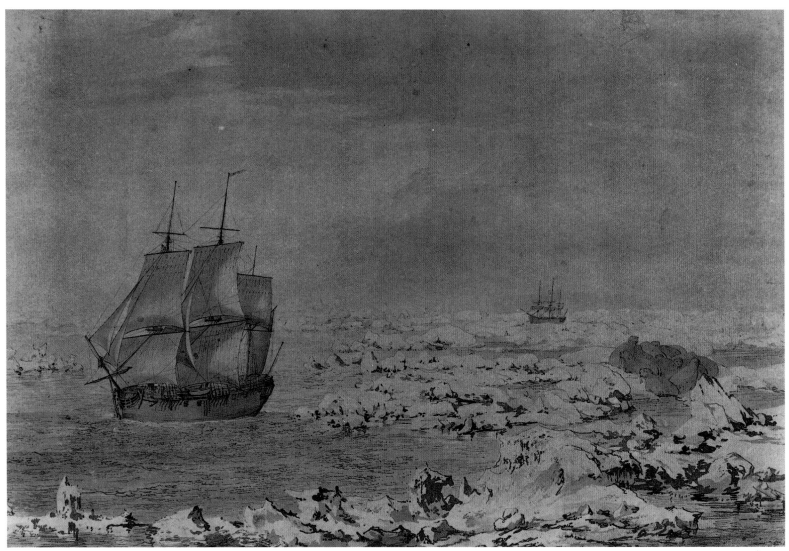

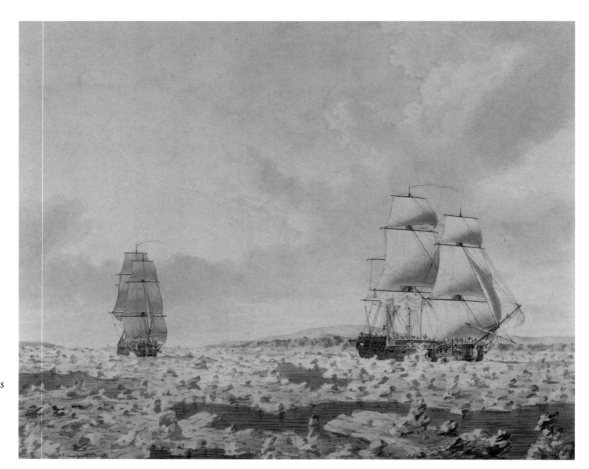

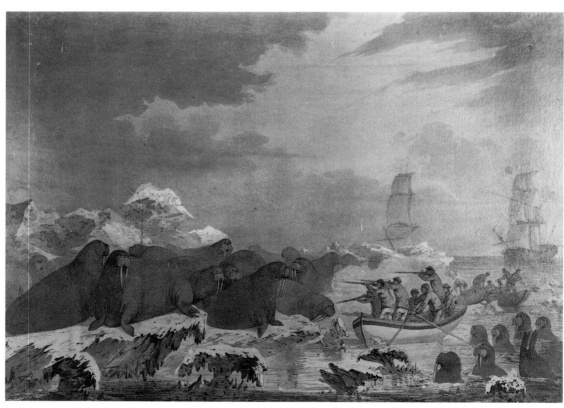

[3] Cook, *Journals* III, 1, 420.
[4] ibid.

[5] ibid., 419, fn. 3.

a composition for which several sketches exist. Apparently Webber was quite fond of the subject. Or was it Cook who encouraged Webber to give this subject such attention? He certainly mentioned the walrus several times in his journal. The fact that large animals of this kind 'lay in herds of many hundreds upon the ice, huddled one over the other like swine, and roar or bray very loud'[3] was certainly surprising. Cook had 'no were seen a good drawing of one'.[4] On several days, beginning on 19 August 1778, walrus were also seen in great numbers, and many were killed for food. The taste of the flesh was a matter for controversy among the crew, but Cook himself noted that 'there were few on board who did not prefer it to salt meat'.[5]

Webber's representation of the event, though obviously the product of several studies,

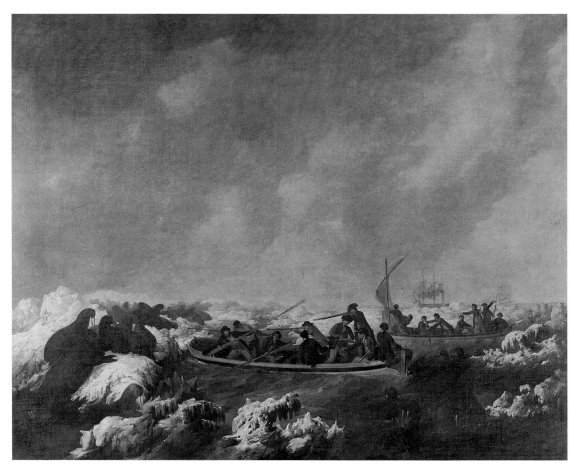

PLATE 142
John Webber, *A Party from His Majesty's ship Resolution shooting Sea Horses*, 1784. Admiralty House, London. (3.280)

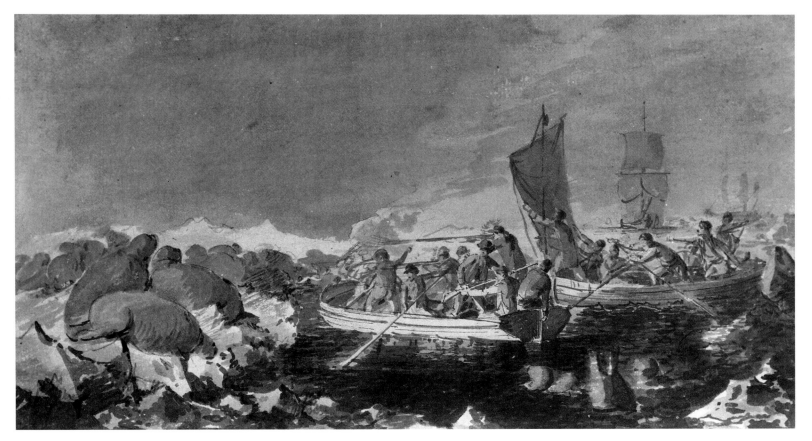

is realistic enough. As two sketches quite similar to each other in The Public Archives of Canada attest (3.281; plate 143; 3.282) the original conception was more informal, showing two boats approaching the ice, some of the crew firing, while the animals take fright and attempt to disperse. In his revised composition he attempts a more dramatic note (plate 141; 3.278). Walrus and man now confront one another, as protagonists must; the walrus awaiting its fate stoically. It enabled them to be drawn both frontally and in profile, for no doubt Webber now had a didactic purpose in mind. That the picture was intended also to serve as an illustration of a little-known animal is underlined by the head of one walrus and upturned

PLATE 143
John Webber, *Shooting Sea Horses on an Ice flow*, August 1778-. The Public Archives of Canada, Ottawa, (3.282).

belly of another shown above water in the right foreground. To add to the action, another boat was introduced in the background, where the body of a slain walrus is to be seen being dragged into it. The weather is misty, almost foggy and this may be intended to depict the weather experienced on 27 August, when a shooting party was taken suddenly by surprise by rising fog and the ships were becoming invisible to the boats' crews. Though more walrus had been killed, Cook ordered a walrus for each ship to be taken aboard the boats, and returned without delay. It was a time when the expedition was in dire need of fresh food.

Webber completed an oil painting of the event several years after the voyage, and exhibited it in the Royal Academy in the spring of 1784 (plate 142; 3.280). The overall scale is now much broader, and Webber puts more stress on the men in the boats. The changes give the picture the character of a traditional marine piece. The subject was well-chosen. It was an event from Cook's now famous last voyage, and a dangerous one, and it reminded the public that the essential task of the voyage was the search for the north-west passage. It was the first time for eight years, the first time since his return from the voyage, that Webber had shown at the Academy and the painting was well-chosen to arouse popular interest. Nor was it too exotic. It fitted well enough into those well-known Dutch seventeenth-century paintings depicting whaling off the coast of Greenland and the eastern seaboard of North America, such as Abraham Storck's picture of a whale hunt among ships and open boats, surrounded by icebergs (plate 144).[6]

[6] Honour, (1975) no. 155A; for another example by Jan Porcellis in Bernt, 2, (1948) no. 651.

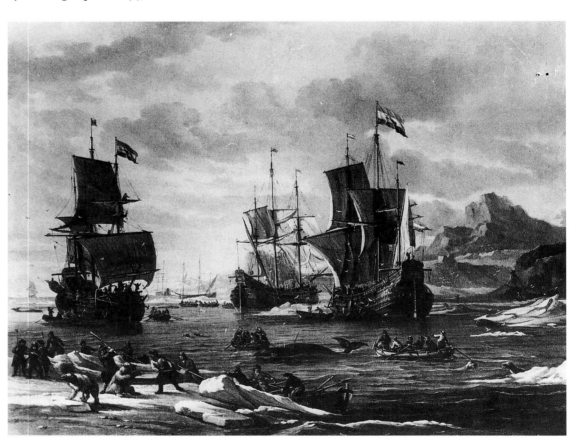

PLATE 144
Abraham Storck, *Dutch Whalers*, 1688, oil on canvas, 21½ × 28 : 547 × 710. Mr and Mrs Douglas C. Fonda, Jr, Nantucket.

# 28. Norton Sound, Alaska:
## 11-16 September 1778

After all hope of penetrating further into the Arctic Sea had faded, Cook returned to Unalaska. On his way he reached Cape Denbigh at Norton Sound on 11 September and stayed for five days. The place was found to be inhabited by people they considered inferior to the Aleut Eskimos of Cook Inlet and Samgoonoodha. Webber's drawing *Inhabitants of Norton Sound and their Habitations* (plate 145; 3.283) reflect the harsh living conditions, and is yet another example of his empirical naturalism, which is seen at its best in his work in the northern Pacific.

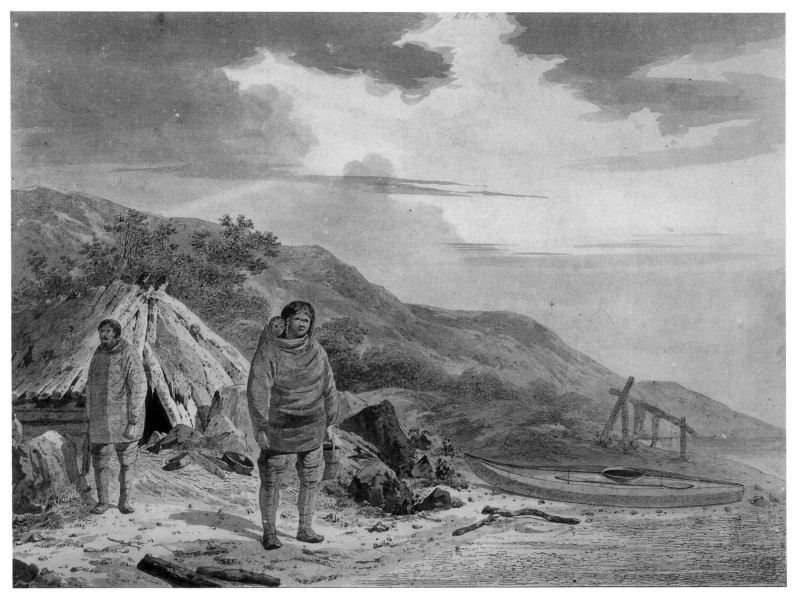

PLATE 145
John Webber, *Inhabitants of Norton Sound and their Habitations*, September 1778-.
British Library, London. (3.283)

# 29. Samgoonoodha, (English Bay), Unalaska: second visit: 3-26 October 1778

[1] Clerke in Cook, *Journals* III, 2, 1334.

[2] Edgar in Cook, *Journals* III, 2, 1351-5.

[3] Cook, *Journals* III, 1, 450.

[4] Edgar in Cook, *Journals* III, 2, 1356-7.

[5] Samwell in Cook, *Journals* III, 2, 1138.

No drawing of Alaskan subject matter by Webber can be dated firmly to Webber's second sojourn at Samgoonoodha. Cook had a good deal to say about the people in general, their dress, food and implements, but almost all he said is incorporated into Webber's drawings dating from the first stay. It is possible of course that some details in his drawings were incorporated from information gained during the second time, when there was more time to wander about and make sketches. Clerke mentions an 'Indian Town'[1] which was visited, and so does Edgar; in fact Edgar records several visits to Indian villages on 8/9 and 15/16 October.[2] In the evening of 14 October, Webber accompanied Cook to an 'Indian Village a little way from Samgoonoodha',[3] but there is no evidence that Webber made drawings on this occasion. Likewise, according to Edgar, Webber went to the 'Russian factory' on 17 October and stayed there for the night.[4] It is in fact astonishing that none of the interactions with the Russians on this island should have left any traces in Webber's work. Likewise, in the various journals we hear of frequent excursions into the countryside, which was still green and must have afforded a pleasant sight. But except for a drawing of a waterfall, which we may tentatively ascribe to Alaska (3.285), no landscape drawings of Alaska seem to exist. The situation is similar with regard to the harbour of Samgoonoodha and the little town at its upper end, for which no drawings survive. It seems inconceivable that an important anchoring place like Samgoonoodha should not have been included into Webber's repertoire of records. All that he delivered at the end of the voyage was *A Sketch for the Harbour of Samganouda*, a drawing apparently of quite some size (as it is listed in the roll section of Webber's Catalogue; Alaska no. 11) but which is otherwise unknown. The length of time during which the ships stayed at Samgoonoodha made it necessary to erect tents and the observatories on shore. Much useful work was performed, as Samwell records: 'Coppers were put up for melting the Sea Horse blubber which we killed to the Northward'.[5] From this, a drawing similar to the *Resolution and Discovery at Ship Cove* might be expected but none such is known.

# 30. Hawaiian Islands, Hawaii, Kauai, Niihau: second visit: 17 January-14 March 1779

Returning from Unalaska to winter in Hawaii Cook sighted land on 26 November and stood in for the Island of Maui. Four days later he was greeted by 'a Chief named Terryaboo',[1] (Kalani'opu'u), the 'King' of Hawaii, who came out to the ships in several canoes. In Cook's and Samwell's journal the meeting is treated only incidentally, probably because both were ignorant of the real identity of their visitor. A drawing of this scene is not known. For the next one and a half months Cook cruised around the island of Maui and Hawaii, looking for a suitable anchoring place. Trading was kept up with the canoes that came regularly, from the shore. Sailing around Hawaii provided an opportunity to learn about the character of the island, its steep cliffs, and mountainous hinterland. On 7 December Cook observed: 'There are hills in this island of a considerable height whose summits were continually covered with snow, so that these people know all the climates from the Torrid to the Frigid Zones'.[2] Cook's insight might have provided a theme in itself for Webber, but was not taken up before the first half of the nineteenth century, when in the wake of Alexander von Humboldt travel artists first became interested in categorical climatic differences.

[1] Cook, Journals III, 1, 476.

[2] ibid., 478.

When finally on 17 January 1779 the ships entered Kealakekua Bay on the west side of Hawaii the relief on the part of the ships' crews (who had begun to show mutinous reactions because of the long time spent at sea) and the welcome from the Hawaiians was overwhelming. An immense crowd greeted the ships both in canoes and on shore. News of the ships had spread during the previous year, when Cook had touched at Kauai and Niihau.

Cook reckoned that about 1000 canoes surrounded the two ships, King estimated 800, many of them filled with up to 10 or 12 Hawaiians. Hundreds swam to the ships, and others made shift with wooden planks. Nowhere before had the reception of Cook's ships been so impressive as here.

Webber's drawing of A View of Kealakekua Bay (plate 146; 3.293) echoes the scene only imperfectly. It may not have been meant to depict the arrival. A number of canoes of different size lie around the ships, but there are no swimmers or crowds along the shore. There is however a man on a surfboard apparently making for the ships; it is perhaps the first occasion such a subject was depicted. The shoreline runs from Palemano Point in the foreground to Kealakekua in the back below the mountain massif. The middle distance is populated with coconut groves and houses which probably belong to the villages of Kalama and Waipunaula, while in the background the Pali cliffs descend down to the village of Kaawaloa on the most westerly point of the bay. Two wash and water-colour drawings in the British Library (3.306 and plate 147; 3.307) represent parts of the bay with greater detail. Both seem to have been taken from on board the ships and do not provide a panorama of the whole bay. It is possible however, that such a panorama existed; 3.306 would only make sense as a section of a wider panoramic view. Webber's view of the western point of Kealakekua Bay is essentially a coastal profile, but historically it is important, because it illustrates the area in which Cook fell. This view was used again to serve as a background in two of Webber's major Hawaiian subjects: Tereoboo (Kalani'opu'u), King of Owyhee bringing presents to Capt. Cook (plate 148; 3.297) and A Canoe of Hawaii, the Rowers Masked (plate 149; 3.308).

Both drawings are canoe-type pictures associated with historic events, for both occasions afforded singular spectacles. After Cook's reception by the priests at the heiau of Waipunaula (see below) it had become evident that some god-like status was attributed to him. Kalani'opu'u's meeting of the ships on 26 January 1779 was intended as homage to Cook. Two large images made of basket work and feathers as well as a magnificent feather cloak in the two front boats give proof of the sacral character of his mission. Very soon Cook was given to understand that he should follow the King to the shore, where a festive ceremony took place. Kalani'opu'u took his cloak from his shoulders and put it around Captain Cook's. In King's words, he also

put a featherd Cap upon his head, & a very handsome fly flap in his hand: besides which he

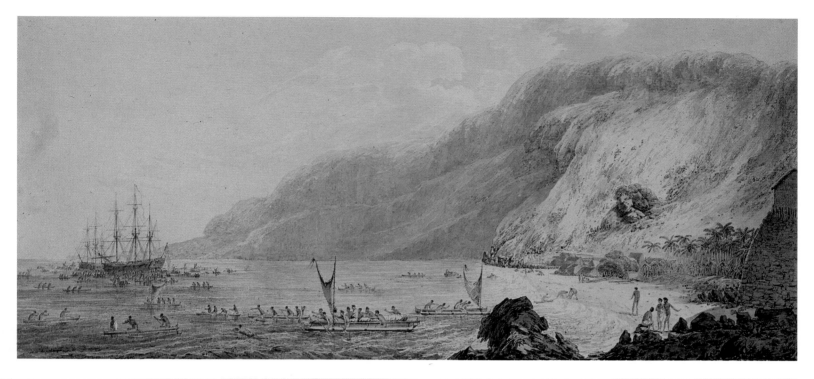

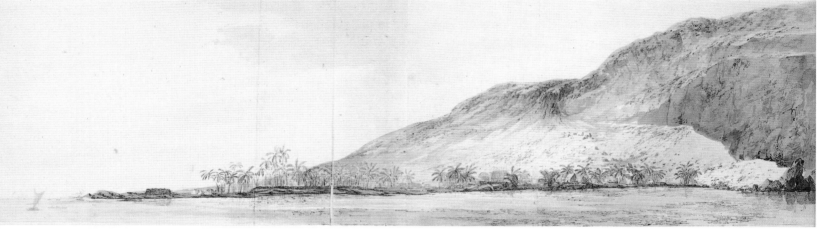

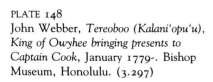PLATE 146
John Webber, *A View of Kealakekua Bay*,
c. 1781-83. Dixson Library, State
Library of New South Wales, Sydney.
(3.293)

PLATE 147
John Webber, *A View of Kealekekua Bay*,
January 1779. British Library, London.
(3.307)

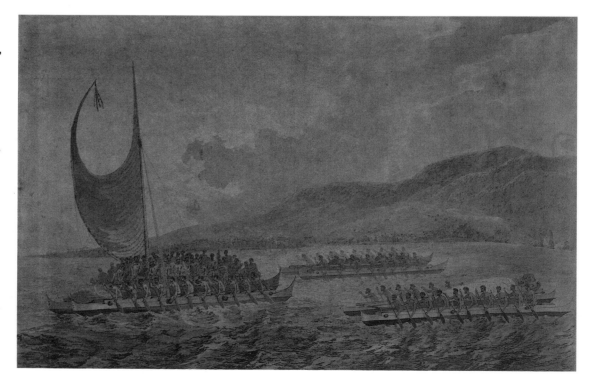

PLATE 148
John Webber, *Tereoboo (Kalaniʻopuʻu),
King of Owyhee bringing presents to
Captain Cook*, January 1779-. Bishop
Museum, Honolulu. (3.297)

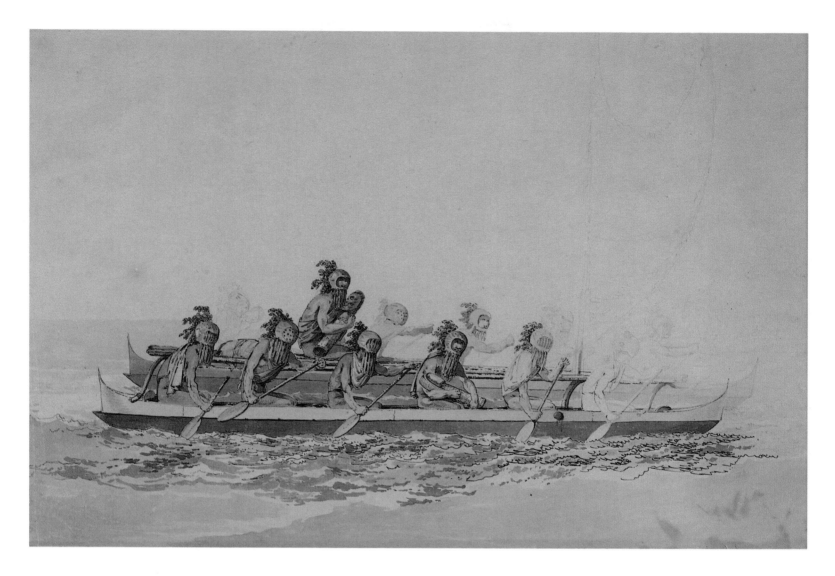

laid down at the Captains feet 5 or 6 Cloaks more, all very beautiful, & to them of the greatest Value.[3]

This scene not only demonstrated the profuse adoration of the Hawaiians, it also served to ratify a friendship between the parties. Many more exchanges of presents ensued. We can only regret that no drawings of this scene exist although the occasion would certainly have deserved one. It would have impressed all eighteenth-century readers to see Cook invested with a royal cloak, cap and fly-flap, as the incarnation of the god Orono (Lono).

A related scene, *An Offering before Captain Cook* (plate 150; 3.294), by the priest of the *heiau* of Waipunaula was witnessed by Webber probably on 19 January. The drawing shows Cook and three of his officers in front of a sacred hut surrounded by about fifteen Hawaiians. Cook is shown taking part in a ritual ceremony. A piece of red cloth has been hung around his shoulders; a man in front of him offers a roasted pig, while a crowd of priests and servants attend. The scene of action is close to the *hikiau* or temple area and set among some coconut trees. The pile of stones on the left (in the engraving also on the right) could well allude to the *hikiau* itself or what seems more likely, a funeral pile.

The scene of action cannot be identified with certainty, for the drawing depicts details which are familiar from several descriptions in the journals. It might be expected that Webber, as in the past, fused several elements into a composite picture. What Webber does not show — and this was frequently mentioned in the journals — is the *heiau* itself. To Cook's men the most remarkable element about the place was the number of carved 'idols' and the skulls stuck on poles (about twenty) which originated from earlier sacrifices. Webber may well have felt unsympathetic towards the subject or else his drawing of the scene has disappeared. In the absence of any such drawing, it is interesting to point to an engraving after a drawing by William Ellis (plate 151; 3.296b), which exhibits a semicircle of carved wooden figures, and in the background a rail with several skulls on sticks. There is no doubt that Ellis's picture is an important addition to our knowledge of Cook's Hawaii.

Webber on the other hand busied himself depicting the entertainments and diversions consequent upon Cook's return. His *A Boxing Match before Captain Cook* (plate 152; 3.300) is a further example of this. Several boxing matches took place between 31 January to 3

PLATE 149
John Webber, *A Canoe of Hawaii, the Rowers Masked*, January-February 1779. Bishop Museum, Honolulu. (3.308)

[3] King in Cook, *Journals* III, 1, 512.

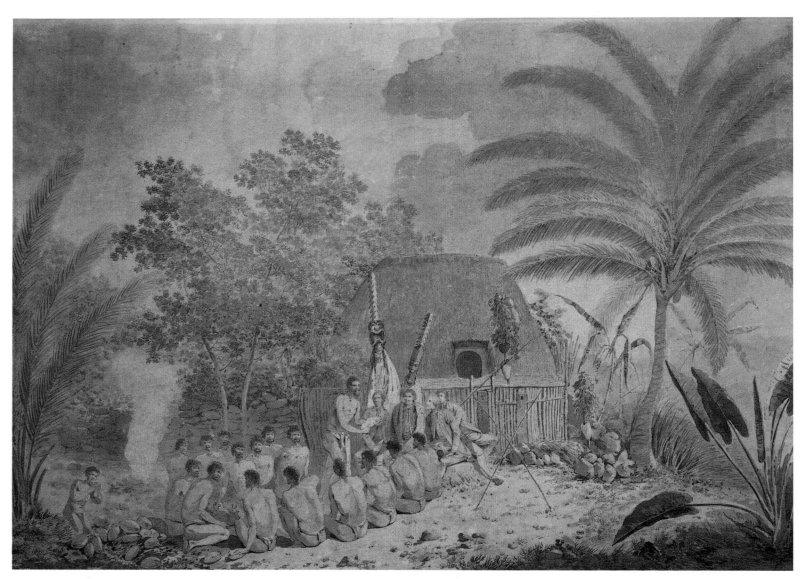

PLATE 150
John Webber, *An Offering before Captain
Cook*, January 1779. Bishop Museum,
Honolulu. (3.294)

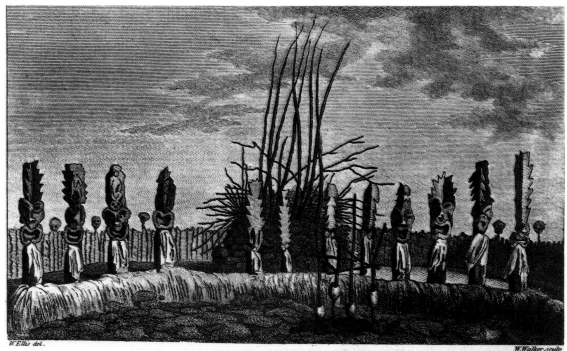

*W. Ellis del.*                                                                              *W. Walker sculp*

*A View of a* Morai *at* O'whyhee.
Published Dec.r 14.1781.by G.Robinson.

PLATE 151
*A View of a Morai at Owhyee.* Engraving
by W. Walker after Ellis. (3.296B)

124

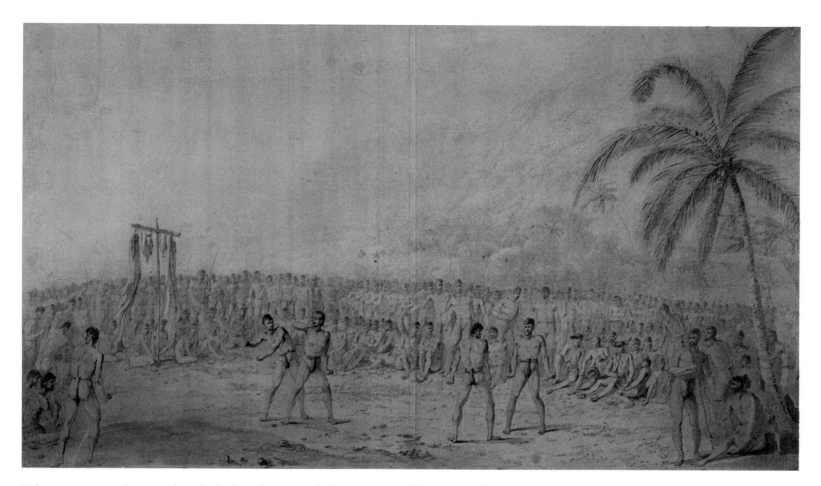

February 1779, that is, shortly before the intended departure of the ships. Seen under such auspices, the matches as well as the ensuing display of fireworks by Cook's men, took the form of popular farewell celebrations. A deeper meaning of the boxing matches is hinted at by Webber's inclusion of the cross-like structure on the left, with sheets of tapa suspended from the bar. As a symbol of Lono, the god of agriculture and peace, the structure signified the festival of *makahiki*, the annual harvest festival lasting from October to February. Cook's accidental arrival at the time of year devoted to Lono had decisively supported his reception as the god. Webber's drawing gives an idea of the importance of the festival, with hundreds of men thronging about. The place of action is described as being near the tents, with some houses and the slopes of the hills in the background. Towards the right, Cook and Clerke are sitting on the ground, accompanied by two officers. Most of the native spectators are drawn quite generally, only a few of them can be singled out more individually, such as the four boxers and the two Hawaiians at the extreme right. Despite their elongated figures they demonstrate an impressive physique, which Samwell compared to the muscular bodies of 'Roman gladiators' engraved by Gerard Van der Gucht (1696-1776). Samwell refers to Bernardino Genga's *Anatomy improv'd and illustrated with regard to the uses thereof in designing . . . demonstrated and exemplified from the most celebrated antique statues in Rome . . .* London (1723)[4] — as we have noted, a book that had already proved to be of great value to Webber's drawing of Tongan boxers (plate 29; 3.47). Though the comparison between the Borghese gladiator and the Hawaiian boxers need not be stressed too much, it must be noted that one representation, showing the gladiator from the front (plate 30) vaguely resembles Webber's second boxer from the left. As at other landfalls Webber's drawings at Hawaii fall into the familiar patterns of receptions, ceremonies and entertainments, portraits and canoes. These, together with some natural history drawings, occupied him from 17 January to 3 February, and we may imagine that he spent much time on board, except when he accompanied Cook on shore. Both King's and Samwell's journals convey the impression that, because of the good nature of the Hawaiians, visits on shore were frequent and not hindered by safety regulations. Several excursions into the country were undertaken by different parties, but we have no knowledge of Webber's participation in any of them. There are no views of the interior of the island, nor does Webber seem to have approached the Hawaiians in order to record their daily life.

As regards portraits, few individual figures are represented. These are all head-and-shoulder portraits and the subjects are of similar age, between twenty and twenty-five years. Lacking are representations of the more outstanding and noteworthy characters, such as Kao

PLATE 152
John Webber, *A Boxing Match before Captain Cook*, January-February 1779-. Bishop Museum, Honolulu. (3.300)

[4] Beaglehole's note in Cook, *Journals* III, 2, 1174. Two of the six engravings of the Borghese gladiator bear an inscription of having been executed by G[erard] V^dr Gucht, one is the work of his father M[ichael] V^dr Gucht. The others are not inscribed but without doubt were engraved by the same masters.

[5] King in Cook, *Journals* III, 1, 629.

[6] ibid., 612.

[7] Samwell in Cook, *Journals* III, 2, 1180.

[8] ibid., 1182.
[9] ibid.

[10] On the all-important relationship between the *Makahiki* festival and Cook's reception during his second visit and his subsequent death, see Dening, (1982), and M. Sahlins, *Islands of History* (1985), 104–35.

the high priest, Kalani'opu'u or Kamakahelei, the 'queen' of Kauai. On Hawaii, Webber appears not to have drawn people interesting because of their elevated status, their age, or their individual features. Nor did he draw infirm or handicapped people, though, as King remarked: 'we saw here more deformed people than in all the other Islands put together'.[5] Webber preferred to draw brave young men and occasionally beautiful girls. His approach followed the convention of ethnic drawing. In King's words: 'Some Portraits which our Painter has drawn, will I think equal, in Nobleness of Countenance, & manliness of figure any Islanders we have seen'.[6]

It seems strange that there is no full-length figure drawing of an Hawaiian woman. Speaking of women Samwell says: 'the better sort have large Pieces of Cloth brought several times round their middle, which comes as low as the Knee & makes them very bulky but does not cover the Breasts',[7] yet there is absolutely no such visual evidence in any of Webber's drawings. Also, his remark, that 'a great number of fine lively Children . . . used to play about us every time we went on shore',[8] something that was never seen 'at any other place during the voyage',[9] was not taken up by Webber. All transactions with the people of Hawaii beyond official communications, ceremonies and entertainments, remain in the dark. Webber was not an artist of a nineteenth century mould who was attracted by the particular, odd and curious. He was not yet accustomed to drawing wherever he went, not given to the practice of exercising his skill in studying the seemingly unimportant. Whatever Webber drew, was close to his commission.

The morning of 4 February was, to all accounts, the last day of the *makahiki*. The two ships left Kealakekua Bay, but, after suffering damage to the foremast of the *Resolution*, were forced to return four days later. On 11 February the ships anchored again in the bay. The natives traded with more reluctance than before, and their behaviour gave reason for complaints. For the *makahiki* had ended.[10] The mutual misunderstanding and the aggression that followed during the next days, mainly over thefts, are too well-known to be repeated here in detail. As the final result of it all in the morning of 14 February Cook was killed on the north-west shore of Kealakekua Bay. Four marines fell with him during the hostilities, while several other members of the last landing party, including Lieutenants Molesworth Phillips, Henry Roberts and John Williamson managed to gain the boats and safety.

When Webber submitted his drawings to the Admiralty after his return from the voyage, there was none that dealt with the death of Cook, neither was the subject included among the engravings of the official account. Perhaps it was felt initially, that an allegorical representation, or apotheosis, would be more to the point. On the other hand the death obviously demanded a realistic representation of a kind. Ever since Benjamin West's revolutionary painting *The Death of General Wolfe* (1771), in which the death of a contemporary hero was made the subject of a major history painting, artists had occupied themselves increasingly with the death of the great and famous of their own times or recent past, such as Copley's *Death of the Earl of Chatham* (1780) and the *Death of Major Pearson* (1783), both large-scale paintings. It was customary for such painters to depict the tragic moment of death and show the varied reactions of those attending the death scene. Webber's *The Death of Captain Cook* (plate 153; 3.304, 3.305) takes a different moment. Cook is represented at the moment immediately prior to death, when he is just about to be stabbed in the back. Not only is he completely surrounded by an enraged mob of Hawaiians and seen to be virtually defenceless, he is killed just at that moment when, with a raised and appealing hand, he attempts to prevent his men from firing at his antagonists. His death is portrayed as that of an innocent victim, killed in the act of pleading for peace.

We have no evidence that Webber's painting was based on personal observation. It was composed well after the event doubtless from several eyewitness reports. Although these were in fact somewhat contradictory as to what actually occurred during the last moments, that did not deter Webber from constructing a picture with an unequivocal message: that Captain Cook was an agent of peace and human understanding. The point is stressed *expressis verbis* in the legend beneath the engraving of the painting by Bartolozzi and Byrne 'The Death of Captain Cook. In February 1779 by the murdering Dagger of a Barbarian at Carakakooa, in one of the Sandwich Isles. He having there become a Victim to his own Humanity'. That only minutes before his death Cook had fired small shot at a man and had apparently killed another in an attempt to disperse the crowd is nowhere indicated by the composition. So Webber, in understandable homage to his beloved commander, began the creation of the myth of Cook as the victim of his humanity — one which had far-reaching consequences for later treatments of the same subject, and for future relations with the people of Hawaii and the Pacific in general.[11]

[11] See Smith, (1979b).

126

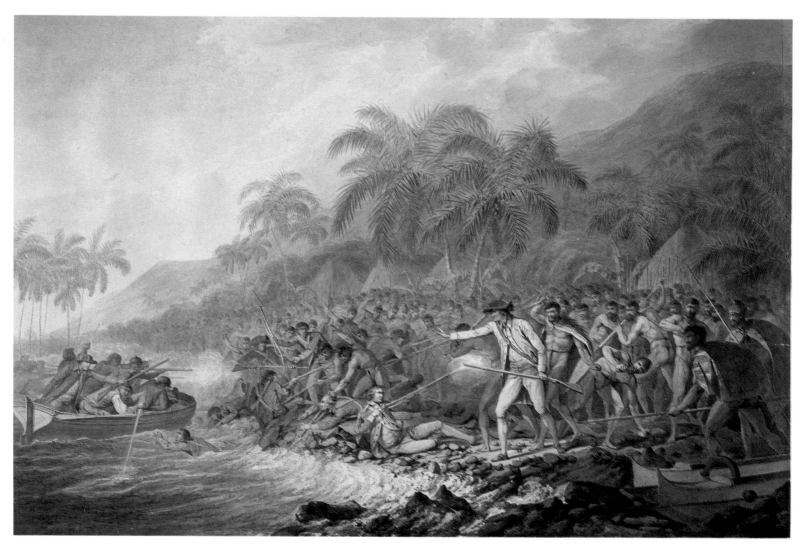

The Death of Captain Cook was invented after the voyage. There are no elements of it which Webber could not have found in his sketches or elsewhere. The figures of the natives are of an athletic build and reminiscent of those in *A Boxing Match before Captain Cook* (plate 152; 3.300). It also provided the background for the scene of Cook's death. As to the feather helmets and capes of the chiefs, King informs us that they were 'appropriated to persons of the highest rank'[12] and worn on three occasions during the ships' stay at Kealakekua Bay: during Kalani'opu'u's visit to the ships, in the battle in which Cook was killed, and when Cook's bones were returned. Several feather objects had been traded with the Hawaiians, and it is interesting that the cape worn by the assailant on the right was copied from a specimen in Webber's own collection.[13]

Within Webber's *oeuvre* the subject holds an important place, for it is one of his very few actual history paintings in oil that we know of (3.305). Though never exhibited at the Royal Academy, it was painted with a view to being engraved by two of the most capable engravers of the time. Its success was thus ensured from the beginning.

Some years later, in 1787, Webber painted another picture in which he depicted the martial character of the Hawaiians from a different but in a sense a complementary viewpoint. In *A Chief of the Sandwich Islands leading his party to battle* (plate 154; 3.313), a chieftain appropriately dressed for the occasion, is to be seen exhorting followers (whose shifty eyes reveal their own suspicions and uncertainties), to follow him against their tribal enemies gathering on the plain below. Precisely what feelings Webber hoped to arouse in his viewers when he exhibited the picture at the Royal Academy in that year is difficult to say, but what comes through clearly is the fragility and uncertainty of the emotional bonds that hold the chieftain and his men together, and, as a result, the endemic violence of Hawaiian — indeed of all — tribal society. It must have been comforting to be reassured that the society responsible for the death of Cook was one ruled not by the rule of law but by violent and wayward emotions.

On 22 February Captain Clerke, who had succeeded Cook in command of the *Resolution*, left Kealakekua Bay and stood for the western isles of the archipelago. Oahu was reached on 28 February and Kauai the following day. The ships stayed in Waimea Bay for a week until 8 March, but because of friction with the the local people only special crews landed for

PLATE 153
John Webber, *The Death of Captain Cook*, c. 1781-83. Mitchell Library, State Library of New South Wales, Sydney. (3.304)

[12] Cook/King, (1784) III, 137.
[13] Kaeppler, (1978a) fig. 108; Henking, (1955/56) 363.

watering and trading. Some important personages, such as Queen Kamakahelei came on board, and portraits no doubt, if any, were drawn in the cabin.

Neither did the stay at Niihau from 9 to 15 March offer many opportunities for going ashore. The visit there seems to have been uneventful. Trading, particularly for yams, was the main concern, and the last repairs to the ships. Ahead of them lay yet another attempt to reach the Arctic Ocean in search of the north-west passage, this time via Kamchatka.

PLATE 154
John Webber, *A Chief of the Sandwich Islands leading his party to battle*, 1787, National Library of Australia, Canberra. (3.313)

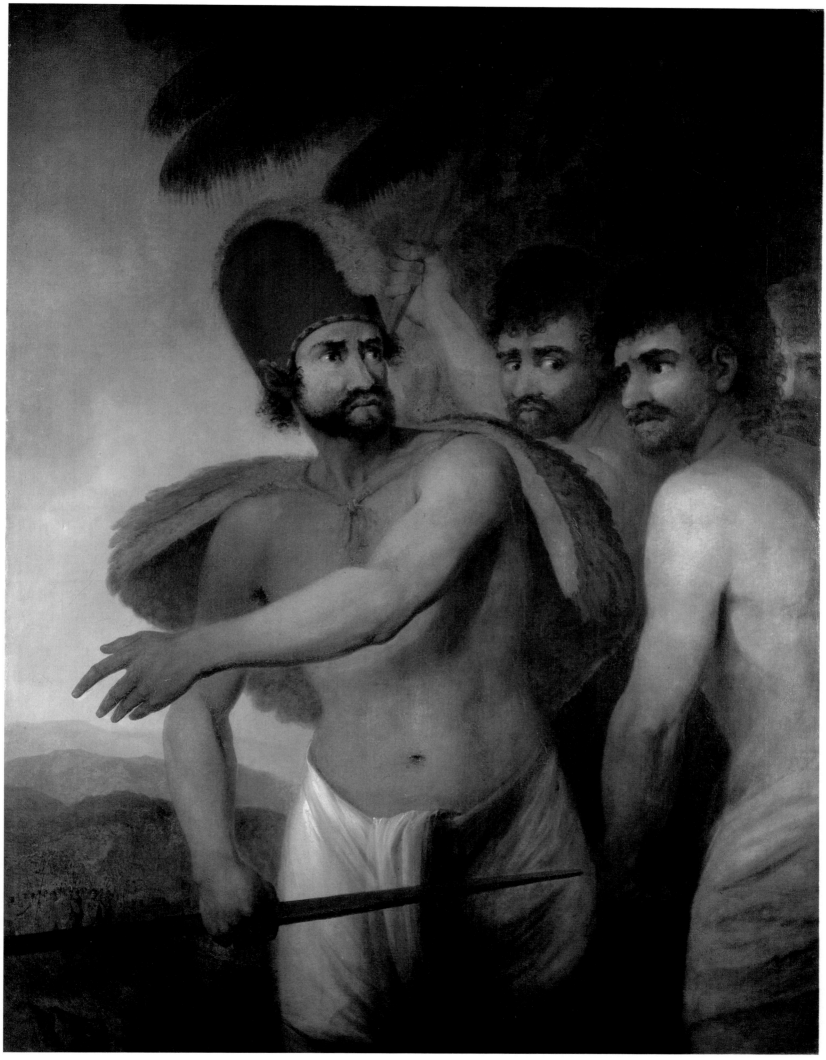

# 31. Avacha Bay, Kamchatka:
## first visit: 29 April-16 June 1779
## second visit: 24 August-10 October 1779

[1] King in Cook, *Journals* III, 1, 650.

Long before the ships sailed into the bay of Avacha, the coast of the Kamchatkan peninsula and its mountains had appeared out of the haze. The crossing from the Sandwich Isles had been uncomfortably cold and foggy with much sleet. On the expedition's arrival, the whole country was found covered with snow. In King's words 'imagination could not paint a more dreary Prospect . . . Some few flocks of duck were all that enlightend this very silent solemn waste prospect'.[1] Also the ostrog or town of Petropavlovsk which amounted to five or six Russian and about twenty native houses, gave the impression of a disappointing place, and seemed to offer little refreshment for the crew. On learning that only the governor of Kamchatka, Major Magnus von Behm, could arrange for the necessary supplies and that he resided in Bolsheretsk on the east coast of the Kamchatkan peninsula a party consisting of Lieutenants Gore and King, and Webber as interpreter, set out to meet him. The travelling was conducted by means of boats and dog sledges and lasted from 7 to 22 May. Because the governor and a few other Russians spoke German, Webber who from his years in Bern spoke German too, acted as the interpreter throughout the period of the stay. This point is important, for now having become an influential figure in the welfare of the expedition, he is mentioned several times in the journals. It is here for the first time that we can follow Webber's moves.

As usual Webber drew a panorama of the harbouring place, showing a view across Avacha Bay with St Peter and St Paul situated on a spit of land (plate 155; 3.328). The ships are anchored about two miles away from the town. The season represented is late winter to early spring. The ice in the bay has already melted and some green bushes appear on the left hand side. Two of Webber's studies of the bay were still taken during the winter period and are of very quick execution, indicating only a few pictorial motives in the midst of a white snowy background (3.329 a, b). The same applies to Webber's views of Paratunka, another settlement in the vicinity of Avacha Bay, which he first visited at the end of May (plate 156; 3.352 and 3.353) after his return from Bolsheretsk.

Webber was quick to notice the different types of houses, the Russian log houses, and the summer and winter houses of the Kamchadals. He made frequent use of them in several of his drawings which relate to both of their stays in Kamchatka. Whereas the *yurts*, or winter habitations, are reminiscent of the mount-like dwellings of the Alaskans, round and partly

PLATE 155
John Webber, *A View of the Town and Harbour of St Peter and St Paul (Petropavlovsk)*, c. 1781-83. Dixson Library, State Library of New South Wales, Sydney. (3.328)

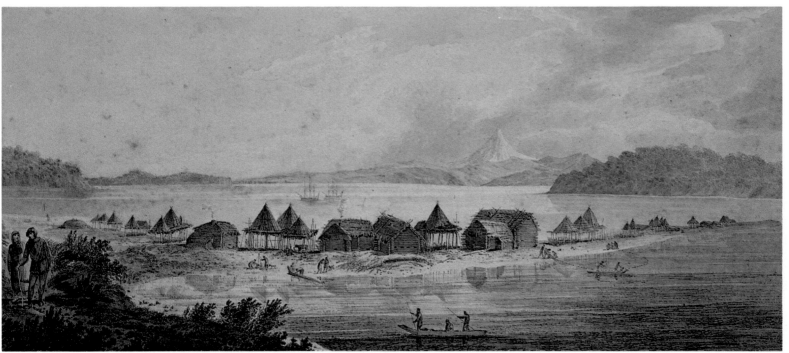

built underground (plate 157; 3.331), the *balagans*, or summer habitations, have the appearance of pointed cones upon stilts (plate 158; 3.362). In drawing these and in adding the characteristic occupations of the people, Webber held to his pictorial programme. People and their houses had become a standard practice. His interior views of a winter and summer habitation (plate 159, 3.332; 3.333; plate 160, 3.363) are variations on the same theme.

Because the Russians were the partners in all matters of importance apparently little contact was made with the Kamchadals themselves. Their state of submission under Russian rule made them appear far less interesting as an ethnic group than people previously met with. It is true that we have a couple of drawings of the Kamchadals' method of travelling in winter (plate 161, 3.336; 3.337) but there are no drawings concerned with their dances or other diversions, their boats or other artefacts.

Webber did, however, continue his portrait programme. Some Kamchadals were drawn full-length, and not without a certain charm (plate 162, 3.343; plate 163, 3.345). These were probably drawn during the trip to Bolsheretsk, as is suggested by their appearance; either as travellers in thick fur coats, or when met in the villages passed, in lighter gowns.

Webber also executed a portrait of a different kind of Magnus von Behm, the Russian governor. Its likeness is known only through a small gouache drawing in the Dixson Library (plate 164; 3.342) which was probably copied after Webber's lost original. The conception is similar to Webber's portrait of Cook (3.451), Gore (3.455) and King (3.456).

Samwell informs us that Webber painted Behm's portrait on 23 May 1779 on board the *Discovery*, after Behm had dined with Captain Gore, and we may assume that Webber as interpreter was an essential member of that dinner party.[2] The original portrait might have been in oil. What is more intriguing is the question whether Behm himself commissioned the portrait, or whether Webber painted the portrait as an act of courtesy. Certainly the Russian governor had given the English expedition an extremely generous reception and personal assistance; and Behm was entrusted with Cook's log and a chart of the major discoveries made in the Pacific, to be dispatched to St Petersburg by land, and thence to London. Thus Behm came to act as a major benefactor to the expedition. No mention of the portrait of Behm occurs, however, in Webber's Catalogue made for the Admiralty of his work done on the voyage.

When the ships returned from the second excursion to the Arctic and stayed in St Peter and St Paul for another seven weeks it was full summer, and to the surprise and excitement of everyone the country had changed totally its appearance. Webber responded to this change of nature with a beautiful drawing of a view of the north end of Avacha Bay, showing a Russian storehouse and barrack together with several English tents, overtowered by the snow-capped volcano Avachinskaya (plate 165; 3.354 and the similar view of 3. 357). Some other drawings represent the houses of the Kamchadals amidst the summer verdure (plate 158, 3.362; also 3.361).

A unique image among the Kamchatka drawings is Ellis's *A Russian Hut* (plate 166; 3.364) with a view across the bay. Making the log house the proper object, the drawing adds a novel element of information, though it cannot be said to be totally original. This is attested by the introduction of the dog at the pole, which Ellis appears to have copied from Webber (3.365).

PLATE 156
John Webber, *A View of the Village of Paratounqua (Paratunka)*, May 1779-. British Library, London. (3.352)

[2] Samwell in Cook, *Journals* III, 2, 1247.

131

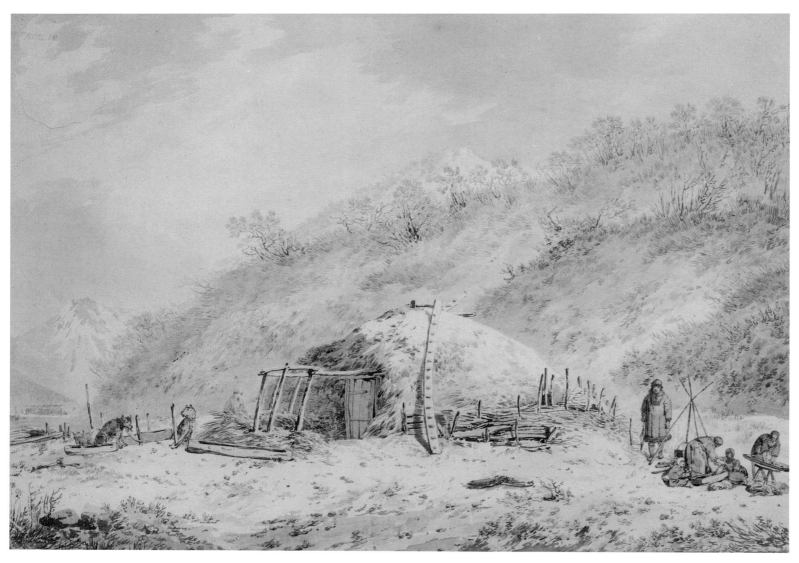

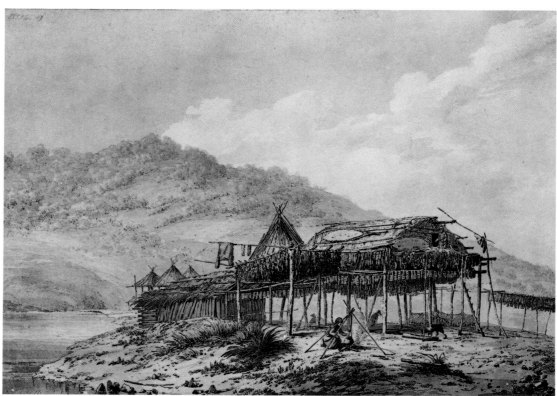

PLATE 158
John Webber, *Summer Habitations in
Kamchatka*, August-September 1779-.
British Library, London. (3.362)

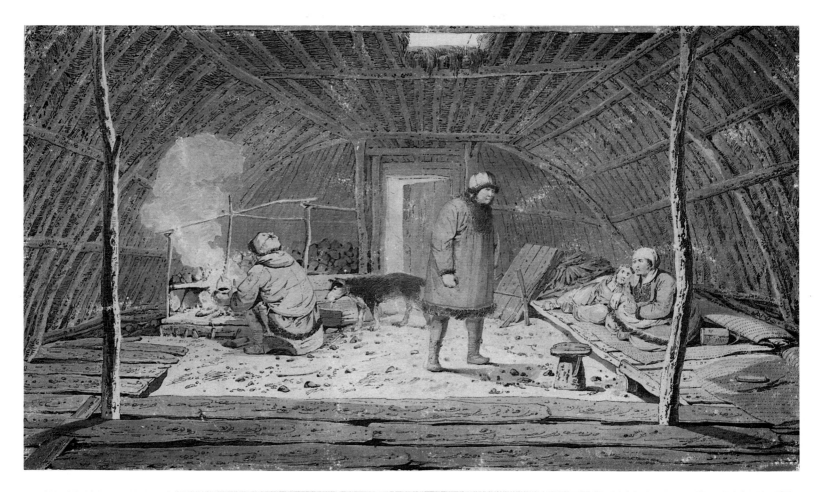

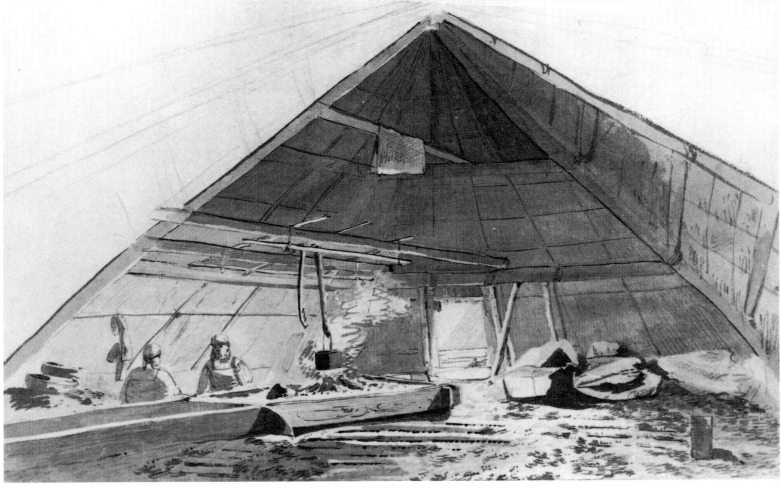

PLATE 159 (top)
John Webber, *The Inside of a Winter
Habitation*, May 1779. National Library
of Australia, Canberra. (3.332)

PLATE 160 (bottom)
John Webber, *The Inside of a Summer
Habitation*, August-September 1779.
Farquhar collection, Berkeley. (3.363)

133

[3] ibid., 1274.

[4] 'Captain Gore went to Paratounca, to put up in the church there an escutcheon prepared by Mr. Webber, with an inscription upon it.' Cook/King, (1784) 309. In September 1787 the escutcheon was noted by J.B.B. Lesseps, participant of La Perouse's voyage, who had left the expedition prematurely in Kamchatka to return to France. After leaving St Peter and St Paul, Lesseps came to Paratunka. On visiting the church he wrote: 'j'y remarquai les armes du capitaine Clerke, peintes par M. Webber, & l'inscription angloise sur la mort de ce digne successeur du capitaine Cook, elle indique aussi le lieu de sa sépulture à Saint-Pierre & Saint-Paul.' Lesseps, (1790) I, 33.

[5] Samwell in Cook, *Journals* III, 2, 1281.

During the second stay a number of dinners were arranged by the captains and officers of the ships for the Russians in port, and there were other social commitments. From Samwell's journal we hear of several hunting, shooting or fishing parties, but no such activities are conveyed through drawings.

On 29 August 1779, Captain Clerke, who had died of consumption seven days previously when still at sea, was interred in the bay of St Peter and St Paul, and his funeral was conducted with military honours. It

> was attended by the Captains & all the Officers of both ships; the Priest, [Roman F. Vereshagen, parson of Paratunka,], Serjeant [of the garrison of St Peter and St Paul] & many other Russians were spectators as well as most of our own Sailors.[3]

This certainly was a memorable moment or transaction in the sense of Webber's commission, but no drawing has survived, nor is any mentioned in any of the documents concerning the voyage. In connection with Captain Clerke's death however, Webber was called upon to do other work outside his usual practice. One was to execute an escutcheon of Clerke to be hung up in the church of Paratunka,[4] the other was the drawing of a crucifixion which was given to the parson, presumably in recognition of his conducting Clerke's burial.[5] No sketch of this composition is known.

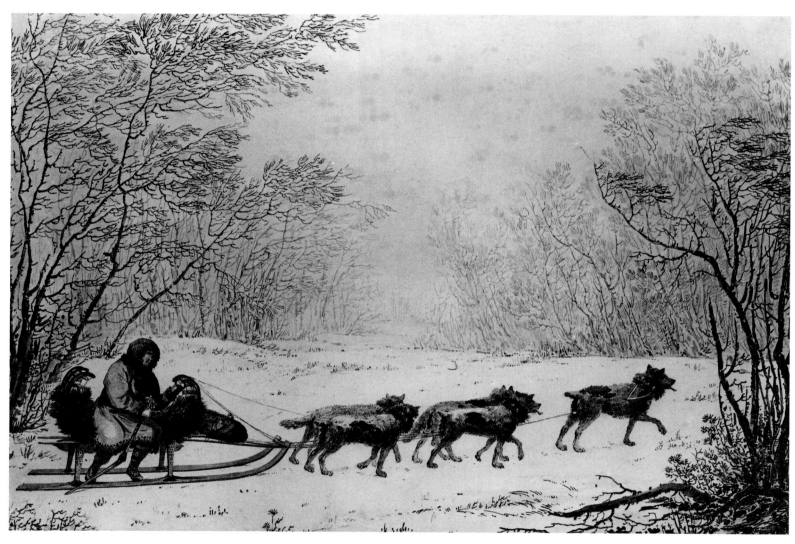

PLATE 161
John Webber, *The Manner the Kamchadals travel in Winter*, May 1779-. National Library of Australia, Canberra. (3.336)

PLATE 162
John Webber, *A man of Kamchatka*, May 1779. Farquhar collection, Berkeley. (3.343)

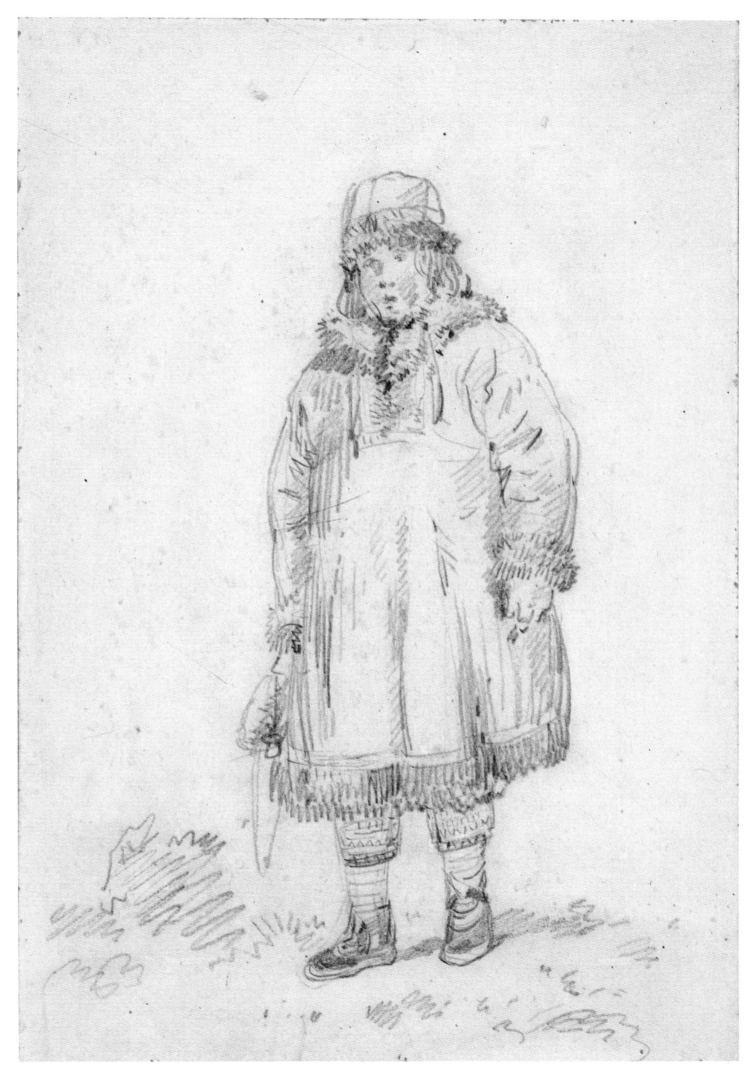

135

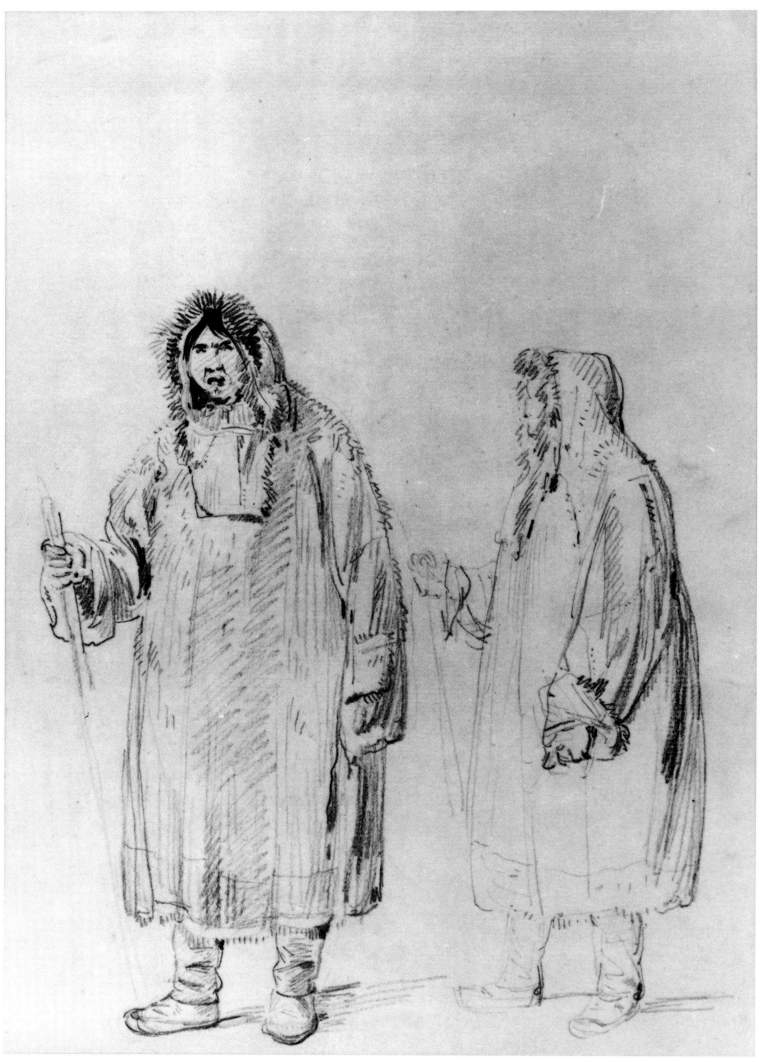

136

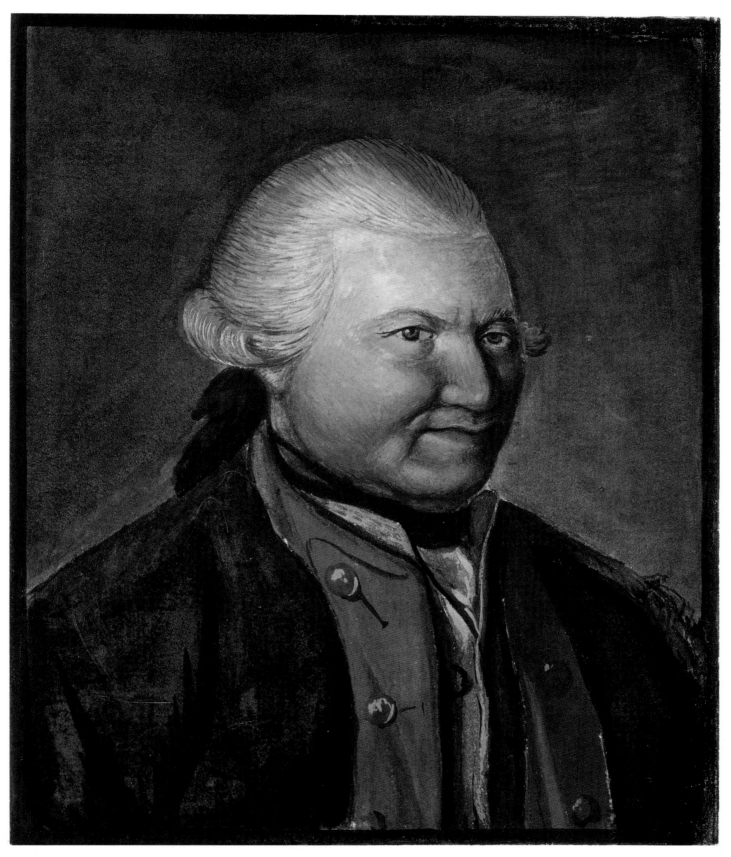

PLATE 164
John Webber, *Portrait of Magnus von Behm, governor of Kamchatka,* May 1779.
Dixson Library, State Library of New South Wales, Sydney. (3.342)

PLATE 163
John Webber, *Native(s) of Kamchatka,* May 1779. Farquhar collection, Berkeley. (3.345)

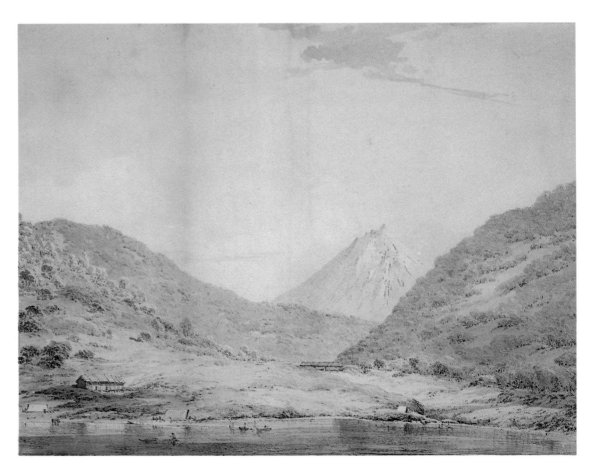

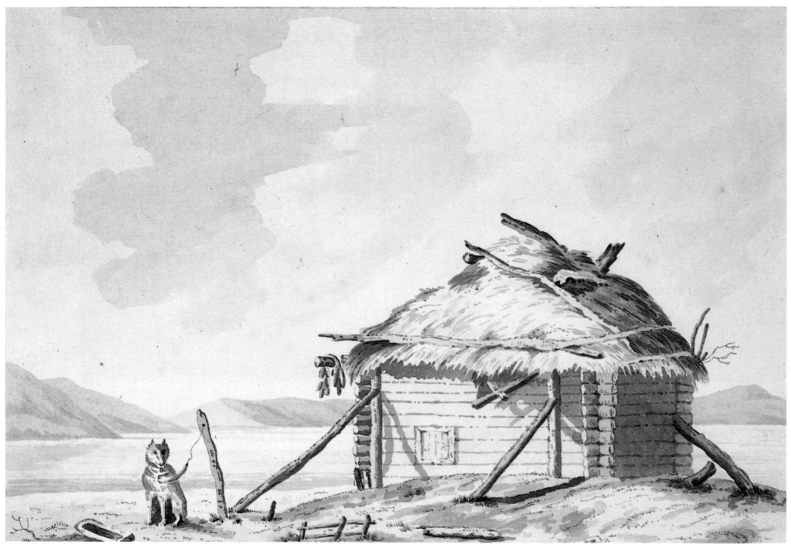

138

## 32. Macao, China:
### 1 December 1779-12 January 1780

From Kamchatka onwards the ships were returning home. After having passed Japan and the Sulphur Islands, they reached the Chinese Coast off the entrance of the Zhujiang Kou (between Hongkong and Macao) on 29 November 1779. Here the captains commanded their officers and crew 'to deliver up to them their Journals, charts, drawings and remarks of all kinds relative to the Voyage'.[1] The next day the ships sailed into the Typa, a strait between four small islands lying to the South of Macao, where they stayed for almost a month and a half.

Webber made a drawing of the Typa (plate 167; 3.369). It signals a change of perception from the previous 'harbour' drawings of the voyage. The Typa was not a bay and there were no canoes or other craft surrounding the ships for trading. This change is revealed in a small detail. Only one three-masted ship is in the background, the other is eclipsed by the rock formation at right. The drawing is, one feels, no longer an 'official' record but a representation of personal choice. This is also born out in the composition. Instead of rendering an overall view, it narrows down on to a restricted field. Proximity and distance are nicely balanced by horizontal and diagonal planes and interlock by different scales of height of land and sea. Foreground and background are represented in recession, one is seen beyond the other. In this, Webber's conception is similar to an oil sketch by François Desportes: *A Bank with trees beyond and plants in the foreground*, which was produced in the first half of the eighteenth century (plate 168).[2] Desportes's composition as well as his method of painting were well in advance

[1] Gilbert in Cook, *Journals* III, 1, 712.
[2] For this and the following example see Bacou et al., (1977) cat. no. 9, 12; see also Duclaux/Préaud, (1982) the section on 'Paysages, arbres, plantes et fleurs' (58-63, cat. no. 50).

PLATE 167
John Webber, *A View in the Typa outside Macao*, December 1779-January 1780. British Library, London, (3.369)

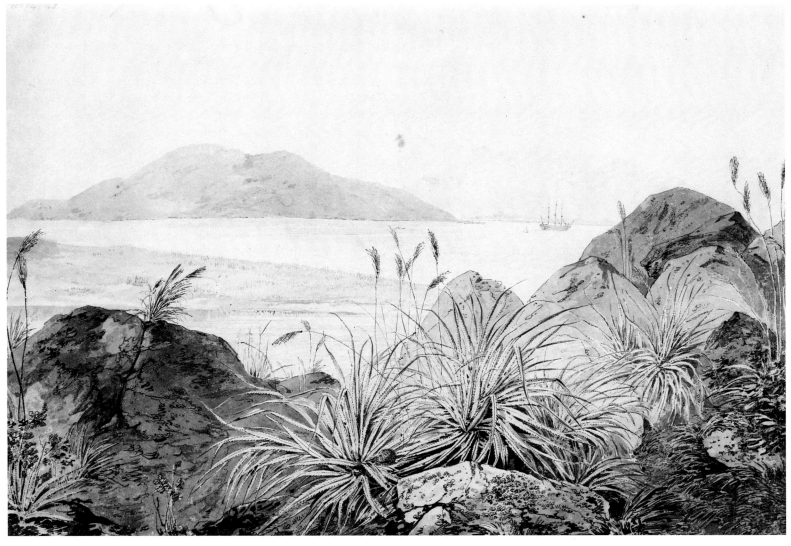

PLATE 168
François Desportes, *A Bank with trees beyond and plants in the foreground*, early 18th century, oil on paper mounted on cardboard, 11⅝ × 19¹¹⁄₁₆ : 295 × 500. Archives, Manufacture Nationale de Sèvres, Sèvres.

[3] See Conisbee, (1979) 413-28; and Smith, (1983) 143-52.

of their time. His *plein-air* work became fully appreciated only at the end of the eighteenth century, when Valenciennes advocated similar ways.[3] In another sketch *A Field bordered by Trees, with Cows grazing and Pine-trees in the Foreground*, Desportes adopts a similar device. By placing the trees immediately behind the frame and across the picture, he enlarges their forms to such a degree that a vista is opened into the back of the landscape. As in Webber's drawing, his viewpoint is generally low. Whether Webber had seen or studied Desportes's work, is unknown. The fact however, that Webber made use of this device only at the end of the voyage, suggests that it was his own invention. The sheer necessity of continually drawing outdoors, which had been his lot during the previous four years, could well have been responsible for Webber developing new ideas in composing. In any case, the drawing of the Typa represents a novel way of looking at landscape, for Webber as for his time. Drawings, in which by a new handling of perspective, the foreground was deliberately enlarged and the background seen as a remote and distinct stage, only became common in the early nineteenth century.

In his other landscape drawings from Macao, Webber achieved some fine work. His *A View at Macao* (plate 170; 3.372) and his *Temple in the Inner Harbour of Macao* (plate 169; 3.371) reflect his now customary interest in peoples, their housing and typical activities. The topographical element is no longer so prominent and Webber freely responds to the visual excitement of the place. His other *View near Macao* (plate 171; 3.374) is a study of light on rocks and a hilly countryside and could represent almost any place, did not the figure with the baskets slung across the shoulders signal South-East Asia. The drawing is remarkable for its rich texture and representation of earth forms. There is a continuing undercurrent of such interests in Webber's work, from *A View of Christmas Harbour* (plate 2; 3.3) and *View in King George's Sound* (plate 99; 3.212) to this drawing, but only in this example is Webber's potential for drawing geological structures fully released. It is from it that we may anticipate the leading concerns and interests of his later work in Derbyshire and Wales.

The voyage proper as an enterprise of exploration came to an end at Macao. This is also reflected in King's account of the rest of the voyage, which covers only the barest of news. The engravings after Webber in the published account of the voyage go only as far as Kamchatka. Yet Webber continued his regular programme of work until the very end. When in October 1780 he delivered his drawings to the Admiralty, his album included a great number of subjects from the China Coast, Pulau Condore, Cracatoa (Krakatau) and the Cape of Good Hope.

Mention must also be made here of Webber's drawings of Chinese portraits and boats. His *Portrait of a Chinese* (plate 172; 3.380) is no longer merely a type but a character. It is probably Webber's only drawing which represents an elderly sitter. With an elegance of line and an economy of means, he creates a head, full of life and experience. The straw hat functions like a sunshade, which deepens the contrast of the face, while the rest of the body disappears into the glaring whiteness of the light.

Webber's drawings of Chinese junks and sampans likewise warrant close attention, for they represent an interesting variety of types. Webber later introduced some of them into his

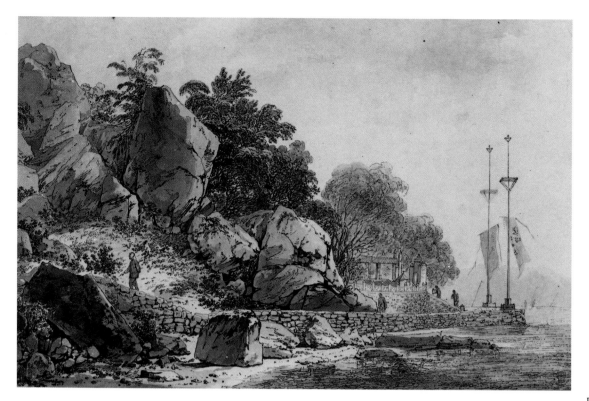

PLATE 169
John Webber, *Temple in the Inner Harbour of Macao*, December 1779-January 1780. British Library, London. (3.371)

PLATE 170
John Webber, *A View at Macao*, 1784. Admiralty House, London. (3.372)

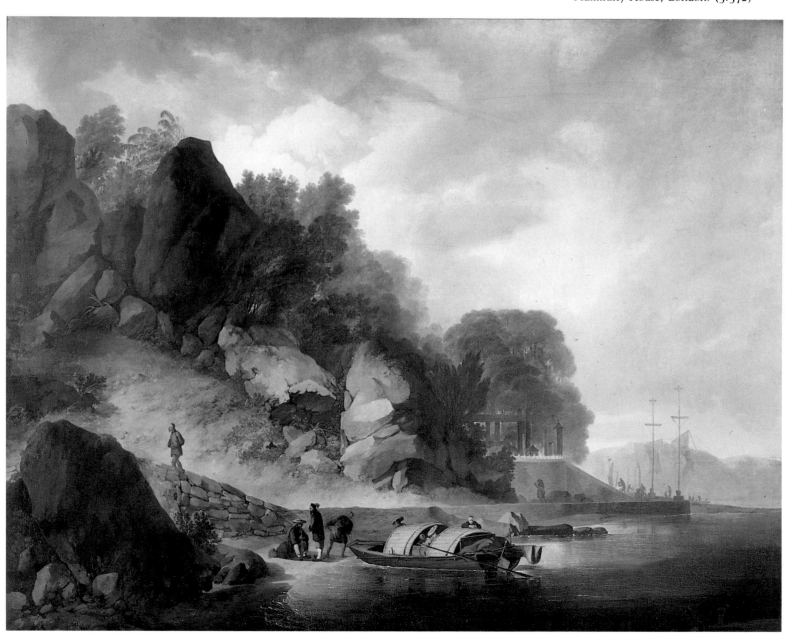

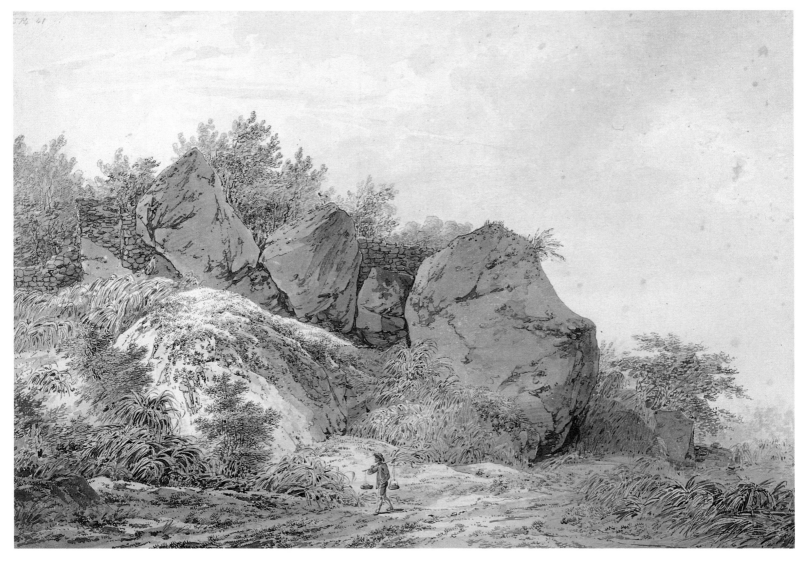

PLATE 171
John Webber, *A View near Macao*,
December 1779-January 1780. British
Library, London. (3.374)

paintings as elements of characteristic staffage. Otherwise however, his drawings of vessels never seem to have been used, and, in fact, being outside the general scope of Cook studies, hardly one has ever been reproduced. Their place in art history before the drawings of William Alexander and George Chinnery has not been fully established, and neither has their scholarly value for the history of Chinese vessels been noted. When G.R.G. Worcester spoke in 1947 about the history of junks as noticed by European travellers and voyagers, he also mentioned the short account of junks by Sir George Leonard Staunton, Secretary to Lord Macartney's Embassy to the Emperor of China in 1792. Regretting the general lack of interest in the subject, Worcester wrote:

> The only valuable record made on the journey in respect to Chinese craft is a set of eight engravings and a watercolour made by William Alexander, the official artist attached to the mission. They are probably the oldest Western drawings of any accuracy of Chinese junks now extant.[4]

How Worcester would have welcomed Webber's drawings, had he known of their existence.

[4] Worcester, (1947) 1, 27-8.

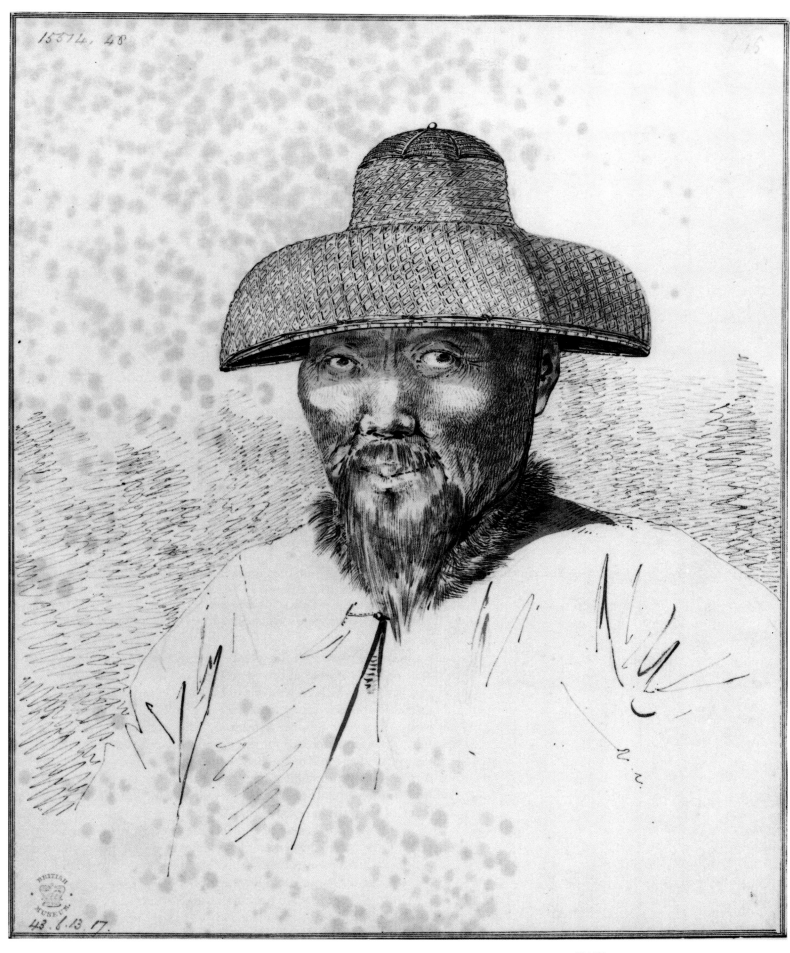

PLATE 172
John Webber, *Portrait of a Chinese*,
December 1779-January 1780. British
Library, London. (3.380)

143

# 33. Pulau Condore (Con Son), Vietnam: 20-28 January 1780

During the ships' stay at this small island outside the Mekong Delta which lasted for more than a week, Webber produced a substantial number of drawings of which ten are listed in his Catalogue for the Admiralty. Half of them are island views, the rest includes two portraits, two natural history drawings and a drawing of a boat. It is a respectable result when we consider his short time there, and it includes one of his most delightful drawings, A *View in the Island of Pulo Condore* (plate 173; 3.396). It can be connected with an excursion that Webber undertook in the company of King, who described the scene:

> We proceeded through a thick wood, up a steep hill, to the distance of a mile, when, after descending through a wood of the same extent, on the other side, we came out into a flat, open, sandy country, interspersed with cultivated spots of rice and tabacco, and groves of cabbage palm-trees, and cocoa-nut-trees. We here spied two huts, situated on the edge of the wood, to which we directed our course.[1]

In the hut they found an elderly man to whom they made signs of wishing to buy provisions:

> A few signs, particularly that most significant one of holding out a handful of dollars, and then pointing to a herd of buffaloes, and the fowls that were running about the huts in great numbers, left him without any doubts as to the real objects of our visit.[2]

In the ensuing conversation, a danger was pointed out to King and his men; in front of the hut a herd of wild buffaloes had gathered:

> The old man made us understand, that it would be exceedingly dangerous for us to move, till they [the buffaloes] were driven into the woods; but so enraged were the animals grown at the sight of us, that this was not effectd with out a good deal of time and difficulty. The men, not being able to accomplish it, we were surprized to see them call to their assistance a few little boys, who soon drove them out of sight. Afterwards, we had occasion to observe, that in driving these animals, and securing them, which is done by putting a rope through a hole which is made in their nostrils, little boys were always employed, who could stroke and handle them with impunity.[3]

Both quotes are relevant to plate 173. Represented is a spot which King had described as a flat countryside with two huts 'situated at the edge of the wood'.[4] Webber's later version of this scene (plate 174; 3.397Ad), which became one of his *Views in the South Seas*, adds some figures below the hut, some fowl and a young man leading a buffalo. The animal is driven as King had noticed: with a long rope through its nostrils. The scene was again observed a few days later, when eight buffaloes, purchased for the maintenance of the crew, were driven over the island to a landing place that could be reached by the ships. Owing to the stubbornness and fury of the animals, the operation lasted for five days. King comments on the buffaloes' furious behaviour and how they could only be handled by young boys. The situation therefore must have been quite different from the sweet idyll that Webber depicts. In his drawing there is no suggestion of danger, and the fact that three buffaloes are resting or standing quietly at the back suggests a prevailing harmony between man and animals; evoking the serene mood of a pastoral. There can be no doubt however that Webber's earlier drawing, executed on the spot (plate 173) is the more uncompromising and arresting one.

The two portraits which Webber listed in his Catalogue, 'Portrait of a Cochin Chinese' and 'A Ditto of a Woman' (plate 175; 3.399 and plate 176; 3.402) are rendered in red chalk. According to King the natives of this island looked 'weak and unhealthy', and were 'of a gentle disposition',[5] and his comments suitably describe the two depicted. The drawings differ from the majority of Webber's portraits which are usually in pen, pencil and wash. Only occasionally were Webber's portraits touched up by water-colour or highlighted by chalk. This is somewhat surprising in the light of Webber's familiarity with French art. Not only was he accustomed to the effects and advantages of crayon, he himself had used it in his Parisian years. Hodges's drawings from the second voyage were mostly rendered in red chalk. Chalk seemed more readily adaptable for expressing light and shadow, the softness of facial texture and the finer

[1] Cook/King, (1784) III, 451.

[2] ibid., 452.

[3] ibid., 452-3.

[4] ibid., 451.

[5] ibid., 463.

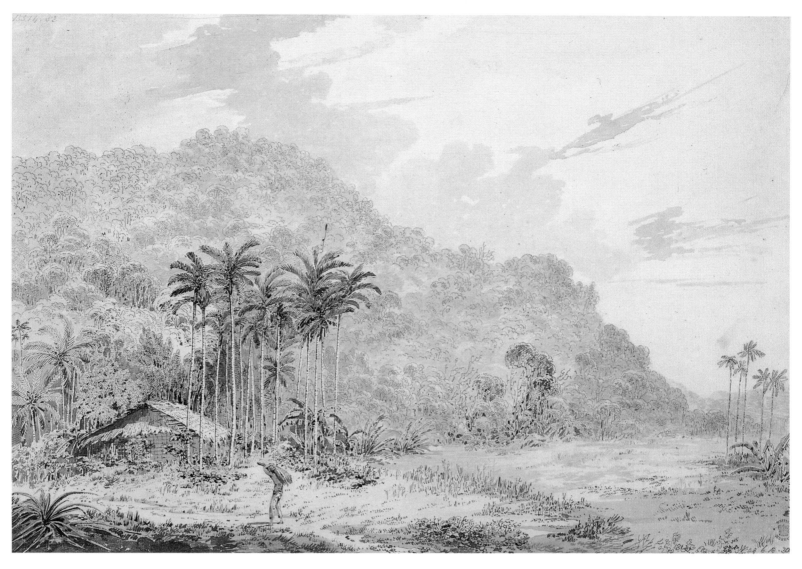

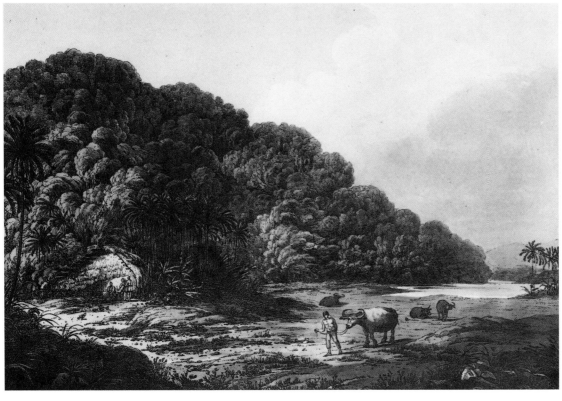

shades of complexion. In the case of the present portraits, chalk was particularly suitable for the smooth features of the subjects, but why Webber used it so sparingly in his other portraits is puzzling. It is possible, of course, that he may have purchased some chalk pastels in Macao.

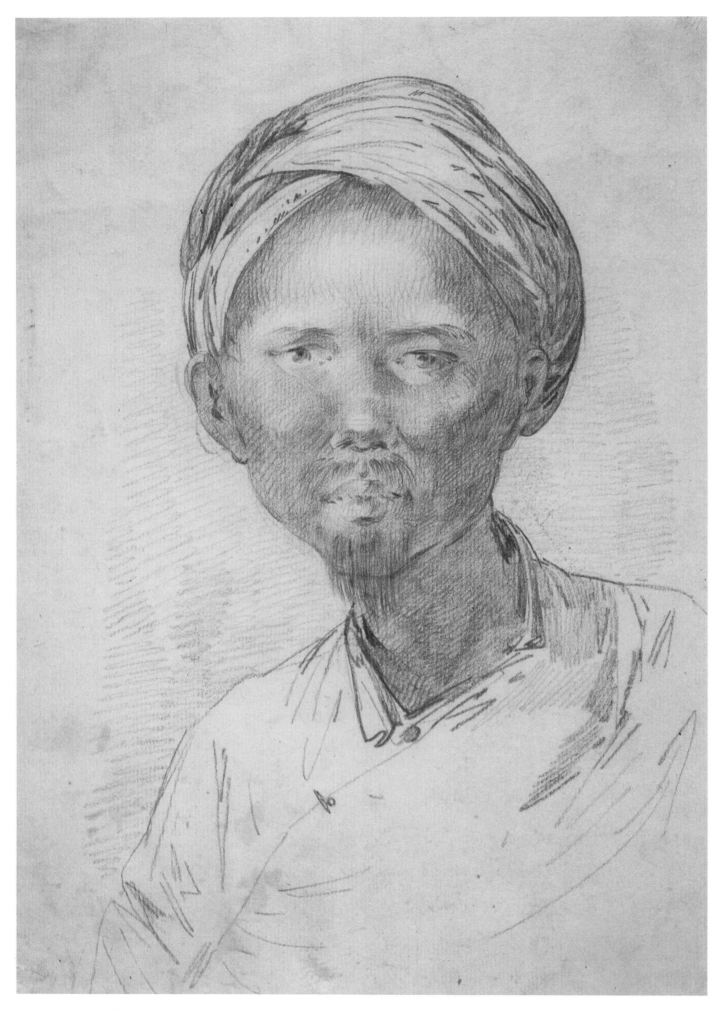

PLATE 175
John Webber, *A Man of Pulo Condore*,
January 1780. National Library of
Australia, Canberra. (3.399)

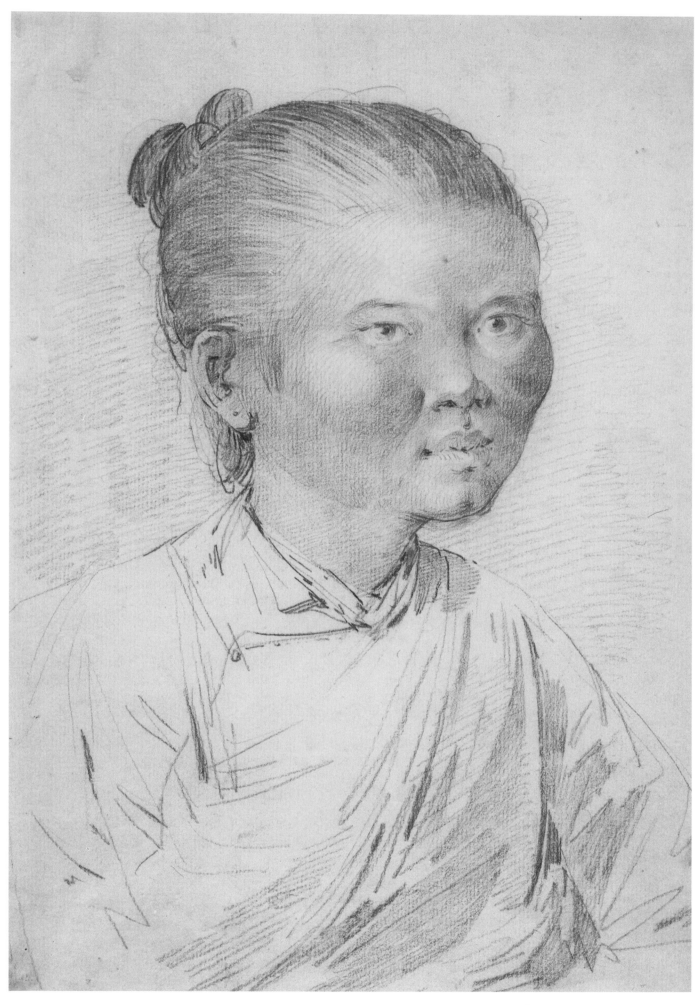

PLATE 176
John Webber, *A Woman of Pulo Condore*,
January 1780. National Library of
Australia, Canberra. (3.402)

147

# 34. Krakatau (Cracatoa), Sunda Straits: 9-14 February 1780

[1] ibid., 471-4.

[2] Gilbert in Cook, *Journals* III, 1, 714-15.

[3] Cook, *Journals* I, 427.

The exact duration of the ships' stay at Krakatau is difficult to determine. Both King[1] and Gilbert relate the ships' movements from the *Discovery*'s point of view.[2] After the sojourn on Pulau Condore, they proceeded along the south-eastern coast of Sumatra to the Strait of Sunda. The *Discovery* lagging behind, joined the *Resolution* at Krakatau on 10 February, and after a one-day stay King proceeded to Princes Island nearby. This was already known from Cook's first voyage.[3] The *Resolution* was sighted approaching Princes Island on 14 February.

Webber thus had four to five days at Krakatau — time enough to make the three drawings which he listed in his Catalogue (nos. 156-158). Among those is his *A View in the Island of Cracatoa* (plate 177; 3.408), which became a popular subject after the voyage and was included in his *Views of the South Seas*. The scene shows two natives among huts in a clearing, surrounded by thick, tropical forest. It was only during the last stage of the voyage that Webber developed a distinct feeling for plant life. Was this owing to the fact that most of the previous nine months had been spent in severely cold regions and that now near the equator the difference was only too striking? More than ever now Webber recorded the botanical production of the tropics, depicting many markedly different plants in the same view.

This new bent may be noted in *The Plantain Tree* (plate 178; 3.413) and *A Fan Palm* (plate 179; 3.415). Both drawings are remarkable for the density and plastic handling of the

PLATE 177
John Webber, *A View in the Island of Cracatoa (Krakatau)*, February 1780-. British Library, London. (3.408)

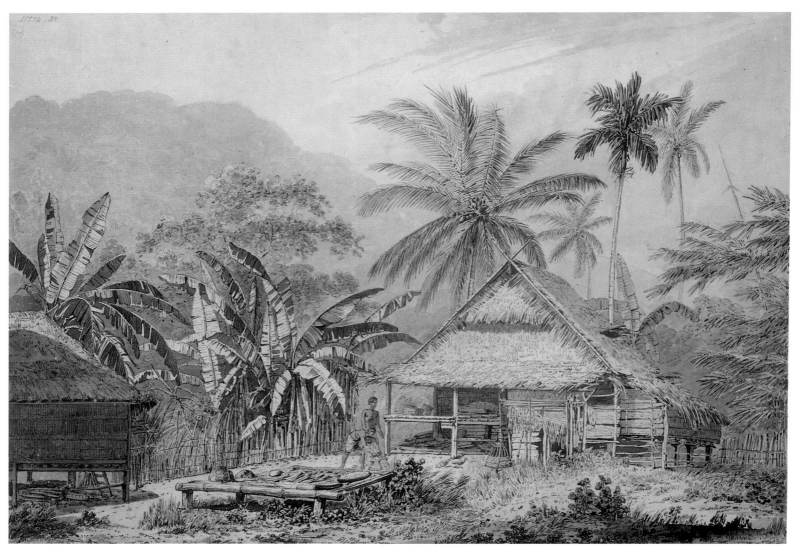

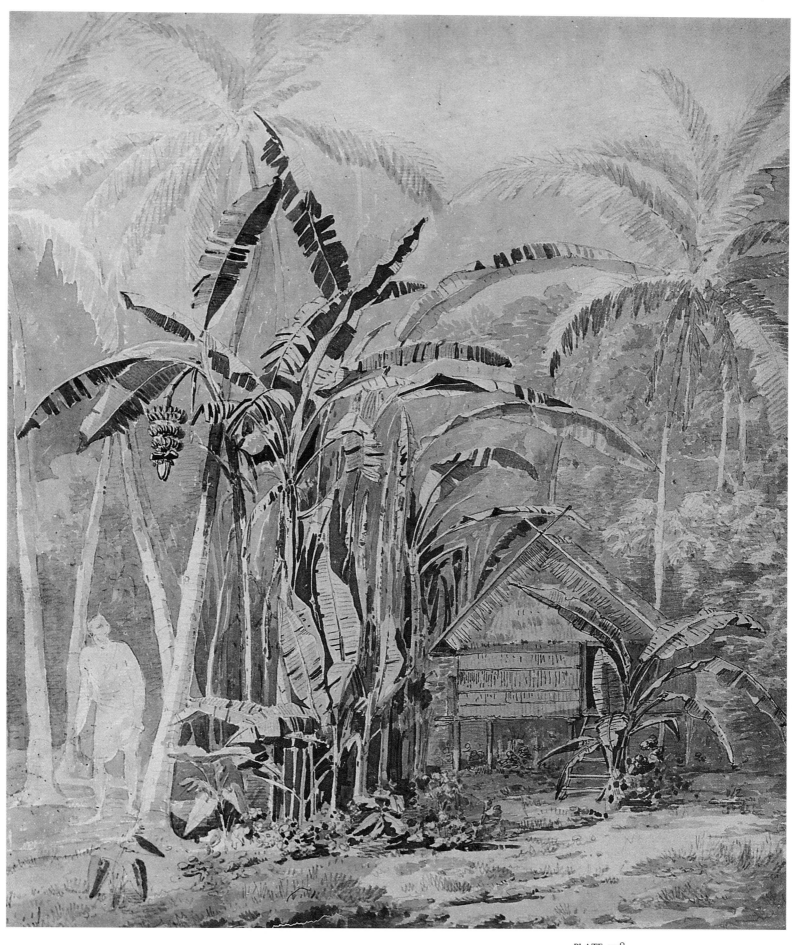

PLATE 178
John Webber, *The Plantain Tree*,
February 1780. National Library of
Australia, Canberra. (3.413)

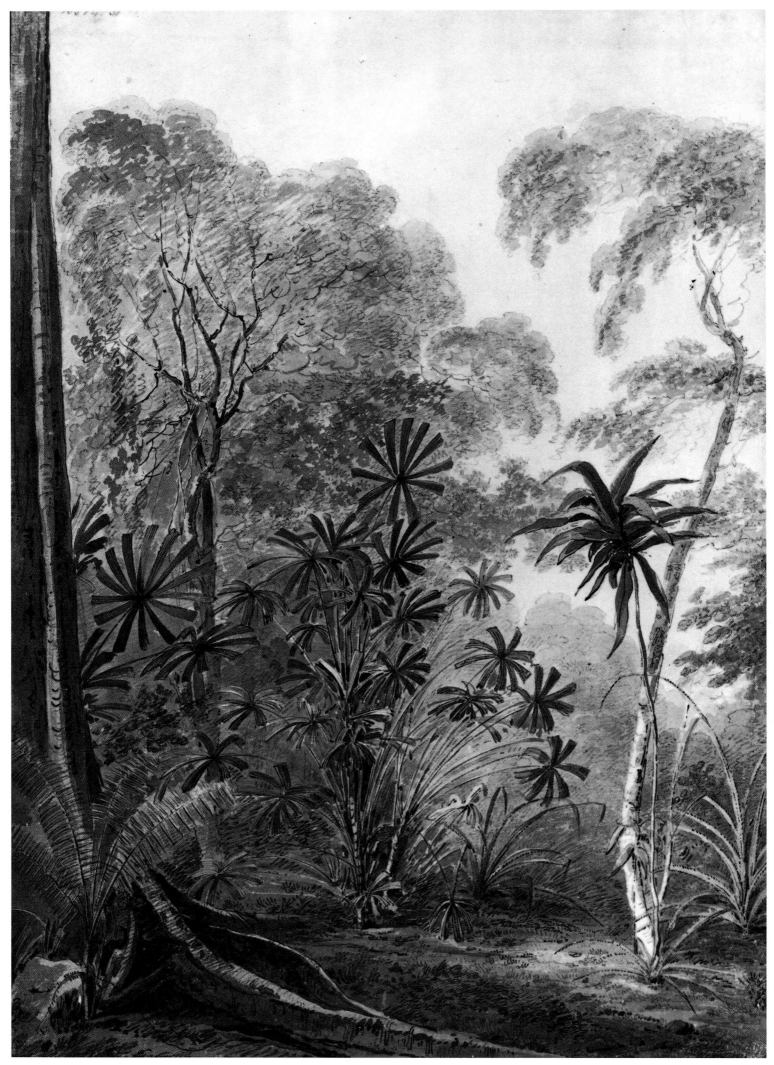

150

organic forms. These slices of exuberant nature differ from all of Webber's previous work. Particularly in *A Fan Palm* Webber heralds a new approach to landscape, in which no longer an extended view is unrolled and distance measured by natural components such as lakes, hills, rocks and mountains. In closing the background and renouncing open vistas, Webber presents us with a close-up of an impenetrable thickness of stems, leaves and branches. Entangled in this luxurious natural growth, the eye confronts little spatial recession, as had been the ruling convention. Proceeding from a new interest in the depiction of exotic plants Webber breaks away from the traditional forms of landscape, in which fore-, middle- and background must play their role. In fact in drawings like *A Fan Palm* the traditional components of the eighteenth-century idea of the picturesque have become obsolete.

Webber's approach in such drawings was distinctively novel, yet it could claim descent from all that earlier work in which empirical observation prevailed over ideal and classicizing modes of composing. Jan Lievens's drawing *Woods* (1645-60) (Institut Néerlandais, Paris) represents landscape from the 'inside' rather than the outside. Generally speaking, Lievens's way of seeing was of little importance during the eighteenth century, though it began to receive better recognition during the early nineteenth century. It was due in large part to the influence of Alexander von Humboldt that landscape attained a more scientific bent and artists were encouraged to understand the ecology of the landscapes they represented. While travelling in South America between 1800 and 1804 Humboldt came to the conclusion that the landscape artist should portray the different kinds of landscape characteristic of different climatic zones.[4] In his *Ideen zu einer Geographie der Pflanzen* (1807) and *Ideen zu einer Physiognomik der Gewächse* (1806) Humboldt developed the idea of specific botanical zones. Just as the northern hemisphere was characterized by large groups of similar species, so the tropical latitudes produced a great variety of comparable plant life. The landscape artists were called upon to provide the evidence for this in their capacities as both recorders and interpreters of the Humboldtian 'Naturcharakter'. In Humboldt's understanding of nature, and understanding for him included both the exploration and appreciation of nature, the aesthetic and the scientific experienced a new conjunction. Johann Moritz Rugendas, Eduard Hildebrandt, and Ferdinand Bellermann, to name but a few, worked in South America and became exponents of this Humboldtian approach to landscape painting. Scientifically minded, these artists also sought to encapsulate the personal experience of tropical scenery.[5]

In his two drawings of Krakatauan plant life, Webber may be seen as a forerunner of this nineteenth-century landscape development. And we may wonder whether, as in the case of Hodges, some of Webber's drawings helped to germinate Humboldt's ideas. This is not unlikely, for it was in the company of George Forster that Humboldt, prior to his travels in South America, visited London, in the spring of 1790. We know that Forster visited Webber and perused his drawings from the Pacific. In his own writings Forster promoted the idea of the great diversity of nature demonstrating paradoxically the unity of all living things. Webber would certainly have been just the kind of person that Forster might have introduced Humboldt to during their London visit. We have no evidence for it at all, but it is intriguing to think that at Webber's lodgings in 312 Oxford Street, Forster, Humboldt and Webber discussed a new role for landscape art in the service of geographical science.[6]

[4] On Humboldt's conception of landscape painting see Smith (1960), 151-7, 224-25 *et al*; Rojas-Mix, (1969) 97-130; also Löschner, (1982) 245-53.

[5] Parallel concerns by English and French artists of the first half of the nineteenth century can be seen in the works of John Skinner Prout and E.A. Goupil, see Smith (1960) pls. 145, 171.

[6] Cf. Joppien, (1976a) 15-16 *et al*. In the introduction to his *Ideen zu einer Geographie der Pflanzen* (Tübingen 1807), Humboldt remarks that the earliest design of a world geography of plants he had discussed with Georg Forster: 'Seit meiner frühesten Jugend hatte ich Ideen zu einem solchen Werk gesammelt. Den ersten Entwurf zu einer Pflanzen-Geographie legte ich meinem Freunde Georg Forster, dessen Name ich nie ohne das innigste Dankgefühl ausspreche, vor.'

PLATE 179
John Webber, *A Fan Palm*, February 1780. British Library, London. (3.415)

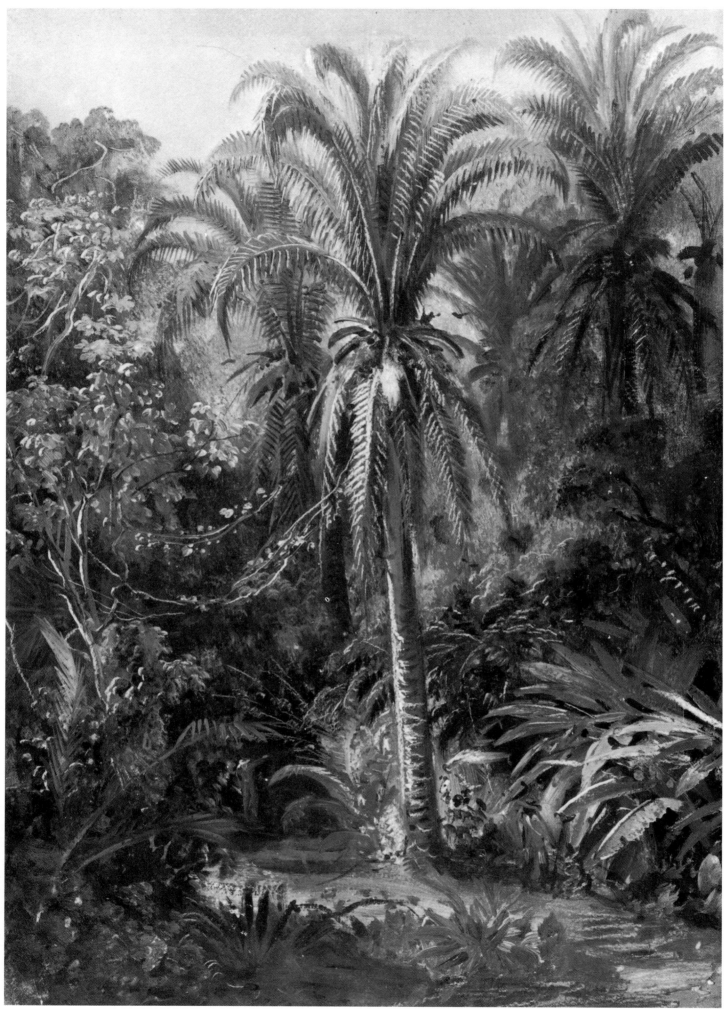

PLATE 180
Johann Moritz Rugendas, *Study of Palm Trees*, c. 1831-34, oil sketch, 15 × 10 ⁷⁄₁₆ :
380 × 265. Ibero-Amerikanisches Institut, Preussischer Kulturbesitz, West Berlin.

152

## 35. Princes Island (Panaitan), Sunda Straits: 15-16 February 1780

The *Resolution's* stay at Princes Island lasted only for a day and a half, while Captain Gore watered the *Discovery*. The one documented drawing Webber made at the time is his *A Deer of Princes Island* (plate 181; 3.442), which is mentioned in his Catalogue as no. 158. It captures the feeling of a nimble but defenceless animal surprised in its lair. To take the drawing out of the realm of the type specimen and compose the animal in close relationship with its habitat, here reveals Webber's 'modernity' in scientific draughtsmanship.

The inclusion of the drawing in Webber's Catalogue raises the question; why were botanical and zoological drawings added to the Admiralty album? For there we find two plant drawings and ten zoological drawings — five of birds, while drawings of fish, insects and crustaceans are missing. There was obviously no attempt to be comprehensive in the field of natural science. Webber rendered rather what he found interesting and he considered representative of the regions visited, just as he drew local people and their habitations. In this his *oeuvre* differs sharply from the work of Sydney Parkinson whose services under Banks were required for taxonomical purposes.

Webber would have realized that drawings submitted to the Admiralty in fulfilment of his commission would be no longer available to him for his own use. So that the inclusion of 'natural history' drawings was probably not his own initiative, nor would the Admiralty been likely to have sought such drawings. No doubt it was with the approval and perhaps with the advice of Cook and Anderson that he included such drawings, for both the list and the album were probably ready, or almost ready, on arrival back in England, and was probably being assembled with an eye to illustrations for the published account from an early stage of the voyage. But that Webber took a personal interest in drawing plant and animals seems clear since he continued to produce them after the deaths of both Cook and Anderson.

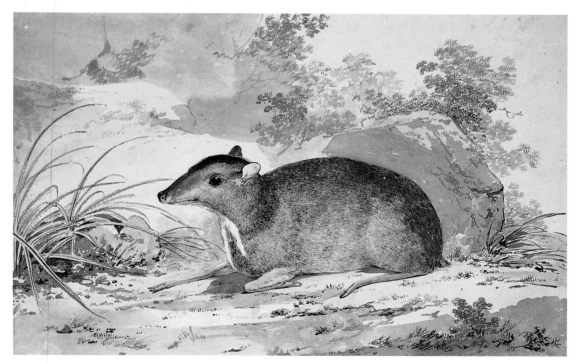

PLATE 181
John Webber, *A Deer of Princes Island (Sunda Strait)*, February 1780. National Library of Australia, Canberra. (3.442)

# 36. False Bay, Cape of Good Hope: 12 April-9 May 1780

[1] On Captain Gordon, see Cook/King, (1784) III, 484 and more specifically Paterson (1789): 'Captain Gordon (now Colonel) . . . had travelled in the country [South Africa] some years before (about 1774) and has lately returned from Holland as second in command, and appointed to succeed Colonel Du Phren, who was then commander in chief. Colonel Gordon is a gentleman of extensive information in most branches of natural history; and I believe, is the only person who has any considerable knowledge of that country, being acquainted with the interior parts for near one thousand five hundred miles from the Cape. He had acquired the language of the Hottentots which together with the perfect acquaintance with the Dutch language, gave him an advantage over most other travellers' (p.4).

Webber's interest in animals continued to occupy him at the Cape of Good Hope. His *A Gnu of the Cape of Good Hope* (plate 182; 3.443) was drawn in the menagerie at the Cape. He also made drawings of a giraffe and a hippopotamus that, according to his own inscriptions, were copied from drawings by Captain Gordon of the Cape (3.444; 3.445). Gordon was Commander of the Dutch forces at Cape Town and a connoisseur in South African geography and natural history. King had befriended him on the outward journey and probably hoped to see him again. But when the ships arrived Gordon had gone into the interior of South Africa. Fortunately he returned before the ships left. It is possible that the drawings Webber copied had been drawn by Gordon during his recent journey for a scientific purpose. According to King, Gordon was a collector of natural curiosities and had sent many items from his collection to the Museum of the Prince of Orange.[1]

PLATE 182
John Webber, *A Gnu of the Cape of Good Hope*, April-May 1780. British Library, London. (3.443)

Was Gordon also responsible for drawing Webber's attention to a woman and child of the Inequi Hottentots (plate 183; 3.421)? The drawing is surprisingly spirited, presenting the subject with vitality and not without dignity. Not only does it depict a mother and child group — otherwise rare with Webber — it is also a full-length study. If we compare this drawing with Webber's *Woman of New Holland* (plate 15; 3.13) executed four years earlier, the difference is striking. It clearly demonstrates his increasing skill in portraying non-European people as individuals. The figure of the woman is drawn in the lightest of pencil lines, the light and sensitive tonal massing of the cloak drapery, the cloth about her buttocks, and the cap are skilfully handled in light wash. Though but a quick impression it is no less convincing and shows no lack of ethnographical interest. Webber's facility in drawing had obviously improved greatly during the voyage.

The same progress is revealed in his landscapes. A *View of the North Part of False Bay — Cape of Good Hope* (plate 184; 3.420a; 3.420b), in two sections, is a splendidly broad and spacious panorama. The treatment of the hilly background under a veil of haze is quite

PLATE 183
John Webber, *Hottentot Woman*, April-May 1780. British Library, London. (3.421)

154

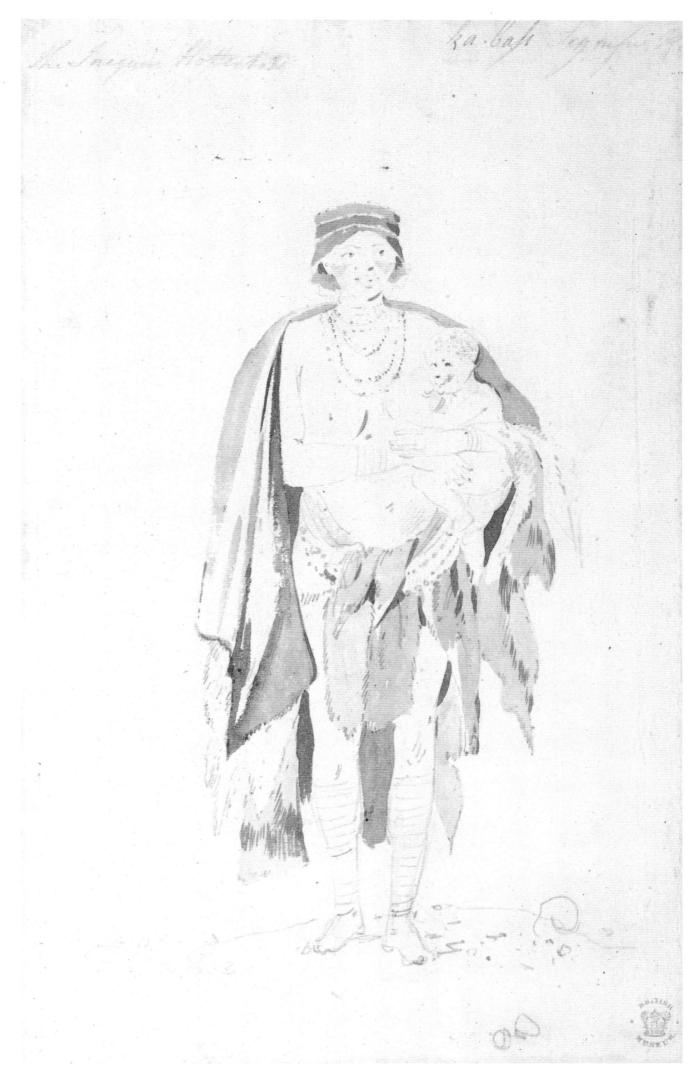

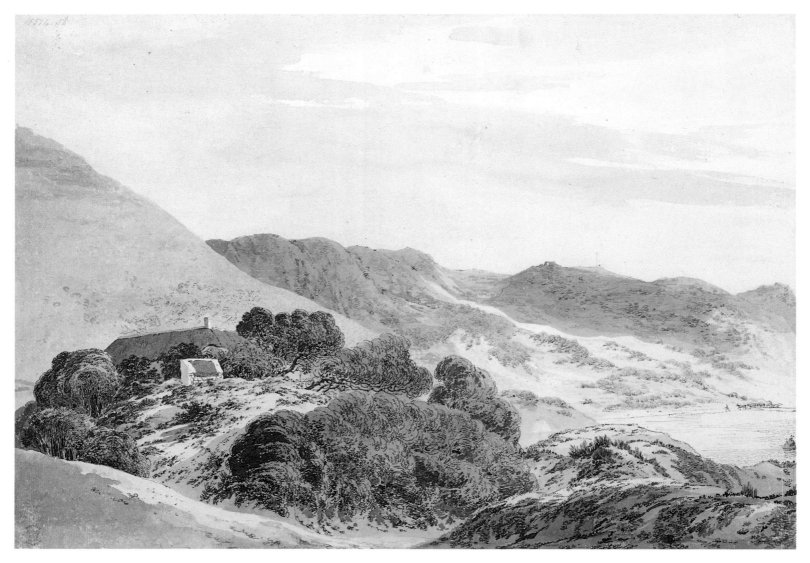

PLATE 184
John Webber, *A View of the North Part of False Bay — Cape of Good Hope*, April-May 1780. British Library, London. (3.420 a,b)

masterly, and the balance between land-forms and the sea is handled with assurance. When Webber returned to England in the autumn of 1780 he had not completed his twenty-ninth year. During his four years away he had developed into a most skilful, faithful and attentive artist. The voyage, for him, had been a school for seeing.

156

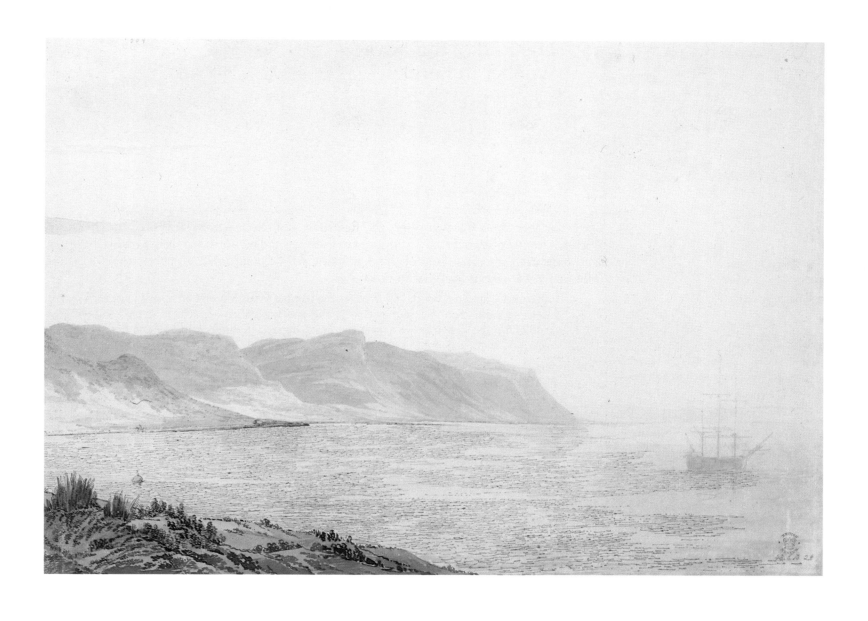

# 37. The End of the Voyage: Webber in London

On 6 October 1780 the two ships, the *Resolution* and the *Discovery* anchored in The Nore. Within a few days Webber was introduced to the King and permitted to show him his drawings. Lord Sandwich, the First Lord of the Admiralty, who accompanied Webber on the occasion, informed Banks about the visit to the King.

> I attended Captain King & Mr. Webber the painter to his Majesty on Sunday last at Windsor, where we went thro' an examination of the drawings, charts & which seemed to give great satisfaction; the drawings are very numerous being 200 in number and I think are exceedingly curious & well executed.[1]

The drawings which Sandwich speaks of were of course not the total number that Webber produced during the voyage, but presumably a portion of those more or less finished and which could serve to illustrate the voyage. What Webber showed the King might well have been that same selection of drawings, water-colours and paintings which he delivered to the Admiralty as his official fulfilment of his contract. This collection Webber probably assembled on the homeward voyage, and listed in his 'Catalogue of Drawings and Portraits in Oyl by Mr. Webber' now preserved in the National Library of Australia, Canberra. The Catalogue lists 172 drawings of two different sizes, located either in a portfolio or a roll, and also 20 portraits in oil.[2] Webber refers to all the places and islands visited, and groups his works according to their geographical location. In his selection he strikes a balance between various topics of interest, places and landscapes, people, their habitations. Also included are a few drawings of birds, two of plants, and a couple of drawings of artefacts. Webber, it seems, had fulfilled, even exceeded the expectations placed on him. His drawings were excellent material that promised to enliven the published account of the voyage. His conduct during the voyage had been impeccable. Cook had often spoken warmly of him and lauded his enthusiasm. On top of his accumulated salary,[3] which amounted to £420 for four years, the Admiralty granted him an additional compensation. As Beaglehole pointed out, Webber was involved in a 'little swindle on the Admiralty, less pardonable'.[4]

> Webber was on 4 August 1778 discharged from the list of Supernumeries for Victuals Only, and entered the following day as an A.B. He certainly did not do an A.B.'s duty, although he could thus collect the pay in addition to his own proper emolument.[5]

Documents of payment in the Admiralty records amounting to £187.8.0 seem to attest to the extra pay.[6]

---

[1] Sandwich to Banks, 10 October 1780. Dixson Library, Ms. Q. 158. f. 139-40, also mentioned in Dawson (1958) 617.

[2] Joppien, (1978) 49-77.

[3] According to the Admiralty accounts Webber received £105 on signing his contract for the voyage, on 24 June 1776: 'To Mr. Webber Painter (engaged to proceed on Capt. Cook's intended Voyage during which he is to be employd in drawing, painting & such objects as may be thought deserving that notice) on account of his said Engagement.' (PRO Adm. 17/7 for 1776.) Webber was paid his four years salary on 14 November 1780: 'To the same Mr. Webber four years Salary (which . . . was promis'd should be paid him, viz. on account from 24 June 1776 to 24 June 1780 420/o/o.' (PRO Adm. 17/7 for 1780.) The difference between June and October 1780 is covered by another £26.5.0 paid to Webber on 7 February 1781: 'To Mr. Webber his allowance for the quarters ending Michaelmas last (when he is to commence new terms) for Painting & of subjects which arose in the late Voyage to the South Seas'. (PRO Adm. 17/7 for 1781.) Thus Webber's total salary seems to have amounted to £551.5.0. Of quite a different category was the Admiralty's payment of a bill for travel equipment which Webber had sent in on 19 July 1776 and which amounted to £52.10.0.

[4] Beaglehole in Cook, *Journals* III, 2, 1459.

[5] ibid.

[6] Payment made to Webber on 14 November 1780: 'To Mr. John Webber the Painter who was sent in the resolution which saild on discoveries to the S°. Seas & to make Drawings & Paintings of Places & Productions in the Countries she might touch at in full for his mess account in the years 1777, 1778, 1779 & 1780 which by letter to him from the Secretary dated the 24 June 1776 the Lords promisd should be repaid him 187/8/o.' (PRO Adm. 17/7 for 1780.)

When the Admiralty began to prepare for the publication of the journals and illustrate them with Webber's drawings, Webber was contracted to deal with the illustrations and supervise the execution of the engravings for an annual salary of £250.[7] This was equal to the amount that Hodges had received.[8] In a letter to his cousin Daniel Funk, Webber says:

> Lord Sandwich honours me with his favour and I am now busy doing the drawings for the copper engravings, of which 63 shall be issued together with the account. These I believe can not be done in less than a year and a half.[9]

As it turned out, producing the drawings for the engravings took two and a half years. This also included redrawing the coastal views, which were probably not considered to be works of art, for in most cases Webber's name is lacking from the plates. Though they do not concern us directly here, suffice to say that Webber seems to have redrawn, or at least finished, several of them.[10]

For the next three and a half years Webber was occupied on the publication of the official account.

---

[7] Webber's new contract with the Admiralty began in October 1780 and ended on 1 July 1785, when last payment of £62.10.0 was made to him. A first pay is recorded on 28 June 1781: 'To Mr. Webber three quarters Salary at the rate of 250 £ a year to be continued while he may be employd to compleat the Paintings & of Views taken in the course of the late Voyage of Discoveries in the South Seas 187/10/0.' (PRO Adm. 17/7 for 1781.) Under the same date Webber is paid £22.4.6 for 'his disbursements relative to Drawings & Paintings to be used in the History of the laste South Sea Voyages'. Like Hodges, Webber continues to remain on the Admiralty's pay list after the completion of the official account and like Hodges he is officially engaged in doing paintings with subjects from the voyage. On 30 June 1785, one day prior to his last payment, the account book records: 'To Mr. John Webber for Frames for the Pictures painted by him by Order of the Board of Admiralty 61/16/-.' (PRO Adm. 17/7 for 1785.)

[8] William Hodges was on the Admiralty's paylist until the end of 1778. First mention of his extended contract with the Admiralty for doing further illustrative work of South Sea subject matter is made in the Admiralty's account books on 2 April 1776: 'To Mr. Hodges to him Lady day last in consequence of the agreement enter'd into with the Lords commencing 1 Sept. 1775 at 250 £ a year till the several Paintings & from drawings taken by him on Capt. Cook's late Voyage are complead 144/17/3.' (PRO Adm. 17/7 for 1776.) Last payment to Hodges is recorded on 29 September 1778. Since the official account of Cook's second voyage had already been published in 1776 the extra years of payment to Hodges must be regarded as a salary for the paintings which are still in the Admiralty's collection.

[9] Wagner (1821), 9. For the original letter see appendix 1.

[10] Webber's activity in this field is indicated by Alexander Dalrymple in two letters to Banks. On 12 December 1783 he wrote: 'I return the two charts of the Sandwich Islands which I took to get the Views reduced for Webber; the reductions are with them Pray let him know that they are done that he may have them to finish.' On 13 December: 'I send you the Plates of Kerguelen's Land & Port Paliser, also the Views N 1 to 10 of America — with the Reductions for Webber', and on 15 December: 'I send you the Views of Sulphur Island and Japan with their Reductions for Webber I also send the Chart of Kerguelen's Land with the Reduction of the Views on it, the Reduction of the other views of Kerguelen's Land are not finished.' NLA, Ms 9/55, 9/56, 9/57.

# THE PUBLICATION OF THE VOYAGE WITH SPECIAL REFERENCE TO THE ENGRAVINGS[1]

In his letter to Sir Joseph Banks, of 10 October 1780, the Earl of Sandwich, first Lord of the Admiralty referred to the drawings which Webber had shown to the King:

> before any measures are taken about them, I wish to consult you how to preserve those that are not published, & to select those that are meant for publication. I allso wish to have your opinion about the Journals which are now in my possession, which I think should be made publick with as little delay as the nature of the business will alow.[2]

This is the first reference to the Admiralty's wish to publish the results of Cook's third voyage. Since Sandwich's second appointment as First Lord of the Admiralty in 1771, the accounts of both the first and second voyage had been published. Now the many geographical discoveries made on the third voyage, as well as the tragic death of the commander, made publication a matter of the highest priority. There were three major decisions to be made: who would be in charge of the organization, who would pay for it, and how would the profits of the publication be distributed. So Sandwich added:

> I had so much trouble about the publication of the two last voyages, that I am cautious or rather unwilling to take upon me to decide in what manner & for whose emolument, the work shall be undertaken; your advice will be of great use to me in the conduct of this matter.[3]

Clearly a publication of this kind leaned heavily on Banks's publishing expertise, and his enthusiasm and energy as an organizing force. It was predictable therefore that Sandwich should communicate with Banks. Banks however, had not as yet seen the journals, charts and drawings and was not likely to see them for two or three weeks. During the late summer and autumn Banks normally stayed at his country house, Revesby Abbey in Lincolnshire. As a result many letters were exchanged over the next three years concerning the progress of the publication. These, together with minutes of meetings held, accounts and other surviving material from Banks's extensive correspondence now scattered among many libraries, add to our knowledge of the various stages of publication. After great effort on all sides and numerous delays, the three volumes of the official account of the voyage, together with the atlas of plates, were issued in early June 1784 under the title:

> A Voyage to the Pacific Ocean. undertaken, by the Command of His Majesty, for making Discoveries in the Northern Hemisphere, to determine The Position and Extent of the West Side of North America; its Distance from Asia; and the Practicability of a Northern Passage to Europe. performed under the direction of Captains Cook, Clerke and Gore, in His Majesty's Ships the *Resolution* and *Discovery*. In the Years 1776, 1777, 1778, 1779 and 1780 . . . Illustrated with Maps and Charts, from the Original Drawings made by Lieut. Henry Roberts, under the Direction of Captain Cook; and with a great Variety of Portraits of Persons, Views of Places, and Historical Representations of Remarkable Incidents, drawn by Mr. Webber during the Voyage, and engraved by the most eminent Artists. Published by Order of the Lords Commissioners of the Admiralty. London, printed by W. & A. Strahan: For G. Nicol, Bookseller to His Majesty, in the Strand; and T. Cadell, in the Strand, MDCCLXXXIV.

After the need for the publication had been agreed upon, a committee was established by Lord Sandwich in late 1780 or early 1781 to decide, on the basis of Webber's drawings, which illustrations should go into the published account. This committee consisted of Lord Sandwich, Sir Joseph Banks, Philip Stephens, the secretary to the Admiralty, Dr John Douglas, the editor, Captain James King, co-author to the late Captain Cook, Alexander Dalrymple the hydrographer, James Stuart for the publishers Strahan and Cadell, and John Webber as the draughtsman and supervisor of the engravings.

Lord Sandwich represented the Admiralty's interest in the publication. Even after 30 March 1782, when Lord Keppel took over as First Lord, and was in turn succeeded by Lord Howe in January 1783, Sandwich remained as the prime negotiator between Sir Joseph Banks, Douglas, King, the engravers and Webber on one hand and the Admiralty and its secretary Stephens on the other. Sandwich had already successfully superintended the previous pub-

[1] The history of the publication of Cook's third voyage was mentioned only in passing by Beaglehole in *Journals* III, 1, cciii-cciv. Douglas Cole wrote a short but well informed article dealing with aspects of the publication 'Cook at Nootka — the Engraved Record' in *Canadian Antiques Collector*, XI, 3 (May/June, 1976) 27-9. The most complete record is provided by Helen Wallis in 'Publication of Cook's Journals: Some New Sources and Assessments', in *Pacific Studies*, 1, 2 (Spring, 1978) 163-94 (on the third voyage, 177-92). Dr Wallis uses the Douglas Letters (British Library, Egerton MS 2180) but does not concern herself with the development of the plates. Since this chapter was first drafted the 'papers of the fourth Earl of Sandwich relating to his patronage of Captain Cook' were auctioned at Sotheby's, London, 22 July-23 July 1985, particularly lot no. 544 deriving from the Sandwich Family archive at Mapperton. They were purchased by John Maggs, London, on behalf of the National Library of Australia. They have since been catalogued by the library as MS 7218/...

[2] Sandwich to Banks, 10 October 1780, Dixson Library, MS Q. 158, f. 271-2.

[3] ibid.

[4] Concerning John Douglas, who later became Bishop of Salisbury from 1791-1807, see DNB, xv, 337 and John Ingamells, *The English Episcopal Portrait 1559-1835. A Catalogue*. Published privately by the Paul Mellon Centre for Studies in British Art, (London, 1981) 174.

[5] The correspondence of Canon John Douglas in the British Library, Department of Mss, Egerton MS 2180 contains several letters relating to the publication of Cook's second and third voyage.

[6] Douglas received Captain Cook's journals, log books and loose manuscripts on 14 November 1780, see British Library, Department of Mss, Egerton MS 2180 f. 19-20. One of his main problems was the lack of charts, which at that time had not yet been prepared. Douglas was critical of this, as is shown in an undated letter to Reverend Dr Shepherd, pointing to the fact that for the edition of the second voyage all charts had been delivered with the manuscript. NLA, MS 7218/10.

[7] On Dalrymple see Howard T. Frye, *Alexander Dalrymple* (London, 1970) though little concern is given there to Dalrymple's part in the edition of Cook's third voyage.

[8] Bligh was severely critical of Roberts's achievement, see Rupert T. Gould, 'Bligh's Notes on Cook's last Voyage', in *The Mariner's Mirror*, XIV, 4 (October, 1928) 371-85.

[9] Apparently this plate was also published individually; it is referred to in P.A. Penfold, *Maps and Plans in the Public Record Office*, 2. *America and West Indies* (London, 1974) no. 79, 18 as: 'Chart of the N.W. Coast of America and the N.E. Coast of Asia, Explored in the years 1778 and 1779. Prepared by Lieut. Henry Roberts under the immediate Inspection of Capt. Cook. London, Published by Wm. Faden, Geographer to the King, Charing Cross, July 24, 1784. Engraved by W. Palmer, no. 128, Chancery Lane'.

[10] T. Harmar and W. Palmer are mentioned in an unpublished manuscript by Paul Ballard, Kaleen, ACT, Australia 2617. A copy of this paper was kindly made available by Commander Andrew David, of Taunton, Somerset.

[11] The National Library of Australia, Department of Mss, MS 9/28 possesses a list of those London engravers who were considered for participation in the official account. Not all of them however, were eventually employed.

lications of Cook's voyages and had in both cases co-operated with Banks. Banks was the intellectual power behind the publication and Sandwich's letter to him of 10 October 1780 pays due tribute to that role, for Banks was president of the Royal Society, a scholar with personal South Seas experience and possessed an unsurpassed library of travel literature and original documents. He was a collector, if not a connoisseur of drawings, had patronized travelling artists himself, and was well versed in problems of engraving, printing and the problems attached to publication. Banks, in short, was indispensable, and it is unlikely that any of Cook's voyages would have been published in the way they were had it not been for Banks's enormous and unselfish professionalism.

The editor chosen was Dr John Douglas, canon of St Paul's since 1776 and fellow of the Royal Society since 1778.[4] He had already edited the journal of Cook's second voyage.[5] In this case his task was not made easier by the fact that Cook was dead and the transactions for the rest of the voyage had to be gleaned from the journals of other participants. It was Captain King who provided the basic text from the second departure from Hawaii onwards. This amounted to one-third of the total text. But Douglas turned to the other journals as well, particularly that of William Anderson, the deceased surgeon of the *Resolution*, whose linguistic interests were invaluable and who had provided detailed observations of Pacific peoples and natural science. Though Douglas was not sufficiently acknowledged as editor — a fact which caused some grievance on his part — he must be credited for several years of hard work, in which he not only had to combine the various texts into one but also to check on nautical, geographical and ethnographical data. Place names were a special problem.[6]

Alexander Dalrymple, with Banks's agreement, superintended the engraving of the charts and coastal views.[7] After his appointment as hydrographer to the East India Company in 1779 Dalrymple continued to work as a private map publisher, selling his work to the Admiralty. The charts of the voyage were produced after survey drawings by William Bligh, James King and Henry Roberts.[8] Roberts had a special task in the final preparation of the charts, but his main responsibility was the preparation of the general map, a mercator projection of the world map as known after Cook's discoveries; with the tracks of Cook's three voyages marked in. It was executed under the direction of the Admiralty. Its engraving was rendered by William Palmer. This capable map engraver also completed the important 'Chart of the NW Coast of America and the NE Coast of Asia, explored in the years 1778 & 1779'.[9] The titling beneath was entrusted to Thomas Harmar.[10] Both engravers were considered specialists and often worked with Dalrymple.

Responsibility for the illustrations was passed from Banks to John Webber as 'art director'. From the drawings done on the voyage he had to draw versions of smaller size for the use of the engravers. These were mainly figurative illustrations but there were also a number of coastal views. Twenty-five engravers were employed, among them such renowned masters as Francesco Bartolozzi, William Byrne, William Sharp, John Sherwin and William Woollett.[11] In addition Webber was to supervise the engraving and printing. In this he acted as mediator between Banks and Sandwich on the one hand and the engravers on the other.

The printing of the plates, an important factor for the quality of the work, was given to the firms of Hadrill, Haines, Coxe, Hixon and Cook.[12] No luxury was spared, and each plate was to be printed 'on a half Sheet all of the same size'.[13] This expense was in Banks's words, to 'contribute much to the ornament of the work and as our plates are far better engravd than any preceeding ones . . . the publick have a right to that indulgence'.[14]

The list is of particular interest as in several cases it quotes the addresses of the engravers (cf. Appendix 2). The engravers finally involved in the publication were: W. Angus, F. Bartolozzi, J. Basire, P. Benezech, W. Byrne, J. Caldwall, T. Cook, Delattre, W. Ellis, C. Grignion, J. Hall, J. Heath, D. Lerpinière, P. Mazell, S. Middiman, Newton, B. T. B. Pouncey, J. Record, E. Scott, W. Sharp, J. K. Sherwin, S. Smith, J. Taylor, Woodyer, W. Woollett. (See appendix 3.) Several of these had already worked on the edition of Cook's second voyage, such as Bartolozzi, Byrne, Caldwall, Hall, Lerpinière, Pouncey, Sherwin, Smith and Woollett. Bartolozzi, Byrne, Hall and Woollett had also contributed to the engravings of Cook's first voyage.

[12] The copperplate printers mentioned are Thomas Cook, Philip Hadrill, John Haines, Henry Hixon (see Ian Maxted, *The London Book Trades, 1775-1800. A preliminary checklist* (Folkestone, 1977) 50, 98, 111). The printer Cox cannot be identified, for Maxted mentions about six printers under that name (54).

[13] Banks to the Parisian bookseller Ch. J. Panckoucke, 7 February 1783, NLA MS 9/16.

[14] ibid.

The quality of the plates of the second voyage was considered to have been inadequate. So after Cook's death a special effort was made to ensure a publication which was exceptional both in content and in form. For the paper of the plates 130 reams of Colombier size (about 34½ × 24 inch) of highest quality were procured through the services of the Parisian bookseller Ch. J. Panckoucke.[15] For the sheets of the three quarto volumes of text ordinary paper was used obtained from the firms of Bowles and Chapman. For the charts Woodmason provided the paper, and for the special paper of the general chart the services of J. Whatman were employed.[16] Printing lay in the hands of Mr William Strahan who had already been engaged for publishing the second voyage, though his performance had not been considered successful.[17]

The last person to be called upon was George Nicol, the King's bookseller, who came in as publisher and in this function advanced the money for the printing. The publishing had originally been promised to Thomas Cadell, and an advertising leaflet for the publication had apparently been printed.[18] Nicol's name was suggested by Banks to Sandwich in September 1782 on the ground that not only the King would be pleased about that appointment but also that Mr Nicol would prove 'a much better tool in my hands'.[19] However, Nicol's employment was delayed. Four months later Banks had to write to Stephens asking for a speedy decision in Nicol's favour.[20]

When Nicol was finally put in charge of the production he took over a great many duties from Banks. As Douglas Cole has aptly put it 'he had to use both his own sharp tongue and the full weight of Banks' authority to chastize tardy engravers, sloppy printers and a dilatory Webber'.[21] Particularly at the end of the production when at first 18 May 1784, the opening day of Parliament, then 4 June, the King's birthday, was planned as an appropriate day for publication Nicol functioned as 'whip', demanding overtime and the fulfilment of contracts.

After the committee for publication was set up in the winter of 1780/81, sixty-one illustrations were selected with regard to both visual and historical interest. A list among the Banks papers in the National Library of Australia entitled 'A list of the Drawings & Charts to be engraved, with the order in which the plates should be number'd agreable to the Narrative'[22] bears testimony to this early selection. It was followed without any major changes.[23] To Douglas the editor, concordance between the text and the engravings was a matter of consequence. Another list, also kept in the National Library of Australia, with the title 'Pages of Capt. Cook's Journal — Date — Drawings omitted in the list selected for Publication but referred to by Capt. Cook',[24] reflects the care with which the edition was being prepared.

The final decision concerning the drawings was that Webber should prepare reduced drawings from his originals for the engravers. This included both human and landscape drawings as well as coastal views.[25] He estimated a year and a half for the work,[26] but this turned out to be much too optimistic. Among the first engravers to receive a drawing from Webber was Francesco Bartolozzi. Webber's *Girl of Tahiti bringing a Present* (3.107) was delivered to him in April 1781 and was not returned until March 1784.[27]

It appears that each engraver received one drawing at a time, the dates of handing out and returning them being carefully noted. They were handed out by Banks.[28] This careful procedure could have no other reason than to ensure secrecy about the publication. No text parts nor plates were to be published or to be made known before the appearance of the whole work. Apparently the engravers were also asked not to withhold any of the proof states of their plates.[29] Normally the execution of an engraving varied between one and eight months,

15 The manufacturer of the paper seems to have been a Mr Prudhomme, whose name is mentioned in the Banks letter to Panckoucke of 28 March 1783: 'I am well contented to pay the extraordinary Price proposd by M[r]. Prudhomme on his own conditions, being convincd that it will in the end turn out to my advantage.' NLA, MS 9/16.

16 Nicol to Banks, undated, early 1784: 'paper for the large Chart — which being of a peculiar size must be made on purpose — Mr. Whatman has undertaken . . . to make it by the end of next month . . .' British Library, Add. MS 33977 f. 282.

17 Banks to Sandwich, 14 September 1782: '. . . the business of printing was in the last case put by Strahan into the hands of Boydell who chargd shamefully for the paper, took an exhorbitant profit on the prices agreed for the work of printing and at last producd the plates miserably printd as everyone who has a copy can testify . . . I long ago wishd that Strahan might not have the control over this which he had over the last, it was ultimately owing to his influence that many evils befell us the chief [being] the ill printing of the plates.' NLA, MS 7218/14.

18 A copy of this advertisement has not yet come to light. Its existence is attested in early 1782, when Philip Stephens, the Admiralty's secretary wrote to Banks, on 30 January 1782: 'Roberts has been with me & is much hurt that his name as well as Webber's is not mentioned in the intended advertisement . . . Lord Sandwich does not see any objection to its being added immediately before Mr. Webber but no time should be lost, as Cadell wants to send it to the Press tonight. Be so good as to do what may be proper to set this matter right.' British Library, Department of Mss, Add. MS 33977, f. 139-139v.

19 Banks to Sandwich, 16 September 1782. NLA, MS 7218/15.

20 Banks to Stephens, 27 January 1783 NLA, MS 9/16.

21 Cole, 1976, 29.

22 NLA, MS 9/29, see Joppien (1978) fig. 5.

23 One change from the original plan was the omission of a frontispiece.

24 NLA, MS. 9/29. Among the drawings omitted were several ones from New Zealand, canoes from Wautieu, Mangia, the Sandwich Islands, and a depiction of the ice.

25 Webber's task of drawing reductions of views for the charts is explicitly referred to in the Dalrymple-Banks correspondence of 12-15 December 1783, NLA, MS 9/55-9/57.

26 See appendix 1 (Webber's letter to Daniel Funk).

27 See the 'Account of Drawings with agreements for engraving them', NLA MS. 9/28.

28 This is born out by the several documents concerning the publication among the Banks papers at the NLA, Ms. section 9. Banks's role in this respect is also suggested by his letter to Thomas Pennant of 15 May 1783: 'I do not know that any drawing the property of the Admiralty is lodged in my hands except such as either have been or are to be engraved in the intended publication of Captn. Cooks voyage.' Kew B.C. 1. 140. (draft.)

29 This seems to be indicated by an undated letter from J. Sherwin to Banks: 'The Impressions which I have given to any one I will get back that the whole I know of may be sent to you and stamped with your sign — as soon as tis possible.' NLA, MS. 9/29. What Banks's sign was, is not clear. In this respect, however it is interesting to note, that most of the proofs before letters in the Mitchell Library, Sydney, PXD 59⁻¹ are stamped with a minute black fleur-de-lis. Other third voyage proofs before letters are kept in the NLA. A further collection of proof plates and charts was auctioned at Christie's, London, 16/17 April 1985, lot no. 257.

but this does not mean that during that time the engravers concentrated solely on Cook plates. Sherwin for example apologized for his delay in handing in some of the impressions, saying that he had hoped to have an order from the French print-dealer Bassan when he was in London and Bassan had taken up some of his time.[30]

Other engravers were equally dilatory, and it has been suggested that it was this dilatoriness which caused the delay in publishing the account four years after the voyage. On 9 September 1782 Sandwich first wrote to Banks concerning the reasons for the delay.[31] Woollett had not even begun his plate, and Hall and Heath were equally slow. To improve matters Sandwich suggested that Webber should act as 'inspector' over the engravers, and 'superintend the rolling press, and see that the plates are properly struck off'.[32] Sandwich here reveals himself sensitive to the fact that such care 'was omitted in the former publication and . . . the work suffered greatly . . .'.[33] So Banks wrote to Webber with notes enclosed for the engravers. Webber's reply to Banks is worth quoting:

> I had the pleasure to receive your letter with those directed to the several Engravers [Hall, Heath, Woollett] all of which I forwarded according to their directions, and receivd satisfactory answers from each of them promising they would omit no time in getting them ready as soon as possible.—I had forgot in my conversation with Lord Sandwich who did me the honor to call himself at my Lodgings to mention Mr. Sherwin, and I should think [?] Sir it would not be lost, would you be at the trouble to send a line likewise to him, all the others are in a fair way but have not been able to get any of the fo[ur] remaining Drawings yet in hand, as they severally urg[ed?] the necessity of forwarding works that have lain by. Middiman has nearly finished his plate, but is slow & has promisd to undertake another as soon as compleated. Mr. Ellis has delivered in his and I hope you will like it; as has also Mr. Pouncy who I think has done very well. Now Sir happy am I to be inform'd that Ld Sandwich is again to assist us in our endeavours & from what I gather from Dr. Sheppard all will do very well particularly the Paper Business.[34]

Proof plates began to circulate at this time.[35] In early November Douglas returned to Banks a number of proof plates to which he had given titles in agreement with the journals.[36] That this was of no small importance transpires from Sandwich's letter to Douglas of 19 November. Though he generally agrees with Douglas's work, he queries three place names on the plates

> which will wait your further opinion whither the trifling alterations underneath should or should not be made. A man of *Mangea*, now it is suggested that Mangea is not the name of the Island but that it was allways denominated Mangeanoenaiva by the natives. A boxing match in *Happee* 2ʸ whither it should not be written *Happi*. These points the original journals will easily decide. The third doubt is upon the inscription a Fiatoka or *Morai* in Tongataboo. Is it proper to explain one Indian term by an Indian term of another country & and would it not be more accurate to describe it by an English appellation calling it a Fiatoka or *burial place* or perhaps a *place of worship*? I am sure I have given these queries the proper term they deserve when I call them trifling, however, accuracy in business of this sort should be attended to . . .[37]

In his answer of 20 November 1782 Douglas justifies his titles by pointing to the information given in the various journals and papers of Cook, King and Anderson, and assures Sandwich by telling him of discussions that he had had on the matter with Roberts and Webber. He also assured Sandwich that whatever names were decided upon eventually, he himself would press for 'Uniformity of spelling',[38] this being one of the reasons why he 'so earnestly [wished] to be favoured with the Charts as soon as they were ready'.[39] Douglas also expressed his anxiety not to repeat any of the 'glaring imperfections as were unavoidable in the Conduct of the former Publication, when all the Narrative was printed off before I could learn from Mr. Stuart an exact Account of the Charts and Drawings'.[40]

[30] NLA, MS 9/29.

[31] Sandwich to Banks, 9 September 1782, University of California, Los Angeles, Kenneth C. Webster Collection, Department of Special Collections, University Research Library: 'The thing that seems most to threaten delay is the engraving the plates that are still behind.'

[32] ibid.

[33] ibid.

[34] Webber to Banks, 27 September 1782, British Library, Department of Mss, Add. MS 33977 f. 178-178v. Dr Sheppard whom Webber mentions was the Reverend Dr Anthony Shepherd, FRS and canon of Windsor from 1777. His name appears a number of times in the correspondence concerning the publication; he was a friend of Douglas and had gained the patronage of Lord Sandwich.

[35] In early September 1782 forty-one plates were already engraved. This can be assumed from a list exchanged between Douglas and Sandwich, 8 September 1782. NLA, MS 7218/12.

[36] In September 1782 Webber had suggested to Banks that (in Banks's words) 'some steps should be taken for procuring the writing under each plate to be engravd ready for printing off. Now as the first preparation must be composing the said writing & as Dr. Douglas has the plates impressions might it not be worth the trouble it would give your Lordship to apply to him requesting him to prepare upon slips of paper the inscriptions he wishes to have put under each . . .' Banks to Sandwich, 2 October 1782. NLA, MS 7218/18.

[37] Sandwich to Douglas, 19 November 1782, British Library, Department of Mss, Egerton MS 2180, f. 55-6.

[38] Draft letter from Douglas to Sandwich, 20 November 1782, British Library, Department of Mss, Egerton MS 2180, f. 57-8 with an additional note: 'Draught of mine to Lord Sandwich Nov 30 [should read 20] 1782'. There are alterations between the draft and the final letter.

[39] Douglas's letter to Lord Sandwich, 20 November 1782. NLA, MS 7218/22.

[40] ibid.

For 1783 little correspondence concerning the plates has survived. In September of that year however when Banks was again at Revesby Abbey, we hear of further progress and complications, in a letter from Webber to Banks:

> Since your absence [I] have frequently attended the Printers, and may we rely on their promise, might expect the Plates to be compleated in May or the beginning of June, according to y$^r$ expectation. But am sorry to add that the Paper now proves some hindrance, as according to their report, in the first place, the last cargo does not answer the first in many respects as to quality, there being also a great mixture, much of which requires so much picking and attendence that they complain heavily of loss of time. The whole sheets that is those without creases seem to be the worst. Therefore Sir you will excuse me if I again trouble you (should it be not too late) that should you write to Paris they would not send the eight reams you were so good as to order for me, unless its quality was much preferable as it would be in a great degree useless for the intended purpose.[41] . . .
> Knowing the great trouble you have been at and desire of doing for the best, however [I] think it my duty you should be informed of whatever may occur during this business.—It may all be made use of. But Mr. Hadrill as well as Haynes assure me that much of the last is not worth two guineas a Ream—it having no substance. As to the remainder of the plates I am promised by the Engravers they shall be finished in good time having positively informed them of y$^r$ intention that the Voyage is to be published in May.[42]

The paper problem had a history. The matter was first raised by King in early September 1782 in a letter to Sandwich:

> I shall take the liberty of giving your Lordship the following information, wishing that it may be communicated to Sir Jos. thro your Lordship & that I might not appear too officious. I am told that it is necessary that 2000 impressions should be taken of each plate, this will require 124 Reams of paper. Mr. Boydell has but little & that not good, & he sells it at 8 guineas a Ream, by getting it at Paris and Mr. Webber would go, a great saving might be made & a certainty of the paper being good. I am really sorry to add that from accounts of many engravers it will be near a year from the commencement of printing before such a number of impressions will be taken as are necessary. I would wish your Lordship would give Mr. Webber & Mr. Byrne permission to explain these things to your Lordship more full than I can.[43]

The matter was then pursued by Sandwich with some urgency in letters to Banks of 9 and 13 September.[44] Not only was it impossible, Sandwich wrote, to find a sufficient amount of first-class paper for printing the plates in England, French paper was also acknowledged as superior. Sandwich's suggestion that Webber might go to Paris to procure it, was not approved by Banks for fear that Webber's absence from London would mean neglecting the engravings.[45] In Banks's judgement no special agent was necessary, instead, he himself would write

> to the principal bookseller in Paris, M$^r$. Pankouke who I can amply reward if the paper proves good by furnishing [him] with the sheets for translation a reward which tho it will cost us nothing will most sufficiently tempt him.[46]

As it proved, Banks was right about his *douceur*.[47] Panckoucke was willing to provide the necessary paper, and was given the rights for the French edition of the voyage, published in 1785.[48]

There was also the problem of meeting costs; Sandwich mentions this point in his letter to Banks. It was not possible for him, Sandwich pointed out to Banks, to deal with the Admiralty after his resignation as First Lord. Yet he realized that the money which would amount to about £1000 'at all events must be advanced, or the work will be at a stand'.[49] Sandwich was of the opinion that only Banks could approach the Admiralty. On 22 September however Sandwich had a meeting with Stephens, Secretary to the Admiralty and reported to Banks the following day: 'he [Stephens[ informed me that he was authorized to assure me that L$^d$ Keppel meant to carry on the scheme of the publication entirely according to the plan I had intended to pursue',[50] and 'With regard to the affair of the paper, Mr. Stephens will undertake that the Admiralty will advance the money you appropriate for that purpose, to be repaid by those who are to have the profit of the publication.'[51] A few days later Sandwich wrote to Banks again about the importance of the paper, stressing that the present Board of the Admiralty remained in a favourable disposition towards the publication. He feared, however, that Lord Keppel might quit office before the meeting of Parliament '& therefore we should by all means go as far as we can in securing all our points with that Office before there is another change'.[52]

Meanwhile Banks appears to have waited for more substantial assurances from the Admiralty that the paper would be paid for, since his letter to Panckoucke asking for the required amount of paper and offering the rights of a French translation was not drafted until

[41] Webber to Banks, 22 September 1783, Alexander Turnbull Library, Holograph Letters and Documents of and relative to Captain James Cook, fol. 25.

[42] ibid.

[43] King to Sandwich, undated but probably early September 1782. NLA, MS 7218/16.

[44] Sandwich to Banks, 9 and 13 September 1782, University of California, Los Angeles, and Dixson Library, MS Q. 158, f. 273-6.

[45] Banks to Sandwich, 9 October 1782: 'Mr. Webber it seems wants to be sollicitd (well paid I suppose) to go & if he does he leaves the plates to take care of themselves in the meantime.' NLA, MS 7218/19.

[46] Banks to Sandwich, 16 September 1782. NLA, MS 7218/15.

[47] Banks uses the term in a letter to Sandwich of 21 October 1782. NLA, MS 7218/20.

[48] The printed sheets of the narrative were sent to France from September/ October 1783 onwards (letters from Nicol to Banks, 9 October and 23 October 1783, British Library, Department of Mss, Add. MS 33977, f. 217 and 226). Panckoucke's name does not appear on the title page of the French edition which was published in four volumes as *Troisième voyage de Cook, ou Voyage à l'Océan Pacifique . . .* Traduit de l'Anglois par M.D.$^{+++}$ [Jean Nicolas Démeunier]. Paris, Hôtel de Thou, Rue des Poitevins, 1785, in 4°. The engravings included in the publication are provided with captions 'Benard direxit'.

[49] Sandwich to Banks, 13 September 1782, Dixson Library, MS Q. 158, f. 273-6.

[50] Sandwich to Banks, 23 September 1782, Dixson Library, MS Q. 158, f. 285-90.

[51] ibid.

[52] Sandwich to Banks, 12 October 1782, Dixson Library, MS Q. 158, f. 295-8.

53 Draft of Banks's letter to Panckoucke, 25 October 1782, NLA, MS 9/16.

54 Draft letter, Banks to Panckoucke, 7 February 1783. NLA, MS 9/16.

55 The paper had not arrived by 9 June 1783 when Banks wrote to Panckoucke to say that as soon as the packages of paper had been received and were approved of he was authorized by the Admiralty to send off the first sheets of Cook's narrative. NLA, MS 9/16.

56 Banks to Webber, 27 September 1783, British Library, Department of Mss, Add. MS 33977, f. 215.

57 Nicol to Banks, 9 October 1783, British Library, Department of Mss, Add. MS 33977, ff. 217-19. In his letter Nicol also mentions Panckoucke's bill for the paper, amounting to £468.13.3. In return he sends the text already printed to France: 'I have got all the Sheets from Strahan (21 in number) & will continue to send them under the cover of M. de Vergennes — by the bye they are making a rapid progress in the printing.' (f. 217).

58 Nicol to Banks, 23 October 1783, British Library, Department of Mss, Add. MS 33977, ff. 226-7. In the same letter Nicol expresses anxiety about a leak among the printers that might allow an unauthorized French translation of the narrative, which he fears could be issued before the edition negotiated with Panckoucke (f. 226).

59 ibid.

60 ibid. The reference to Webber portraying Dr Douglas in October 1783 is worth mentioning, since it emphasizes Webber's role as portraitist. The present location of the picture is unknown. It is not mentioned in John Ingamell's catalogue The English Episcopal Portrait, 1559-1835 (1981) where other portraits of Douglas, for example by William Beechey and George Romney, are listed (174).

61 Nicol to Banks, 28 October 1783, British Library, Department of Mss, Add. MS 33977, f. 229.

62 ibid.

25 October 1782.[53] Sandwich's fears however were only too true. On 27 January 1783 a decision as to whether the Board of Admiralty should advance the money for the paper had still not been taken, owing to the resignation of Keppel from office and the ensuing appointment of Richard Howe as First Lord. The situation was outlined by Banks in a draft letter to Panckoucke of 7 February 1783,[54] but it seems that at about that time a final and positive decision was underway.

The paper arrived from Paris during the summer of 1783,[55] and the printing of the plates began in early autumn. But on receiving Webber's letter of 22 September 1783, already mentioned above, Banks became indignant and expressed surprise that every packet of the paper had not been opened, checked and the results reported to him.[56]

At this stage, the publisher and newly appointed manager of the publication, George Nicol, took matters in hand, checking on production and accelerating work wherever possible. He soon came to the belief that production was being artfully slowed down. His suspicions were directed particularly against Webber and the printers. Though there was probably some truth in his communications to Banks they reveal him as eager and zealous, happy to please his patron, but strict and stern with those under his eye. On 9 October 1783 he reports to Banks:

It is necessary to inform you that in consequence of my remonstrating very severely against the delay, that had been used in the printing of the plates — Mr. Haynes the *good* printer sent me home three large parcels, said to contain *three* plates — 2000 each — [. . .] I unpacked the parcel & counted with the assistance of my young man each plate — when behold of the first plate 'The inside of the Morai in atooi' instead of 2000, there was but 1717 wanting 283, 2d plate 'Woman of Nootka' — but 1630 wanting 370, 3d Do. 'Man of Nootka' — but 1581 wanting 419, so that in 3 plates only there was wanting in all 1072. Add to this that there is hardly a good impression among the whole — that the plates are entirely worn out — that the impressions are all very dirty & many of them mildened [?] in the soaking — & such as they are the whole of them *purposely* mixed — no two succeeding impressions being alike — all these facts & many more too numerous to mention, Mr. Webber is so sensible of, that he confesses he is ashamd to write to you on the subject — after such a conduct I was clear for taking the remainder of the plates & paper out of his hands, in wh. measure Mr. W. seem'd to acquiesce — but when we went to his House, he thought he was going on so much better, that he should finish those he had in hand . . . You hardly believe after all this villainous conduct of the good printer, wh. Mr. W. admits in its fullest extent — I cannot get him persuaded to enter heartily into the measures of looking out for other Printers, nor indeed to take any other step to accelerate the work — in short, Sir, if the work goes on as it has done for these five months, it cannot be published for some years to come — while *our friends* the Letterpress people are going on at a very rapid rate, & of course will be ready very soon . . .
I had proceeded thus far when I was favour'd with yours of the 6th Inst. and I am happy to find that you have wrote to Mr. W. because I know that will stimulate him more than any thing — all I wish is, that his studied delay may be little counteracted without our seeming to observe his views (wh. are clearly to delay the publication as long as possible) by that means we shall gain our End without giving any offence — As you have now put it into my power to accelerate the publication, it is less important to trouble you w[ith] a conference.
Postscript: 'I think it is but Justice to Hadrill to say that he really seems a good Printer — though a slow one he has not delivered a compleat plate — but he is going on seemingly w[ith] great care — & says he has 5 near ready.[57]

In further correspondence with Banks (23 October 1783) Nicol reported his visit to the printers, with the result 'that we are going on much better'.[58] Meanwhile a new printer, Hixon was employed. After having 'totally destroyed' 'the Masked Battery of delay call'd the Printers', Nicol's next attempt was to speed up the engravers but was warned, apparently by Webber (whom he does not mention by name) that they 'will not be ready in time & that they are a *kind of people*, that must not be spoken to . . .'.[59] He developed an idea of a conspiracy between Webber, the engravers and the printers reporting to Banks:

I calld a day or two ago at Mr. W. & there found Dr. Douglas sitting for his picture, I was not [at] all acquainted with him — but I soon found he had got his Lesson — for the whole conversation (wh. was addressed to me) was not to hurry the printing the Plates . . .[60]

Nicol's communications continued during the following weeks. He obviously delights in his function as watchdog. By 28 October he had convinced himself that 'there is something rotten in the State of Denmark',[61] assured Banks that 'I will go on wearing a wary Eye on all Parties till you come to Town',[62] and reported that Hadrill had five plates completed and was indeed a very good printer. Between his first and 2000th impressions little difference was to be found. But to accelerate the process another printer, Mr Coxe, had been taken on. The

quality of the paper Nicol considered to be settled for the moment, and described the earlier criticism of it as 'a villainous & unfounded outcry, to cover the rascality of the Printers'.[63] His suspicion of dishonesty among the craftsmen was particularly directed against those who had offered to go to Paris to buy the paper: 'Indeed', he writes to Banks, 'you have never been forgiven for getting this paper over at *prime cost* & prevented Mr. Byrne & Mr. Somebody else going to Paris to purchase it — how could you prevent so disinterested a Journey?'[64] The following day Webber, the accused, sought to be acquitted. He wrote to Banks describing the situation in more appealing terms than Nicol:

> If I have defered answering yr. letter It was from the motive of not having such satisfactory matter as I could wish to communicate to you. Therefore I hope you excuse it. For Mr. Haynes who was recommended to me as a remarkable good printer having printed 3 plates which from several circumstances were not so well as could be wished, made me I must own somewhat uneasy, but from a promise of greater attention he was admitted to proceed, since that time he has been printing 6 plates which I am happy to find he has done justice to. As for Mr. Haddril every part of his undertaking succeeds admirably well and expect much satisfaction from him, being a steady man. Mr. Nicol supposes they will not be able to print the number in due time therefore has engagd two more Hixon & Mr. Cox. These are yet to give specimens of their attention. I have also engagd Mr. Cook who engravd the mask'd Head as he keeps a printing room desiring he might print his own plate, supposing he would do it well it was granted him, as also a little plate of Instruments. thus far it gives me pleasure to find everything goes well, some difficultys will naturally arise on first setting out — As to the Engravers I have constantly or do on every occasion inform them with your resolve hoping they will do their utmost in forwarding the plates & whi[ch] they have promis'd me — that is all I have in my power to do — Mr. Sherwin has entirely finishd his plate. and have the pleasure to say he has taken much pains. but from the nature of the work will require great care in the printing to preserve it. Mr Wollet has forwarded much of late his plate and assures me he will not leave it til finished. Much of the paper is very good and hope all of it will do well.[65]

The bulk of the printing of the plates was carried out between September 1783 and the spring of 1784. On 21 February 1784 Captain King reported to Douglas:

> I had a letter from Mr. Webber yesterday who says that in a fortnight they will begin to print off 3 of the plates that besides them there are six more in the hands of the Engravers but in great forwardness & that these were all.[66]

In early March 1784 Webber received an order from Banks to acquaint all the engravers 'that whatever plate was not finished this month was to be laid aside, as it was determined that the voyage should be published in May'.[67]

On 29 April 1784 Nicol sent Douglas the last 'four remaining plates of the Voyage viz No 17, 85, 86 & 87 which compleats that part of the work'.[68] Douglas had regularly received the plates as they were finished by the printers, some thirty-seven 'additional plates'[69] on 22 April, in order to check the titles and inscriptions. Proofs were now being sent almost day by day. By 14 May all plates appear to have been printed and approved, for Nicol instructed Douglas about binding 'the ornamental plates' into a separate volume, i.e. the folio atlas of the published account.[70]

Thus the engravers and printers had finally won their race against time. At least in one instance we know of measures taken by Banks to secure a timely completion of the engraved work. The engraver Samuel Middiman who had proved to be unable to go on with the engraving of *The Inauguration of the King's son in the Friendly Isles* (the plate was taken over by Hall), had to agree to finish the plate of the *Reception of Capt. Cook* 'by the last day of February next'[71] or 'forfeit the sum of ten Guineas' to the Board of Admiralty.[72] No contract with the engravers or printers seems to have survived which spells out the conditions of their employment or the dates to be kept.

It had long been decided that 18 May 1784, the day of the opening of Parliament, was an appropriate day for the delivery of the finished publication, and all efforts were directed toward it. But it had to be changed, not because of a dilatory Webber or tardy engravers and inefficient printers, but because of difficulties that arose in editing the text and the charts.

As can be gathered from various letters addressed to Dr Douglas his manuscript was lagging behind schedule. Webbers's account of his adventure at Nootka where an Indian threatened him with a knife while he was drawing in a communal house, is dated 31 December 1783;[73] yet it was inserted as a footnote in the second volume which suggested that this volume was not printed before 1784.[74] But the main problems were caused by the third volume. Certain parts of it had not even been delivered to Douglas by the early months of 1784. It was King who was responsible for the hold-up. On 8 January 1784 he wrote 'I sent

63 ibid, f. 230.

64 ibid.

65 Webber to Banks, 29 October 1783, British Library, Department of Mss, Add. MS 33977, f. 231-231v.

66 King to Douglas, 21 February 1784, British Library, Department of Mss, Egerton MS 2180, ff. 155-6.

67 King to Douglas, 8 March 1784, British Library, Department of Mss, Egerton MS 2180, f. 173.

68 Nicol to Douglas, 29 April 1784, British Library, Department of Mss, Egerton MS 2180, f. 205. This included the last of the historical subjects, Sharp's engraving A *Night Dance by Women* (no. 17).

69 Nicol to Douglas, 22 April 1784, British Library, Department of Mss, Egerton MS 2180, f. 201.

70 Nicol to Douglas, 14 May 1784, British Library, Department of Mss, Egerton MS 2180, f. 219.

71 NLA, MS 9/29.

72 ibid.

73 Webber to Douglas, 31 December 1783, British Library, Department of Mss, Egerton MS 2180, ff. 112-13, see Cook, *Journals* III, 1, 319-20 n.

74 Cook/King, *Voyage* (1784), 2, 317-18.

[75] King to Douglas, 8 January 1784, British Library, Department of Mss, Egerton MS 2180, f. 115.

[76] ibid.

[77] King to Douglas, 14 January 1784, British Library, Department of Mss, Egerton MS 2180, f. 16. King's life of Cook had been read before and approved by Sandwich, cf. letters from King to Sandwich of 31 December 1783 and 9 January 1784. NLA, MS 7218/26 and MS 7218/29.

[78] King to Douglas, 25 January 1784, British Library, Department of Mss, Egerton MS 2180, f. 125.

[79] Walter King to Douglas. May 1784, British Library, Department of Mss, Egerton MS 2180, f. 210.

[80] Walter King to Douglas, May 1784, British Library, Department of Mss, Egerton MS 2180, f. 220.

[81] First mention about the general map is made in King's letter to Douglas on 25 July 1782, British Library, Department of Mss, Egerton MS 2180, ff. 34-5.

[82] King in a postscript to a letter from the Reverend Dr A. Shepherd to Douglas 9 September 1782, British Library, Department of Mss, Egerton MS 2180, f. 44.

[83] In an undated letter of early 1784 Banks writes to Sandwich: 'M$^r$. Palmer has promisd to finish the general chart by the last day of March . . .', NLA, MS 7218/27.

[84] Helen Wallis has suggested that the problems arose from difficulties between King, Roberts and Douglas on one hand and the 'formidable alliance' of Banks and Dalrymple on the other, particularly over the 'General chart' and the 'Chart of the NW Coast of America and NE Coast of Asia' (Wallis, 1978, 182). In this connection it is worth quoting Banks's letter to Sandwich of 27 November 1783: 'in conversation with Mr. Dalrymple yesterday on the subject of the charts I find they are all except the general nearly finished but that the finishing is delayd by trifling matters questions cheifly in which Cap$^t$. King & M$^r$. Roberts disagree but which for that reason M$^r$. Dalrymple positively refuses to put out of hand without Cap$^t$. King's absolute consent whether from jealousy or some other cause matters not, Cap$^t$. King is at Woodstock & answers very carefully or rather takes care if possible not to answer at all the questions put to him by M$^r$. Dalrymple in this state the charts may remain till the worlds end within a few days of being finished & I know only one remedy which I submit to your Lordship /which/ it is to contrive a meeting between the two gentlemen at your Lordship's house at which I will with pleasure attend & if we once get them together I will not

off today the third and fourth Chapters to Mr. Fraser'.[75] Since the engraving after Webber's *A man of the Sandwich Islands dancing* (3.301A) had no proper reference in the text, King agreed to send a description to be inserted into chapter 2.[76] A week later King hinted to Douglas that by now he might well have received his life of Captain Cook, which was to form the end of chapter 3.[77] On 25 January King sent a manuscript to Douglas that, he said 'still wants many corrections'.[78] Finally, in an undated letter of May 1784 addressed to Douglas, Walter King, brother of James, mentioned that King was involved with chapter 10, and that Mr Roberts would finish chapter 11 by the middle of the week.[79] This surely must refer to proof-reading, probably not yet in its final stage, considering that in another undated letter of May 1784, Walter King sends Douglas 'the end of my Brother's Journal'; this still contained a blank but could be filled by information procured from Mr Stephens.[80]

With regard to the charts and to the general map in particular the situation cannot have been too rosy either. Again, the last to deliver his information and make corrections was Captain King. The general chart was to be the centrepiece of the folio atlas, a map of the world on Mercator's projection showing the known coasts in outline together with the tracks of Cook's three voyages.[81] As early as October 1782 King had hoped that between himself, Roberts and William Palmer the engraver, the chart would be finished by April the following year.[82] More than a year later Banks suggested that the end of March 1784 was a more realistic date for its completion.[83] The cause for the delay was created by personal difficulties between the contributors involved, mainly King and Dalrymple. The charts had been finished except for details,[84] and Banks suggested to Sandwich that he arrange a meeting between the two in order to discuss all open questions. The meeting took place at Lord Sandwich's house in Hertford Street on 5 December 1783. A protocol was drawn up according to which seventeen points were subjected to detailed discussion, at the end of which King promised further co-operation.[85]

At the end of May the plates and charts were ready, though some of the letter-press possibly still had to be printed. The great hurry to meet the deadline of 4 June is expressed in a letter by Nicol to Douglas of 31 May, in which he apologizes for the pressure which he had exerted.[86] He did not want to incommode Douglas but it had been his intention to publish on 4 June

> even if it should be in the Evg. of Tuesday — for I will keep the Binders in waiting to work all night. — But after that time it is impossible to get the Presentation Copies bound in any respectfull time. . . . It must therefore of course be postponed — However awkward this may be (the day being a particular one) yet it is better than that the Work shoud appear imperfect in any degree . . .[87]

suffer them to part till every matter between them is somehow or other settled.' NLA, MS 7218/28.

[85] NLA, MS 9/18: 'Minutes in meeting held at Lord Sandwich's house in order to facilitate the finishing of the charts supposed to be delayed by misunderstandings between Mr. Dalrymple, Capt. King and Lieut. Roberts. Decr. 5 1783.' On the bacground of the grievance between Dalrymple and King see Wallis (1978) 180-2.

[86] Nicol to Douglas, 31 May 1784, British Library, Department of Mss, Egerton MS 2180, f. 229.

[87] ibid. In his letter to Douglas of 2 June 1784 Nicol states that he was 'allowed but eight days, (exclusive of Sunday), from finishing the work to the day of publication', ibid, f. 233.

The three quarto volumes and their accompanying folio atlas were published early in June,[88] in an edition of 2000 copies, for £3.5.0[89] each. It has been stated that these were sold out in just three days, demanding a second edition of another 2000.[90] Eleven were delivered to the Stationer's Office and forty-seven given as presentation copies, to the King and the Queen, the Lords of the Admiralty, Mrs Cook, the British Museum, The Royal Society, the Empress of Russia, the King of France, and Dr Franklin.[91]

The costs of the production were conspicuous. An 'Account of the Expence of the first Edition of Captain Cook's Voyage' quotes the total costs as £3596.0.1, among which £1064.13.4 were paid for the paper of the plates and £924.8.3 for the five copperplate printers, amounting to £1989.1.7.[92] A memorandum on the publication drawn up several years after its completion, gives details of the financing of the edition.[93] The costs of producing the plates, as well as Webber's salary, were borne by the Admiralty, in other words: 'as the Public bear the Expence of the Plates, the Book be sold at the same Price as it would be if without Plates'.[94] On the other hand the expenses for the text volumes, letter-press, binding and advertising were advanced by the bookseller and financed on the expectation of the profits. The same document concludes:

> The Publication consists of three large Volumes in Quarto containing 1528 Pages, The Plates without counting Charts or Views of Land are 61 in number, about one to every 25 Pages of Letter Press, the whole including Charts &c 78, about one to every 20 Pages; the Cost of the Plates was £2997/12/0, the highest price given for any one was 150 guineas which Woolet receivd for the Human Sacrifice[95] . . .

A list of engraved illustrations preserved among the Banks papers gives Woollett's honararium as £157.10.0.[96] After Woollett, the second most expensive engraving was Sherwin's *Dance in Otaheite*, amounting to £126. All other engravings were below £100, the most inexpensive being Woodyer's print of *A Sledge*, costing 3 guineas. Thus, in all, about £1000 was set aside for the engravers.

Bearing in mind that almost £3000 for the plates and another £1000 as salary to Webber was paid by the Admiralty, one cannot recall an earlier example of a nation state having advanced an equal sum of money for the publications of its discoveries; discoveries made for the benefit of science and geography. The publication of Cook's voyages is ample testimony — in its time almost a unique testimony — to the state's subsidizing role in the name of geographical knowledge.[97] Among all the travel books of the eighteenth century Cook's third voyage holds a unique place; as a model for the future publications of voyages of discoveries. Its influence lasted well into the nineteenth century, as an enviable precedent for many works of a similar kind.[98]

---

88 Dr Johnson, who is reported to have said to Boswell on 15 June 1784: 'These Voyages . . . who will read them through? A man had better work his way before the mast, than read them through; they will be eaten by rats and mice, before they are read through. There can be little entertainment in such books, one set of Savages is like another'. *Boswell's Life of Johnson*, Oxford University Press, London, (1953) 1304.

89 Beaglehole, in the introduction to Cook's *Journals* III 1, cciv asserts that copies were sold for four and a half guineas. This figure however, is at odds with a financial statement among the Banks papers in the NLA, MS 9/30, according to which '1942 [copies were] sold at £3.5.0.' netting '£6311.10.0.'.

90 In a letter to Banks of 14 September 1784 Nicol informs him of a recent conversation with Captain King on the profits of the edition. King had complained and Nicol wrote: 'I told him by way of comforting him that the 2$^d$ Ed$^t$ of 2000 — would certainly be sold within a few months of this being finished, w$^h$ will certainly be the case, as the demands increase daily.' Alexander Turnbull Library, Misc. material relating to Captain James Cook, 1768-84.

91 A list of the presentation copies is kept in the NLA, MS 9/27.

92 NLA, MS 9/30 (see Appendix 4).

93 Dixson Library, MS Q. 158, ff. 49-52. This memorandum was accompanied by an original letter (ff. 45-8), dated 16 January 1795 by Sir Joseph Banks to the Rt. Hon. Henry Dundas. It was probably written by a member of Sir Joseph's staff.

94 ibid., f. 49.

95 ibid. The same source gives an account of the division of the profits. From these Webber was excluded. Already on 28 September 1782 Banks had written to Sandwich: 'Mr. Webber cannot claim if the draughtsman of the last voyage hadnt any share & I am almost sure he had not.' NLA, MS 7218/78.

96 NLA, MS 9/29 (see Appendix 3).

97 The only other work that can be compared with the publication of Cook's third voyage, both from the point of the geographical knowledge contained therein and the sponsoring role of the government, that we know of, is Frederick Wallet des Barres, *The Atlantic Neptune*, published for the use of the Royal Navy of Great Britain . . . London. The Admiralty [1784]. It contains charts and views of the East Coast of North America from Nova Scotia to the Gulf of Mexico.

98 The official account certainly was a model for the publication of the voyage of La Pérouse. When this was published by Milet-Mureau in 1797 he expressly justified the lavish illustration of the work with reference to Cook: 'Le nombre, la grandeur et la beauté des gravures et des cartes m'ont déterminé à réunir dans un atlas séparé et d'un plus grand format. J'ai cru qu'un ouvrage national exécuté avec autant de soins, méritait cette précaution conservatrice. Si elle n'est pas généralement goûté, je répondrai qu telle est la forme de la belle édition du troisième Voyage de Cook, publié par ordre du gouvernement anglais, et à ses frais.' (vol. 1, xv-xvi.)

# THE ARTISTS

## 1. John Webber

### Early life and training: 1751-1776

It is mostly owing to his association with Cook's third voyage that today John Webber is well known as a draughtsman and water-colourist. Through Swiss sources, we know most about Webber's life. An account of it was first published in Zurich by Sigmund (von) Wagner in 1821,[1] based on letters and oral communications Wagner had collected shortly after Webber's death.[2] Later works have given additional information.[3]

John Webber was born on 6 October 1751 in London in the parish of St George's Church, Hanover Square as the second of six children.[4] Here he was baptized on 30 October 1751.[5] His father Abraham Wäber (1715-1780), a sculptor, was a native of Bern, who had moved to London in the early 1740s. Here he changed his name to Weber or Webber and on 18 February 1744 married at St George's Chapel, Hyde Park Corner, an English girl, Mary Quant, from the parish of St Martin's-in-the-Fields.[6] Webber's family on his father's side can be traced back to the sixteenth century, but nothing is known about his mother's family. In 1544 the Wäber family in Bern became members of the Gesellschaft von Kaufleuten (The Corporation of Merchants), who were to play an important role in both Abraham's and John's

---

[1] Sigmund Wagner, Leben Johann Webers von Bern, published as Siebenzehntes Neujahrsstück, herausgegeben von der Künstler-Gesellschaft in Zürich auf das Jahr 1821.

[2] The Staatsarchiv des Kantons Bern keeps under shelf-mark 'Wagner 47' a number of papers relative to Webber's life that served as the basis for Wagner's essay. They include: 1) the copy of a letter from Webber to his cousin Daniel Funk, dated London 4 January 1781, 8 pp. (See appendix 1.) There is an additional passage, which was later crossed out for unknown reasons but is worth quoting: 'Les dern: annees qu'il fut chez M.ʳ Aberli it fit quelques portraits à l'huile, celui de son ami Fueter, qui est chez Md.ᵉ Risold Fueter; celui de son Cousin Founck, — L' Abbaye des Marchands, ou M.ʳ Webber etait ressortissant, lui donna 30 Louis pour son voyage, et le petit conseil le gratifia pdt ses études à Paris sous differentes fois, il etudia à Paris à l'academie de peinture & y fut avec Freudberger & Dunker, Mr. le Banneret Hackbrett le protega.' (Rudolf Hackbrett, 1718-1790, a patrician of Bern, was a high authority in the city's finance and government.) 2) notes from a conversation between Sigmund Wagner and Henry Webber that took place on 31 July 1816, 4 pp. 3) a petition by Henry Webber for assistance from the city

of Bern. 4) Wagner's manuscript for a biography of Webber.

In the first footnote of Wagner (1821) it is said that the biography was based partly on oral communication from Henry Webber, partly on letters by John Webber to Mr Fueter, master of the mint at Bern. Although this looks like a confusion of names (Fueter meaning Funk), it cannot be excluded that letters from Webber to Fueter had been available to Wagner as well.

[3] Works which deal with Webber's biography are the following, listed in chronological order:

Ludwig Lauterburg, 'Biographische Literatur enthaltend eine Sammlung gedruckter, biographischer Quellen aus dem Zeitraume von 1785 bis 1840 über das Leben und Wirken hervorragender verstorbener Berner und Bernerinnen des alten deutschen Kantonstheils', in Nachtrag zum Berner Taschenbuch (Bern, 1853), 305-6; Bernhard Emanuel von Rodt, 'Die Gesellschaft von Kaufleuten in Bern. Ein Beitrag zur Geschichte des Stadtbernischen Gesellschafts- und Zunftwesens', Berner Taschenbuch (Bern, 1862) 1-171, regarding Webber, 56-60; F. Romang, 'Johann Wäber', in Sammlung Bernischer Biographien, II (Bern, 1896) 295-307; H. Türler, 'Wäber', in Carl Brun, Schweizerisches Künstler — Lexikon, III, vol. L-Z (Frauenfeld, 1913, reprint 1967) 409-10; U. Thieme/F.

Becker, Allgemeines Lexikon der bildenden Künstler, 35 (Leipzig, 1942) 212; Karl H. Henking, 'Die Südsee- und Alaskasammlung Johann Wäber', in Jahrbuch des Bernischen Historischen Museums, XXXV/XXXVI (1955/56) 325-30; [based on Henking is Adrienne Kaeppler's biographical account on Webber in her book Cook Voyage Artifacts in Leningrad, Berne and Florence Museums (Honolulu, 1978b) 25-9]; Douglas Cole, 'John Webber: A Sketch of Captain James Cook's Artist', in B.C. Historical News, 12, 5 (1979a) 18-22; Douglas Cole, 'John Webber', in Dictionary of Canadian Biography 1979, IV (1771-1800) (Toronto, 1979b) 762-3; Harald Wäber, Die Familie Wäber von Bern (Bern, 1979) 57-70, typed ms., privately bound, a copy is kept in the Staatsarchiv des Kantons Bern.

[4] The eldest child, Rudolph Webber, who was baptized there on 5 April 1747, probably died young, for Wagner (1821) says that John was the eldest.

[5] Birth and baptism records, St George's Church, Hanover Square, London, vol. 3, 7 (City of Westminster Archives, London, in litt. Miss M. J. Swarbrick, Chief Archivist, 24 January 1986).

[6] The wedding date was first correctly established by Cole (1979) and Wäber (1979), after consulting the marriage records of St George's Chapel, Mayfair (vol. 2, entry 1342). Wagner (1821) had given the date of marriage as 1749 (p. 4), an error repeated by von Rodt in Berner Taschenbuch (1862), 57. About the location of the wedding, St George's Chapel, Mayfair, Miss Swarbrick informs us: 'This was a Chapel, within the parish of St George Hanover Square, in which clandestine marriages took place — that is to say without obtaining a licence or publication of banns. These marriages were considered irregular but were valid and binding.' (in. litt., R. Joppien, 18 November 1985).

[7] Wäber (1979).

[8] Burgerbibliothek Bern, Archiv der Gesellschaft zu Kaufleuten, Stuben — Manuale, vol. 5, 16 January 1732, ff. 277-8. All references to the Stuben-Manuale we owe to the courtesy of Harald Wäber, archivist at the Staatsarchiv des Kantons Bern.

[9] See Hermann von Fischer, *Die Kunsthandwerker — Familie Funk im 18. Jahrhundert in Bern*, Berner Heimatbücher 79/80 (Bern, 1961) 7.

[10] Various Swiss historians, Sigmund Wagner, Ludwig Lauterburg and Friedrich Romang, believed that Abraham Wäber had worked with or trained under Nahl. Considering that Nahl was in Bern between 1746-1755, when Abraham Wäber was already living in London, this is unlikely. What relationship existed between Wäber and Nahl is not known, except that Abraham's sister Rosina was godmother to Nahl's daughter Anna-Maria in 1747, see Eduard M. Fallet, *Der Bildhauer Johann August Nahl der Ältere, seine Berner Jahre von 1746 bis 1755*, Archiv des Historischen Vereins des Kanton Bern, 54 (Bern, 1970) 79. Also Wäber (1979) 56.

[11] Abraham Webber's departure from Bern could have occurred around 1742/43. A law case which was conducted in February 1757 concerning the possibility that Abraham was the father of a girl born in Bern on 5 June 1743 (Burgerbibliothek Bern, Archiv der Gesellschaft zu Kaufleuten, Stuben-Manuale, vol. 9, 19 February 1757, ff. 181-3) resulted in Wäber's acquittal. However, to have brought the case forward at all must have meant that Wäber was in all probability still in Bern in late 1742.

[12] According to Wagner, John Webber was sent to Bern at the age of six, that is in 1757.

[13] Fischer (1961), 31.

[14] Fallet (1970), 79.

[15] On Aberli see Bernhard Geiser, 'Johann Ludwig Aberli und sein graphisches Werk', in *Das graphische Kabinett*, Heft 3 (Winterthur, 1923); F. C. Longchamp, *J. L. Aberli, Catalogue Complet* (Paris/Lausanne, 1927); Bernhard Geiser, *Johann Ludwig Aberli, 1723-1786, Leben, Manier und graphisches Werk* (Belp, 1929); M. Huggler, 'Johann Ludwig Aberli und

career.[7] When Abraham was seventeen years old, in 1732, he applied to the commission of orphans (Waisencommission) for payment of an educational stipend to become a sculptor.[8] This was granted and he was apprenticed to the decorative carver Johann Friedrich Funk I, into whose family his sister Maria Magdalena had married.[9] It has been said that he worked with the famous sculptor Johann August Nahl,[10] but irrespective of whether this was the case, his career does not seem to have been particularly noteworthy.

Abraham's motives for going to England and his early work there are unknown.[11] Apparently he and his family lived in tight circumstances, for as a matter of relief, in 1757 young John was sent to Abraham's unmarried sister Rosina Ester Wäber in Bern.[12] Aunt Rosina educated John and discovered her nephew's inclination for drawing.

In Bern Webber profited from his family's connections with Mathäus Funk, the famous ébéniste (1697-1783), who in 1724 had married Webber's aunt Maria Magdalena Wäber. Another family bond was constituted by the sculptor Johann Friedrich Funk (1706-1775), who had taught Webber's father Abraham.[13] When in 1750 Maria Magdalena Funk died, her sister Rosina took over the household of her brother-in-law.[14] Thus it seems that Webber grew up among the family of one of the most celebrated craftsmen of Bern.

In 1767 Webber was apprenticed to Johann Ludwig Aberli (1723-1786), one of the foremost Swiss landscape artists of his time and father figure to a whole generation of Swiss landscape artists of the later eighteenth century.[15] Aberli's favourite subjects were views from the Berner Oberland, mountainous scenery and lakes. In the wake of a new interest in alpine scenery Aberli's work was at the height of fashion for a long time. As a recorder of topography Aberli was faithful, as a colourist, delicate, and he heightened his panoramic views with subtle tones and hues. Though only modest in scale, Aberli's art was inseparably linked with the idea of discovery and the conveyance of visual information.

In order to meet the public demand for his Bernese views especially, Aberli had 'invented' a method of multiplying his pictures, which soon came to bear his name, the 'Aberli manner'. He produced etchings, which were so faintly imprinted that they could hardly be recognized as such. They were coloured by hand and could thus pass as original works. When in 1766 Aberli received a 'privilegium' for his method, he needed colourists, and it is to be wondered whether Webber was not set that task, when he entered Aberli's studio in 1767. Webber stayed with Aberli for three years, concentrating, one presumes, upon drawing and colouring landscape views.

None of Webber's drawings from his time with Aberli have been identified, and therefore our knowledge of the influence of the training can only be tentative. The first year with Aberli would have been probationary followed by another two years. His education fee 'Lehr- und Kostgeld' amounted to 12 'Neue Duplonen' and was paid by the Corporation of Merchants.[16]

Considering that Aberli was not only the leading artist of Bern but one of the most popular artists in Switzerland, young Webber was well placed for a start to his career.

What Webber probably learnt from Aberli was an immediate approach to landscape rendering, an unbiased point of view; of which Aberli's drawing of the city of Bern (c. 1769) might be cited.[17] Panoramic in breadth, the drawing reflects an acute interest in the undulations of the hills and slopes of the river valley. The fact that the drawing is unfinished and certainly a sketch on the spot, focuses on the new conception of landscape after which Aberli was groping (plate 185).

die Malerei des 18. Jahrhunderts in Bern', in *Festgabe Hans von Greyerz* (Bern, 1967). Drawings and paintings by Aberli are kept in all the larger Swiss museums, such as the Kupferstichabinett, Basel; Kunstmuseum Bern; Kunstmuseum Winterthur; Graphische Sammlung, ETH, Zürich etc.

[16] Webber's education fee was discussed by the council of the Corporation of Merchants on 31 December 1766 (Burgerbibliothek Bern, Archiv der Gesellschaft zu Kaufleuten, Stuben-Manuale, vol. 12, ff. 359-60); it had to be decided whether the applicant

was worthy of the Corporation's support and the financial state of his father. After information had been received from London, the council resolved on 18 February 1767 to pay for Webber's education for the length of a year as probationary period (vol. 12, 377-84).

[17] Kupferstichkabinett, Kunstmuseum Basel, pencil and grey wash, 19.6 × 37.6 cm, signed 'Berne prise de l'Engi — L. Aberli ad: nat: del:', see Yvonne Boerlin-Brodbeck, *Zeichnungen des 18. Jahrhunderts aus dem Basler Kupferstichkabinett* (Basel, 1979) 36, no. 51, fig. 44.

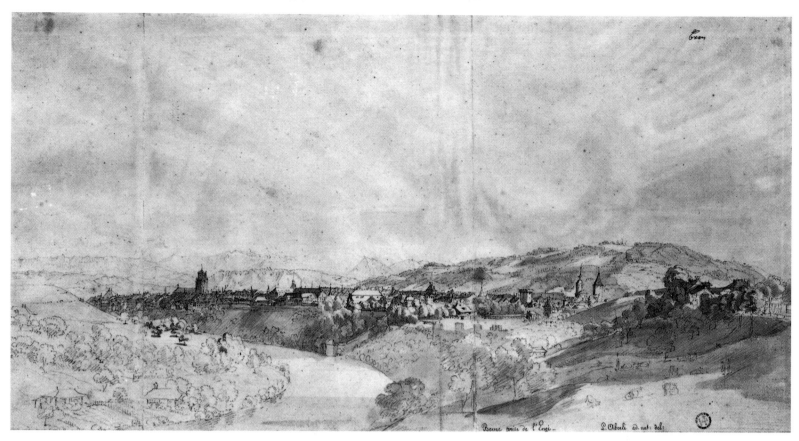

By comparison Aberli's drawing of the *Lake of Lucerne (Vierwaldstätter See)* is more finished (plate 186). Hills and water are again the main elements but are contrasted more dramatically; almost perpendicular mountains are here juxtaposed with the smooth surface of the lake. The stressing of depth and the repoussoir elements at the sides reveal, however a traditional and formal structure. The drawing (undated) seems to have been created during the 1760s. It may be noted that its rhythmical structure is apparent in some of Webber's work on Cook's last voyage, such as the views at Nootka (plate 98, 3.190; 3.191).

It is conceivable that in Aberli's studio Webber came into contact with oil painting, in which Aberli did not specialize but which he certainly practised. A landscape painting of *Scherzlingen near Thun in Switzerland*, which is thought to have been executed around 1770 (plate 187), may have been seen by Webber in Aberli's studio. It is as notable for its light, with its long evening shadows, as for its composition, which again has a vast stretch of water in the centre. There is a melancholic quiet over the scene, which also anticipates Webber's later work in landscape painting, particularly his views in the Society Islands.

Sigmund Wagner informs us that during his last years with Aberli Webber 'did some

PLATE 185
Johann Ludwig Aberli, *View of the city of Bern*, c. 1769, pencil and grey wash, 7¾ × 15¾ : 196 × 376. Kupferstichkabinett, Kunstmuseum, Basel.

PLATE 186
Johann Ludwig Aberli, *Lake of Lucerne*, 1760s, water-colour, 8½ × 13¾ : 214 × 349. Kupferstichkabinett, Kunstmuseum, Basel.

173

PLATE 187
Johann Ludwig Aberli, *View of Scherzlingen near Thun in Switzerland*, c. 1770, oil on canvas, 14¹⁵⁄₁₆ × 21¼ : 380 × 540. Kunstmuseum, Bern.

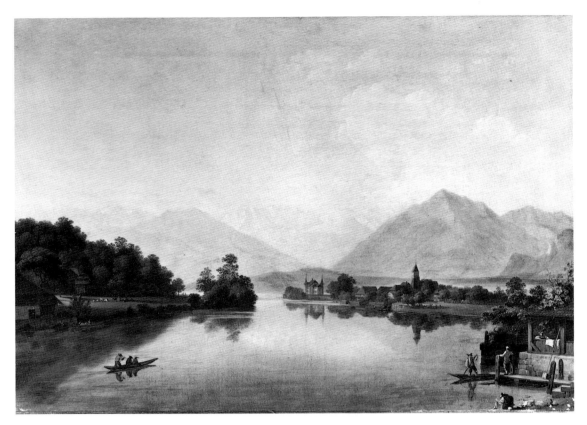

[18] Staatsarchiv des Kantons Bern, 'Wagner 47' (see fn. 2). Christian Fueter who had learned the art of medalling under J. C. Mörikofer, was the son of Daniel Fueter (1720-1785), goldsmith and friend of Abraham Webber. Daniel Fueter took part in a conspiracy and fled to London in 1749, from where he only returned in 1770. Christian was born in London in 1752 and was remembered in Webber's will, Christian remained strongly attached to English culture and spoke English with his children. He revisited London in 1791. For his biography see Lina von Greyerz, Christian Fueter, 1752-1844, in *Sammlung Bernischer Biographien*, IV (Bern, 1902) 384-95 as well as J. Strickler, 'Die Berner Münzstatt und ihr Direktor Christian Fueter 1789-1803', in *Neues Berner Taschenbuch* (1905) 15-62.

[19] On 13 January 1769 the Corporation of Merchants wrote to Abraham Webber in London, notifying the father of John's third year with Aberli and asking what plans Abraham had for the future education of his son. Abraham's letter arrived in Bern on 17 May 1769 and resulted in asking Aberli's opinion about Webber's artistic career. Aberli, no doubt, thought it best for Webber to go to Paris (Burgerbibliothek Bern, Archiv der Gesellschaft zu Kaufleuten, Stuben-Manuale, vol. 13, fols. 165, 211, 220). The Corporation of Merchants continued to pay for Webber's education in Paris. A reference to the payment of '10 neue duplonen' in answer to Webber's application is given in the Stuben-Manuale for 27 December 1771, vol. 14, f. 166. For further payment see fn. 31.

[20] On Wille see: Charles Le Blanc, *Catalogue de l'Oeuvre de Jean Georges*

portraits in oil, including one of his friend Fueter . . .'[18] Though the whole passage, from which this quote is taken, was afterwards crossed out for unknown reasons, this is the earliest reference to Webber's painting in oil.

After three years of training with Aberli, Webber left Bern in the summer of 1770 to continue his studies in Paris at the Académie Royale, receiving an annual stipend of 12½ Louis d'Or from the Bernese Government.[19] He left with a recommendation to Jean-Georges Wille (1715-1808), engraver and also one of the most respected authorities on art of his time.[20] His fame today rests largely on his engravings of portraits by Hyacinthe Rigaud, Nicolaus de Largillière and Jean-Baptiste Greuze. In 1761 he was made a member of the Académie Royale de Peinture and later received the title 'Graveur du Roi'. He also was a member of several foreign academies.

In his house at 29 Quai des Augustins Wille entertained connoisseurs, art dealers and foreign agents. His house was a stock exchange of paintings, prints and books, and as such a meeting place for art lovers from all over Europe. Wille was a major figure for the revival of Dutch and Flemish art of the seventeenth century, and took great interest in genre painting and landscape. He also deserves to be remembered as a collector of pictures and prints by Berchem, Gerard Dou, Metsu, Netscher, Ostade, Rembrandt, Teniers, Terborgh etc., and of Jordaens and Rubens. Many of the German-speaking artists who visited him became champions of this revival. Possessed of considerable kindness and human warmth Wille held a crucial position as patron of young artists from the German-speaking countries, helping them into the art world of Paris. Swiss students who trained under Wille included Balthasar Anton Dunker, Sigmund Freudenberger, Christian von Mechel, Johann Caspar Mörikofer and Adrian Zingg, all of whom became respected masters as draughtsmen, painters, engravers, or medallists.

*Wille, Graveur* (Leipzig, 1847); Werner R. Deusch, 'Der Kupferstecher Johann Georg Wille und sein Pariser Tagebuch. Ein Beitrag zu den deutsch-französischen Kunstbeziehungen im 18. Jahrhundert', in *Imprimatur*, N.F., II (1960) 100-13. On a similar line: Yvonne Boerlin-Brodbeck, 'Johann Caspar Füssli und sein Briefwechsel mit Jean-Georges Wille', in *Beiträge zur Kunst des 17. und 18. Jahrhunderts in Zürich*, Jahrbuch 1974-77, Schweizerisches Institut für Kunstwissenschaft (Zürich, 1978) 77-

178, especially 131-9, and also Michael Levey, 'Some Paintings by Dietrich for J.-G. Wille', in *Gazette des Beaux-Arts* (January, 1958) 33-40. Only recently Hein-Th. Schulze-Altcappenberg finished a dissertation on J. G. Wille: *Jean-Georges Wille und seine Schule. Zeichnungen und Druckgraphik — Studien zur Künstlergenese, zum 'Hollandismus' und zur bürgerlichen Wahrnehmungs-ästhetik der Aufklärung*, Philosophical Faculty, University of Bonn, 1985 (not yet published).

It was in this context that Webber came to see Wille on 25 July 1770. Wille kept a note of the meeting in his diary:

> Mr. Webber, a young painter from Berne, came to see me. He is a student of Mr. Aberli, my friend, of whom he had a letter of introduction. He also gave me those of Mr. Ritter, architect, and of Mr. Mörikofer, engraver of medals, coins and gems, with the same purpose. They too are my friends and of my acquaintance. These gentlemen gave testimonies of praise for Mr. Webber, of his very good manners and his strong attachment to his talent. I am disposed to believe this for he seems to me to be a very nice young man. Mr. Freudeberg brought him to my house. He showed great pleasure of my cabinet.[21]

As a teacher of drawing Wille held an influential position. He specialized in genre subjects and rural landscapes with figural staffage, as in Dutch landscape. His contribution to the rise of a new landscape art is important. Once a year he undertook a sketching tour to the rural outskirts of Paris looking for subjects which reflected the Dutch manner. During these tours he was regularly accompanied by friends and pupils, to whom he often referred in his diaries. Of such an occasion Wille noted on 29 August 1773:

> Early in the morning I left for Longjumeau in order to draw the countryside and also in the villages and hamlets of the area. My eldest son was with me and also Mssrs Pariseau, Vangelisti, Müller, Weber, Tischbein and Nadal. We had two carriages . . . we had the most beautiful time imaginable and I made fourteen drawings almost all of which I rendered in red crayon. We had a very agreable time during our outing and we ate and drank with the greatest appetite. Our pleasures were endless, and we constantly found something to laugh about. At Sceaux-les-Chartreux there was a mad woman whom I had already met during the preceding years . . .[22]

The following year Webber was again a member of the party. Wille who was himself susceptible to good humour and fun, called him a 'jolly garçon'.

> On the fourth [September 1774] I left Paris for Longjumeau in the carriage accompanied by my son and Mssrs Pariseau, Baader and Bervic, my student; Mssrs Guttenberg brothers and Weber had already gone out in the early morning. Thus we were eight this year for drawing the countryside. I drew nine landscapes, that is to say, seven at Saucière, one at Sceaux-les-Chartreux and one at Longjumeau either in red crayon or black or coloured. We had much pleasure in this excursion . . .[23]

Wille's favourite medium for sketching outdoors was red crayon, pen and wash. Many of his works from the 1760s and 1770s show his spontaneous approach and intense interest in rural scenes, depicting the occupations of the peasant folks and their austere lives.

Such features are present in a drawing in the Städelsches Kunstinstitut, Frankfurt, showing a straw hut and a peasant couple nearby (plate 188).[24] This interest in the depiction of uncompromising poverty was strongly influenced by drawings of rural life from seventeenth century Dutch art. For the general conception of the hut compare, for example, drawings by

[21] Georges Duplessis (ed.), *Mémoires et Journal de J.G. Wille, Graveur du Roi*, Publiés d'après les manuscrits autographes de la Bibliothèque Impériale 1, (Paris, 1857) 449. Aberli's letter of introduction is reprinted by Duplessis on 442. Mssrs. Ritter and Mörikofer, mentioned in the diary, are the Bernese architect, Erasmus Ritter (1726-1805) and the medallist Johann Caspar Mörikofer (1738-1800).

[22] Duplessis, (1857), 1, 555.

[23] ibid., 577.

[24] See Edmund Schilling, *Katalog der deutschen Zeichnungen*, Städelsches Kunstinstitut, Frankfurt a.M., (München, 1973) 1, 208, fig. 2144; also Boerlin-Brodbeck (1978), 88. For another drawing of similar character see Wille's *Le fagottier* (1760) in the Musée des Beaux Arts, Orléans, inv. no. 1147 in exh. cat. *Frankreich vor der Revolution. Handzeichnungen aus dem Musée des Beaux Arts, Orléans*, Westfälisches Landesmuseum (Münster, 1973) no. 117.

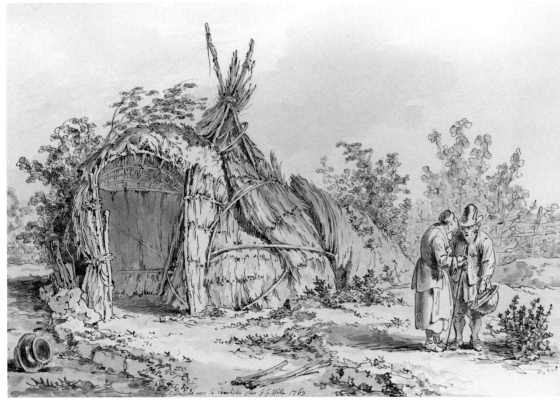

PLATE 188
Jean Georges Wille, *A straw hut with a peasant couple*, 1763, pen and sepia wash, 7⅝ × 11 1/16 : 193 × 281.
Städelsches Kunstinstitut, Frankfurt.

[25] See for example Regina Shoolman Slatkin, 'Abraham Bloemaert and Francois Boucher: Affinity and relationship', *Master Drawings*, XIV, no. 3, Autumn 1976, 247-60. On the subject of the delapidated hut as a *leitmotif* in eighteenth-century art, see also Joachim Gaus, 'Die Urhütte. Über ein Modell in der Baukunst und ein Motiv in der bildenden Kunst', *Wallraf Richartz Jahrbuch*, XXXIII (Köln, 1971) 7-70, with another related drawing by J. G. Wille of a haystack and farm figures on p. 55.

[26] Sigmund Freudenberger (1745-1801) who is known as one of Bern's most popular artists in the eighteenth century, had arrived in Paris in 1765 and made a living by engraving works by Francois Boucher and Jean-Baptiste Greuze. He became one of Webber's closest friends in Paris and may well have been helpful in introducing Webber into the artistic circles of Paris. On Freudenberger, see the *Schweizerisches Künstler-Lexikon*, vol. 1 (Frauenfeld, 1905) 485 and Max Huggler, *Sigmund Freudenberger, Der Berner Kleinmeister* (Bern, 1976).

[27] Webber's *Two children* has an old pencil inscription on verso: 'Slg. Wil[le] Paris'. The other drawing, *Thatched cottage with a rider on a donkey* derives from the collection of Sigmund Wagner.

[28] Schilling (1973), 1, 206, repr. 2121 and 2122.

[29] Gabriel Rouchès, 'Documents figurant au fond d'archives de la Bibliothèque de l'Ecole de Beaux-Arts', *Bulletin de la Société de l'Histoire de l'Art Français* (Paris, 1913) 52, manuscript 45, with reference to a 'liste des élèves de l'Académie de 1758 à 1776'. This list provides the following entry on Webber: 'Octobre 1770. Jean Weber De Berne en Suisse agé de 19 ans Protegé par M. Wille demeure Rue St. Severin Ché le Caffé. en 1772 Protegé par M. Vassé demeure rue des Grans Augustins à cauté d'un Traiteur.' (f. 88.)

Abraham Bloemaert, who seems to have been well known to French artists of the mid-eighteenth century (plate 189).[25] Investigating the living conditions of farm labourers and seeking inspiration from hitherto little noticed and low, 'ignoble' subjects, the drawings of Wille and his circle assume an 'ethnographic' quality. It is remarkable how much the construction of the straw hut, its building in the round, and the piling up of its segments, anticipate Webber's drawings from Cook's voyage, such as the tents of the Chukchi (plate 138; 3.270-3.272) or the hut of the inhabitants of Norton Sound (plate 145; 3.283). This interest for rural subjects was shared by Wille's students, as is apparent from a drawing by Webber's friend Sigmund Freudenberger, *Peasant scene*, 1770, (plate 190).[26] The drawing deliberately centres upon rural images, such as the thatched hut, the ladder, the debris on the ground, etc., motives which also appear in Webber's drawings.

From Webber's Parisian years a number of drawings in red crayon or brush and sepia wash have been preserved. They are all of rural subject matter. Two drawings in the British Library, kept in an album of Webber's sketches (Add. Ms. 17277, no. 66, 68) are undated but from the same period. Both show corners of peasant cottages and are almost certainly studies from Wille's sketching tours.

Cottage life is again taken up in two of Webber's drawings in the Kunstmuseum Bern (plates 191, 192).[27] The subject is expressed in different ways. Whereas the first, representing figures on the steps of a house, appears to have been based on actual observation and taken on the spot, the second is a more picturesque rendering: the woman on the back of the donkey being a fashionable motive for representing the sweeter side of rural existence — an aspect also repeated in two of Webber's drawings of 1773, now in the Städelsches Kunstinstitut, Frankfurt.[28] Here, rural activity shifts towards a more topical genre, a horseman driving cattle (plate 193), and an amorous encounter at a well (plate 194): both popular images in the eighteenth century search for an aesthetic realism in the Dutch manner, in which artists like Francois Boucher and Phillippe Jacques de Loutherbourg excelled. Drawings like these reflect Webber's interest in an alternative world outside the realm of the Parisian metropolis, but they also move away from the Wille influence. They are no mere on-the-spot drawings but professionally commendable works of the pastoral genre, concomitant with the taste of their time. As such they give a good idea of Webber's skill and interests a couple of years before his departure on Cook's third voyage.

Apart from drawing in the company of Wille, Webber visited the Académie Royale as a regular student,[29] where he also trained to become a painter in oils. This is confirmed

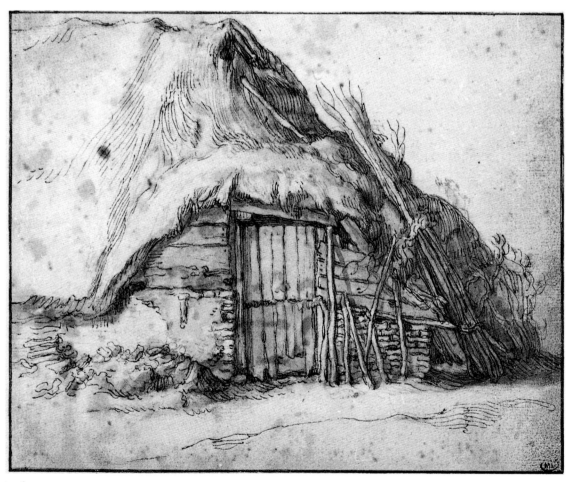

PLATE 189
Abraham Bloemaert, *Thatched Cottage*, crayon, early 17th century, 5¾ × 7¹⁄₁₆: 147 × 180. Cabinet des Dessins, Musée du Louvre, Paris. Inv. no. 31189.

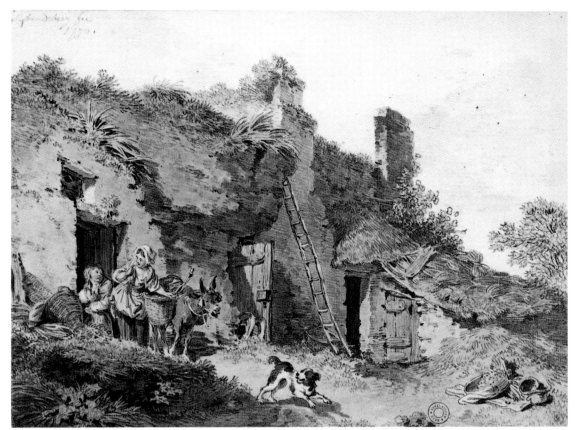

PLATE 190
Sigmund Freudenberger, *Peasant scene*,
1770, black chalk and water-colour, 9¼
× 12½ : 235 × 317. Kunstmuseum,
Bern.

PLATE 191
John Webber, *Two Children before a clay
hut*, 1771, red crayon, 8¹¹/₁₆ × 10⁷/₁₆ :
224 × 265. Kunstmuseum, Bern.

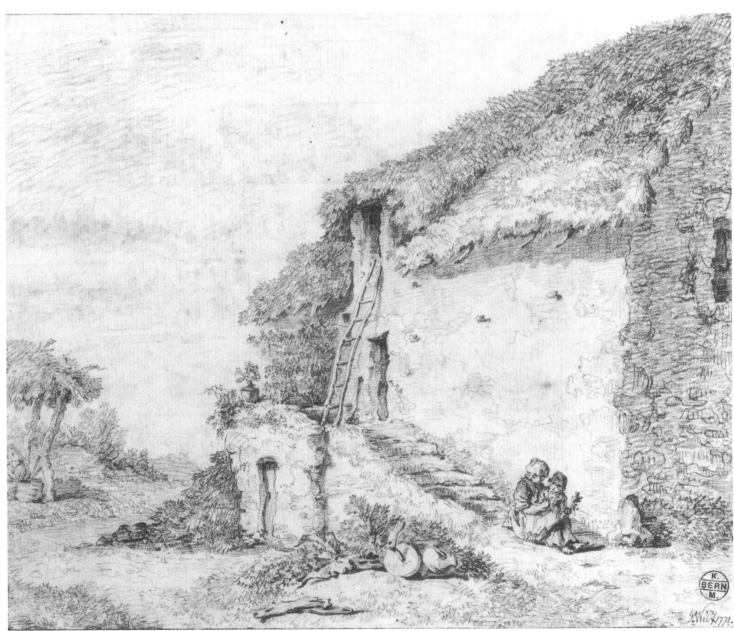

177

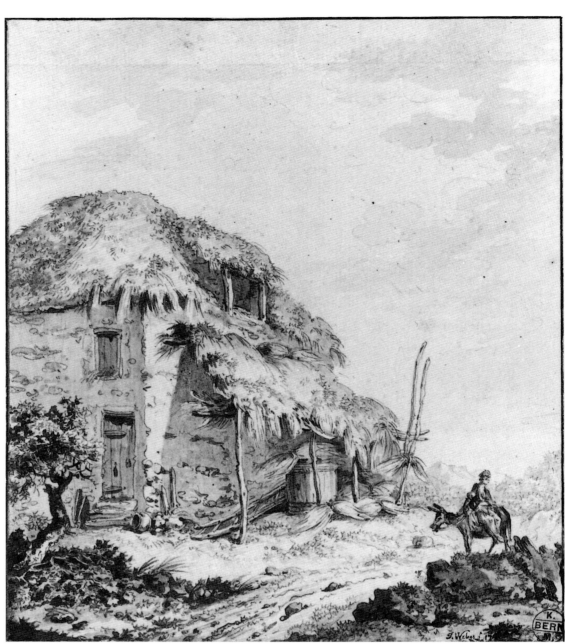

PLATE 192
John Webber, *Thatched cottage with a
donkey rider*, c. 1771, brush and sepia
wash, 7¾ × 6⅞ : 197 × 175.
Kunstmuseum, Bern.

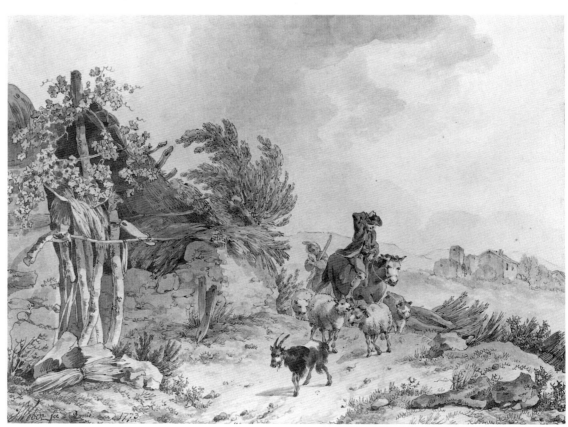

PLATE 193
John Webber, *Rural landscape with drover
and flock*, 1773, pen, and water-colour,
7⅞ × 11 : 201 × 279. Städelsches
Kunstinstitut, Frankfurt.

178

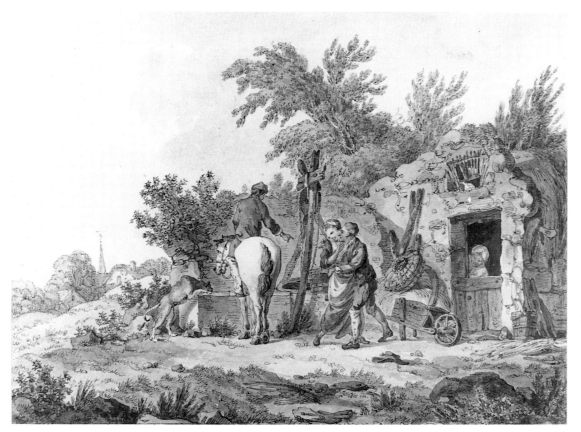

PLATE 194
John Webber, *An amorous encounter at a well*, 1773, pen, brush and water-colour, 8⅛ × 11⅛ : 206 × 283. Städelsches Kunstinstitut, Frankfurt.

by Wagner who tells of Webber's progress in painting, revealed in a 'light hand and in very pleasant colours'.[30] When, on 29 March 1774, the council of the Corporation of Merchants of Bern agreed to pay Webber another 15 'neue Duplonen' in recognition of his progress, his portraits as well as his landscapes were singled out for praise.[31]

Webber's ability in portraiture is demonstrated in his oil paintings, now in the Kunstmuseum, Bern, of a young sculptor in front of a pedestal with the marble bust of a child[32] (plate 195). He wears a grey coat and cream-coloured shirt, holds a hammer and chisel in his hands, and might be about 25-30 years of age. Though Webber still works here within the classic conventions of portraiture, utilizing a heavy green curtain and the base of a pillar, the sitter is portrayed with intimacy and kindness. Turning his body to the left and facing the viewer, he looks as if he has just interrupted his work on the bust. It has been suggested that the sitter was Henry Webber, John's brother, who became a sculptor.[33] However, the picture was probably painted in Paris, since the signature, 'J. Weber, px. 177 . . .' is characteristic of Webber's Parisian years, whereas pictures done after his return to England were signed 'Webber'. It has also been suggested, and this sounds probable, that the sitter is Johann Friedrich Funk II (1745-1811), the son of the teacher of Webber's father, Abraham. In this connection it should be remembered that Webber had belonged to the Wäber-Funk household during his formative years in Bern.[34] Funk the younger trained in Paris as a sculptor at the same time as Webber, and the picture might well have been one of those which came to the attention of the council of the Corporation of Merchants when they referred to Webber's portraits. In any case the picture seems to be the earliest known oil from Webber's hand and gives a good indication of his training.

After almost four years in Paris, Webber, aged twenty-four, returned to London in 1775 in order to continue his studies at the Royal Academy. On 8 April 1775 he was admitted as a student.[35] Visitors during 1775 were Nathaniel Dance, Benjamin West, C. Catton, E. Burch, Francesco Bartolozzi, James Barry, Nathaniel Hone, Joseph Nollekens and P. Toms;

[33] Henry Webber (1756-1826) studied sculpture under John Bacon the Elder and at the Royal Academy, receiving a gold medal of the Academy in 1776 for his relief of the *Judgement of Midas*. In 1785 he became head of the ornamental department of Josiah Wedgwood's Etruria works on the recommendation of Sir Joshua Reynolds. He was 'esteemed the first of his profession in England' (Wedgwood to Sir William Hamilton, 24 June 1786, quoted in Eliza Meteyard, *The Life of Josiah Wedgwood from his private correspondence and family papers*, 2 (London, 1866) ch. X, first page.) Between 1787 and 1789 Webber studied antique sculpture at Rome. After his return he modelled, it may be noted, the medallion of *Hope addressing the Figures of Peace, Art and Industry* by T. Medland and reproduced on the title page of *A Voyage of Governor Phillip to Botany Bay* (London, 1789). He also worked on Wedgwood's Portland Vase, and in 1795 erected a monument for David Garrick in Westminster Abbey. After the execution of a monument commemorating Henry Askew in the Cathedral of Newcastle-on-Tyne in 1801, Webber's sculptural activities slowed down. When he died on 7 August 1826 Josiah Wedgwood the Younger acted as his executor. See Rupert Gunnis, *Dictionary of British Sculptors (1600-1851)* (London, 1953) 417-18; also Margaret Whinney, *Sculpture in Britain* (Harmondsworth, 1964) 171-2, and Bruce Tattersall, 'Henry Webber: Art at the Service of Industry', *Apollo*, July 1985, 36-42.

[34] Fischer, (1961) 31.
[35] Information kindly supplied by Miss Constance-Anne Parker, Librarian of the Royal Academy, 21 December 1984. For Webber's entry into the school, see Sidney C. Hutchinson, 'The Royal Academy Schools, 1768-1830', *Walpole Society*, vol. 38, London 1960-62, no. 252, 141.

[30] Wagner (1821), 5.
[31] Burgerbibliothek Bern, Archiv der Gesellschaft zu Kaufleuten, Stuben-Manuale, vol. 15, 29 March 1774, 56.
[32] Inv. no. 1428, acquired 1935, *Führer durch die Sammlungsausstellung. Gemälde und Plastik*, Kunstmuseum Bern, 1936, no. 208; Sandor Kuthy, *Die Gemälde*, Kunstmuseum Bern, 1983, no. 257, fig. on p. 83.

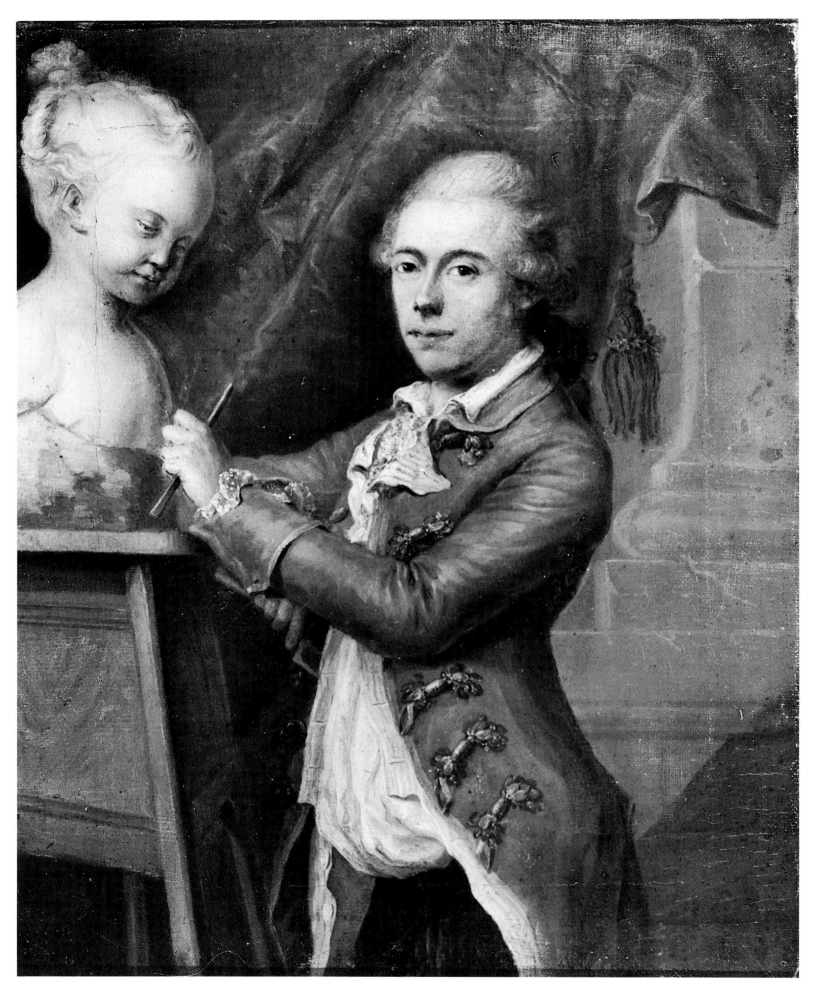

PLATE 195
John Webber, *Portrait of a Sculptor*, early
1770s, oil on canvas, 17¹¹⁄₁₆ ×
14¹⁵⁄₁₆ : 450 × 380. Kunstmuseum,
Bern.

as was customary, each of them taught for a month. In 1776 the students had Edward Penny, Agostini Carlini, Joseph Wilton, G. B. Cipriani and Francis Hayman as instructors.[36] With Bartolozzi, Cipriani, Dance and West, Webber was thus in a position to meet four artists who had varying degrees of experience with subject matter relating to Cook's voyages, either as portraitists, history painters, or engravers. Would any of them, one wonders, have influenced Webber's later career?

Wagner, the official source for Webber's biography does not mention any such contacts. Of Webber's first year in London he writes: 'In London M.[r] Webber painted a number of mythological subjects in oil as interior decorations for an architect who speculated in the building of houses which he rendered to individual tennants; the houses were finished and ready to be inhabited.'[37]

No such works are known to us and they represent a gap in our knowledge of Webber's early achievements. To some extent however, it is filled by his painting *Abraham and the three Angels*, now in the Landesmuseum, Münster, (plate 196), which was probably painted after his return to London when he used the anglicized spelling of his name.[38] It is an ambitious subject indicating his interest at the time in history painting. Sixteenth-century Italianate figures are situated in a 'Flemish' background and a basin and ewer typical of seventeenth-century French classicism are included. It all reveals Webber's eclectic search for a coherent style, but the result is laboured. Not only the grand style preferred by the Academicians at this time but also the necessities of life may have forced Webber to try his hand at 'history', though no doubt he felt happier with less powerful subjects that allowed more for observation and spontaneity.

In 1776 Webber's employer suggested he should participate in the annual exhibition of the Royal Academy, and Webber sent in a 'Portrait of an artist', together with 'Two views

[36] Miss Constance-Anne Parker, *in litt.* 24 September 1984.

[37] Quoted from the Wagner papers of 1816, (fn. 2).

[38] F. Koch, *Verzeichnis der Gemälde im Landesmuseum der Provinz Westfalen* (Münster, 1913) 135. The year and the circumstances of acquisition of this painting are unknown.

PLATE 196
John Webber, *Abraham and the three Angels*, c. 1775/1776, oil on canvas, 35⁷⁄₁₆ × 45½ : 900 × 1150. Landesmuseum, Münster.

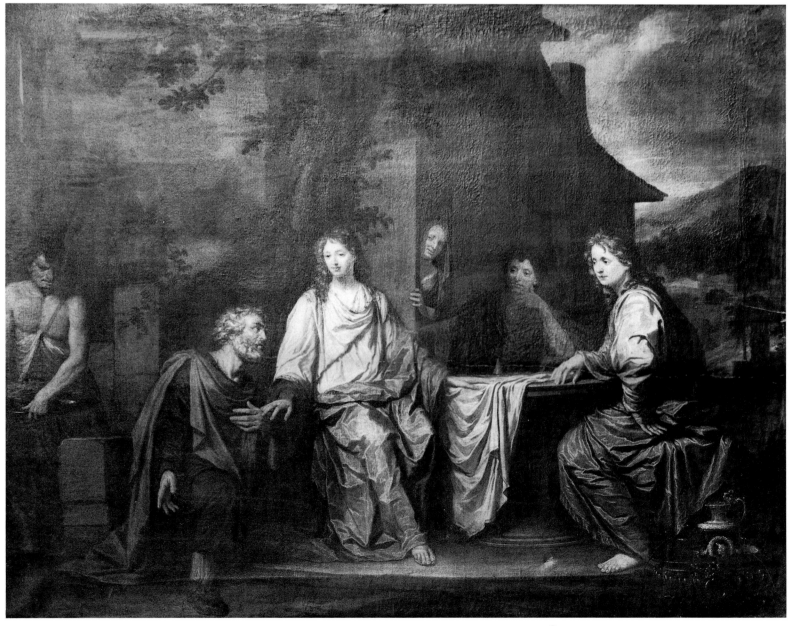

[39] Algernon Graves, *The Royal Academy of Arts, a complete dictionary of contributors and their work from its foundation in 1769 to 1904*, vol. 8 (London, 1906) 186.

[40] Douglas Cole, *John Webber: A Sketch of Captain James Cook's Artist* (1979) 19.

[41] Cf. *Philippe Jacques de Loutherbourg, RA, 1740-1812*, exh. cat. Kenwood, The Iveagh Bequest (Joppien, 1973) cat. no. 22. The belief that Webber was among the sitters portrayed is based on an old tradition, and is mentioned in Algernon Graves, *Art Sales from early in the Eighteenth Century to early in the Twentieth Century* (London, 1918-21); see vol. 1 under de Loutherbourg sale, 9 July 1887, 215.

[42] Cole, *John Webber: A Sketch of Captain James Cook's Artist* (1979), 19-20.

of the environs of Paris'.[39] 'This was Webber's first exhibition in his home country, a country where he had absolutely no reputation, no influential friends, barely any acquaintances, and to which he had scarcely returned after an absence since childhood. Yet chance smiled upon him.'[40] Whether Webber was as lonely as is here suggested is open to question. He certainly knew the engraver William Byrne, who had worked in Wille's studio and had been entrusted with a number of engravings for the publication of Cook's first and second voyages. It is also thought that Webber was in touch with the Alsatian painter Philippe Jacques de Loutherbourg, into whose painting *A Winter Morning with a party skating*, signed and dated 1776, Webber was introduced together with some other friends of de Loutherbourg.[41]

In a decisive turn of events for him, Webber's exhibits at the Royal Academy attracted the attention of Daniel Carl Solander, particularly his 'Portrait of an artist' said to have been a drawing of his brother, Henry Webber. Unfortunately the work has never come to light, but a drawing that probably gives some impression of Webber's style in portraiture at that time is the profile of a young man preserved in an album of Webber's sketches, mostly from the third voyage (plate 197).

The drawing is executed in black pencil and chalk and is full of artistic promise. The profile is firmly drawn, with a beautiful sculptural effect, while the shading of the eye and modelling of the hair possesses a sensitive, almost lyrical, quality. Was this the kind of work on the basis of which Webber was recommended?

In any case, Solander went to Webber's house, proposed that the young artist accompany Cook on his third and last voyage and arranged for Webber's introduction to the Admiralty. As Douglas Cole puts it:

> The standard Swiss account tells the story very dramatically: two days after the pictures went on view, Solander came to Webber's rooms, 4, Down Street, Piccadilly; eight days later Webber embarked from Plymouth on Cook's *Resolution*. While the appointment was done swiftly and only shortly before the ship departed, it was not quite this way. The exhibition ran from April 24 to May 22. Webber received his Admiralty appointment on June 24; he joined the *Resolution* at Plymouth on July 5, and it sailed for the Cape seven days later.[42]

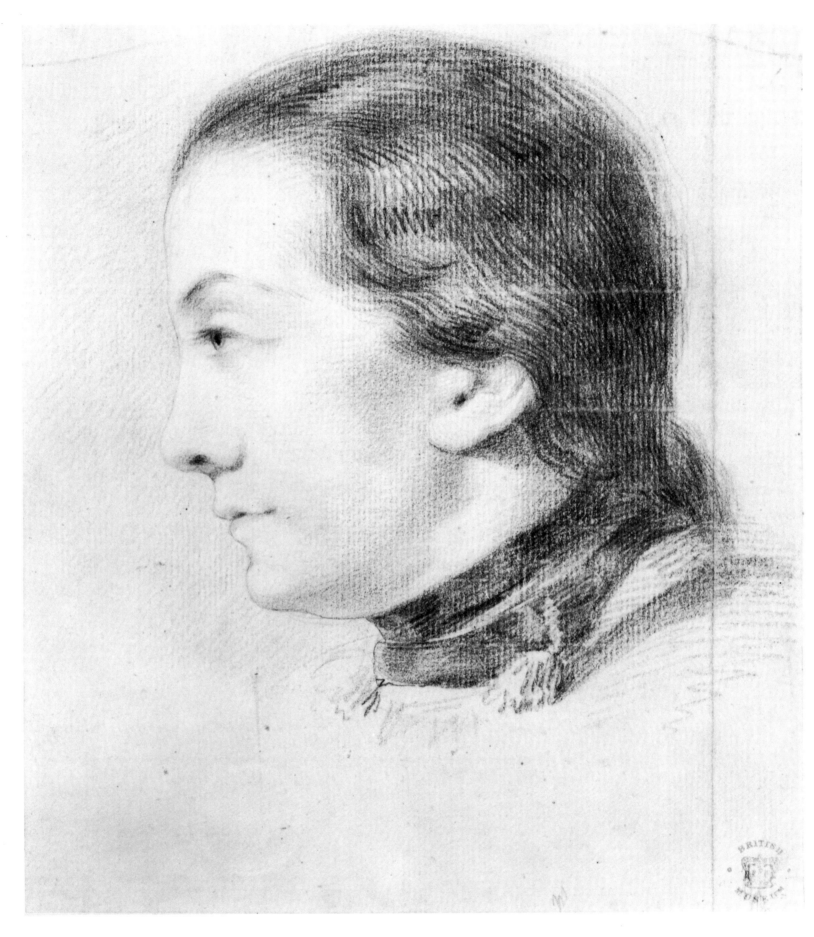

PLATE 197
John Webber, *Portrait of a Young Man*,
c. 1776, pencil, 8 × 6¹⁵⁄₁₆ : 203 ×
176. British Library, London. Add MS.
17277 no. 6.

183

# Growing reputation in London: 1780-1785

Before the publication of the official account, only a few people in London knew of the existence of Webber's drawings, and less had access to them. While publication was in progress, all records of the voyage were considered 'classified' material. Apart from the King, Sir Joseph Banks, the Lords of the Admiralty and the engravers, among those privileged to see the drawings was Fanny Burney.

> We went to Mr. Webber's to see his South Sea drawings. Here we met Captain King who chiefly did the honours, in showing the curiosities and explaining them. He is one of the most natural, gay, honest and pleasant characters I ever met with. We spent all the rest of the morning here, much to my satisfaction. The drawings are extremely well worth seeing; they consist of views of the country of Otaheite, New Zealand, New Amsterdam, Kamschatka and parts of China; and portraits of the inhabitants done from the life.[1]

So deep was the impression Webber's drawings made on Fanny Burney that she remembered them vividly ten years later while on a visit to Devonshire:

> Here we saw a sight that reminded me of the drawings of Webber from the South Sea Isles; Women scarce clothed at all, the feet and legs entirely naked, straw bonnets of uncouth shapes tied on their heads, a sort of man's jacket on their bodies, and their short coats pinned up in the form of concise trousers, very succinct, and a basket on each arm, strolling along with wide mannish strides to the borders of the river, gathering cockles, they looked indeed, miserable and savage.[2]

Doubtless over the years many such curious visitors[3] visited Webber's house, first at 3 Bolsover Street, and then at 312 Oxford Street, to see his drawings and interesting collection of Pacific artefacts, and carried away varied impressions.[4] One such visitor was the *ingénieur* Monneron. The Archives Nationales, Fonds Marine, Paris hold his letters written from London on 11, 12, 13 and 14 April 1785, containing information he obtained from Webber.[5] Monneron was an elected member of the ill-fated French expedition around the world (1785-88) under the command of Jean François Galaup de La Pérouse (1741-1788) and as such was deeply interested in the results and experiences of Cook's third voyage. La Pérouse and the organizers of the French voyage regarded Cook's voyages as a model on which they should shape their own. Monneron made contact with Webber on the pretext of having his portrait painted and while sitting to him took the opportunity to question Webber. Though Monneron does not say so, it is likely that he saw some of Webber's drawings and artefacts. Webber gave him a feathered necklace, presumably of Hawaiian origin. Monneron was fired by Webber's stories. 'I assure you' he wrote to La Pérouse, 'that his conversations are most interesting. As I know you might be curious, I shall be pleased to describe them to you'.[6] Monneron was greatly interested in two questions: the nature of the food and drink Cook gave his crew to prevent scurvy; and the kind of objects acceptable to Pacific islanders in trading. Both questions were adequately answered by Webber, in whose company Monneron visited a number of shops where he bought knives, beads, mirrors, and needles for trading, as Webber advised. Specimens were then sent to France.[7]

[1] Burney (1904-05), 1, 466.

[2] ibid., entry for 16 August 1791, 5, 18-19.

[3] One of them was Georg Forster, accompanied by the young Alexander von Humboldt, see above p. 00; also Georg Forster, *Werke in vier Bänden*, ed. by Gerhard Steiner (Leipzig, 1971) vol. 4, 605; and Joppien, (1976a).

[4] The addresses are quoted first in an undated letter of early September 1782 by J. King to Lord Sandwich (NLA, MS 7218/16), and then in the exhibition catalogues of the Royal Academy from 1784 onwards. Webber lived at the Oxford Street address until his death in 1793.

[5] We have worked from copies of the French text in the Mitchell Library, Sydney, B. 1207 ('La Pérouse', Voyage 1785-8, Stores, Letters, Reports &). For a transcription of Monneron's letters see Appendix 5.

[6] Letter of 11 April 1785.

[7] La Pérouse was very conscious of the moral support he received from the English and had profound admiration for Cook's achievement. He refers to it in his journal: 'Je dois ici témoigner ma reconnaissance au chevalier Banks, qui, ayant appris que M. de Monneron ne trouvait point à Londres de boussole d'inclination, voulu bien nous faire prêter celles qui avaient servi au célèbre captaine Cook. Je reçus ces instruments avec un sentiment de respect religieux pour la mémoire de ce grand homme.' (Milet-Mureau, 1797, vol. 2, 8.)

Webber's portrait of Monneron reminds us that he continued to practise portraiture after he returned from the Pacific. Some years prior to painting Monneron, he had painted the portrait of Dr John Douglas,[8] Cook's editor, and he had, of course, also painted the portraits of Captain Cook and Captain King (plates 198, 199). Indeed, his practice as a portraitist was continuous[9] and a portrait of an African boy in the Historisches Museum, Bern, signed and dated 1792 (or 1793)[10] indicates that he continued to practise portraiture until the end of his life (plate 200).

However, it was in the field of landscape that he excelled. On his return from the Pacific he was drawn more and more to the landscape of the British Isles, while continuing to depict from his earlier studies (one might almost say exploit) the scenery of the South Seas. For such work he found several outlets. One was the production of the stage spectacle 'Omai, or a trip round the world' in which Webber participated with de Loutherbourg in creating the designs and stage scenery. It opened its long and distinguished run at Covent Garden on 20 December 1785. A clever popularization of Cook's voyages, centred on the historical Omai and constructed on the traditional pattern of a Christmas pantomime, it took London by storm. Several of its landscape scenes and costumes were based upon Webber's drawings. He acted as a paid consultant and may have been responsible for some of the costume designs. The pantomime blended the attractions of art and science, transporting its exotic subject matter into the glamour and drama of the theatre.[11] With it, doubtless, Webber's reputation as Cook's artist spread beyond the learned circles of London society.

[8] Nicol to Banks, 23 October 1783: 'I called a day or two ago at Mr. W. and there found Dr. Douglas sitting for his portrait . . .' British Library, Department of Mss, Add. MS 33977 f. 226, see p. 166, fn. 60.

[9] A number of Webber's portraits in oils from Cook's third voyage are listed in Webber's sale catalogue of 1793 (Webber, 1793). Among them are no. 85: 'Five portraits in oil colours, from Cook's voyage', no. 86 'Four ditto', no. 88 'Captain Cook's portrait, a small ditto', no. 91 'A portrait of a chief of the Sandwich Islands . . .', no. 92 'Three ditto, chiefs of Otaheite . . .', no. 93 'Two portraits of Sandwich Islands and Otaheite', no. 94 'Three large portraits of Cook's voyage', (2nd day, p. 10).

[10] It may be tentatively identified as an Hottentot of about fifteen years-of-age. The painting is mentioned by Adrienne Kaeppler (1978b, 21), but it is not known precisely what circumstance led to its creation. It may depict an African visitor to England, or have been developed from a lost study of an African made during the voyage. The painting has an unfinished appearance.

[11] Joppien (1979).

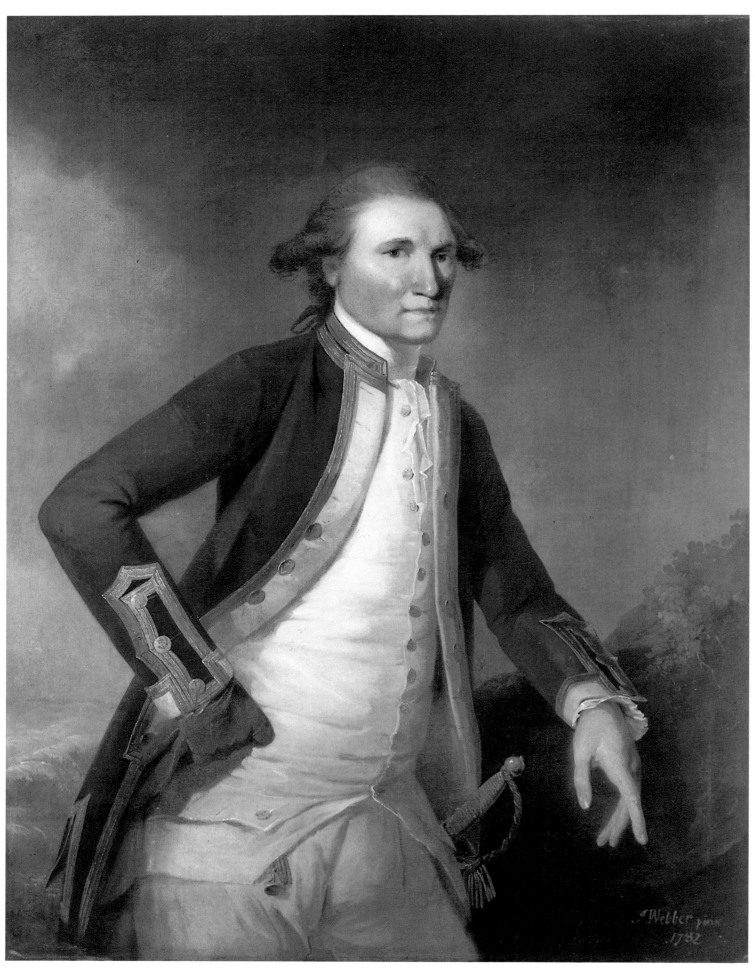

PLATE 198
John Webber, *Portrait of Captain James
Cook*, 1782. Private collection,
Australia. (3.452)

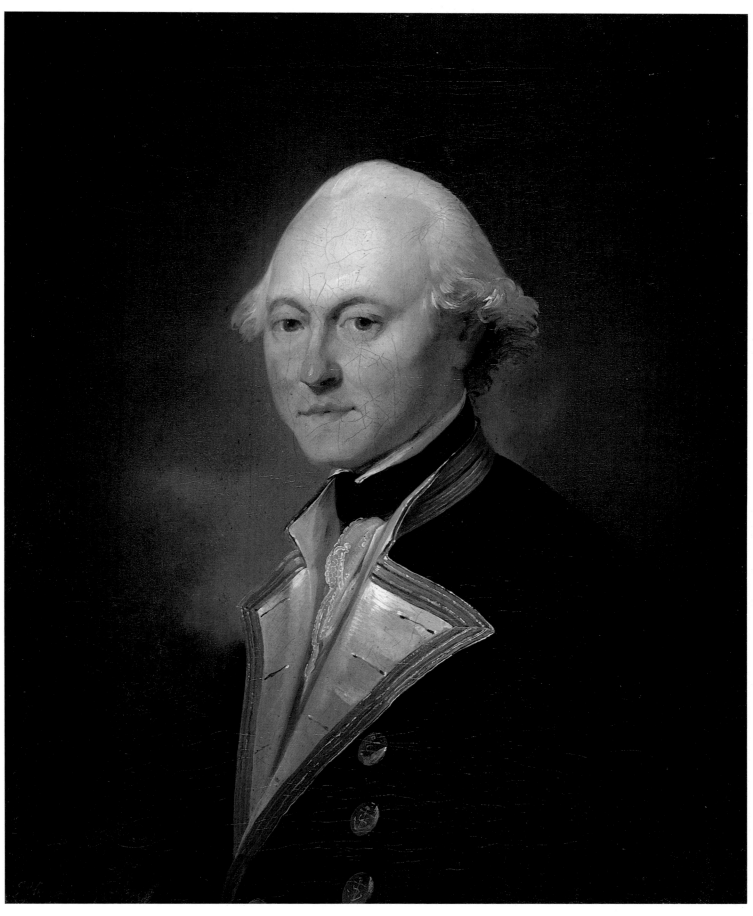

PLATE 199
John Webber, *Portrait of Captain James King*, 1782. National Library of Australia, Canberra. (3.456)

187

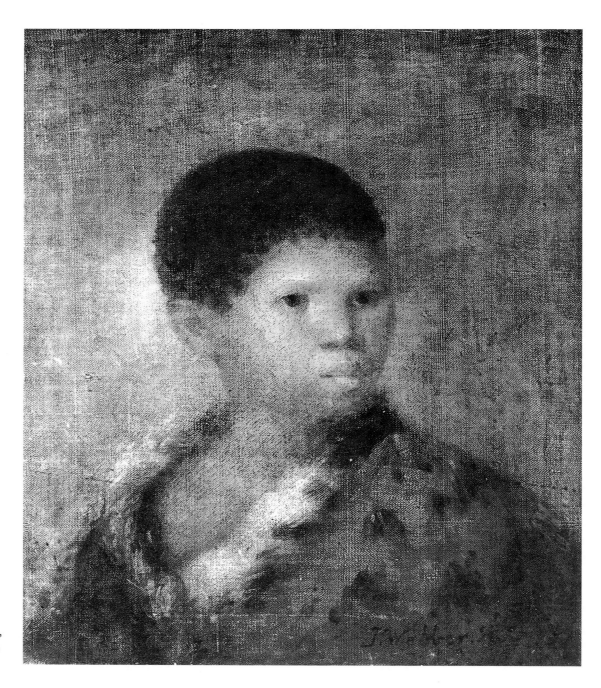

PLATE 200
John Webber, *Portrait of an African Boy*,
1792, oil on canvas, 20⅝ × 17¾ : 524
× 452. Historisches Museum, Bern.

188

# Exhibits at the Royal Academy: 1784-1791

From 1784 onwards Webber exhibited paintings and drawings of Cook voyage interest at the Royal Academy. In 1784 he exhibited *A Party from his Majesty's ship Resolution on Capt. Cooke's last voyage shooting Sea-Horses, latitude 71 north in the year 1778* (plate 142; 3.280) and also two views of Pulau Condore. These were the earliest of his pictorial records of the voyage to be publicly displayed and it is significant that Webber was apparently given permission by the Admiralty to show them a month or two ahead of the publication of the official account of the voyage. With publication imminent Webber's paintings might well have been regarded as an ideal advertisement for the forthcoming publication.

A *Party shooting Sea-horses* certainly struck a sensational note. Perhaps never before had sea-horses (walrus) been the subject of an English painting, and it possessed that additional element of terror of ships enclosed by ice — a chilling foreboding of the adventurous stories soon to be released. The *Morning Post* for 4 May 1784 called the picture a 'most extraordinary scene, and probably well expressed. There is, however, nothing very painter-like in the execution'. The two views of Pulau Condore were probably intended to establish contrast. Though they have not been identified precisely we may assume that their tropical subject matter created a general effect that was light and pleasing. At any rate Webber continued such an approach for the Academy of 1785. The official account of the voyage had been published six months before, so that now there were no constraints on voyage material. The net of Pacific peoples and places was cast widely. The far east again featured prominently in four paintings: *A View in Macao, View in Cracatoa, An island in the China seas,* and *View in Macao, near the entrance of the river Canton, China.*

At that time China and the China Sea were more familiar to Academy viewers than was New Zealand, Hawaii or Alaska. China was better known to Europeans and the difference between the European and the Chinese landscapes was not so marked as for the little known regions of the Pacific. Nevertheless pictures of a more exotic cast were exhibited, including: *Picturesque scene, in Nootka (or King George's Sound), west coast of America,* and *Poedua, daughter of Oree, chief of Ulaietea, one of the Society Isles* (plate 79; 3.149). The news concerning the great wealth of fur on the north-west coast of America, and the current interest being taken in founding companies for the fur trade and fitting out ships for the purpose would have made the former picture of current interest. It is probably the painting now in the Yale University Art Gallery (3.213). The portrait of Poedua was Webber's first picture of South Seas interest to be shown at the Academy. When we recall the erotic images of the Pacific that had become current in England since the publication of Hawkesworth's *Voyages* it is not surprising that he chose to exhibit the portrait of a sensuous beauty with heavy black curls and brown skin, bare to the waist; the flowers in her hair and innocent melancholy were a symbol perhaps of the natural state of civil society.

Webber also exhibited three views in 1785: in Nootka, Kamchatka and Tahiti, and the review in the *Morning Post* was more lavish in its commendations than the previous year. There is now not only praise but some astonishment and critical assessment:

No. 26. View in Macao, Webber. A very well finished painting but with great poverty in the design. (30.4.1785)

No. 110. Picturesque Scene in Nootka, on the Western Coast of America. This may be a natural representation (and there are few persons who can question it) but if so, it is of an extraordinary country. The rocks are so smooth as marble, and at the same time green as the foliage of the trees. The water too runs over the craggy stones without rippling. The figures however are good, and the picture, upon the whole has effect. (7.5.1785)

No. 211. View at Cracatoa. Webber — This landscape has great sweetness of pencil and delicacy of colouring. It is remarkable that not one of the works of this ingenious artist is placed in a favourable situation. (11.5.1785)

No 231. View at Macao. Webber — Beautifully picturesque and romantic: the rocks and the water in particular are executed with great boldness and at the same time with the most exact conformity to nature. (17.5.1785).

Upon a retrospect of the works of several artists we must consider apart from the others, Sir Joshua Reynods and Mr. Loutherbourg; nor does any one follow them unless magno intervallo . . . After Loutherbourg Webber has distinguished himself as the best landscape painter, in which line Wheatley also holds a respectable rank. (26.5.1785)

Nothing can emphasize more strongly the recognition which Webber enjoyed that year than the handsome praise paid by the Academy's President. On 30 May 1785 Sir Joshua Reynolds wrote to the Duke of Rutland:

He [Webber] is much in the habit of taking Views from Nature, some of which are in the exhibition, which he did from drawings he made when he was with Captain Cook; They are excellent pictures, and I am sure Your Grace will approve of his manner of painting.[1]

[1] Reynolds to the Duke of Rutland, 30 May 1785, quoted from *Letters of Sir Joshua Reynolds*, F.W. Hilles (ed.) (Cambridge, 1929) 123.

Praise of this kind from Sir Joshua is unexpected, in the light of his known low esteem for landscape painting. Was he just being kind to a fellow-artist, who had distinguished himself in the service to his country, who had been presented to the King and had received the confidence of the Lord Commissioners of the Admiralty? Or does his judgement indicate a change of attitude? Was he at the end of his life prepared to reconcile himself with the existence of a topographical school, which was predominantly British in subject-matter? At any rate a change of thinking from the Grand Style favoured by Sir Joshua to the more homely aspects of landscape and topography is most certainly present in a newspaper comment in the *Morning Post* of 14 November 1785 on the occasion of Webber's election as an Associate of the Royal Academy,[2] on 8 November 1785.

[2] Webber was elected an Associate with 9 votes against William Hodges and J. Bonomi, who both received 4 votes (General Assembly Book, Royal Academy, vol. 1, f. 192). Webber had been suggested as an associate the year before but was defeated by Thomas Banks, the sculptor, and William Hamilton (C.F. Bell, *Annals of Thomas Banks, Sculptor, Royal Academician* (Cambridge, 1938) 66).

The election of Mr. Webber as an associate in the Royal Academy, is a proof that the shameful and indecent partiality of the *Italian Junto* which has so long and so improperly affected the counsels of that institution, begins somewhat to subside. These ungrateful men are not satisfied with having procured situations, to which artists of this country by abilities, as well as other solid pretensions, are more fairly entitled, but endeavour, upon all occasions, to depreciate British countrymen, without any regard to honour, principle or decorum. Two or three individuals of the mean, paltry and invidious faction alluded to, have peculiarly distinguished themselves in this shameless monopoly: and unless some speedy reformation appears, a few strokes, descriptive of their character and conduct, shall be given to the public, which will shew malignity, ingratitude, and envy, in such colours as must always be viewed with indignation, while there is a spark of virtue and dignity in the human heart.

In 1786 Webber submitted six paintings and two drawings to the Royal Academy, based as before on his voyage material. The *Morning Post* apparently makes no mention of them. One of the paintings, *View in Ohaite Pecka Bay, in Otaheite* is most probably the painting now in the Art Gallery of New South Wales, Sydney, signed and dated 1783 (3.87). If the many versions which Webber made of this scene are any indication, it was one of Webber's most successful subjects. Water-colour versions are in the British Library (3.86), and the Dixson Galleries, State Library of New South Wales (3.88, 3.89). Oil paintings, apart from that already mentioned are in the Honolulu Academy of Arts (3.90), and the Royal Academy, London (3.91). On 1 August 1791 Webber published a coloured softground etching of the view. He was quick to realize that if he wanted to be successful with the public his pictures had to be 'decorative', so he chose subjects and scenery attractively exotic and of tangible beauty. In most of his paintings the human element plays only a subordinate role, the emphasis being placed upon the surroundings. Only pictures like *Natives of Kamchatka, Poedua* and *The Chief of the Sandwich Islands* (exhibited in the RA of 1787) focus on the human figure and the portrayal of Pacific Islanders. Making records of the physiognomy, costumes and ornamentation of Pacific peoples had been one of Webber's prime functions during the voyage, and this is duly reflected in the illustrations of the official account. However, exhibiting such works at the Royal Academy was a different matter. Its information would have been too specific and of little general interest. His pencil drawings had fulfilled the task of 'reporting' and conveying information and ideas to the learned but his landscape paintings sought wider appeal. Tranquil bays or shaded clearings, the tranquillity of sailing boats on the ocean, or the solemnity of an exotic funeral function offered nourishment for wonder and association. In almost all of his representations, the note which is struck is a peaceful one and the setting gloriously picturesque.

It would seem that Webber prepared his audience only gradually for this new world. In the RA exhibitions of 1784, 1785 and 1786 he showed eight subjects which were either taken from Macao, Pulau Condore or Cracatoa, though they were of relatively little importance to the voyage as a whole. On the other hand they were important for the European perception of Asia. It is only from 1786 that the balance of subjects Webber exhibited turned in favour of the Society and Friendly Islands. These of course had been visited on all three voyages and had become increasingly appreciated and understood by visitors to Academy exhibitions. However, not all critics were convinced about the validity of Webber's representations. When he exhibited the picture of A Scene in the Friendly Islands, with a Woman playing on the Nose Flute at the RA of 1787, the critic of the World (7 May) snapped: 'Webber unquestionably has much merit. But why not employ himself on objects that may interest? On such dreary nonsense as the Nose Flute etc, etc or the Pacific Ocean who can waste a moment, however he may design with truth and finish with beauty.'

Was the medium of painting not yet appropriate for the exotic subject matter he represented? Were the sights of the unknown world of the Pacific more easily accepted in works on paper? This idea is suggested by the review in the St James Chronicle (24-27 May 1788): 'This gentleman's Drawings are preferable to his Paintings: They are free, clear and highly finished.'

Acquainting the audience with bizarre views of the other side of the globe cannot have been a straightforward undertaking, and a great deal of tact and a bow towards public taste was required. How else can we account for the fact that among the forty-seven paintings and drawings exhibited between 1784 and 1793 only one subject from the Sandwich Islands was shown? The Sandwich Islands was of course a major discovery of the third voyage and from the point of landscape was also highly attractive. However, the death of Cook had given it a tragic notoriety, and Webber appears to have been most careful that nothing should disturb the pleasant and gentle view of the Pacific as an arcadia. The one Hawaiian picture, is most probably identical with the one now in the National Library of Australia, Canberra (plate 154; 3.313). Webber's painting of the Death of Cook was likewise not exhibited, though as a history painting it would have received extensive comment. Webber preferred to popularize it through Bartolozzi's and Byrne's print of it. On the other hand there is a close relationship between Webber's RA paintings and several of his softground etchings Views in the South Seas. It is as if the paintings provided a test case for the success of the subject-matter. There is for example Webber's painting of Cook's Cove in Queen Charlotte Sound, New Zealand (3.20) which may be his View of Queen Charlotte's Sound, New Zealand (RA 1789, no. 212). From this picture Webber published his etched View of Queen Charlotte Sound. Other views, of Raiatea, Macao, Tahiti, or the boats of the Friendly Islands were also featured as print-subjects.

In a number of cases the titles of paintings which Webber exhibited are remarkably close to titles of those in the etchings. We may expect other paintings to come to light which relate closely to the Views. Indeed the Views may have been published as a kind of substitute for the oil paintings, and geared to a print collector's market of a wider and less expensive appeal. In this, after all, Hogarth had already shown the way. We can only conclude that Webber carefully selected the paintings he exhibited, and consciously omitted disagreeable subject matter. His art, one feels, was less controversial than that of Hodges some ten years earlier and he desired it to be so. It was probably this consideration that became the key to his artistic and financial success.

In 1791 Webber was elected a full member of the Royal Academy.[3] For his diploma piece Webber chose a version of his views in Vaitepiha Bay, a re-make of earlier pictures (3.91) but in its choice certainly of programmatic importance. Consciously topographical, the picture is also the epitome of a shaded, sequestered, almost mysterious region, the two figures in the front creating the pensive mood of an arcadian nowhere. The South Seas are represented in a suave, romantic way and invested with the contemporary ideas of an earthly paradise. Within the picturesque framework of a Pacific reality, a new topos of the ideal is created.

At the age of thirty-nine Webber was at the peak of his career. Of all members of the Academy, indeed of all English artists, Webber had travelled the most widely and witnessed the greatest diversification of landscapes throughout the world. In this, it was only Hodges, another of Cook's artists, who could be compared with him. He had drawn landscapes in the tropics as well as in the northern ice, in Northern Italy, Switzerland and Britain. The recognition of his merits with a full membership of the Academy, indicates a major break-through in the appreciation and recognition of exotic landscape painting in Britain at the end of the eighteenth century.

[3] Webber received 18 suffrages against 12 for the next best competitor Ozias Humphrey (General Assembly Book, Royal Academy, London, vol. 1, f. 256).

# Views in the South Seas: 1786-1820

[1] Thieme/Becker state that she settled down in London in 1786, thus her collaboration with Webber may be counted as among the earliest works she did after her arrival. She did an aquatint after W. Hodges's *Landscape, The Retreating Shower*, published on 31 May 1790 by R. Pollard; it is interesting that the print bore the text of a poem by Henry James Pye and a dedication to Sir Joseph Banks. In 1787 she aquatinted P. J. de Loutherbourg's *View of Black-Lead Mine in Cumberland* (published 1788).

[2] Duplessis, (1857), vol. 2, 145-6 (translated from the French).

[3] ibid., 146.

In early 1786 Webber began to work on his series of etchings of South Sea scenery, from drawings not made use of in the official account of the third voyage. Presumably the success of his paintings at the Royal Academy in 1784 and 1785 encouraged him in the venture.

Apparently the first subject to be etched was *A View in Otaheite*, published on 1 November 1786. The known version of this etching is not coloured, and we do not know whether coloured ones were sold at that stage. The print bears the inscription 'Publish'd as the Act directs, Nov.r 1st 1786 by J Webber N.o 312, Oxford Street' (3.120Aa).

It was again published on 1 February 1787 as an aquatint, under the title *A View in Matavai, Otaheite* (3.120Ac). Looking at Webber's fine water-colour of that scene in the British Library (plate 70; 3.119), there can be no doubt that the drawing represents one of the most romantic and tropical scenes encountered during the voyage. Webber's outline etching of 1786 does not do justice to the quality of the drawing, and we may presume that he was looking for a printing method which allowed greater freedom and a wider range of evocative tones of light and shade. The aquatint is the beginning of Webber's short-lived co-operation with Marie Catherina Prestel, an aquatint artist of some note, who had recently come to London from Frankfurt.[1] We know of three other South Sea views executed in collaboration with Prestel, that also appeared on 1 February 1787: *View in Ulietea* (3.157Ab), *A View in Annamooka, one of the Friendly Isles* (3.44Aa,b) and *A View in Pulo Condore* (3.397Ac). Prints of two of these, the *View in Ulietea* and the *View in Annamooka* are also known with inscriptions referring to 1 February 1788, but it is probable that these were later prints taken from the plates which had been executed at the beginning of the previous year.

Among the three paintings which Webber exhibited at the Royal Academy of 1787 were two which relate to his aquatinted views issued in that year: no. 72 *A Scene in the Friendly Islands, with a Woman playing on the Nose Flute* and no. 143 *View in the Island of Ulietea, one of the Society Islands*. It seems that the exhibition of the paintings and the parallel publication of the prints were carefully staged events.

In the early summer of 1787 Webber visited Paris to see his old teacher J.-G. Wille, then travelled to Switzerland and Italy. Webber's visit and his publication of the South Seas prints were recorded in Wille's diary:

> On 1st June 1787, M. Webber, this old friend of mine, who had taken part in the circum-navigation of that famous Captain Cook in the quality of draughtsman and engaged for this task by the Admiralty of Britain, came to see me immediately after his arrival from London. As soon as he introduced himself — he had changed quite a bit — we embraced each other most cordially. M. Guttenberg, having returned from London and being very pleased with his trip, came immediately to see me. He brought me several prints, which M. Webber had entrusted to him, and which the artist had etched himself after his drawings brought back from his voyage around the world with Captain Cook. He was on the spot when this famous navigator was killed on the Sandwich Islands. Those etchings have been washed (lavées) in bistre by Madame Prestel, who is actually now in London but her husband has remained in Frankfurt.[2]

On 28 June Wille wrote again:

> M. Webber, after he has supped with me a number of times, has now come to say Good Bye. He is going to Berne to see his parents [relatives]. He has promised me, the good friend, that he is, after his return to London, to send me one of his drawings of the harbour of one of those islands which were discovered during the circumnavigation. The voyage lasted for 4 years and three months. He has told me some quite unbelievable stories about this voyage.[3]

Wille no doubt discussed the prints which Webber had published so far. It is possible that he suggested the new technique of softground etching to Webber. Though on 1 February 1788 two of M. C. Prestel's aquatints were still issued, Webber severed his professional relationship with her and set up his own prints in the new technique. He thus became one of the earliest artists to use this technique in England.

On 1 August 1788 Webber issued the first three softground etchings which were later to become known as *Views in the South Seas*: the *View in Macao* (3.372Aa), the *View in Macao, including the Residence of Camoens . . .*(3.372Ba), and *The Fan Palm, in the Island of Cracatoa* (3.415A). They are the first three of a series of sixteen views which he published in an uneven sequence until 1 August 1792. Following the first three, the others were published on:

— [1] November 1788: *The Plantain Tree, in the Island of Cracatoa* (3.414A)
— 1 July 1789:      *Waheiadooa, Chief of Oheitepeha, lying in State* (3.95A)
                          *View of the Harbour of Taloo in the Island of Eimeo* (3.138A)
                          *The Narta, or Sledge for Burdens in Kamtchatka* (3.340A)
                          *View in the Island of Cracatoa* (3.410Ab)
— 1 October 1789:  *A Toopapaoo of a Chief with a Priest making his offering to the Morai, in Huoheine* (3.146Aa)
— 1 October 1790:  *View in Queen Charlottes Sound, New Zealand* (3.21Aa)
— 1 August 1791:  *A View in Oheitepeha Bay, in the Island of Otaheite* (3.92Aa)
                          *Boats of the Friendly Islands* (3.73Aa)
— 1 August 1792:  *A View in the Island of Pulo Condore* ((3.397Ad)
                          *A Sailing Canoe of Otahaite* (3.133Aa)
                          *The Resolution beating through the Ice, with the Discovery in the most eminent danger in the distance* (3.276Aa)
                          *Balagans or Summer Habitations with the Method of Drying Fish at St Peter & Paul, Kamtschatka* (3.362Aa)

The etchings are titled and inscribed with the author's line 'J. Webber fecit', either with the monogram 'R.A.' or without, according to the date of their publication, pre- or post-1791. Each etching has a reference also to the volume and page number of Cook/King's third voyage account, on which the incident depicted is described.

The unusual number of sixteen views and the fact that no cover was provided for them suggests that the series was left unfinished in 1792. The etchings show pictorial motifs which had not been used in the official publication. They represent Webber's personal choice of South Seas material in which, as has already been mentioned above, the human element is largely subordinated to the tropical surroundings and characterized by peaceful, passive occupations. Unpleasant elements were deliberately avoided. The South Seas was thus rendered as an alternative, happy and carefree, utopian world. South East Asia and the Society Islands again figure prominently among the views with the Friendly Islands, Kamchatka and New Zealand following in second place. Striking again is the exclusion of motifs from the Sandwich Isles, as if nothing should disturb the pleasant and gentle picture of the Pacific world.

Webber's undertaking to publish a select number of travel images was not yet common practice. Apart from Sydney Parkinson's *Journal* and a number of his drawings which had been published posthumously by Sydney's brother Stanfield, and various series of Russian folk characters in the dress of their country by J. B. Le Prince (c. 1764-68) there was then no living tradition of travel art to promote the representation of and reflections about exotic countries in the little known parts of the world. The work of earlier travelling artists who come to mind, such as John White, Jacques le Moyne or Frans Post, was turned into engravings by other publishers. The idea that the artist himself should undertake responsibility for selecting the pictures, apparently only became established practice with Webber's *Views*. Shortly afterwards it was adopted by William Hodges and the Daniells in their publications concerning India, but the field was really left to nineteenth century artists to fully exploit. According to Martin Hardie 'the years 1790 to about 1830 form the great period of coloured aquatint illustrations — the golden age it may be called — of coloured books in England.'[4]

The views which Webber selected were rendered in pencil and squared for transfer.[5] In early 1984 the London dealers Eyre and Hobhouse (now Hobhouse Limited) offered five pencil drawings of the following subject matter:[6]

1 A *View in Queen Charlottes Sound, New Zealand* (published 1 October 1790) (3.21)
2 *Boats of the Friendly Islands* (published 1 August 1791) (3.73)
3 A *Sailing Canoe of Otahaite* (published 1 August 1792) (3.133)
4 A *Toopapaoo of a Chief, with a Priest making his offering to the Morai, in Huoheine* (published 1 October 1789) (3.146)
5 *The Narta, or Sledge for Burdens in Kamtchatka* (published 1 July 1789) (3.340).

The drawing of the Toopapaoo (no. 4) is inscribed in pencil in Webber's hand: 'Topapao of a chief with a priest making his offering of red Feathers to the Eatooah or Diety'. None of the drawings are signed or dated. They measure between 30.5 × 44.7 cm.

It is of interest to compare these drawings and Webber's softground etchings side by

[4] Martin Hardie, *English Coloured Books* (London, 1906) 126.
[5] They are probably the ones which were sold at Sotheby's, 16 June 1825, in the sale of George Baker, p. 39: '605 Ditto Plates to Captain Cook's Last Voyage, by Webber, aquatinta prints and etchings, original sketches and tracings, by Webber, (in black lead) for the purpose of engraving the prints'; they were purchased by Holferd.
[6] The following passages concerning the Eyre and Hobhouse drawings were prepared by R. Joppien in summer 1984 under the title: *John Webber's Views in the South Seas*, an unpublished group of related drawings (typescript). We extend our thanks to Niall Hobhouse, London, to allow us to quote from that paper.

side, for it helps to assess the nature of the drawings. In no case does the size of the image of the drawing fit that of the print; on the contrary, the proportions between prints and drawings differ in significant detail. For example the drawings of the Narta (no. 5) is 1 cm shorter in height than the print. So is the drawing of the *View in Queen Charlottes Sound* (no. 1), where the image has been reduced at the bottom. However, though the scales have been modified, no detail from the images is missing. In the drawing of the *Sailing Canoe of Otahaite* (no. 3) the coastline behind is nearer than in the print. The vastness of the sea and the horizon which has been created in the print is also emphasized by a native boat which in the print has receded further back. Again, in the *View in Queen Charlottes Sound* (no. 1) the two English ships are set apart, separated by the bow of the front boat while in the print they are placed together. A tent clearly visible on the right hand side of the print, set among the shrubs, is omitted from the drawing. These and other examples which refer to figure details establish a distinct difference between the drawings and the prints. Indeed, they suggest that the drawings precede the prints and that Webber introduced some detail variation as he worked on the plates. The fact that all five drawings are squared for transfer further suggests that they were used as models.

Stylistic evidence also points to Webber as the artist of the drawings. They show his idiosyncracies of draughtmanship, consisting of little crown-like zigzag lines for a grassy surface or for leaves. Between areas of grass and moss Webber would also place some characteristic boulders and pebbles, which he simply draws in outline and dots. Being the factual and faithful recorder that he was required to be, Webber carefully notes topographical settings and also supplies reliable ethnographic information. Anything general, however, which only served to embellish the scene — trees, ground, water and sky — he represented with much less attention and rather schematically. In his landscape views he is scrupulous in detail yet of an uncommitted uniformity, particularly when handling leaves and stones. This trait can also be detected in the present drawings. Therefore, from a stylistic point of view there seems no doubt that these drawings are by Webber's hand.

A discussion of this group of drawings would not be complete without considering the watermarks. Two drawings show a lily in a shield under a crown and the initials GR below: another one has a similar symbol with a banded 'W' underneath, representing the paper mill of J. Whatman. On the fourth the name Whatman is cut off, leaving however, MAN still visible. The fifth drawing, the *View in Queen Charlottes Sound* (no. 1) is watermarked PORTAL & BRIDGES.

While both GR and the Whatman paper are familiar from other drawings which Webber did during the voyage, the paper marked 'PORTAL & BRIDGES' constitutes a novelty. Our initial attempt in dating it seemed frustrated by the information which Alfred Shorter supplied in *Paper Mills and Paper Makers in England, 1479-1800*, (Hilversum, 1957). According to Shorter, about 1794 'John Portal was joined in partnership by Bridges and the firm was known at times as "PORTAL & CO", which appears in watermarks of 1795, 1796 and 1801.'[7] Shorter did not seem to know the watermark here under discussion, but if his information about the firm's history was correct, then at least one of the five drawings had to be dated post 1794, a year after Webber's death. The conclusion would be inevitable that probably not only one but all of the drawings were later copies.

With the help of the London paper historian Peter Bower it can be established that the sheet of paper marked PORTAL & BRIDGES was made during the last twenty years of the eighteenth century. It has hitherto been assumed that John Portal of the Great Paper Mill at Laverstock went into partnership with his cousin William Bridges at the time when he inherited the business from his father, Joseph Portal, on the latter's death in 1793. Mr Bower however thinks it more likely that Joseph Portal was already in partnership with Bridges at the end of his life. Evidence for this is given in the *Universal British Directory* for 1791, in which the mill at Laverstock House is mentioned as the one 'in which the Bank of England paper is made, by Portal and Bridges' (vol. 4, 937).[8] According to Mr Bower it is possible to push this date even further back: in his own collection of papermarks he has a legal document which is dated 21 August 1790 and which shows an extremely close variant on the mark which Shorter published as being by Portal & Bridges (no. 135) and which consists of a P & B monogram in a circle. Thus from the paper's point of view, partnership between Portal & Bridges must have existed in 1790 and possibly even before that date. An interval of several years between the date of the making of the paper and its use was customary for eighteenth century paper, and according to Bower's opinion 'a document bearing a particular date would probably have been made at least a year earlier'. It would therefore seem logical that the paper used for the drawing of the *View in Queen Charlottes Sound* was made at least in 1789 and then

[7] A. Shorter, *Paper Mills and Paper Makers in England, 1479-1800* (Hilversum, 1957) 169.

[8] *The Universal British Dictionary of Trade, Commerce and Manufacture* (London, 1791), 4, 937.

used by Webber during the first half of 1790, in order to tally with the publication of the softground etching of 1 October 1790.

Other transfer drawings which Webber made in preparation of his *Views* are kept in the (i) Alexander Turnbull Library, Wellington: *Waheiadooa, Chief of Oheitepeha* (3.95), *A View of the Harbour of Taloo in the Island of Eimeo* (3.138), *A View in Oheitepeha Bay in the Island of Otaheite* (3.92), (ii) The Yale Center for British Art, New Haven: *A View in Annamooka* (3.44), *A View in the Island of Pulo Condore* (3.397) and *The Resolution beating through the Ice with the Discovery . . . in the distance* (3.276). These drawings match those formerly with Eyre & Hobhouse in several particulars: they all differ in significant detail from the prints, they are of varying sizes, they reveal Webber's style and their papers possess the similar watermarks.

Another drawing of this kind *A Village, near Macao* (3.377) is also in the Yale Center for British Art, New Haven. A print of this was probably intended, but owing presumably to Webber's bad health, was not carried out. The drawing can be related to two earlier water-colour drawings in the British Library and the Victoria & Albert Museum (3.375, 3.376) that lack the two Chinese figures carrying baskets slung from a stick across the shoulders. The latter are important features of the drawing, qualifying it as an independent record in its own right. This circumstance tends to support our earlier suggestions that the series of *Views* was planned to be larger but was left unfinished.

Webber's *Views* have all the characteristics of softground etchings, leaving light chalky imprints on the plate. To us they are known in two states, either coloured in light tones of water-colour or in brown and grey monochrome wash. Both states may be compared in the Department of Prints & Drawings in the British Museum.[9] The etchings which were finished in water-colour must be regarded as the more successful of the two states, for the lightness of the etched chalky lines and the light water-colour combine to give the effect of an original drawing. Colouring the etchings was a more elaborate and lengthy undertaking than washing them with grey and brown ink. One would therefore expect the two different states to be sold at different prices, if indeed they were published by Webber simultaneously. The other possibility would be that the monochrome series was issued later, perhaps after Webber's death.

Webber sold his views on subscription, but his terms have not come to light.[10] An indication of the interest in them may perhaps be gained from the fact that some were copied by a late eighteenth century, or early nineteenth century hand. The National Maritime Museum, London, the Yale Center for British Art, Paul Mellon Collection and the National Library of Australia possess copies of the *View in Oheitepeha Bay* (3.92B); *A View of the Harbour of Taloo, in the Island of Eimeo* (3.138B); *A Toupapaoo of a Chief, with a Priest making his Offering to the Morai* (3.146B); *The Resolution beating through the Ice with the Discovery . . . in the distance* (3.276B); *Balagans, Summer Habitations* (3.362B); and *A View in the Island of Cracatoa* (3.410B). Their predominantly blue, grey and brown colouring suggests that they were copied after the 'monochrome' prints. No attempt was made by the copyist to copy them faithfully. All are notably larger than Webber's prints by extended areas along the margins which are filled by a number of irrelevant plants, such as cacti. The interpretation of the views are comparatively flat and lack the deep and romantic lushness of Webber's drawings and prints. There can be no doubt that these drawings are copies, and from the inscription it seems certain that the copyist was French. This is suggested by the inscription of the *Toupapaoo of a Chief* (3.146B) which ends with 'London 1789 *par* Webber'.

After Webber's death on 29 April 1793, a substantial collection of his paintings, drawings, prints and books were auctioned by Mr Christie on 14 and 15 June 1793. The annotated sale catalogue[11] mentions as among the more active purchasers 'Boydell', i.e. Alderman John Boydell (1719-1804), owner of the Shakespeare Gallery and a late eighteenth century 'maecenas of the Arts'.[12] That Boydell had a special interest in Webber's drawings from Cook's third voyage, and in particular in Webber's *Views in the South Seas* is supported by M. H. Grant: 'We have seen a letter from Webber to Boydell, in which the painter consigns to the Alderman six sets of his prints, presumably on "sale or return".'[13] Grant's statement is corroborated by Joseph Farington who writes in his diary entry for 15 January 1794: 'I was employed today in tinting Webbers Outlines for Boydell and in washing outlines of Rivers.'[14] Farington was not only a close friend of Webber's, he also was one of Boydell's long-standing professional associates[15] and would certainly have taken over obligations that he 'inherited' from Webber. The foregoing evidence seems to suggest that as early as 1794 Boydell continued Webber's project after his death. Though the last four prints were published on 1 August 1792 (that is about nine months prior to Webber's death[16]) the *Views* must still have been selling well. It would have been possible and understandable for Boydell and Farington to continue

[9] No. 246ᵃ.2. and C.6ᵃ.

[10] Webber's friend Joseph Farington noted in his diary on 18 January 1796: 'Bacon called on me this morning abt. Mr. Humberstone Mackenzies subscription to Webber's South Sea etchings' Farington (1978) 2, 473.

[11] An annotated copy of this catalogue is preserved at Messrs Christie's London, another is in the library of the Victoria and Albert Museum.

[12] On Boydell see Thomas Balston, 'John Boydell, Publisher, The Commercial Maecenas', *Signature*, VIII, n.s. (1949), 3-22, and Winifred H. Friedman, *Boydell's Shakespeare Gallery*, (New York, 1976).

[13] M. H. Grant, *A Chronological History of the Old English Landscape Painters* (Leigh-on-Sea, 1959) vol. 4, 289.

[14] Farington, vol. 1, (1978) 143. The 'outlines of rivers' Farington washed were his own drawings for W. Combe's *History of the River Thames* published by Boydell in 1794.

[15] Farington and his younger brother George worked for Boydell already in 1775, when they copied paintings from Houghton Hall.

[16] As stated by Webber's surgeon Heaviside, Webber's illness lasted for nine months and required 'many surgical operations'. (Farington, 20 November 1793, vol. 1 (1978) 96).

[17] Cole (1975), 26.

[18] A copy of this catalogue is in the British Museum, Department of Prints and Drawings.

[19] Alphabetical Catalogue . . . (London, 1803) 59.

[20] This edition is listed in J. R. Abbey, *Travel in aquatint and lithography, 1720-1860, from the Library of J. R. Abbey*, vol. 2 (Asia, Oceania, Antarctica, America) (London, 1957) 539-40. Earlier works which mention Webber/Boydell's *Views in the South Seas* (and which are referred to by Abbey), are Martin Hardie, *English Coloured Books* (London, 1906) 127; T.M. Hocken, *A bibliography of the literature relating to New Zealand* (Wellington, NZ, 1909) 35; Sir Maurice G. Holmes, *Captain James Cook, R.N. F.R.S. A biographical excursion* (London, 1952) no. 78; Sarah T. Prideaux, *Aquatint Engraving* (London, 1909) 268, 355; R. V. Tooley, *English Books with Coloured Plates 1790-1860* (London, 1954) no. 501, 397-8.

[21] A. Murray-Oliver suggests that 'it would seem that Boydell's plates were re-drawn, although scrupulously carefully', but remarks 'They quite lack the charm and delicacy that is so apparent in the Webber plates when the Boydell [ones] are placed against them,' Murray-Oliver (1969b), 76, 79.

[22] The National Maritime Museum owns a print of Toopapaoo which is watermarked 'J. WHATMAN 1805', one of the Narta, watermarked 'J. WHATMAN 1818' and two prints of sailing canoes of Otaheite and Balangas or Summer Habitations, both dated 'J. WHATMAN 1820'. Another set in the National Library of Australia (NK 4120) is watermarked 'J. WHATMAN 1818', and the title page signed and dated 'Hugh Booth, 1820'.

[23] *A Catalogue of More than Five Thousand Copper Plates . . . Comprising the Entire Stock of Messrs. John and Josiah Boydell, Deceased*, (London, 1-6 June 1818), no. 221, 43.

[24] Cole (1975), 26.

the project, even if only to satisfy paid subscriptions. However no clear evidence of such an arrangement is known.

What is known is that the publishing house of John Boydell carried the selling of Webber's *Views* into the nineteenth century. Douglas Cole has noted that 'by at least 1803 ten years after Webber's death, Boydell was selling Webber's Pacific Views'.[17] This is confirmed by Boydell's *Alphabetical Catalogue of Plates engraved by the most esteemed artists after the finest pictures and drawings of the Italian, Flemish, German, French, English and other schools which compose the Stock of John and Josiah Boydell, Engravers and Printsellers, No. 90 Cheapside, and at the Shakespeare Gallery, Pall Mall*, London 1803.[18] Webber's *Views* are advertised as 'The following 16 beautiful coloured prints, in Imitation of Mr. Webber's Original Drawings, are printed on a paper, uniform with the Volume of Prints to Captain Cook's last Voyage, which they are calculated to illustrate.'[19] Their individual price was 10 shillings 6 pence. This suggests that Boydell published the *Views* as Webber had done: 'coloured . . . in imitation of Mr. Webber's Original Drawings'. Certainly he would have retained Webber's author line in compliance with copyright laws of the time. A clear distinction between those *Views* which Webber issued himself and those that were published by Boydell is thus not possible. It would not be inconceivable to think that Boydell also published the monochrome series of the *Views*, which technically, from the point of colouring, was much easier to achieve and less expensive.

Several years later the firm of Boydell, then under the directorship of John's nephew Josiah Boydell (1752-1817) decided to bring out a new edition of the plates, a folio volume entitled *Views in the South Seas, from Drawings by the late James Webber, Draftsman on board the Resolution, Captain James Cooke from the year 1776 to 1780*. 'With Letter-Press descriptive of the various Scenery &c, These plates form a new series, and are of the same size as those engraved for Captain Cook's last Voyage. The drawings are in the possession of the Board of Admiralty. London: Published by Boydell and Co, No. 90, Cheapside. Printed by W. Bulmer and Co, Cleveland Row, 1808.' The price for the volume was 6 guineas. The work lists sixteen views in aquatinta, which except for a few alterations, such as the *Plantain Tree in Cracatoa*, are arranged according to the chronology of the voyage.[20] There are, however, two differences from the earlier *Views*: each plate is accompanied by an excerpt from the official account on the opposite page and the plates are aquatinted and hand-coloured.

To publish the *Views* as aquatints was a much more economic way of producing the plates. Colouring the softground etchings, with very little outline work, had required some skill. Producing them as aquatints meant more graduation in tone and a better guide to the colourist. The process could rely on an almost mechanical execution. However, changing the character of the plates made it necessary to rework the earlier plates and to strengthen their colours. Most of the outlines were enforced so that they lost their original character as softground etchings. Their colours show up darker and heavier than the earlier plates, particularly where contrasts of orange and green are involved.[21]

But there is a problem concerning the publication date of that volume. Whereas the title page for this series is invariably dated 1808, the publication date on the prints themselves is always given as 1 April 1809. In a number of copies which we have seen, the pages of the accompanying text bear the watermarks of 'J. WHATMAN 1805'. Even more surprising, the watermarks on the paper used for the prints vary between 1805 and 1820, most being of the years between 1818 and 1820.[22] Thus, we cannot assume the Boydell edition was published in either 1808 or 1809.

Douglas Cole has shed some light on this situation, explaining that in 1817 Josiah Boydell died and the whole property of the firm was sold by auction in June 1818, including 'Sixteen Views in the South Seas, — Drawn and Etched by James Webber, Esq. R.A. Draftsman on board the Resolution, Captain Cooke, with Descriptions of each View; one volume folio. The Drawings are in the possession of the Board of Admiralty, With 130 copies of the Descriptions; and about 440 odd prints, coloured, plain, and etchings'.[23] Cole noted that 'the principal, though not exclusive purchaser at the sale was Hurst and Robinson, who intended to carry on as "successors to John & Josiah Boydell". It thus appears that the purchaser issued the folio edition of the *Views* in c. 1820 (using the title page that had already been printed), without even changing the Boydell pressmark.'[24]

From the several copies of the *Views in the South Seas*, watermarked 1818, 1819 and 1820, it seems that even at that time, sales of the *Views* were still selling well. We can thus conclude that Webber's *Views* sold for about thirty-five years, which is a tribute to the standing interest sustained in them as well as to the pleasing quality of Webber's work.

# Last years: 1786-1793

Little is known of Webber's last years but a sketch may be given of his work, mainly of his extensive travels in the British Isles and on the Continent. These he often took in the company of friends. Instigation and encouragement was probably provided by Joseph Farington (1747-1821)[1] or Thomas Hearne (1744-1817)[2] who were both singled out in Webber's will as recipients of money and drawings. Another artist of the circle around Webber was the engraver William Byrne. After having trained with Wille in Paris, Byrne returned to England around 1770 and found engagement on all three official accounts of Captain Cook's voyages. He also engraved Webber's painting of the death of Captain Cook in collaboration with Francesco Bartolozzi (3.305A), published on 1 January 1784. Byrne also worked with Farington and Hearne.[3] We may presume that through this circle of friends Webber was introduced to the idea of drawing the scenery of Great Britain for the last seven years of his life.

The beginning of Webber's interest in the English countryside and its topography is marked by two water-colour drawings: *Boyd's Rock on the Wye*; and *Chepstow Castle, Monmouthshire*.[4]

Both are dated 1786, which suggests a sketching tour in the west of England that year. In the following year Webber travelled to his native Bern, visiting the Swiss branch of his family and a number of friends of his student years. He went via Paris, where he met his old teacher Jean Georges Wille and spent most of June.[5] After Paris Webber travelled to Lyon and thence to Geneva. Travelling in the company of two fellow-Englishmen, he reached the St Gotthard Pass and from there entered Italy, heading towards Lake Como and Milan. For the return journey back into Switzerland Webber proceeded over the St Bernard Pass, towards the Wallis and spent some time sketching Mont Blanc. From there he finally proceeded to Bern.[6] On arrival he learnt that his old teacher J.L. Aberli had died the previous year, and it is said that in consequence Webber assiduously began to collect the works of this master wherever he could find them.[7] His old friends Sigmund Freudenberger (1745-1801) and Balthasar Anton Dunker (1746-1807), fellow artists of his Paris years, had in the meantime settled in Bern and became respected painters, draughtsmen and engravers.[8] Webber found a new friend in the person of the Swiss landscape painter Heinrich Rieter (1751-1818).[9] Together with him Webber made several excursions into the mountainous Bernese countryside. He probably returned to England in late 1787 or early 1788, in time to complete his *View of the Pisevache, a cascade between St Maurice and Martinach in Switzerland*, exhibited at the Royal Academy in 1788.[10] The various stages of Webber's journey can be deduced from the drawings

---

[1] Webber rewarded Farington as one of his most attached friends. Besides £100 in cash he left Farington his 'drawings of Portfolio No. 1 with any small picture I may have in my possession of my painting' (see Webber's will: appendix 6). What picture Farington received is not known, but compare Col. M.H. Grant, *A Chronological History of the Old English Landscape Painters . . .*, IV (Leigh-on-Sea, 1959). Speaking of Webber: 'he imitated none, and had no imitators, unless it be Joseph Farington, whom Edwards records to have possessed Webber's best picture . . .' (p. 289).

[2] Hearne received £50 plus six of Webber's remaining drawings (see

appendix 6). Among Hearne's property, auctioned after his death by Mr Christie on 11 June 1817, were several drawings by Webber, one of Kamchatkadals, views of Geneva and Boissy, a view of the city of Bern (p.8, nos. 97-9), a view of the entrance to the Park [Peak?] at Castleton, Derbyshire, and a 'View of a Cascade in one of the South Sea Islands and Natives with a Canoe' (p. 10, nos. 148-149).

[3] With Hearne, Byrne collaborated extensively on the *Antiquities of Great Britain*, for which Hearne drew fifty-two views of Gothic churches and ruins or cloisters in England and Scotland. With Farington he worked on the *Views of the Lakes of*

*Cumberland and Westmorland* (1789), as well as on the *Views of the Cities and Towns in England and Wales*(1790).

[4] Collection of Sir H. Wilson and Collection of Vassar College, Pough Keepsie, NY, sold at Sotheby's, 15 July 1976.

[5] Duplessis, (1857), vol. 2, 145-6.

[6] A water-colour drawing of a *View of the city of Bern, Switzerland* by J. Webber, was included in the Annual Exhibition of English water-colour drawings at Spink & Son, 17 April-12 May 1978.

[7] Webber's sale catalogue of 14 June 1793 lists twenty-five prints after Aberli and seventy drawings and oil sketches by this master.

[8] On Freudenberger see above, p. 176. On Dunker see *Schweizerisches Künstlerlexikon*, vol. 1, (1905) 398. Another one of Webber's contacts in Bern was the architect Erasmus Ritter (1726-1805), who had provided Webber with a letter of introduction to Wille in 1770 (see p. 175). He was the author of *Mémoire et Recueil de quelques Antiquités de la Suisse, avec des dessins lévés sur les lieux dépuis 1783 . . .* (Bern, 1788). The Burgerbibliothek Bern holds a letter from Webber to Ritter of 21 April 1789 (Mss. Hist. Helv. XXV/71, fol. 65) which seems to deal with this book. On behalf of Ritter, Webber had presented a copy to the Society of Antiquaries.

[9] On Rieter see *Schweizerisches Künstlerlexikon* (1908), 2, 628. Rieter had also been a student of J.L. Aberli and worked in the tradition of this master.

[10] The picture, (no. 137) was mentioned in the RA review of the *Morning Post* (12 May 1788) and the *St James Chronicle* (6-8 May 1788 and 24-27 May 1788). Wagner asserts that Webber's *St Maurice* was considered the best painting beside de Loutherbourg's *Fall of the Rhine at Schaffhausen*, also exhibited that year (Wagner, 1821, 11-12).

[11] A painting of a *View of the Grindelwaldgletcher* signed and dated by Webber in 1788, was auctioned at Jörg Stuker's, Bern (1966), cat. no. 3860.

[12] The European places listed therein are Lyons, Lago Majore, the Pissevache Cascades, Le Glacier des Bois, and Le Nan Darpenaz, Como, St Gothard, Mont Blanc, St Morice, Lucerne, Castle of Pierenoise at Lyons and Cascade of Maglan on the road to Solenche. Webber continued to exhibit views from that journey until 1792: *View of Mont Blanc, with the Glacier des Bassons, Chamounix* (RA 1789), *View on the river Soane, near L'Ile Barbe, Lyons* (RA 1789), *View near Cerdon, between Lyons and Geneva* (RA 1789), *View of the Torrent on the Simplon Mountain, on the borders of Switzerland* (RA 1790), *Pliniana, a Villa on the lake Como, a site remarkable for being the retreat of Pliny, the Younger* (RA 1791), *A View on the lake of Como* (RA 1792). See Graves, vol. 8 (1906) 186-7.

[13] Webber exhibited further views from South Wales at the Royal Academy exhibition in 1790: *View on the river Monow, near Monmouth* and *View on the river Wye, near Monmouth*.

[14] Judy Egerton, 'William Day, 1764-1807', *Connoisseur* (July 1970) 176-85.

[15] See Clare Stuart Wortley, 'Amateur Etchers', *Print Collector Quarterly* (July 1932) 199.

[16] Egerton, (1970) 179. Their friendship continued until Webber's death; in his will Webber left Day the sum of £20 'for mourning — in remembrance of a friend' (see appendix 6).

[17] Egerton, (1970) pl.4 (Whitworth Art Gallery) and pl. 5 (collection Mr Ian Fleming-Williams).

[18] Derbyshire water-colour drawings by Webber are kept in the Yale Center for British Art, Paul Mellon Collection, The Pilkington Collection, Eton College and the National Gallery of Scotland, Edinburgh.

At the sale of prints and drawings from the collection of George Baker several Derbyshire views by Webber were included, see lot nos 582-7. *Catalogue of the highly valuable collection of prints and drawings the property of the late George Baker Esq. of St. Paul's Church Yard . . . which will be sold by auction by Mr. Sotheby . . . 16 June 1825 and nine following days,* p. 38 (copy in the library of the Victoria & Albert Museum, London).

[19] Both drawings in the Victoria and Albert Museum, London, inv. nos. 1732-1871 and 1097-1884.

[20] Both in the National Gallery of Ireland, Dublin, acquired 1872, (cat. no. 2304 and 2305).

[21] Colnaghi's, London, *English Drawings, Watercolours and Paintings,* (November-December 1973).

which he made, but only a few of these can be located today.[11] The sale catalogue of Webber's collection auctioned at Christie's on 14-15 June 1793 however gives numerous hints as to places.[12] Most of Webber's Swiss drawings are of mountain views, so dear to him since his early days of apprenticeship with Aberli. For the British, Swiss scenery had only recently become fashionable as a proper pictorial subject for both their sublimity and their picturesqueness.

Travelling, sketching and developing his sketches into oil paintings at home became a habit with Webber during his later years. The pictorial results of his journeys were never exhibited as coherent groups but were spread out over the years. As a result more and more subjects from different parts of Europe and other parts of the world could be freely mixed and interchanged. Webber's repertoire of places thus became more impressive from year to year.

In 1788 Webber made a tour through South Wales; this can be assumed from two water-colour drawings of Chepstow Castle in the Whitworth Art Gallery which are both signed and dated 1788.[13] It is possible that already that year Webber was accompanied by the young natural historian William Day (1764-1807), whom his family nicknamed 'Rocky Day' for his sustained interest in geology and mineralogy. The Victoria & Albert Museum holds Day's water-colour drawing of *A View on the River Wye north of Chepstow* signed and dated 1788. Mrs Egerton in her article on Day[14] suggests, on grounds of style, that Webber's influence on Day is already noticeable here. Another interest which Day and Webber shared, were plants. Both have left drawings of plants, representing them in a singular 'portrait' fashion.[15] According to Egerton, the 'almost self-taught artist' William Day 'owed his improvement above all to his friendship with the artist John Webber'.[16]

In 1789 Webber and Day set out for another sketching tour through Derbyshire, and this time their joint travels can be better documented. Both men made drawings of Odin Mine, Mam Tor, sketching side by side.[17] Places they visited during their journey included Reynard's Hole, Dovedale, Mounsoldale, and Cromford.[18] Both artists revealed great interest in the tectonic structure of the earth, building up their compositions from semi-abstract, diagonal and slanting planes and underlining the mighty prominence of rocks and mountain peaks. In other drawings, such as *Near Cromford taken from the Bridge*, a more lyrical and serene mood is introduced, in which small cottages and figures are balanced against a hilly and dignified landscape panorama.

During the summers of 1790 and 1791 Webber again undertook sketching tours through Wales. Judging from drawings dated 1790 he visited Millpond, near Shrewsbury and Dolgellan,[19] Bala, Merionetshire and Thanethlide,[20] and Ponte Cainante, near Bala.[21]

A water-colour of the *River Cynwud, near Corven, North Wales* is dated 1791,[22] and so is a drawing of *Conway Castle, Carnarvonshire*.[23] Egerton has suggested that in 1791 Webber and Day were again sketching together in Wales, and for this she refers to Webber's drawing of *Pont y Pair on the River Oawen at Llanwrst*, dated 1791.[24] Other drawings with Welsh scenery, which could derive from that year were called up in Webber's sale in 1793.[25]

From other entries in Webber's sale catalogue it can likewise be assumed that Webber also visited the Lake District, a very popular area for most British topographical artists in the late eighteenth century.[26] It would also seem that Webber travelled in Scotland, as is suggested by a representation of Kirkwall in the Orkneys,[27] however, no other drawings of Scottish scenery have been identified. From this scanty information, not many biographical details can be reconstructed, except that Webber sustained a strong interest in topographical landscape drawing. His bonvivant, carefree temperament might have made him — as in his earlier years

[22] ibid.

[23] British Museum, London Department of Prints and Drawings, 1880-2-14-319.

[24] Egerton, (1970), 181; repr. in Martin Hardie, *Watercolour Painting in Britain,* I, Dudley Snelgrove (ed). with J. Mayne and B. Taylor (first publ. 1966, London, reprinted 1969), pl. 239, it is now in the Yale Center for British Art, New Haven.

[25] Webber (1793), nos. 52 (p.5), 49 (p.9.), 103 (p.10). At the sale of prints and drawings from the collection of George Baker (1825) more views of South and North Wales were listed, lot nos. 577-81. Wagner, (1821) confirms Webber's sketching tour through Wales in 1791. Webber is thought to have brought back with him more than thirty drawings which he intended to develop into paintings (p. 12).

[26] 'Four Views on the Lakes in Cumberland', handwritten addition in the annotated sale catalogue of Webber's art works (Webber 1793, 8, no. 48).

[27] Webber, (1793) 9, no. 52. Wagner, (1821), 11 also refers to Webber's travels in Scotland.

with Wille — the ideal travel companion. It is obvious that Webber also sketched around London and in the south of England. An engraving of Twickenham Meadows by J. Landseer after Webber was published by Cadell & Davies in 1803.[28] A drawing of Lavant, Sussex, was executed in 1792,[29] the year Webber fell seriously ill.

Nothing much is known about Webber's travels in the Isle of Wight. His visit is attested by an entry in Farington's diary for 29 December 1794:

> Mr. Cambridge, called to see my portfolio of Webbers drawings particularly those made in the Isle of Wight. Landseer sent him to me. — He is the eldest son to Mr. Cambridge of Twickenham and has resided in the Isle of Wight.[30]

The reason why none of Webber's drawings from the Isle of Wight figured in his sale catalogue may be due to their being all beqeathed to Farington.

When Webber died on 29 April 1793 of diseased kidneys he left a substantial fortune to his family and friends. That assiduous biographer of eighteenth century British artists, Edward Edwards comments:

> At his death he left a very decent property, acquired by his own industry and which descended to his brother William [i.e. Henry], who is a sculptor, and was a pupil of the late Mr. Bacon.[31]

Farington says that Henry Webber got £3000 from his brother's possessions, which may have been the net result from the two sales of John Webber's belongings, held at Christie's in 1793.[32] In the first sale several hundreds of drawings by Webber are listed, spanning from Cook's voyage to his later travels, but in most cases the entries are too summary to allow for specific identification. They are mostly landscape views of buildings and park scenes, views of shipping and canoes, portraits and figure drawings of different nations, also a small number of animal drawings. We thus get the impression that Webber's *oeuvre* — considering of course that the sale represented only the work that had remained at his house — was by no means small. It is of some interest who bought at this sale. The annotated copy of the catalogue mentions a number of familiar names such as Monro (Dr Thomas Monro, graphic collector and founder of the private drawing school at which Turner and Girtin took lessons) and John Boydell, the publisher, buying mostly drawings from Cook's third voyage (Unalaska, Society Islands, Nootka, Friendly Islands, the Sandwich Islands etc.). Views from Europe and the Pacific, including forty-two 'sketches in oil, studies in nature' by Webber's teacher Aberli were bought by a Mr Strange. Thomas Hearne purchased a couple of English views and three portraits, while Webber's sketching partner William Day acquired views of Wokey Hole, near Wells and two other views. It cannot be ascertained whether the Mr Turner who purchased Bartolozzi's sleeping child and a madonna as well as Webber's views in Otaheite and China, was in fact J.M.W. Turner. A big buyer was Sir Henry Englefield, abbreviated 'SHE' or 'S! H. Englef'.d The fact that Englefield bought 'Three views near Lyons' and 'Two large views, Le Glacier des Bois and Le Nan Darpenaz' leads one to speculate, whether he was not one of the two English co-travellers of Webber through France, into Italy and Switzerland.[33]

Another most important buyer was George Baker (1747-1811), lace merchant and print-collector of St Paul's Church yard, who may have been Webber's closest friend among collectors.[34] Webber left him in his will his portfolio no. 2, together with £100 in cash and a picture of his choice. This may have been partly in recognition of Baker's nursing of Webber during the latter's illness.[35] Together with Farington, Baker was Webber's executor, and is often mentioned in Farington's diary.

[28] British Museum, Department of Prints and Drawings, C. 17*.

[29] British Museum, Department of Prints and Drawings, 1880-2-14-320.

[30] Farington, 1, (1978), 282.

[31] Edward Edwards, *Anecdotes of Painters who have resided or been born in England* (London, 1808) 219.

[32] In addition to Webber's sale of 14 and 15 June 1793, there was another on 24 June 1793, offering Webber's furniture and household articles. Among these were 'a mahogony painting box with three drawers on castors, tin lining, 15 pencils, 9 brushes, 77 new brushes, 5 pallets, and 2 rolls of primed canvas' (lot 43), a 'mahogany travelling paint box, sundry chip boxes, and a small case containing a quantity of dry colours' (lot 44), a 'mahogany camera obscura and a deal writing box brass bounds and two drawers' (lot 47).

[33] Sir Henry Englefield (1752-1822), almost of the same age as Webber, like the latter, sustained a great interest in landscape and geological phenomena. As an amateur he made topographical drawings such as *View in Dove Dale* which he exhibited at the RA in 1787. He became fellow of the Royal Society in 1778, a Fellow of the Society of Antiquaries in 1779, joined the Dilettanti Society in 1781 and was a Fellow of the Linnean Society. He published widely in the *Philosophical Transactions*.

[34] George Baker, the son of the Reverend Thomas Baker of Hungerford, Berks., was an ardent collector of prints, especially rare, unique ones. In the advertisement of the sale of his library it is said: 'With him the names of either Woollett or Hogarth formed an irresistable talisman; and his collection of the works of those engravers may be considered as eminently rich, and probably matchless.' Eu. H. in: *A Catalogue of the very choice and select library of the late George Baker, Esq. of St. Paul's Churchyard*. 'Sold by auction by Mr. Sotheby, Monday, June 6 1825 and two following days, London 1825' (copy in the library of the Victoria and Albert Museum, London). This sale had 855 lots of rare books, among them editions of 'J. Cook's Second Voyage round the World, 2 vols in green marocco, and Cook's and King's *Voyage round the World*, 3 vols (lots 196-7).'

[35] Wagner, (1821) refers to him as 'Kaufmann Bäcker', a 'loyal friend . . . and an inspired connoisseur, who nursed him [Webber] most amiably through his long and painful illness.' (p. 13).

[36] Baker sale, 16 June 1825.

[37] For material relating to Cook see 38-9 (lot nos. 589-609). On 10 May 1949 the Commonwealth Library, Canberra, later National Library of Australia, acquired four folios of 317 plates of Cook's voyages at a Sotheby sale in London (lot. 419, 'mostly in two states — proofs before letters and as published'). Two volumes alone are reserved for the engravings of Cook's third voyage. They are titled in pencil in Webber's hand and may thus derive from Webber's own collection. The volumes bear book-plates from the Scottowe Hall Library, the location of which is uncertain but which seems to have existed somewhere in Yorkshire. Light on their provenance is thrown by the catalogue entry of 1949: 'From the collection of George Baker; sale at Sotheby's June 26, 1825, lots 592-3, 595-7 and 600-602. They have been arranged in order of the voyages and bound since then. A manuscript index of the plates is included in each volume.' The nineteenth century buyer of the folios was a certain Moltens; there is however, no evidence between him and the Scottowe family, into whose possession the folios finally came. The Baker source is particularly interesting because of seventeen water-colour drawings of costumes for the eighteenth century stage production of 'Omai, or a trip round the world', which were contained among them. As is well known P.J. de Loutherbourg and J. Webber collaborated on this show.

[38] For the apotheosis of Captain Cook, see Joppien (1979), 89-90, figs. 60-2.

[39] Farington, 2 (1978), 18 January 1796, 473.

[40] Farington, 1 (1978) 20 November 1793, 96; 11 December 1793, 112; 29 January 1794, 151; 18 February 1794, 163; 27 November 1794, 264.

[41] Farington, 1 (1978), 25 November 1794, 263.

[42] Farington, 3 (1979), 697. Webber's intention had been to give his diploma to the library of Bern (see his will: appendix 6).

[43] See appendix 6. On Webber's ethnographical collection see Karl H. Henking, 'Die Südsee- und Alaskasammlung Johann Wäber', in *Jahrbuch des Bernischen Historischen Museums*, XXXV/XXXVI (1955/56) 325-89; H.G. Bandi, 'Einige Gegenstände aus Alaska und British Kolumbien, gesammelt von Johann Wäber (John Webber), Bern/London, während der dritten Forschungsreise von James Cook 1776-1780', in *International Congress of Americanists*

Baker was a fervent collector of engravings and illustrated books and particularly admired the work of Hogarth and Woollett. But he also owned an extensive collection of works by Webber. When his own estate was sold by auction in 1825, perhaps the most comprehensive contemporary collection of prints deriving from Cook's voyages came on to the market.[36] It covered sixteen lots and included a great number of proofs, first impressions of copperplate engravings, aquatints as well as 'original sketches and tracings, by Webber'.[37] In this connection it is interesting to note that the names of Baker, Webber and Cook were linked on a print which appeared after Webber's death in 1794 as *The Apotheosis of Captain Cook*. When Webber and de Loutherbourg designed the stage spectacle of 'Omai, or a trip round the world', the last scene required an allegorical elevation of Cook as a hero. De Loutherbourg's design (plate 201) shows Cook hovering on a cloud above Karakakooa Bay with his sextant in one hand, flanked by Britannia on his right and the winged allegorical figure of fame with a trumpet on his left. The view of Karakakooa Bay, the place of Cook's murder, is diffused by the smoke of the guns from the fighting parties, while the *Resolution* and the *Discovery* are placed on the right side of the composition. The engraving is inscribed 'The Apotheosis of Captain Cook, from a design of P.J. De Loutherbourg. The View of Karakakooa Bay is from a drawing by John Webber, R.A. (the last he made) in the collection of Mr. G. Baker'.[38] Published on 20 January 1794, eight months after Webber's death, the drawing is among other things a final and public gesture of loyalty by Baker to his deceased friend.

This loyalty was proved in other instances too; even against members of the Webber family. Henry Webber in particular seems to have regarded his deceased brother's possessions as a constant gold mine and in Farington's words 'never seemed to have the feeling of honor or principle, or even anxious to preserve the appearance of it'.[39] Farington's remarks about Henry Webber are often tinted with indignation, especially when he mentions the wrangle that ensued over the final demands of John Webber's surgeon Heaviside, which Henry Webber successfully avoided paying and which were finally settled by Farington and Baker.[40] On 25 November 1794 Farington records that Henry Webber offered to sell him all of John Webber's ultramarine colours[41] and two years later, on 18 November 1796 he notes that 'I met Baker there [at the Shakespeare Gallery] who told me Henry Webber has sold his late Brothers Diploma & some drawings of his to Foxhall the Frame Maker'.[42]

Apart from the unfavourable light thrown upon Henry, this information suggests that other objects of interest, such as drawings by John, had remained in the custody of the family and were likewise sold off. This would also apply to Webber's papers, letters and possibly a diary from Cook's voyage. A good deal could have been destroyed.

One bequest however, was fulfilled as Webber wished: his ethnographical collection, which he donated to the Library of Bern.[43] It must have arrived by 1791, for during that year all objects were listed in the Library Manual. With seventy-five lots the collection might be described as of 'moderate size',[44] on the other hand, with the dispersal of the third voyage collections Webber's gift to his family's home town 'is the largest extant third voyage collection from the hands of a single person'.[45] Because collecting to Webber was subsidiary to his drawings, he may have traded randomly, collecting whatever attracted him. Kaeppler's qualification 'much of Webber's collection compromises ordinary, useful things'[46] need not refute our assumption that it originally was collected for studious purposes or perhaps material to be drawn later. At least in one instance, however, a feather cloak introduced into his composition of *The Death of Captain Cook* (plate 153; 3.304, 3.305) gives proof that Webber did draw from objects which he had collected during the voyage.[47] There is some evidence that Webber did not retain all that he collected. As we have noted, for example, he gave a feather necklace to the French *ingénieur*, Monneron, in April 1785.[48]

(Copenhagen, 1956) 214-20; Adrienne L. Kaeppler, *Cook Voyage Artifacts in Leningrad, Berne and Florence Museums*, Bernice P. Bishop Museum, Special Publications 66, Honolulu, (Hawaii, 1978b).

[44] Kaeppler, (1978b) 18.

[45] ibid.

[46] ibid, 19.

[47] Kaeppler maintains that objects which Webber depicted *during the course of the voyage* were not from his own, but from Cook's collection.

[48] Monneron's letter from London, 11 April 1785 (appendix 5).

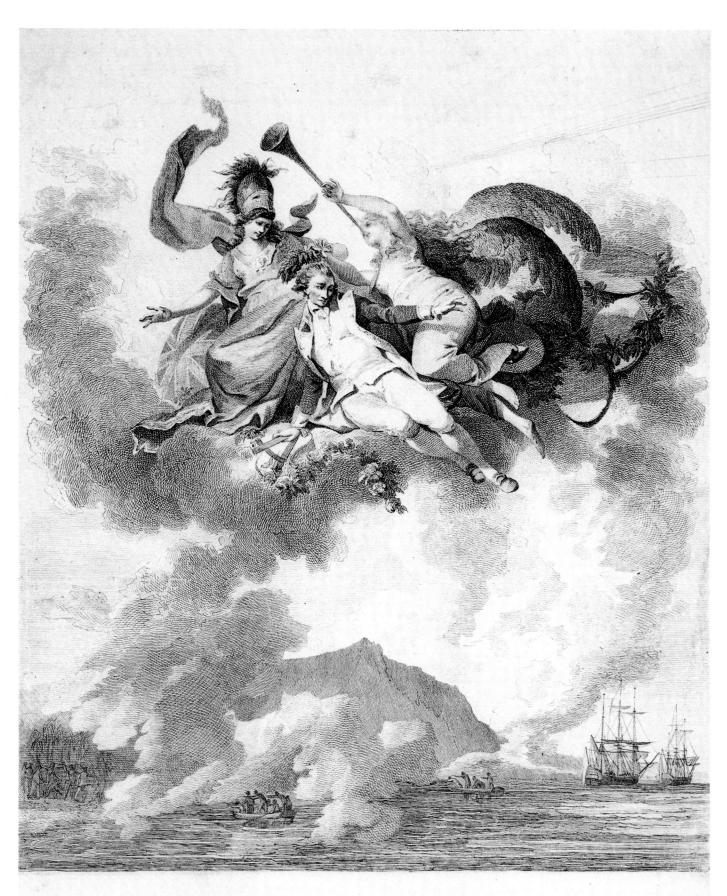

The APOTHEOSIS of CAPTAIN COOK.

*From a Design of P.J.De Loutherbourg, R.A . The View of KARAKAKOOA BAY Is from a Drawing by John Webber, R.A the last he made in the Collection of Mr.G.Baker.*

London. Pubd. Jany. 20. 1794 by J.Thane, Spur Street, Leicester Square.

PLATE 201
*The Apotheosis of Captain Cook,* 1794.
Engraving after Philippe Jacques de
Loutherbourg and John Webber.

[49] Mrs Elisabeth Degoutes [Degouttes, née Funk (1735-1803)] was the wife of Gottlieb Peter Degouttes (1745-18...?). She was a daughter of the ébéniste Mathäus Funk and of Maria Magdalena Wäber, and thus a cousin of Webber's.

[50] C.F. Bell (1938), 7.

[51] See Hugo Wagner, Robert L. Wyss, *Die Bildnisse im Bernischen Historischen Museum*, (Bern, 1957), 177, no. 253, inv. no. 32206. A second copy by Mottet was hung up in the general hall of the Corporation of Merchants (cf. Erich Gruner, *Die Bürgerliche Gesellschaft zu Kaufleuten in Bern*, (Bern, 1944) 10; Wäber, (1979), 69). Johann Daniel Mottet (1754-1822) took up portrait painting in 1780 and lived in Bern from 1794.

[52] The name of the artist reads Hunnemann, but according to Thieme/Becker no artist of that name would fit as Webber's portraitist. It is more likely that the artist was Christian Hornemann (1765-1844), a miniature painter from Copenhagen, who undertook a great many travels through Germany, Austria and Italy between 1786 and 1803. If he was Webber's portraitist, one must assume he met Webber in Switzerland in 1787, possibly in Bern. Another spelling of the name, as Honneymann, is offered by Romang (1896), 307.

[53] The Kunstmuseum Bern keeps another portrait of the original miniature by David Sulzer (1784-1868), painted in 1828 (inv. no. 1237). This picture derives from the estate of Sigmund Wagner and was first mentioned in the *Auktion der Sammlung Sigmund Wagner, Verzeichnis der von Herrn Sigmund Wagner sel. hinter-lassenen Kunstsachen*, (Bern, 1836) no. 63.

[54] Walter E. Gawthorp, *Notes and Queries*, 152 (21 May 1927) 368 and 152, (25 June 1927) 466.

[55] ibid.

[56] According to Richard A. Bowden, Archivist of the Marylebone Library, London, the Chapel of the Ascension 'was built in 1890-94 [Webber's tablet must therefore have been transferred] as a place for private worship at the expense and invitation of Mrs Russell Gurney. It was mainly well-known for its painted frescoes by Frederic Shields, and it actually stood at right angles to the old mortuary chapel of the burial ground, which belonged to St Georges, Hanover Square, but closed as a burial ground in 1858 . . . Any last remains of it [the chapel] disappeared during the early 1970s when the old burial ground was built over'. (*in litt.* to R. Joppien, 8 April 1986.)

Generosity and loyalty to friends seems to have been characteristic. In concluding we might well ask what kind of a man he was. His gift to Bern is enough indication that he wanted to be remembered by those who had contributed to his training. The Corporation of Merchants who had helped him were rewarded by 100 guineas in his will. Apart from his London friends Webber also remembered his Swiss friend Christian Fueter, and the children of Mrs Degoutes from Bern to whom he was related.[49] He also included his maid servant Mary Davis, the lad who lived with him, and his landlord. A bachelor throughout life Webber appears to have been well-liked. He was apparently humorous and vivacious, and possessed a talent for mimicry. The latter is revealed in a memoire of John Bacon the Younger (1777-1859):

> I well recollect the time when there were four vacancies amongst the Academicians to be filled up from the Associates, and those who expected to be successful assembled in the neighbouring tavern to learn the result when the election should be over. Webber the landscape painter, who sailed around the world with Captain Cook, was one of the four who were elected and I remember his calling on my father the next day, to thank him for his vote. My father, John Bacon, R.A. had told us that when the result of the election was declared, Mr. Banks good-humouredly said, 'I will go and apprise the gentlemen of their success', and Webber, who was a very facetious fellow, told us the way in which Banks announced to them the good news. He entered, with all his usual gravity, saying 'Gentlemen, I come to you with a cheerful countenance', but not a muscle moved which imitated cheerfulness of any kind. Those who knew the countenance and manner of Banks and who witnessed the excellent imitation of Webber, can alone conceive the amusing nature of this little occurrence.[50]

Some idea of Webber's likeness is conveyed through a portrait of the artist (plate 202), painted by Johann Daniel Mottet in 1812 after a contemporary miniature.[51] To judge from the costume Webber wears, the picture belongs to the last decades of the eighteenth century, and was certainly painted after the return from Cook's third voyage. The original was perhaps the one painted by Christian Hornemann (1765-1844) which Webber mentioned in his will and bequeathed to his friend Christian Fueter.[52] The location of the picture is unknown.[53]

Another testimony of Webber existed in the form of a memorial tablet in the Chapel of the Ascension, Bayswater Road, London (on the south wall of the ante-chapel); the old burial ground of St George's, Hanover Square. Originally devised by Webber's brother Henry, the tablet was ornamented with 'a large female figure mourning over a partially draped profile portrait. Above this there is the usual urn and a palette and brushes'.[54] It read: 'To the memory of John Webber, Esq. who as draughtsman accompanied Captain Cook on his second voyage of discovery round the world and died in London 29 April 1793, aged 41 years'.[55] The memorial tablet was apparently destroyed during the bombing of the chapel during the Second World War,[56] removing another vestige of Webber's existence. What is left of him — for our perennial elucidation and pleasure — are his works.

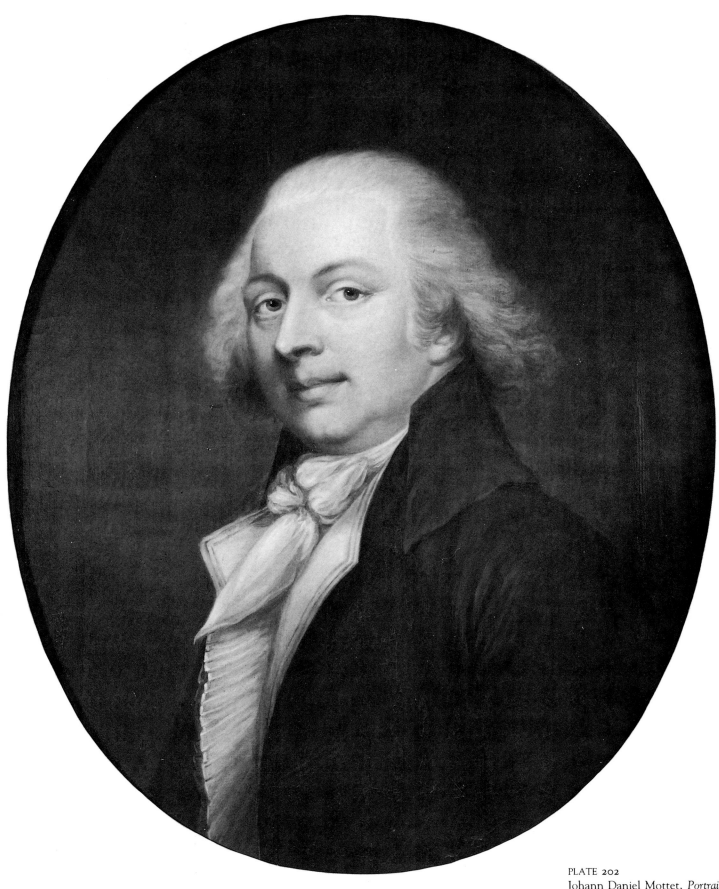

PLATE 202
Johann Daniel Mottet, *Portrait of John Webber*, 1812 (after a contemporary miniature), oil on canvas, 26½ × 21¾ : 672 × 552. Historisches Museum, Bern.

# 2. William Webb Ellis

## Biographical notes

William Webb Ellis was the other active draughtsman of the third voyage. He worked mostly in pencil and water-colour, making drawings of native peoples, landscapes and subjects related to the natural sciences. He is perhaps better known for his *Authentic Narrative of a Voyage performed by Captain Cook and Captain Clerke in his Majesty's Ships Resolution and Discovery . . .* (2 vols, London, 1782).[1] His drawings, however, which are readily identifiable stylistically provide us with, as Beaglehole remarked, an extra 'bonus' to our visualization of the voyage.[2]

Ellis was enlisted as surgeon's second mate on the *Discovery* until transferred on 16 February to the *Resolution*. As in Webber's case no diary has come to light, but that it is possible he kept a notebook is attested by a manuscript fragment preserved with his natural history drawings in the British Museum (Natural History), which describes birds and animals seen in Pulau Condore (plate 203).[3]

Ellis was probably about twenty when he joined the *Discovery* in 1776. Of his early life little is known except that he is said to have been from Cambridge.[4] It is also said that he studied medicine at St Bartholomew's Hospital, London; but no records have survived.[5] David Samwell, surgeon's second mate on the *Resolution*, who became the surgeon on the *Discovery* following William Anderson's death in August 1778 and thus became Ellis's superior until February, said of him that he was a 'genteel young fellow of a good education'.[6] Charles Clerke, the commander of the *Discovery*, seems to have encouraged Ellis to draw, and Ellis may have done some copying for him.[7] Clerke had travelled on the *Endeavour* with Banks and was keen to collect artefacts and specimens for him, being well aware of his interest in natural history.

On 10 August 1779, while close to death, Clerke wrote a letter to Banks bequeathing his natural history collection to Banks and in doing so commended Ellis to his attention.

> I must beg leave to recommend to your notice Mr Will. Ellis one of the Surgeon's mates who will furnish you with some drawings & accounts of the various birds which will come to your possession, he has been very useful to me in your service in that particular.[8]

Following his return home Ellis seems to have presented his drawings to Banks. He may have hoped for some substantial reward, or an improvement of his position, but such apparently did not materialize. Soon Ellis was in debt and seems to have borrowed money from Banks. After a while another source of income offered itself through the publication of his own account of Cook's third voyage, though Ellis was quite aware that by doing so he might compromise his career. Writing to Banks on 25 December 1781 Ellis attempts to excuse himself for publishing his *Narrative* without Banks's permission: 'I would never have applied to you again for supply who had before so readily and generously granted it'.[9]

Not wishing to take advantage of Ellis's straitened circumstances, Banks, in his return letter of 23 January 1782, decided to buy Ellis's drawings which, strictly speaking, Ellis had presented to him. He offered to cancel Ellis's note of hand for £20, add another £30, and thus bring the purchasing sum to £50.[10] The collection bought is identical, we believe, with the album of Ellis drawings now in the British Museum (Natural History) (3.432), amounting to 115 animal drawings, of which 90 alone are birds. The original album may have been larger and might have been broken up into groups. This is suggested, for example, by the pencil numbers on the versos of the bird drawings, which could easily have constituted a separate collection.

[1] Illustrated by twenty-one engravings after sketches by William Ellis, issued on 14 December 1781 and 1 January 1782.

[2] Cook, *Journals* III, 1, ccxii.

[3] British Museum, (Natural History) Zoological Library, 88q. E, fol. 4, MS in Ellis's hand, in brown ink on a sheet, measuring 31.6 × 19.6 cm, wm. LVG.

[4] *Gentleman's Magazine*, July 1785, 571. In Cook literature Ellis's obituary has often been quoted. Ellis's education at Cambridge, it should be noted, is not mentioned in J.A. Venn's *Alumni Cantabrigiensis. A Biographical list of all known students, graduates and holders of office at the University of Cambridge, from the earliest times to 1900*, pt. 2 from 1752-1900, II (Cambridge, 1944).

[5] Michael Hoare refers to Ellis's 'medical experience at St Bartholomew's Hospital' (Hoare, (1977) 11), but apparently there is no firm evidence for this. Enquiries at the Wellcome Institute, London and at Bartholomew's Hospital, met with no success. Ms Janet Foster, the District Archivist of the City and Hackney Health Authority advised 'the Medical College [of St Bartholomew's Hospital] was not founded until 1822 and there are no formal records of students before 1842. Prior to this pupils made their own arrangements with individual surgeons, the Hospital Governors took no part in these arrangements and, therefore, no record of them remains in the Hospital's archives'. J. Foster to R. Joppien, *in litt.*, 13 August 1984.

[6] Letter from Samwell to Matthew Gregson, 16 May 1782, Liverpool Public Library. For the full quotation see Cook, *Journals* III, 1, ccvii.

[7] Beaglehole is critical of Samwell's statement (in the letter above fn. 6) that Ellis used to write Captain Clerke's log, pointing out that 'Clerke's extant log in its original is certainly in Clerke's own hand, except for the very last few entries' but thinks it possible that Ellis 'may have done some copying for Clerke', see Cook, *Journals* III, 1, ccvii, fn. 2.

[8] Cook, *Journals* III, 2, 1543.

[9] Banks, corr. Kew BC 1.113. For the complete letter see Appendix 7.

[10] See Appendix 8. A transcript is in Dawson (1958), 2.89. Bank's letter was first published in Smith (1911), 52-3.

The two facsimile pages of William Ellis's journal contain handwritten natural history notes in English (left page) and Latin species descriptions (right page). The left page includes text such as references to "Coropitteci," "a large white Pigeon," species of Herons, "Dragons" (Draco volans of authors), lizards, snakes, "Tetrodon hispidus Linnei," fish, insects of the "Coleoptera Order," the mantis genus, wasps, ants, "Scolopendra," fruits, coconuts, bananas, shaddocks, breadfruit, and other observations. The right page contains Latin descriptions headed "E. Pulo-Condore. Lat: 8.40 N°" with entries for Turdus, Coracias, Columba nicobarica, Gracula religiosa, Phasianus Gallus, Motacilla Tiphia, Tanagra (olivacea), Falco Palpebris, Sciurus (dissimilis), and other taxa, together with a small watercolour sketch of a bird's head.

No doubt it was with considerable anxiety that Ellis decided to go ahead with the publication of his *Narrative*, for which the publisher granted him the sum of £40, plus another £10 for some drawings to serve as illustrations. The conditions for Ellis were poor ones, but he could not afford to wait for the sales; thus a contract for immediate payment was drawn up. When Ellis wrote to Banks on 25 December 1781 explaining the bargain and indeed his situation, he also mentioned the drawings just sold: 'As I had (and now have) many drawings by me, he [the publisher] made choice of ten others . . .'[11] This comment can only refer to Ellis's human, landscape and topographical drawings, which he seems to have kept in his possession, and for which he was now probably seeking a profitable outlet. Banks's reply does not suggest that he acquired any more of those, and neither have drawings of this category been found among his collections. But the question arises whether the drawings which Ellis was ready to sell were the originals which he brought back from the voyage, or whether, against the stressful urgency of his living conditions, Ellis made more accomplished drawings from earlier sketches with the plan to sell them. This might explain the various states of the rather amateurish early drawings and the more finished versions that characterize his *oeuvre*.

Banks sympathized with Ellis and was considerate of the 'Judaic treatment' which Ellis had received.[12] On the other hand, he made it clear that it was not within his power to further commend Ellis in his profession, after the publication had been released. When the *Narrative* appeared, Samwell noted that it was well written but not copious enough, being written from memory, to be satisfactory. 'I think he never thought of publishing till after he came home.'[13] Even so it reached a second edition before the official account appeared, and may have brought him a little more money. Henry Roberts was angry about its appearance

---

[11] Ellis to Banks, (Appendix 7).
[12] Banks to Ellis, 23 January 1782.
[13] Samwell's letter to Gregson quoted above, see fn. 6.

and proposed to Douglas that it should be suppressed.[14] No doubt the appearance of the *Narrative* isolated Ellis from many of his former friends. He certainly had no part in the publication of the official account, though he has been confused with William Ellis, the engraver, who worked on some of its plates.[15]

The last we hear of Ellis is that in 1785 he decided to join the scientific team of an Austrian ship fitted out for circumnavigation by Joseph II, the German Emperor. While at Ostend, then the main harbour of the Austrian Netherlands and the point of departure of the expedition, Ellis fell from a main mast in June 1785, and was killed. He was still probably under the age of thirty.[16]

[14] Letter from Henry Roberts to Canon Douglas, 4 January 1783, British Library Department of Mss., Egerton MS 2180 f. 61: 'Dear Sir, Finding by several of the Daily Papers that Mr. Ellis has brought forward the second Edition of his Spurious Narrative of our Voyage, I have had some Conversation with Mr. Cadell, who is of Opinion with myself that an Advertisement of our Intended Publication is absolutely necessary & should appear in the public prints without any delay, in order to suppress, and check the sale of the other, If therefore Sir you will be so obliging, as to write a letter to Mr. Cadell, on the subject, he will in Consequence, immediately wait on Sir Jos. Banks, with the Contents which (most probably will be the only means of the Advertisement taking plan, I remain Dear Sir, with the greatest respect & sincerity Your very hble serv! Heny Roberts.'

[15] Hoare, (1977), 14. The same William Ellis (1747-1810) also engraved three plates of Ellis's *Narrative*.

[16] *Gentleman's Magazine* (1785).

# The Ellis drawings

Ellis's drawings are housed in a number of institutions and fall into several heterogeneous groups. They are best considered here according to their present location.

1. The Alexander Turnbull Library group

This is the largest collection of Ellis's work. Most of the drawings are rendered in pencil with an occasional addition of wash. A smaller number are executed in pen and water-colour. It is interesting to note that those pencil drawings that relate to the voyage from Kerguelen's Land to Kamchatka reveal an untrained hand especially in the rendering of figures, perspective, and proportions between figures and objects. Ellis was about twenty when he embarked on the *Discovery* and it is to be doubted whether he had any previous training in drawing. Yet his eye was sharp and his technique may be seen to be constantly improving. Not surprisingly he is better at representing objects such as fans, feather caps and canoes than human beings. Even so his portraits of natives encountered are interesting, for though they suggest no more than a fleeting communication between artist and portrayed, they do add to our knowledge of the voyage. The faint outlines of so many of the drawings suggest an initial timidity but there is an increasing assurance evident as the voyage proceeds.

Several of the drawings are signed and dated, either in pencil or ink. Most drawings are numbered in brown ink on verso, though some are numbered on the recto only. A few are numbered on both sides. The verso numbers at least seem to belong to a sequence beginning with 8 (264.4) and ending with 76 (264.49), but with several omissions. The sequence includes drawings of heads, canoes, native artefacts, coastal profiles and specimens of natural history. There is, however, another numbering system written on the recto of the drawings that uses both digits and letters, for example, 2b, 3c, 5e, 6f. This additional system would seem to suggest that there were once additional drawings in this collection that originated perhaps from a separate and distinct group.

The drawings are of no uniform size. Many have been cut down and their verso numbers added afterwards. But most are of foolscap size on paper with watermarks of Britannia and GR in a circle of wreaths. Ellis used this kind of paper for many of his drawings. It came perhaps from his sketch book.

Most of the drawings bear inscriptions in pencil or ink. The ink inscriptions are in pale black ink and/or brown ink. It is significant to note that many of these inscriptions are inaccurate or intentionally vague in their determinations, and there is much use made of a terminal question mark. To take an example. 'Two natives in a canoe off Mangaia' (3.29) possesses various inscriptions in black and brown ink. Its verso has in pencil 'Whatdue'. Apparently referring to this inscription 'Whatdue? /see back/ Atowi ?' is written in black ink on the upper right of the recto. However this was later crossed out, in brown ink. The inscription, across the upper part of the drawing reads 'South View of [in black ink] Mangia-nooe [in brown ink] — distant 2 Miles [in black ink]'. This is then followed by a reference to Ellis's *Narrative* (1782), in brown ink.

The fact that the brown ink inscription superceded the black ink one, that it identified the island as Mangia-nooe and then added a reference to Ellis's published account, is clear evidence that it was added to the drawing only after 1782. This is important for it means that the brown hand is more reliable than the black hand, and probably neither belonged to Ellis.

This may be deduced from several other inscriptions. 'A double Canoe' (3.67), 'Portraits of natives' (3.77; 3.78), 'Portraits of a native woman' (3.80), all read, in black ink, 'Friendly Isles?' indicating the uncertainty of the inscriber. This surely could not be Ellis's inscription. 'A native and a hut' (3.85) has 'Otaheite?', in black ink. It is a study for 3.84, which is correctly inscribed, in brown ink. 'An Island View in Oitapeeah Bay, in the Island Otaheite'. Clearly the inscriber of 3.85 was in doubt about where the drawing was executed. This could not have been Ellis himself.

[1] See Medway (1977), 24, 26.

Quite different from the above inscriptions are the annotations made on the bird drawings in the Turnbull collection.[1] These suggest first-hand knowledge. For example 'Butcher bird caught at sea between Asia and America' (plate 204) in brown ink. Some of these annotations are written over older and partly erased pencil inscriptions.

The natural history drawings have the most complete inscriptions. If the brown hand is not Ellis, then it might be of some person knowledgeable in natural history.

Finally, a particularly important drawing from the viewpoint of inscription is 3.41 showing a coastal view of Anamooka. Its first inscription in black ink 'Friendly Isles' was later corrected to 'S.Point of Anamokka Capt.D' in pencil. The name of 'Capt. D.' crops up on a number of Ellis drawings.

## 2. The La Trobe Library group

There are four drawings. Three possess verso and/or recto numbers; the smaller verso numbers are in brown ink, and their sequence 3,5,13 fill gaps in the brown verso number sequence of the Turnbull group. Both the Turnbull and La Trobe drawings come from the Astley family of Liverpool (see page 00). It is unclear however to what sequence the recto numbers, also in brown ink, belong. They appear to follow the chronology of the voyage (64 on 3.7 precedes 68 on 3.25); but this could be coincidental.

*View of the Fluted Cape* (plate 10; 3.7) contains an extended inscription in pencil on verso in a small neat hand and is signed 'G.H. 6 Oct. 88'. Two references are made to 'Capt. D.' and Captain Dixon in the inscription. He is referred to as an authority and witness of the place depicted.

## 3. The National Library of Australia group

This, the second largest collection of Ellis's drawings fall into two distinct groups: (a) five drawings tipped into a copy of Dixon *Voyage* (1789); (b) seventeen water-colour drawings that must be regarded as Ellis's most efficient and accomplished works. The (a) group is inscribed in the neat brown ink known to us from the Turnbull drawings. There are no numbers and none of the drawings is signed. Four are certainly by Ellis, but two *Natives of Prince William Sound in their Canoes* (3.242) and *A Marae in Tahiti* (3.101) may be attributed to Webber on stylistic grounds. It may be noted here that the *morai* depicted in 3.101 was probably not seen by Ellis, at least he makes no reference to having been there in his *Narrative*. The drawing is puzzling in another respect. It is inscribed 'Sandwich Islands' in brown ink, yet the scene is clearly a portion of Webber's *Human Sacrifice at Otaheite* (plate 54; 3.99) which after 1784 was known from an engraving in the official account (3.100A). Such a mistake could only have been made by a person ignorant of that engraving. As we have noted above brown inscriptions indicate a post-1782 date, and this instance suggests a pre-1784 date, when the engraving was published.

Another curious drawing is *A man of New Caledonia* (2.M11), which is inscribed in ink and in pencil 'Priest of Sandwich Isles' and 'This was the Friendly priest, ment.d in Ellis's Voyage, Capt D'. The man portrayed however is not connected with the third voyage and he could not have been portrayed by Ellis. It is in fact copied from the engraving after Hodges (2.137A) published in the official account of the second voyage. The inscriber seems to have taken Dixon's word for it. It is the same hand as that on the verso of the *View of the Fluted Cape* drawing (plate 10; 3.7) in the La Trobe group.

We wonder whether Ellis was teaching himself to draw by copying engravings available on the *Discovery*. *A Dancing Girl* (3.105) in the Turnbull group was obviously copied from the engraving in Hawkesworth (1.87B), and in two other instances Ellis appears to have copied drawings by Webber: *A Girl of Otaheite bringing Presents* (3.108) and *A Chief Mourner* (3.112).

The (b) group are coherent and developed; perhaps they are presentation works. Several have elaborate framing lines. All are landscape views, some with singular motifs such as rocks and trees. All are signed and dated. As is common to most Ellis drawings they are numbered with brown ink. Thirteen show recto numbers in brown, ranging from 4 to 84. But these do not relate to the chronology of the voyage, and we have been unable to decipher their intention. One of them (3.206) is numbered in brown on the verso.

The inscriptions beneath these drawings are also in brown ink but larger than those on other Ellis drawings. The writing is neat and even. Two drawings 3.235 and 3.243 also have inscriptions in a later hand: 'P. Will.m Henry's Sound. Cap.t Dixon' and 'Snug Corner

PLATE 204
William Ellis, *Butcher bird caught at sea, and other drawings*, 1778-1779, pencil, pen and wash, 12³⁄₁₆ × 7⅞ : 310 × 200. Alexander Turnbull Library, Wellington. (3.433)

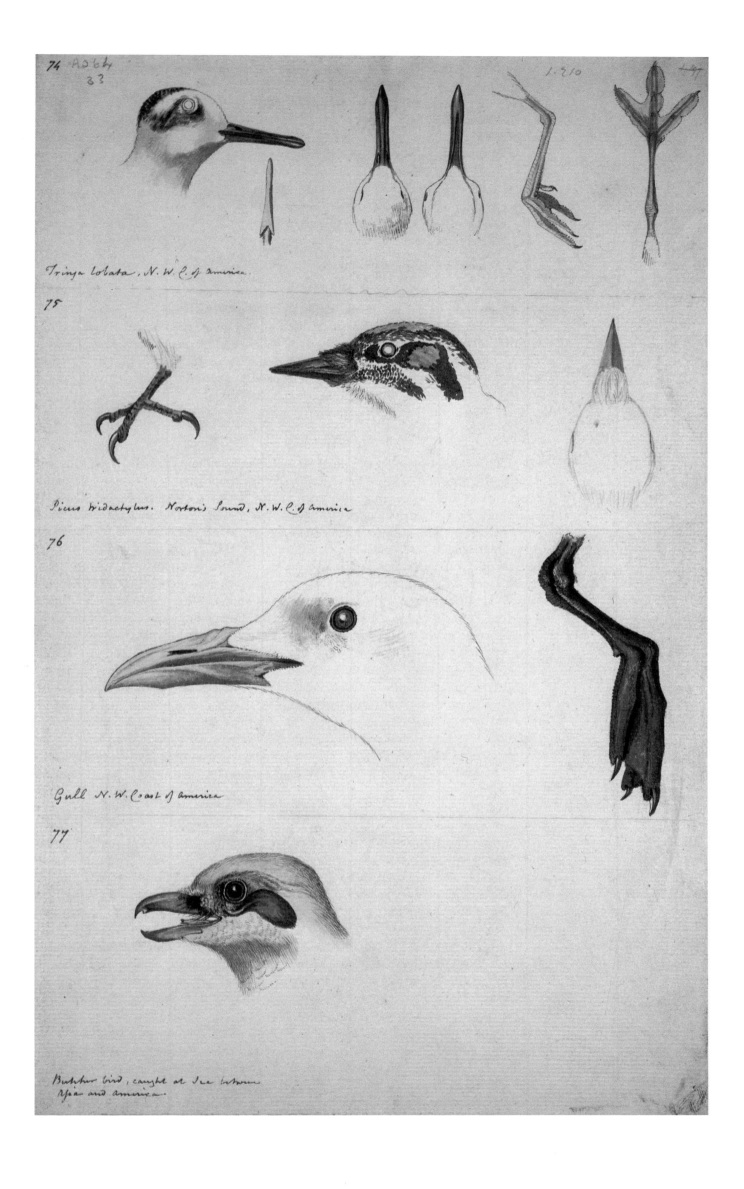

74 A264
33                                                    1.210

Tringa lobata . N. W. C. of america.

75

Picus tridactylus. Norton's Sound, N. W. C. of america

76

Gull N. W. Coast of america

77

Butcher bird, caught at Sea between
Asia and america.

P W Henry's Sound. Capt. G.D.' They pose an interesting problem. The inscription 'Prince William Sound, in Sandwich Sound' (see 3.243) indicates some confusion on the part of the inscriber. Sandwich Sound was the name given to the entire sound by Cook. While the official account was being prepared the name was changed to Prince William Sound, after Prince William Henry (1765-1837), third son of George III. In Ellis's *Narrative* (1782) it is still referred to as Sandwich Sound. The inscription therefore was almost certainly added after the publication of the official account in 1784 gave currency to the new naming. And by referring to Prince William Henry's Sound, Dixon's information was even more precise. Dixon was also correct in identifying the view as Snug Corner, Harbour, Cook's second station in Prince William Sound, as may be judged from a similar drawing by Webber (3.240).

4. The Bernice P. Bishop Museum group

These include a Tahitian view (3.83), five coastal views, three of which derive from the Searle group (see below), and a missing drawing which was entitled *The Friendly Priest's House* (3.296). The first drawing (3.83) is inscribed in the familiar small, neat brown hand, and numbered 6 on the recto. Two of the coastal views, *The View of Oneehow* and *Part of the West-Side of Owhaow* which, because of their particular nature as coastal views, are not covered in this volume, are numbered on their versos, 48 in pencil, and 18 in ink respectively. We have not been able to fit these numbers into any logical sequence.

5. The Rhona Townley Searle group

This group, which originally consisted of ten drawings of predominantly coastal scenery, was sold at Sotheby's London on 26 January 1984, and is now separated into at least five collections. Drawn in pen and water-colour over pencil, the execution is delicate and lively, revealing considerable skill. The predominantly yellow and greyish-blue washes are similar to the Ellis water-colours in the National Library of Australia. Before their auction they were contained in an album which also contained many prints after Cook's second and third voyage. The paper on to which the drawings had been stubbed was of eighteenth century origin. This suggests that the album was bound up after 1784 but most probably still in the eighteenth century. The inscriptions on two coastal views of Hawaii, *Views of Atowa, one of the Sandwich Islands* and *Atowi, the King's Mount* (now in the Bishop Museum, Honolulu) which are rendered in ink on verso made it necessary to transcribe them (almost) identically on the folios of the album when the drawings were bound up. Both drawings make reference to 'Capt.D.' and both bear recto numbers 9 and 10 in brown ink.

It has not been possible to decide who assembled the album or who was responsible for the inscriptions, nor why ten sheets of coastal views were brought together in this way. There are several coastal views among the Turnbull group but none were developed to a standard that matches the Searle drawings. Of what special interest then for Ellis, we might wonder, were these views? Were they commissioned by someone who wished to make use of them as possible anchorages in the Pacific and along the north-west coast of America?

6. The National Maritime Museum group

These are similar to the Searle group, being ten in number, rendered in pen and water-colour, signed and dated, and inscribed in dark blue ink with identical words. Their execution however is considerably rougher than those of the Searle drawings, which would lead one to believe that the Searle drawings are later, more developed versions of the Greenwich drawings, just as *A View of Christmas Harbour* (3.5) is a more developed version of 3.6. There are however difficulties with this conclusion.

As will be argued below there is good reason to believe that the marked improvement evident in Ellis's drawings, from those in the Turnbull group to those in the National Library of Australia group is due to his association with Webber following his transfer to the *Resolution* on 16 February 1779. If we assume this to be true than we would expect to see an improvement in the quality of his coastal views drawn on location after that date. We would expect, for example, the view *The Entrance to Avatcha Bay (Kamchatka)* and the view *Sulphur Island*,[2] both drawn after February 1779 to be better drawn than coastal views rendered by Ellis when he was still serving on the *Discovery*. Yet, there is no stylistic change or development discernible in the Maritime Museum group. They all appear as if they were executed at about the same time. Moreover they bear Ellis's signature. The possibility therefore arises that the National

[2] These coastal profiles will be published in *The Charts and Views of Captain Cook's Voyages*, III, Cambridge University Press for the Hakluyt Society (forthcoming).

Maritime Museum group were the first draftings of a special set of views made or commissioned for a special purpose, from which the Searle group drawings were developed as more finished versions. They might have been copied in the first place from original sketches made on the voyage by Ellis but now lost or copied from on-site views made by others who travelled with him, to whose drawings he had access after his return.

One drawing in the Greenwich group however, constitutes a problem on the basis of the above conclusion. The *View of Atowa*[3] shows on the extreme right, set apart from the steep rocks of Atowa (Kauai) a single mountain of conical shape. This feature is missing from the Searle drawing of the same view, now in the Bishop Museum. If Ellis copied his own drawings one wonders why he missed this prominent feature. The problem is compounded by the fact that it is believed that from the perspective of the drawing, no such hill as appears on the Greenwich drawing could be seen by the draughtsman.[4] This does suggest the possibility that the Greenwich drawings are not by Ellis but copies. Against that opinion there is the authority of his signature. True, he might have been called upon to authenticate with his signature the accuracy of drawings copied from his which he had not himself made and missed the inaccuracy mentioned above. But on the present evidence we have not been able to come to a clear decision as to the relationship between the Searle and the Greenwich group of Ellis drawings.

## 7. The British Museum (Natural History) Group

Because these 115 drawings relate to natural history they lie beyond the range of our catalogue, but it will be useful to relate them here to the rest of Ellis's work.

They are in his best style, the colour schemes adopted being similar to those of the water-colour drawings in Canberra, but unlike them have no elaborate framing lines or inscriptions in ink along the lower margins. Instead the inscriptions are in pencil either on recto or verso in a hand which is clearly Ellis's. Moreover some of the inscriptions possess an 'on-the-spot' quality, like 'Flew on board off Japan' (no. 7); or 'Lat: 66°: 00′N; 'Caught on board' (no 91). Most are signed in ink, in several ways: either 'W. Ellis'; 'W. Ellis del.'; or 'W:W Ellis ad vivum del.' & pinx.' followed by the year of execution. There are indications, however, that some of the signatures were added some considerable time after the drawing was completed. Thus a bird drawing from the Friendly Isles (no. 9) was first dated 1779 then altered (correctly) to 1778. A bird drawing of Kamchatka (no. 51) is dated 1778, but the expedition arrived there only in the spring of 1779.

The numbering has little in common with those discussed earlier. Each drawing is marked with a large number in dark brownish ink, from 1 to 115, signifying the folio number. These numbers were most probably added when the drawings were entered in the present album. The ninety bird drawings, the largest group in the album, possess pencilled numbers on their versos, ranging from 1 (f.7) to 159 (f.96). Does this mean that at least 159 bird drawings existed at one stage and formed a separate group? The numbers in brown ink on the bird drawings in the Turnbull Library (see 3.433) do not relate to the numbers on these drawings. So it must be assumed that they were originally different groups.

On the evidence examined above it is not possible to come to decisive conclusions. Most drawings are inscribed in pencil and in different inks. Several hands have been noticed. Although some pencilled inscriptions on some Turnbull Library and British Museum drawings are — we believe — clearly by Ellis, others in pen, inscribed after 1782 or after 1784 or even later perhaps, are probably not by him.[5] Many drawings refer to Ellis's *Narrative*. There are mistakes and uncertainties in many of the Turnbull Library drawing inscriptions that suggest they were not authenticated by the artist himself. Several drawings refer to 'Capt. D.' or Captain Dixon. Many bear signatures as well as dates that are supposed to be by Ellis. Taking into account the difference in quality in drawings in different collections and assuming that many of the developed drawings were prepared from earlier sketches, the dates on the drawings do not always, it must be concluded, indicate the date of execution but rather the year on which the subject portrayed might have been witnessed by Ellis.

We have no doubt that most if not all of the Turnbull drawings were produced on the voyage — if only because of their unashamed amateurish style. The dates on the Canberra water-colour drawings probably do not indicate the date of execution. They seem to have been dated retrospectively. We can draw no firm conclusions from the various numbering systems inscribed on the drawings. If other drawings by Ellis eventually come to light inscribed with numbers, they may throw further light on the dates of the drawings.

At this point a word must be said about Captain Dixon on whose authority many of

[3] ibid.

[4] Mr Lee Motteler of the Bishop Museum is of the opinion that 'if the perspective of the Ellis drawing of south-eastern Kauai is as we have determined, there could be no hill in the position shown on the National Maritime Museum Ellis'. Cynthia Timberlake, Bishop Museum to R. Joppien, *in litt.* 20 August 1984.

[5] Specimens of Ellis's handwriting are provided by his notes on the natural history drawings of Pulau Condore provenance in his album of drawings in the British Museum (Natural History) 88q.E. and by his letter to Banks of 25 December 1781 in the Botanical Library, Kew.

[6] Beaglehole in Cook, *Journals* III, 1475. Dixon was a native of Kirkoswald in Cumberland. He was baptized on 15 September 1727. There are 'brief mentions in county directories both of which say he died about 1791'. (Information kindly supplied by the Cumbria County Council, Archives Department, *in litt.* to R. Joppien, 10 July 1984.) The Crosthwaite Museum in Keswick, founded by Peter Crosthwaite (1735-1808) and opened in 1780, had a number of objects from George Dixon's collection, see Daniel Crosthwaite, undated ms. cat. in the Keswick Museum, A Catalogue of Crosthwaite's Museum (c. 1800) 80-1. 'A European Bow made of yew, & backed with ash, in imitation of the Ancient English Bow; the Asiatic Bow from the Sandwich Islands, brought thence by Captain Dixon, Circumnavigator, a native of Kirkoswald, in Cumberland, he sailed twice round the Globe, once with Capt. Cook & once with Capt. Pocock [Portlock]. An African Bow with a Cane string, & it is one of the strongest of them; An American Bow brought from Noutca sound by the above Capt. Dixon; & presented by him to this museum.' The catalogue also contained 'A most ingenious machine which the late Capt. Dixon invented for measuring Deapth of the Sea, when lead & line will not answer; after getting to a certain depth with lead and line, the pressure is so great upon them that you lose the weight, & cannot tell when the lead reaches the Bottom; this curious & ingenious little model was made by Capt Dixon's & is very much admired; it answers at all time if there are no currents.' Crosthwaite's Museum was carried on by the family, until it was disposed of in 1870. We are indebted to Jonathan King for drawing our attention to the Crosthwaite catalogue. Enquiries at the Naval Historical Library revealed no evidence that Dixon was ever a commissioned officer in the Royal Navy. His title, no doubt, derived from his command of the *Queen Charlotte*, a merchant ship. A.C.F. David to R. Joppien, *in litt.*, 20 December 1983.

[7] William Lewin was a natural history draughtsman and publisher in natural history, patronized by Banks. His son John William Lewin later went to New South Wales to collect for natural historians. Mazell was well-known as an engraver of natural history subjects.

[8] Dixon (1789), 173, 208.

[9] ibid, 356. On George Humphrey see Dance, (1966) passim, especially 99-101; Whitehead (1969) 172-3; and

the drawings were inscribed or identified. Dixon served as armourer on the *Discovery* and so was a companion of Ellis for a large part of the third voyage. 'After the voyage', Beaglehole writes:

> he may have risen to command a merchant ship, for in 1785 he was engaged by the King George's Sound Company to sail with Portlock. He must also have had some surveying experience, to enable him to do his useful work on the north-west coast in the 1787 season, when he discovered Queen Charlotte's Islands. His later years are obscure — possibly he taught navigation and died about 1800.[6]

The date of Dixon's promotion to captain is indicative, as it gives a *terminus post quem* for several inscriptions on the Ellis drawings referring to him.

Dixon is best known for his account of his *Voyage . . . to the North-West Coast of America* (1789) in which he commanded the *Queen Charlotte*, and Nathanial Portlock (who had also sailed with Cook on the third voyage) commanded the *King George*. Portlock was the leader of the expedition. The purpose of the voyage was to barter furs for trinkets with the Indians of the north-west coast and sell them at considerable profit on the Chinese coast. The *Queen Charlotte* left Gravesend in August 1785 and returned to Dover in September 1788. Dixon wrote his account in the form of letters and published it under the pseudonym 'W.B.' His last letter is dated '12 September 1788 off Dover'. The publication of the voyage was both quick and efficient, its engravings being published between October 1788 and 2 February 1789 — the last engravings being of natural history subjects. The classification of the birds was undertaken by John Latham and was probably the last section of the book to go into print. It was published late in February or in March 1789. The appendix dealing with natural history provided seven plates devoted to crustaceans, shells and birds after drawings by W. Lewin, engraved by P. Mazell.[7] The book was dedicated to Banks, and a canoe from Port Mulgrave, an Indian lip-piece[8] and probably many other artefacts and specimens of natural history came into Banks's collection from the Dixon voyage.

Another recipient was George Humphrey,[9] a London dealer keenly interested in shells and ethnographica. In his *Voyage* Dixon published an extremely rare shell 'Anomia venosa' which he had found in the Falkland Islands, and recorded that 'The specimen, from which the engraving was made, is in the private collection of Mr George Humphrey, dealer in natural curiosities, Albion Street, near Blackfriars Bridge, London'.[10] Now it seems quite likely to us that the person who signed the inscription on the back of the Ellis drawing of *View of the Fluted Cape* (plate 10; 3.7) with his initials 'G.H. 6 Oct. 88' was George Humphrey.

As we noted above, Dixon published his *Voyage* in the form of letters and had his manuscript ready for the publishers on his return. Its publication appears to have proceeded with alacrity, for the first chart, a *Sketch of Port Banks* was issued on 8 October. Two days earlier 'G.H.' had finished reading the text of Dixon's manuscript. For he tells us in his inscription on 3.7. that Dixon had told him about a rocky cave on the north-west coast of America with shelter for thousands of birds but that it was 'not mentioned in his *Voyage*'.

Humphrey was certainly an extremely keen collector of South Seas exotica of all kinds, and had shown a great interest in all three of Cook's voyages.[11] He would have been just the kind of person to lend a helping hand to Dixon's publication, perhaps even to assist financially. If, as we suggest, he may have been the person who wrote the extensive description on 3.7 then it makes it extremely likely that he was responsible for the inscriptions relating to Dixon on the other Ellis drawings. Could it be his neat brown handwriting which, as we

(1978a), 72. Thomas Martyn says in his introduction to his *Universal Conchologist*, (London, 1784): 'Genius, abilities and experience in the knowledge of shells are happily united in Mr. George Humphries; consequently his private collection possesses every requisite, attendant on such superior advantages.' (p. 22).

[10] Dixon (1789), 355.

[11] See Whitehead (1969), 172-3 and Whitehead (1978a) 72 in particular. Useful information on Humphrey as a collector of artefacts is also provided by Kaeppler (1978a), 44-5.

Humphrey's *Catalogue of the . . . Museum of Mr. George Humphrey . . . sold by auction*, London, 15 April 1779, contained 'the best and most extensive collection of the Cloths, Garments, Ornaments, Weapons of War, Fishing tackle, and other singular inventions of the Natives of Otaheite, New Zealand, and other newly discovered Islands in the South Seas' (title page). When the ships from Cook's third voyage returned, Humphrey formed a new collection, which he sold to the Königliches Academisches Museum, Göttingen in 1782, see Urban (1982), 21-5.

have noted, could not be Ellis's own? Might we not assume that Ellis in his desperation and poverty during 1781 and 1782 sold his drawings to an interested dealer? When he wrote to Banks on 25 December 1781 he had already sold twenty-two drawings to his publisher and still had others in his possession. If he sold them to Humphrey prior to the appearance of his *Narrative* (1782) it would have been natural enough for the owner to check their location against Ellis's published text, correcting as best he could, earlier inscriptions and making additions. At a later stage he might well have consulted Dixon and made further amendments.

There are then some grounds for maintaining that George Humphrey was responsible for the inscriptions in neat brown handwriting that appears on so many of Ellis's drawings. But the evidence is not conclusive. Furthermore when these inscriptions are compared with a page of his writing which bears his signature the evidence presented is not sufficient.[12] Whether these differences can be explained simply by the different occasions for the writing and the six year interval, it is not possible to be certain. Humphrey's hand in the matter must remain for the moment as a tentative hypothesis that requires further investigation.

The connection between Dixon and Ellis and the existence of two almost identical sets of coastal views, the Searle and the National Maritime sets, prompts further speculation.

Coastal and harbour views were drawn essentially as aids to the identification of useful havens and anchorages. When Portlock and Dixon knew that they were about to embark upon a voyage to the north Pacific in which the Hawaiian islands would feature as winter havens it would not be at all surprising for them to approach their old shipmate on the *Discovery*, William Ellis, for a set of coastal views that might well be of practical help to them. They would serve as an important supplement to the information recently available from the publication of the official account of the third voyage. It would have been equally prudent on Ellis's part, having regard for his straightened circumstances, to sell them a set of useful views. Who took the initiative in the matter is here largely irrelevant but the situation is such that it is highly likely that copies of Ellis's views were made. Even more likely indeed when one recalls that Ellis himself was planning to embark on a circumnavigation, and in those circumstances would have been likely to keep a set, if not his original set, for his own use on the voyage. Such a decision to make copies of his views would have taken place during the last few months of Ellis's life, between the formation of the King George's Sound Company in the spring of 1785 and Ellis's death in June. Since two ships were involved, one set of ten views for Dixon and a second set for Portlock would have been in order. Indeed one set might have been copied by someone other than Ellis, but on his behalf, which he later authenticated. This at least would provide a plausible explanation for the existence of the Searle and Greenwich sets of views, which are both signed by Ellis. The fact that these sets contain a preponderance of views that could well have been perceived, at the outset of Portlock's voyage, to be of direct practical use lends considerable strength to our speculation. Half of them are devoted to the north-west American coast or Hawaii, regions where they planned to work and to winter. The views of the entrance to Avacha Bay, Kamchatka, of Sulphur Island, and of Adventure Bay, might all have been considered of possible value for the homeward leg of the journey. As to the views of Matavai Bay, Tahiti and the island of Eua in Tonga, about the latter of which Ellis himself wrote 'This island is by far the most pleasant of the whole (of Tonga) as beautiful as can be conceived',[13] what eighteenth century Pacific voyager could resist the dream of a sojourn in such delectable islands, even if they were officially bound for the northern ice? Certainly Cook himself could not.

[12] Compare the catalogue of ethnographic objects Humphrey sold to Göttingen. It bears Humphrey's signature and address. Photograph by courtesy of Dr Manfred Urban, Institut und Sammlung für Völkerkunde der Universität Göttingen, to R. Joppien, *in litt.* 24 June 1985.

[13] *Narrative* (1782) 1, 88.

# Ellis and Webber

Webber's work quite clearly exerted an influence on Ellis. His draughtsmanship echoes Webber's predilection for small rather scribbly lines, and for spirals and spiky crescents in drawing tufts of grass and clusters of moss or earth. Webber's small zigzag lines and his habit of breaking lines into small strokes and dots are also to be found in Ellis's drawings. It was from Webber that Ellis appears to have learnt how to texture an object by means of parallel strokes and hatchings, though the effect in his case is often formalized and lacks Webber's immediacy of perception.

There is also a similarity of approach to subject matter. Both artists ensured that objects of natural history were depicted in their appropriate settings. In both their drawings of animals, particularly of birds, a feeling for ecology is present; a feeling that has little or no place in the natural history drawings of, for example, Sydney Parkinson. Both were also interested not only in landscape painting but also in specialized studies of rocks and trees, particularly during the later part of the voyage. Such interests induced in Ellis at times some quite novel compositions, such as *View in King George's Sound* (plate 101; 3.207) which is organized both vertically and horizontally, in a fashion that he could not possibly have managed at the beginning of the voyage. Some of his drawings on the north-west coast of America of clumps of rock, trees and grass (3.208; 3.211) reveal a surprising and unusual sensitivity to natural forms. It is also present in some of his ethnographic work. His *A Russian Hut* (plate 166; 3.364) becomes a symbol for the severity and loneliness of the region. There is an impersonal, detached air about much of his work. In this perhaps his very inability to draw human figures with assurance stood him in good stead. It helped him to express the grandeur and desolation of vast scenes where human beings, and at times even animals, might have introduced a jarring note. If his output of landscapes is any indication he preferred the sublime scenes of the northern Pacific to the arcadian beauty of the South Seas made popular by Cook's earlier voyages. To modern eyes there is an abstract quality about his work that is vaguely reminiscent of the art of Francis Towne. Like Towne he is prepared to sacrifice the topographic detail for the general truth. In this regard his water-colour landscapes are quite distinct from his painstaking pencil studies.

The landscapes of Webber and Ellis, though distinct in their approach to detail, often reveal that they were drawn from the same, or almost the same, spot. In this, Ellis's *Christmas Harbour in the Island of Desolation* (plate 3; 3.5), his *A View up the valley . . . from Matavai-Bay* (plate 71; 3.121) and his *A View of Snug Corner Cove* (plate 122; 3.243) should be compared with those of the same scenes by Webber.

Of course, in such cases where the same viewpoint is evident it cannot be ignored that Ellis's drawing may not be the original drawings but rather reduced copies of those by Webber. Indeed it was, and is, a common way to learn the techniques of water-colour painting. There can be little doubt that Ellis did at times copy Webber's work. The Chukchi peninsula was reached on 10 August 1778, and a short landing, which lasted no more than two or three hours, was effected. The landing party, headed by Cook, appears to have consisted of people from the *Resolution* only. With reference to the landing Clerke, the commander of the *Discovery* speaks in his Journal of 'our people who were on shore',[1] implying that he was not of the party, and Ellis in his *Narrative* does not appear to have been either. When speaking of the arrival of the two ships in St Lawrence Bay, where the landing was made, Ellis uses the pronoun 'we'. But when speaking of the landing party he relates how 'they' approached the natives and what they observed with regard to their manners and custom. Thus, there is evidence to suggest that the information he gained was gleaned from the landing party. Similarly his *Tents of the Chukchi* (3.274) appears to have been based, not upon personal observation, but upon Webber's drawing. That Webber accompanied Cook is attested by the sketches he made at the time (plates 136-138; 3.269-3.273). And, in this regard, it may be noted that whereas Webber noted the way the skins overlapped on Chukchi tents, Ellis drew them as if they had been patched together.

[1] Cook, *Journals* III, 1, 412, fn. 2.

214

Other cases where Ellis was clearly copying from Webber might be cited. Consider Ellis's *Girl of Otaheite bringing presents* (3.108), wherein he follows plate 67, 3.106 closely. Webber's full-length figure drawings usually depict one foot slightly retreating and touching the ground lightly by the toe. It is a pictorial stereotype that Ellis obviously learned from Webber's work.

Such similarities of style have sometimes led to confusion. Webber's drawing of a taro plant (3.295), that came to light in an Ellis provenance, was once considered to be by him. The forms of the plant depicted however are identical with those in Webber's *An Offering before Captain Cook* (plate 150; 3.294) which could be interpreted as an indication that Webber copied Ellis's work. But the style of the drawing is unquestionably Webber's. This is evidence enough that some of Webber's work became mixed with Ellis's.

During the period that Ellis remained on the *Discovery*, however interested he may have been in Webber's work, there could have only been rare occasions when they might have met and worked together. On 16 February 1779 however, Ellis joined the *Resolution* and was thus in a position to be in daily contact with Webber until the end of the voyage. During those last one and a half years and particularly after they had passed the Chinese coast Webber must have been busy preparing finished drawings for the Admiralty, redrawing, colouring and inscribing many of them. In this situation it would not have been at all surprising for Webber to give Ellis lessons in drawing and painting. Hodges had taught midshipmen on the second voyage, as we have seen, and the making of replicas was a common practice since the drawings were primarily for purposes of information. Webber might even have used Ellis to lay some of his colour washes; at any rate he became, during the voyage, quite skilful at it. In such circumstances it would have been normal for Ellis to use some of Webber's drawings and paintings as study material, just as he had used the engravings published in the accounts of the first and second voyages to assist him with the figure (see his *Dancing Girl*, 3.105). In this connection it may be noted that for many of his more mature and skilled water-colours, Ellis used a paper with different watermarks, such as Whatman and Villedary, from that which he used for his less mature work. Webber used such papers and it is quite likely that Ellis gained the paper from Webber.

All this certainly reduces Ellis's claims to originality, an originality that has at times been overstated.[2] Yet he did make an original contribution to the visual repertoire of the third voyage, particularly in the field of natural history. Most of his portrait drawings too, however inept, are original work made, it would seem, at the time of observation. And his landscape work, though it obviously owed much to Webber, at its best possesses a clarity and charm of its own. More could well have been expected of him had fortune and Sir Joseph Banks seen fit to favour him more than they did.

[2] Murray-Oliver (1977), 28.

# 3. The Cleveley problem

The publication of Cook's third voyage encouraged a number of British artists to undertake subjects associated with the voyages, for the Pacific had become a highly fashionable topic and Cook's death provided a new subject for contemporary history painting. Such subjects held the promise of financial reward, particularly if turned into prints.

From May 1787 until July 1788 Thomas Martyn (fl.1760-1816), a London collector of shells and exotica and also a publisher, undertook the publication of four prints in monochrome aquatint, the work of Francis Jukes, a well-known aquatint engraver. A view of Huahine (plate 205) appeared in May 1787, a view of Moorea (plate 206) in September 1787, a view of Matavai Bay (plate 207) in February 1788, and a view in Hawaii with the death of Cook (plate 208) in July 1788.[1]

The view of Matavai was incorrectly titled *View of Charlotte Sound in New Zealand*, and the *View in Moorea* was said to be in the 'friendly' islands. Obviously Martyn was not particularly well versed in Cook's voyages or Pacific geography.

In the prospectus which he published to promote the prints, Martyn claimed that the views were taken 'on the spot' by Mr James Cleveley of the *Resolution* and 'afterwards redrawn, and inimitably painted in water-colours by his brother . . . John Cleveley, and from which the plates were engraved, in his best manner by Mr Jukes'.

Martyn's claim raises a number of issues, the central one for the scope of this book being whether the prints were based on original drawings executed in the Pacific or are inventions based upon textual and visual knowledge assembled by John Cleveley — an artist who never visited the Pacific.

It will be useful to quote Martyn's prospectus in full:

VIEWS IN THE SOUTH SEAS,/ Dedicated, by Permission, to HIS MAJESTY./ Mr. MAR-TYN,/ THE PROPRIETOR OF THE PLATES/ Of those celebrated and interesting/ VIEWS/ OF DIFFERENT ISLANDS IN THE SOUTH SEAS,/ Discovered by the late CAPT. COOK, deems/ it necessary, occasionally, to remind the pub-/ lic, that the SET comprises REPRESENTA-/ TIONS, of the four following places; VIZ./ HUAHEINE, one of the SOCIETY ISLANDS; MOREAE, one of the FRIENDLY ISLANDS;/ OWHYHEE, one of the SANDWICH ISLANDS./ And CHARLOTTE SOUND in NEW ENGLAND/ THE ORIGINAL DRAWINGS of these several/ places were taken on the spot by Mr. JAMES/CLEVELY of the RESOLUTION ship of war,/ and afterwards re-drawn, and inimitably/ painted in water-colours by his brother, the/ late celebrated artist, Mr. JOHN CLEVELY,/ and from which the plates were engraved, in/ his best manner by Mr. JUKES./ THESE PRINTS EXHIBIT PORTRAITS OF/ THE NATIVES of the aforesaid Islands; with/ their curiously constructed BOATS, and other/ singular objects, as well by land as by water,/ peculiar to that quarter of the globe; and/ altogether, afford both a NOVEL AND PICTO-/RESQUE EFFECT. / The View of OWHYHEE included a faithful/ representation of the Death of Capt. Cook./ With the situation of His Majesty's ships/ the Resolution and Discovery in the bay, firing/ on the natives, as described in the several nar-/ratives of that fatal event./ THE SIZE OF THE PRINTS are 24 by 18;/ Price Half a Guinea each./ THESE VIEWS may also be had finely paint-/ ed in water-colours, in a style equal to the ori-/ginal drawings./ At One Guinea and a Half each./ The high finish bestowed, and the rich effect/ altogether produced by the peculiar mode in which/ these VIEWS are executed, have thus far produ-/ ced them universal esteem, and an unbounded sale,/ considerations which will ever impress the most/ grateful sentiments on the mind of the Proprietor./ sold at NO 12, GREAT MARLBOROUGH Str. LONDON.[2]

Before we consider the status of the prints it will be useful to outline the little that is known about Thomas Martyn. In 1782 he purchased a large quantity of shells brought back from Cook's third voyage and used the collection as a base for 'a great illustrated catalogue of all the shells of the world'. Unlike earlier books on conchology every item was to be illustrated 'with the greatest precision and in the greatest detail in colour'. The first edition of *The Universal Conchologist* was published in 1784.[3] It contained up to eighty engraved and hand-coloured plates in two volumes. A nomenclature was used to classify the shells, but its origin or its principles were not discussed, and scientific descriptions of individual shells were

[1] On Martyn see Smith (1960) 158-9, and Dance (1966) 100-3.
[2] We owe our knowledge of this prospectus (which has an English and French text) to the courtesy of John Maggs, London. It was found in a copy of Martyn's *Psyche* (London, 1797).
[3] Smith (1960) 158.

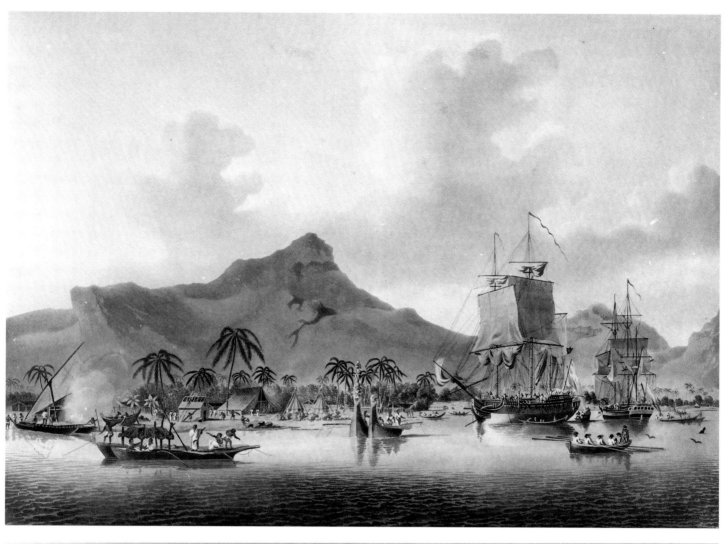

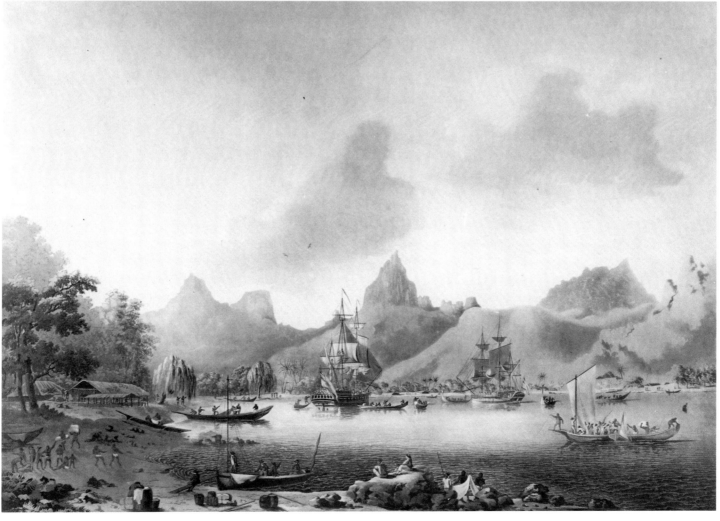

217

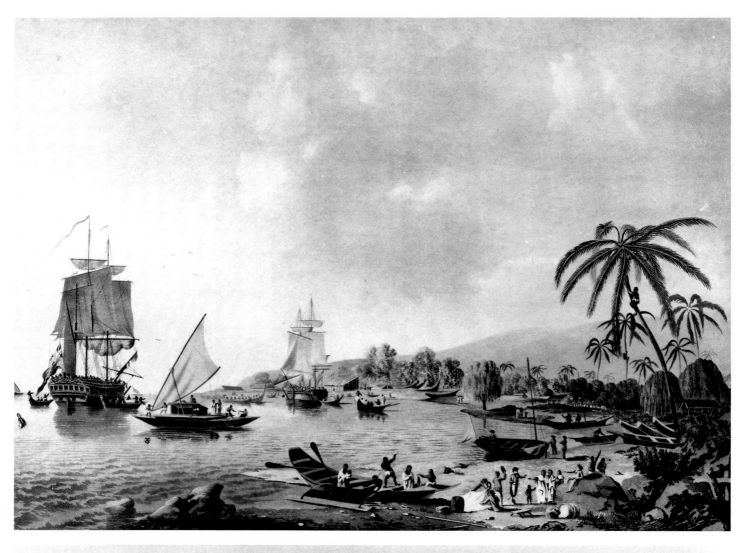

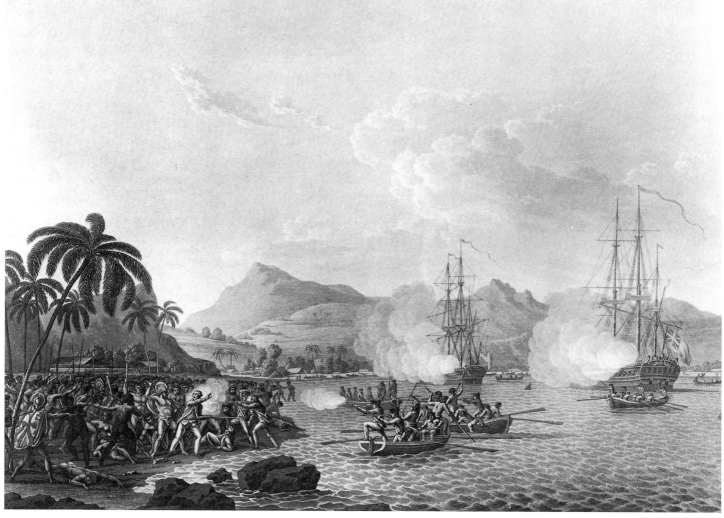

omitted. As Peter Dance has noted 'The Universal Conchologist is really a collection of coloured plates with a minimum of text'.[4]

[4] Dance (1966) 101.

Martyn became something of a specialist for the hand-colouring of monochrome or outline engravings. At his house at 16 Great Marlborough Street he established an 'Academy for Illustration and Painting Natural History'. In a brochure which was first intended as a preface to the second edition of The Universal Conchologist (1789) but also published separately, Martyn explained that he employed 'a number of young persons, who, born of good but humble parents, could not from their own means aspire to the cultivation of any liberal art; at the same time that they gave indications of natural talent for drawing and design . . .'[5] Martyn also explained that, following the failure of a professional etcher to meet his commission he had introduced 'this additional branch of business into the Academy' and the art of etching had been 'assiduously cultivated' by some of his pupils. 'The English Entomologist, The Work on Spiders and the etchings of several views of different islands in the South Seas . . . afford pleasing and satisfactory testimonies of their merits in that department'.[6]

[5] A Short Account of the Nature, Principle and Progress of a Private Establishment for the Purpose of Instructing Youth in the Art of illustrating, and painting, Subjects in Natural History. At his House, No 16, Great Marlborough Street, London. Martyn had moved apparently since he issued his prospectus.
[6] ibid. 32.

There is no good reason to doubt that the four prints of Pacific views 'engraved' by Jukes were based on drawings by John Cleveley. He was a skilled marine artist, a member of a family of artists (both his father, also named John, and his brother Robert were artists), and he had a long association with Banks.[7] What is in question is the extent to which he was indebted, if indeed he was indebted in any way, to four earlier drawings, or sketches, or field studies made by his brother James Cleveley, who was carpenter on the Resolution.

[7] On John Cleveley, see vol.2, 127.

The problem may be stated thus. The only evidence known for James Cleveley ever having made drawings is that contained in Martyn's prospectus and restated on the captions to the prints ('Drawn on the Spot by Ja.ˢ Clevely'). From this Beaglehole and others before and after him have assumed that James Cleveley made the original drawings that his brother John developed later.[8] But this view must be questioned. None of the journals relating to the third voyage mention James Cleveley as a draughtsman, nor have any sketches that can confidently be associated with him come to light. It is of course likely that as a carpenter James would have possessed some rudimentary skills in draughting and it is possible that drawings which may be confidently attributed to James Cleveley will one day come to light. But these possibilities are obviously not in themselves proof that the John Cleveley drawings were based on so-called 'on the spot' drawings by James.

[8] Cook, Journals III, i, ccxiv.

John Cleveley certainly had experience in working up drawings made on the spot by artists attached to voyages of expedition. It has long been assumed that he had accompanied Captain John Phipps to the Arctic in 1773. But recent research has shown that he was not on the ship's list and that, in all probability, he based his water-colours which illustrate the voyage on drawings made by one of the midshipmen, Philippe d'Auvergne (1745-1816).[9] But none of d'Auvergne's sketches that can be related to Cleveley's drawings have yet come to light. In this case however we do have some evidence that there was an artist whose drawings Cleveley might have used. The only drawings of d'Auvergne at present known are of natural history specimens, though he is recorded by Phipps as having also drawn landscapes. John Cleveley's skills in drawing ships accurately and also in animating landscapes with small active figures were very useful for the purpose of illustrating far voyages. But these illustrations it seems were skilfully made up, as was often the case with material deriving from eighteenth century voyages and travels.

[9] On Cleveley's works concerning Phipp's voyage, see Savours (1983) 301-4.

John Cleveley, Junior, exhibited at the Society of Artists from 1767 to 1780 and at the Royal Academy from 1770 to 1786. His first interest in the results of Cook's third voyage (he had already drawn artefacts from the second, 2.37, 2.38, 2.81-2.89, is to be seen in a water-colour entitled The Resolution and Discovery making Amsterdam, one of the Friendly Islands exhibited in the Academy in 1781 (no. 150). Three years later he exhibited A View of the Morea, one of the friendly isles in the South Seas (R.A. 1784 no. 438). This is probably identical with the painting now in the Mitchell Library (plate 209). Moorea, of course, was not in the Friendly Islands and the Mooreans had not been particularly friendly to Cook when he visited the island — they stole one of his goats, for which he exacted a terrible revenge, burning a large number of their houses and canoes before the goat was eventually returned. Cleveley might have been using the term 'friendly' in a general sense, applying it rather to the reception that Cook had received from the Polynesians in general (at least that was the popular view when the prints were produced), or the location may have been incorrect. But this line of argument only stresses that Cleveley and later Martyn was not so much interested in providing actual information through the prints as providing the scene of a typical friendly reception of Cook by native peoples. The later part of Cook's stay at Moorea was far from friendly. James Cleveley was doubtless one of the carpenters that Cook instructed 'to break up three

PLATE 207
A View of Matavai Bay, February 1788. Monochrome aquatint by Francis Jukes after John Cleveley. National Library of Australia, Canberra.

PLATE 208
A View of Owyhee, July 1788. Monochrome aquatint by Francis Jukes after John Cleveley. National Library of Australia, Canberra.

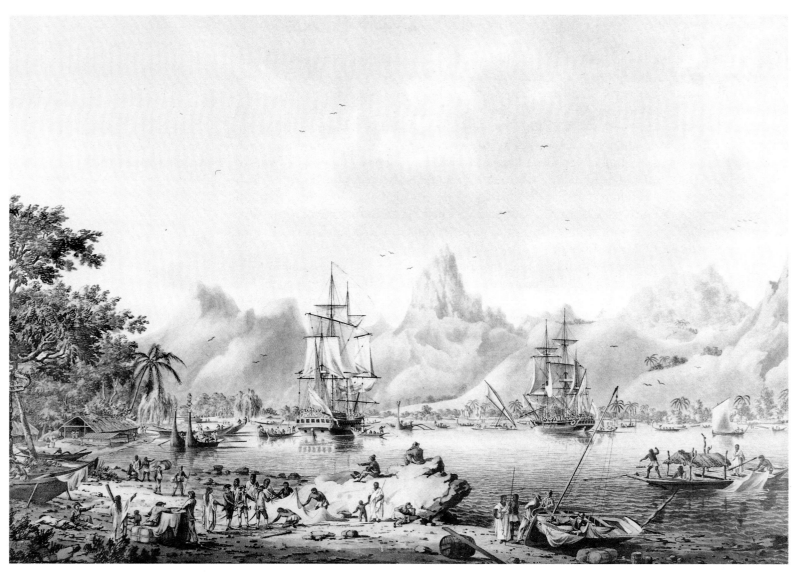

PLATE 209
John Cleveley, *A View in Moorea*, 1784,
pen, wash and water-colour, 16½ ×
28⅛ : 490 × 715. Mitchell Library,
State Library of New South Wales,
Sydney.

or four Canoes that lay a shore at the head of the harbour; the plank we took on board to build Omai a house at Huaheine'.[10]

Since *A View in Moorea* (plate 209) precedes the plates published by Martyn by three years, it is probably the prototype that inspired their publication. But there is no visual motif in it that John Cleveley might not have had access to in London in 1784. Because of his close association with Banks and his high reputation as a marine painter it is highly likely that he would have had access to Webber's drawings particularly during the protracted period of their publication for the official account. Either of Webber's views of Papetoai Bay (plate 74; 3.135, 3.136) would have provided him with a knowledge of the dramatic skyline of volcanic cones that serve as the horizon line. Again, though Cleveley makes use of a viewpoint closer to the head of the harbour than Webber he places the two ships in a similar position, but with the *Discovery* turned more to the left. More significantly Cleveley places a house that parallels in construction and proportion the house that appears also to the far left of Webber's drawing (3.137). Other aspects of Cleveley's drawing are more fanciful. The canoes with high sterns are hybrid inventions. They seem to depend in part on Webber's drawings of Raiatean *pahi* (plate 80; 3.152), one of his favourite subjects, and in part on the high-sterned canoes in paintings, or engravings after, Hodges (for example, 2.108A). The strongly-bowed stanchions of the outriggers are characteristic of Raiatean but not of Moorean canoes of Cook's time. The sailing canoe between the two ships is not a Tahitian type, and could not have been derived from a drawing made on the spot in Moorea by James. John probably appropriated it from the engraving of a large Tongan canoe (*tongiaki*) by Watts after Hodges (vol. 2, plate 105). The numerous little figures selling tapa or chatting with sailors are picturesque inventions. For the 'classical' dress of the Mooreans, Cleveley need have looked no further than the engravings in Hawkesworth, Parkinson's *Journal*, and the official account of the second voyage.

For this reason works such as John Cleveley's *A View in Moorea* and those that followed and resulted in the production of Jukes's prints do not fall within the scope of this book. They belong to the iconography of Cook's voyages not to that empirical informational art that Banks initially sponsored on the voyage of the *Endeavour*. But they are illuminating in that the very

[10] Cook, *Journals* III, i, 231.

220

problem of authenticity they present underlines the difficulty we face in marking a clear dividing line between the kind of art that seeks to inform and that which seeks to invent in order to reinforce popular interests and popular prejudices. It is not of course, as the discussion above may have suggested, simply a matter of distinguishing between the art of those who travelled with Cook and those who, not having travelled, developed an iconography and an ideology concerning the voyages from the materials, either textual or visual, ready to hand. Even those who travelled with Cook as we have constantly seen, interpreted, as well as they could, their novel experiences, within the terms of references that the cultural baggage they brought with them allowed; and those who remained at home continued to be drawn by the fascination of the exotic, that is to say, of the non-European.

Although it is difficult to point to any specific images in the Cleveley drawings that provide visual information about the Pacific that is not already available from more direct sources, there is an important sense in which the drawings develop out of the voyage art. They may be read as a new development in the imagery of cultural contact which is first figured fourth (in its Pacific context) in Buchan's small drawing of Cook's men meeting Fuegians (1.3) and is then further developed by Hodges, on the second voyage, in his 'landing' paintings and engravings, in which the European is seen confronting the stranger, as often as not in a state of hostility and conflict. This theme, this *topos* of cultural contact was, as we have seen, an abiding concern for John Webber during the four years of the last voyage. He endowed it with a significant new modulation, that of Cook, the enlightened messenger of peace and civilization to the new Pacific world, both in his life and in his death. The Cleveley drawings do not, of course, aim at such high concerns. Their overriding interest is in the bustling and exciting activity that contact with the strange brings at each landfall, of seamen watering the ships, trading for cloth, or chatting-up the natives. And over it all are the two, ever present ships, which was their home. They are the kind of prints that anyone who travelled with Cook, whether officer, midshipman or able seaman, might want to possess to remind him and his family of the days when he travelled with Cook. They are obviously aimed at a broad, popular market. The busy activity at each landfall depicted is not aimed at presenting Cook in heroic terms, nor do the prints either elevate or denigrate the local people. Even in the print depicting his death, Cook looks rather like one of his own seamen who has been caught up in a street brawl outside some Deptford pub.

It is the excitement of the voyage itself that is being celebrated in the Cleveley drawings; the voyage from the point of view of the men who manned the ships, a kind of British broadsheet art that was eminently suited to begin the preparation of the nation for its great nineteenth-century imperial adventure. But it was not, paradoxically, an outward-looking art, that sought to embrace the strange; no longer an art of information or curiosity. It was not a school for seeing. Topographical art had begun to turn inward upon itself to enjoy, perhaps a little self-indulgently, the personal excitements of the imperial adventure.

# APPENDIX 1

## Webber's letter to his cousin, Daniel Funk

London, 4 Jan<sup>y</sup> 1781

My very dear Cousin,

at this moment, as I take up my pen, in order to tell you that I am alive and to ask you to tell me about the state of health of all my very dear relatives and friends, I receive a letter from you. What pleasure this has given me. When I discovered your signature, I went to my brother in order to let him take part. I had learnt from him that he had had no answer to his last two letters, from that I could only wonder whether the letters had been lost or whether death had taken away relatives and friends which are so dear to me.

My letter, or the enclosure in that of my dear father, if I remember rightly, was addressed to my dear aunt. From her I had impatiently expected some news, I then announced my plan or intention to make a voyage round the world with the famous navigator Captain Cook, in order to find a passage between the West-Coast of America and Europe. This idea, my dear Cousin, no doubt will seem rather strange to you, but to me it was enough to see that the offer was advantageous and besides, contained the matter which I had always desired to do most (to know, to sail and to see far away and unknown countries). The Admiralty appointed me for 100 Guineas per year and above that paid all the expenses of my work. This, together with the means which I hoped to receive on my return, in order to distinguish myself with images of novelties, gave me hope that my lot would be happier in the end, if God spared my life. All this was decided eight days before my departure, and I was in quite a hurry to persue all matters that were necessary. After I received the order, I rendered myself to Plymouth harbour, where I met the two vessels at anchor. The Resolution commanded by Capt. Cook and the Discovery under Captain Clerke.

The ship on which I served, was that of Captain Cook, who honoured me with his particular amiability [through his death I have lost a most worthy friend — crossed out again.]. Omai, who was an inhabitant of Otaheite, and of whom you have certainly heard, was taken back to his country on our vessel. In the middle of July 1776 we made our good-byes to Europe, at least for a number of years, and after 4 months of voyaging we arrived at the Cape of Good Hope. There we were furnished with everything we needed, and then we said good-bye to the entire world, that is to say to the civilised world. Then all communications between us and her were cut off. In the course of our voyage we visited the most distant countries and in this we made several discoveries. After having sailed through different parts of the Southern Ocean and visited a number of islands which until then were unknown, we returned to cruise along the coast of West America; crossing the Pacific we hit upon an Island in lat. 18 D.N. which was well populated and very pleasing, and which supplied us with all provisions that we required. There we made only a short stop; Capt. Cook gave it the name of Sandwich Island, in honour of the First Lord of the Admiralty.

Finally we arrived on the coast of America in the latitude of 44 N., and from there we continued to sail along the coast, often escaping the danger of shipwreck, which one has to expect on a coast entirely unknown. The inhabitants are poor and of savage nature, living mainly from fishing or hunting. The countryside is covered by pine-trees.

In the latitude of 71 N. the unpenetrable ice prevented us from proceeding any further, and at one time we were in the greatest danger of running on ground. Winter approached rapidly and because there was nothing else to do that season, and being pretty convinced that no N.-W. passage was practicable, it was convened that we should spend the winter in some warmer climate and wait for the following season. We decided to make for the Sandwich Island. On arriving we discovered the whole group of which this island was only one part. The biggest island is called Owhyhee by the natives, who are almost the same as the other natives of the Pacific islands. Their colour approaches that of copper; There we found a harbour with new provisions, and everything that was wanting to refresh ourselves we received; our conduct was of the greatest happiness imaginable; but unfortunately this did not last long, for some ill-disposed natives abducted our best boat, and in the attempt to recover it, a struggle ensued, in which to our distress five of our people were killed on the spot; of these one loss can never be repaired, this was our most unfortunate Captain, who remained among those killed. Never was an event more tragic. It was the third time that this celebrated and worthy man sailed around the world, and I don't think that any other man will be so rightly and universally regretted. The King took care of his family. Captain Clerke succeeded him in command, and we left a place which to us had become

detestable, in order to sail to the Icy Sea, for a second time and to make a last effort to discover a passage. In the course of our voyage we took up new provisions in a harbour in Kamtschatka, a country in the East of Asia, belonging to Russia. There we were very well received and provided with everything that the country produced. The Govenor was German by birth and I had the honour of negotiating all matters between us as interpretor, because we had nobody on board who spoke Russian.

After we had reached the ice and after it had become sufficiently clear to us that all our attempts to find a N.W. passage were in vain — because of the ice barrier which stretches between the coasts of the two continents — for the first time we believed in the probability of ever returning to our country. We returned to Kamtschatka to repair all damages which the ships had received among the ice. On entering the harbour, Captain Clerke died of an illness of the lungs. He was interred with great ceremony. It was from here that — after an absence of nearly three years — the first news about us reached Europe through the lucky services of the Govenor who returned to Russia and who took our letters and journals with him.

On our return journey we visited China and subsequently the Cape of Good Hope which to us was a very nice sojourn after we had left it previously. There nothing was wanting, and we were in need of everything as you can imagine. We were men who had lived only on the sea or among savages during the period of four years. What was extraordinary and what had never quite been seen before, was that the crew of the two ships arrived in perfect health, not having lost since our departure more than two men through natural illness.

On 21 August 1780 we set foot again on the soil of our island, after the absence of 4 years and several mounths, all in good condition, and I can say without exaggeration that this voyage holds the first rank among all that have taken place before.

The only thing we lacked was the discovery of the gold mines, in order to go through everything. Instead we had much hardship and hardly any profit; however, the pleasure of having been there, is enough recompensation. I have brought with me nearly two hundred drawings, besides an important number of portraits in oil. Shortly after my return, I had the honour of showing these to the King and to the Royal Family who were very kind in their appraisal. Lord Sandwich honours me with his favour and I am now busy doing the drawings for the copper engravings, of which 63 shall be issued with the account. These I believe can not be done in less than a year and a half. The account will contain three volumes in quarto.

Since my arrival in England I have an appointment of 200 gns per annum, for as long as the Admiralty pleases to employ me, thus, my dear cousin, I have every right to expect that the means which I presently enjoy, will improve my finances and put me well into the position of seeing you again some day and telling you by mouth what can not be written.

<div align="right">

Staatsarchiv des Kantons Bern, Switzerland,
Kept under 'Wagner 47'.

</div>

The letter is not in Webber's hand but is a French copy of his original which we have here translated into English. It is not known whether the letter was originally written in French by Webber or translated by the copyist.

# APPENDIX 2

## List of engravers, originally selected for engraving the plates for the Atlas to Captain Cook's third voyage, with their London addresses where known

1. Byrne Tichfield Street 79
2. Caldwal Angel Court Windmill Street
3. Basire Great Queen Street Lincolns inn Fields
4. Smith
5. Delatre Gresse Street Rathbone place
6. Sharp Kennington Lane
7. Lerpiniere Walcot Place Vauxhall
8. Sherwin S? James's Street 28
9. Pouncey Pratt Street Lambeth
10. Middiman
11. Mazel Portland Street N? 64
15. Grignion Islington
16. Ellis
13. Bartholozi North End
17. Hall Bentink Street
    Woollet Green Street Leicester square
    Thornthwaite
    Müller
    Bonner
12. Ch. Taylor Dyers Buildings N° 8
    Newton Bolt & Tun Passage, Fleet Street
14. Benezech
    Chesham No 4 Richmond Buildings
22. Record — [further to the right the names Dodd, Edwards and Heath appear, but without addresses]
19. Scott, Greys inn Lane
    Morris Parsons Green N? 1 North End
    Watts Chelsea
20. Woodyer Same houses
    Fitler Tottenham Court Road
    Walker Rosamond Row, Clerkenwell
18. Angus Rosamond row with the last
    Ryder Long Acre
    Scott 74 Greys inn Lane [crossed out again]
    Sparrow 54 Rosamund Row [crossed out again]
21. Heath Ropemakers Alley little Moor Fields N? 4
18. Angus Rosamundst. Clerkenwell [crossed out again]
    Cooke
    Collier White Lion Row, Islington N? 7

National Library of Australia, MS 9/28.

# APPENDIX 3

## List of the engravers and engravings in the Atlas to Cook's third voyage, with their costs

| Pl. no. | Title | Engraver | Price |
|---|---|---|---|
| 4 | Christmas harbor in Kerguelens Land | Newton | 31/10 |
| 6 | Man of Van Diemens Land | J. Caldwall | 36/15 |
| 7 | Woman of Van Diemens Land | J. Caldwall | 42/- |
| 8 | Opossum of Van Diemens Land | P. Mazell | 10/10 |
| 10 | Inside of a Hippah in New Zeland | B.T. Pouncey | 47/5 |
| 11 | Man of Mangéa | W. Sharp | 26/5 |
| 13 | View at Anamoka | W. Byrne | 94/10 |
| 14 | Reception of Cap.t Cook at Hapaee | Heath | 84/- |
| 15 | a boxing match at Hapaee | J. Taylor | 31/10 |
| 16 | Night Dance by Men at Hapaee | W. Sharp | 94/10 |
| 17 | Night Dance by Women at Hapaee | W. Sharp | 94/10 |
| 18 | Poulaho King of the Friendly Islands | J. Hall | 36/15 |
| 20 | Poulaho drinking Cava | W.m Sharp | 73/10 |
| 21 | a Fiatooka or Morai in Tongataboo | W.m Ellis | 47/5 |
| 22 | Natche a Ceremony in Tongataboo figures | J. Hall | |
| | Landscape | S. Middiman | 94/10 |
| 23 | a woman of Eaoo | J. Hall | 36/15 |
| 25 | a Human Sacrifice in Otaheite | W. Woollett | 157/10 |
| 26 | The body of Tee as preserved after Death | W. Byrne | 52/10 |
| 27 | A Young Woman of Otaheite bringing a Present | F. Bartholozi | 52/10 |
| 28 | a Dance in Otaheite | J.K. Sherwin | 126/- |
| 29 | a Young woman dancing in Otaheite | J.K. Sherwin | 36/15 |
| 31 | a view in Huaheine | W. Byrne | 63/5 |
| 33 | a Morai in Atooi | Lerpiniere | 31/10 |
| 34 | Inside of a house in the Morai at Atooi | Scott | 10/10 |
| 35 | inland view at Atooi | S. Middiman | 73/10 |
| 38 | a Man of Nootka Sound | W. Sharp | 26/5 |
| 39 | a woman of Nootka Sound | W. Sharp | 26/5 |
| 40 | Various articles in Nootka Sound | J. Record | 5/5 |
| 41 | View of habitations in Nootka Sound | S. Smith | 52/10 |
| 42 | Inside of a house in Nootka Sound | W. Sharp | 63/- |
| 43 | Sea otter | Mazell | 10/10 |
| 45 | Snug Corner Cove | W. Ellis | 63/- |
| 46 | a man of Prince Williams Sound | J. Basire | 26/5 |
| 47 | a woman of Prince Williams Sound | J. Basire | 26/5 |
| 48 | a man of Oonalashka | W. Sharp | 26/5 |
| 49 | a woman of Oonalashka | Delatre | 31/10 |
| 50 | Canoes of Oonalashka | W. Angus | 10/10 |
| 51 | The Tschukshi & their habitations | Lerpiniere | 46/5 |
| 52 | Sea Horses | E. Scot, J. Heath | 52/10 |
| 54 | Inhabitants of Norton Sound | B.T. Pouncey | 47/5 |
| 56 | Caps of the natives of Oonalashka | J. Record | 6/6 |
| 57 | Natives of Oonalashka & their habitations | J. Hall, S. Middiman | 52/10 |
| 58 | inside of a house in Oonalashka | W. Sharp | 63/- |
| 60 | Offering before Cap.t Cook Figures | J. Hall | 73/10 |
| | Landscape | S. Middiman | 42/- |
| 61 | Terreoboo bringing Presents | B.T. Pouncey | 68/5 |
| 62 | Man of Sandwich Island Dancing | C. Grignion | 26/5 |
| 63 | Young Woman of Sandwich Islands | J.K. Sherwin | 31/10 |
| 64 | Man of Sandwich Islands with his helmet | J.K. Sherwin | 31/10 |
| 65 | A Canoe with the Rowers maskd | C. Grignion | 42/- |
| 66 | a man in a mask | Cooke | 21/- |

| Pl. no. | Title | Engraver | Price |
|---|---|---|---|
| 67 | Various instruments of Sandwich Isles | J. Record | 8/8 |
| 68 | View of Karakakooa bay | W. Byrne | 78/15 |
| 70 | a Man travelling in a Sledge | S. Middiman | 42/- |
| 71 | A Sledge | Woodyer | 3/3 |
| 72 | View of Bolchearetskoi | P. Benezech | 42/- |
| 73 | a White Bear | Mazell | 10/10 |
| 74 | Town & harbour of Sᵗ Peter & Paul | B.T. Pouncey | 68/5 |
| 75 | a Man of Kamptchatka | W. Sharp | 26/5 |
| 76 | a woman of Kamptchatka | W. Sharp | 26/5 |
| 77 | Summer & Winter habitations | S. Smith | 52/10 |
| 78 | inside of a winter habitation | W. Sharp | 52/10 |

National Library of Australia, MS 9/29.

# APPENDIX 4

## 'An Account of the Expence of the first Edition of Capt. Cook's [third] Voyage'

*Plates*

| | | |
|---|---|---|
| Paper Panckoucke's Account }£<br>    Livres 14,534..15.. 9 | | £ 635..18..— |
| Duty & Expences of Ditto | | 310..17.. 4 |
| Paper for Charts  Woodmason's Bill | | 117..18..— |
| | | £1064..13.. 4 |

*Copper Plate Printers*

| | | |
|---|---|---|
| Hadrill's Accounts | | £ 177..12.. 5 |
| Haynes's Dº. | | 143..16.. 4 |
| Coxe's Dº. | | 339..10..— |
| Hixon's Dº. | | 182..19.. 6 |
| Cook's Dº. | | 80..10..— |
| | Total of the plates | 924.. 8.. 3 |
| | | £1989.. 1.. 7 |

*Letter Press*

| | | |
|---|---|---|
| Paper as Bowles's Bill | | £1016.. 3.. 6 |
| Dº. Chapman's Dº. | | 63..15..— |
| Printing Strahan's Dº. | | 402..10..— |
| | Total of Letter Press | £1482.. 8.. 6 |

*Incidental Expences*

| | | |
|---|---|---|
| Advertising paid Cadell | | 14.. 5..— |
| Dº. pᵈ by G.N. | | 19..19.. 6 |
| Binding Presents & other Miscellaneous Expences, as p. Particular Accounts | | 90.. 5.. 6 |
| | Total of Incidˡ Expenses | £ 124..10..— |

*Recapitulation*

| | | |
|---|---|---|
| Plates | | £1989.. 1.. 7 |
| Letter Press | | 1482.. 8.. 6 |
| Incidental Expences | | 124..10..— |
| | Total | £3596.. 0.. 1 |

National Library of Australia, MS 9/30.

# APPENDIX 5 (1)

## Letters by the French engineer Monneron to La Pérouse and the Maréchal de Castries

*11 Avril [1785]* [to La Pérouse]

Je fais faire mon portrait par M. Webber qui a fait ces beaux dessins qui ornent le 3ᵉ voyage de M. Cook; j'ay le plaisir d'etre en connaissance intime avec luy, et je vous assure que sa conversation est des plus interessantes; Comme je sais que vous êtes curieux je me fais un plaisir de transcrire ses discours: comme je vous écris par une voye extraordinaire, je ne vous enverrai que par le courrier de demain une lettre qui contiendra bien près de douze pages. Les échantillons que vous demandez sont chez moi depuis deux heures. Demain, ils seront empaquetés, et tout de suite expédiés. La Commission de M. Le Conteulx sera faite aussi bien qu'il me sera possible, c'est je crois ce que les anglais appelent *Malt* qu'il faut embarquer; c'est la farine d'orge preparée pour faire la bière Le sweet . . . [?] dont parle chose, ou le moult de bière. Le faisoit a bord et a mesure des besoins. A present je nage en grande eau, et tous les jours mes connaissances augmentent. M. Webber m'a fait présent d'un collier qui est un tissu de plumes rouges: il m'a dit qu'il croyait que le duc de Chaulaes avoit acheté un casque et un manteau, chose qu'il vous serait facile de vérifier. Je ne vous écris que un mot ce soit, et c'est particulièrement pour vous prevenir que toute ma journée de demain sera employée en grande partie a vous écrire. Je vous salue. M.

*Londres Le 12 Avril 1785* [to the Maréchal de Castries]

Monseigneur

Je prends la liberté de vous adresser deux colliers de plumes Rouges, dont se parent quelques insulaires de l'Ocean Pacifiques. Je les ai obtenus d'un curieux, dans l'intention de les faire parvenir a M. de La Pérouse, a qui je vous prie d'avoir la bonté de les faire passer. Je suis avec respect, Monseigneur, votre très humble et très obeissant serviteur. Monneron

*[Without date]* [to La Pérouse]

M. Webber m'a dit que leurs couteaux de traite etaient bien inférieurs en qualité a ceux que j' envoye pour modèles, et qu'ils en avaient beaucoup qui leur ressemblaient pour la forme: Je présume que de pareils couteaux pris en grosse partie ne doivent guère couter que 48 f la douzaine.

M. Webber m'a conduit dans la Boutique ou le Capitaine Cook s'etoit pourvu de ses verroteries. Malheureusement le Marchand qui la tenait a fait banqueroute. Nous avons été chez celui qui a acheté son fond de boutique, il nous a dit qu'il ne tenait plus de ces sortes de marchandises.

En courant de boutique en boutique, j'ai trouvé des verroteries de différentes sortes: celles qui sont en grains sont extrêmement communes, ou peut s'en pourvoir d'une certaine quantité, en variant toutefois les couleurs et les grosseurs: celles qui sont taillées a facettes selon lui seraient d' un grand prix surtout a la côte Nord-Ouest de l'Amerique. On pourrait encore varier les couleurs dans ce genre. Mais si j'en juge par le prix des échantillons de ces verroteries a facettes, un assortiment complet couterait fort cher quoique je présume qu'en France ou doit avoir ces marchandises a moitié prix de cequelles coutent en Angleterre. On les fabrique autant que je puis croire dans une petite ville d'Anjous, il vous sera facile de prendre des informations certaines a ce sujet. Les petits Miroirs communs sont un article qu'il ne faut pas négliger.

Je dois vous prévenir au sujet des verroteries, qu'un marchand m'a promis de m'envoyer demain des échantillons de la plus grande partie des especes qu'on peut trouver a Londres. S'il me tient parole, je demanderai a M. Webber ce qu'il en pense, et je vous communiquerai son avis en vous envoyant ces échantillons. Depuis que les colonies Anglaises se sont separées de leur Métropole, il y a très peu de ces marchandises dans les magasins de Londres.

J'ay joint à ce paquet un rang de fausses perles tres grossières; mais commes elles ne résistent point a l'essay des dents, dont je vous ai parlé dans ma dernière, ce n'est presque d'aucune ressource.

*Londres le 13 Avril 1785* [to the Maréchal de Castries]

Monseigneur,
Je prends la liberté de vous adresser un petite boite contenant quelques menus objets, que je vous prie de faire parvenir a M. de La Pérouse, avec l'explication détaillée cy- jointe. Je suis avec Respect, Monseigneur votre très humble et très obeissant Serviteur Monneron

*Londres le 14 Avril 1785* [to the Marechal de Castries]

Monseigneur,
Je donne avis a M. Mouron, négociant a Calais que je fais partir d'icy pour vous faire parvenir a Paris: 1.par la diligence de Calais a Paris, un caisse contenant un Sextant de Madley: 2.un paquet contenant quelques articles destinés pour M. de la Pérouse, et détaillés dans l'explication cy jointe qui lui est adressée: Je charge M. Mouron d'envoyer ce paquet par la poste, afin qu'il parvenir plus promptement. Je suis avec regret (misspelling for respect?), Monseigneur, Votre très humble et très obeissant Serviteur Monneron

*Londres le 14 Avril 1785* [to La Pérouse]

Le Marchand de verroteries, dont je vous ay parlé hier, m'a tenu parole, et m'a envoyé differents modèles appartenant a cette sorte de Marchandise: Je ne vous fais aucune mention des prix de détail que je les ay payés, parce que je suis persuadé qu'on doit se les procurer en France a beaucoup meilleur marché qu'on ne le ferait a Londres: On aura soin de varier les couleurs autant que possible, ainsi que les grandeurs, quand les formes en seront susceptibles: il y en a deux espèces surtout que M. Webber, a qui je les ai montrées toutes, et qui m'a paru satisfait de tous ces échantillons; il y en a dis-je deux espèces, qu'il conjecture devoit parfaitement reussir, surtout quand les couleurs seront variées: ce sont les paquets sur lesquels, j'ai mis une note a cet effet. Je dois vous observer que ces verroteries sont infiniment plus commerciables sur les Côtes de l'Amerique que dans les isles de la Mer du Sud. Sur une grande quantité de couteaux patrons que je luy ai montrés, il m'a designé les trois que je vous fais parvenir, comme étant les modèles de la plus grande partie de ceux dont était pour ce le Capitaine Cook: les deux plus petits qui sont joints a ces trois, sont plus faciles a traiter a la côte d'Amerique En effet, vous devez vous rappeler qu'au mois de 7^bre 1782 vous en avez vu une très grande quantité de cette espèce: il est vrai, qu'il y une grande conformité d'habitudes, et d' usages entre ceux-ci et ceux-la.

Je vous envoie un patron Général de beaucoup de Sortes d'aiguilles: quant a cette partie la je vous conseille d'en faire l'achat en Angleterre: C'est une marchandise très propre pour le Continent: elle est de peu, ou pour mieux dire, elle n'est prèsque d'aucun usage chez les peuples du Sud.

Je vous envoie un patron Général des differents hameçons. Cette marchandise, aussi que celle dont je vous de parler, est a bon compte a ce pays: Comme elle a cependant deux objets essentiels, l'un de vous servir a la pêche, et l'autre d'être propre a la traiter, vous feriez bien de me marquer quels sont les numeros qui vous conviennent le plus, et en quelle quantité vous désirez vous en procurer. Je fais partir a l'adresse de M. le M^al de Castries, un sextant pour M. de Langle. Les autres instruments ne tarderont pas a suivre. Pour éviter l' inconvenient de cahotement surtout sur le pavé, j'ai imaginé un emballage qui tient l'instrument suspendre dans son etui, par différentes cords qui le retiennent, par dessus, par dessous, et par tous les côtés attaché a une caisse qui contient du air (?) qui entoure cett étui dans toutes les parties. Vous m'obligerez de me mander si cet emballage a prévenu tous les accidents. Si cela n'etait pas, il faudrait se resourdre à faire aller tous les autres par eau, a moins que M. le Ch^n de Tilenrien ou vous, ne connaissiez quelques moyens de les faire cheminer par terre sans aucune risque. Si au contraire cet emballage a réussi, il sera bon de l'étudier, afin de suivre la même practique pour fair parvenir tous ces instrumens a Breste.

Sur les cinq Couteaux que je vous envoye, vous pourrez vous procurer en France la quantité conforme aux trois plus grands quant aux deux petits, je pourrai en prendre ici quelques grosses de semblables; par deux raisons: la première, c'est qu'ils seront moins couteux, et la seconde, c'est qu'il n'est pas d'usage d'en fabriquier en France de pareils, en consequence ce sera pour éviter une sorte d'embarras.

Archives Nationales, Fonds Marine, Paris, vol. 109, no. 14, copies in the Mitchell Library, State Library of New South Wales, Sydney, B.1207
(La Pérouse Voyage 1785-8, Stores, Letters, Reports.)

# APPENDIX 6

## John Webber's will

From the uncertainty of life being well & of sound mind I make my last Will and Testament.

1$^{st}$ I will & bequeathe to my friend Joseph Farington Esq$^r$ of Charlotte S$^t$ Rathbone Place the sum of one hundred Pounds, also all my drawings of Portfollio N$^o$ 1 with any small picture I may have in my possession of my painting —

2$^{dly}$ I will & bequeathe to my friend M$^r$ George Baker of S$^t$ Pauls Church Y$^d$ the sum of one hundred Pounds also one Portfolio N$^o$ 2 with the Drawings therein and any small picture I may have of my painting

3$^{dly}$ I will and bequeathe the sum of one hundred Pounds to my friend John Steers Esq$^r$ of the Temple also 2 of my largest pictures of my painting I may have in my possession

4$^{th}$ I will and bequeathe the sum of fifty pounds to M$^r$ Thomas Hearne of Macclesfield S$^t$ Soho my particular acquaintance & friend, also 6 of any of my remaining drawings done by me —

5$^{th}$ I will and bequeathe the Sum of one hundred pounds to the children of M$^{rs}$ Degoutes wife of M$^r$ Degoutes Dyer at Berne in Switzerland to be equally devided between them.

6 I will and bequeathe to the Chest establishd for by my late Cousin Rudolph Webber the Sum of one hundred Guineas to be applied according to his will —

7 I will and bequeathe the sum of one hundred pounds to my friend M$^r$ Christian Fuetter of Berne in Switzerland, also my half share of the house we have jointly between us & whatever money may be due to me from it — also my portrait painted by M$^r$ Hunnemann [Hornemann] also request him to receive my Diploma and present it to the Library at Berne.

8 I will and bequeathe the sum of one hundred Guineas to the Abaye of Merchants at Berne in Switzerland for the Attention I had the honour to receive from that Body as a Member — during my stay there

9 I will and bequeathe to Edward Coxe, Esq. my picture painted by Both — as a small remembrance of friendship.

10 I will and bequeathe to M$^r$ William Day the sum of twenty pounds for mourning — in remembrance of a friend

It is my will that Joseph Farington Esq$^r$ of Charlotte S$^t$ Rathbone Place, and M$^r$ George Baker of S$^t$ Pauls Church Yard be my Executors. Done under my hand and seal at London in the year of our Lord 1792

<div align="right">John Webber</div>

P.S. I will and bequeathe the Sum of fifty pounds over and above wages due to my maid Serv$^t$ Mary Davis — also twenty pounds to Thos. Wyatt the young lad who now lives with me, as also ten pounds for mourning to my Landlord M$^r$ Henry Humphry — in remembrance of an old acquaintance.

7$^{th}$ May 1793

Joseph Farington Esquire and George Baker the Executors within will named were duly . . . [?] that the whole of the Goods, Chattils and Credits of the Deceased do not amount in value to the Sum of Five Thousand Pounds.

Testator died 29$^{th}$ of April last and was late of Oxford Street in the Parish of Saint George Hanover Square in the County of Middlesex.

Public Record Office, Chancery Lane, London.

# APPENDIX 7

## William Ellis's letter to Sir Joseph Banks

25 December 1781

Sir,

Having been inform'd that I have incurred your displeasure, in consequence of publishing an Account of Cap.<sup>t</sup> Cooks Voyage, I must request the favor of your patience a few minutes, whilst I lay the whole before you in a true light, & in as few words as I can; after which you will be able to judge, how far I have acted wrong, and how much I am to blame.

The few poor Observations and Remarks which compose the Work, were never collected with a view in making them publick, but solely for the perusal of my friends; and that this is a truth, I solemnly vouch and affirm upon the word and honour of a Man.

Had I form'd the least Idea of disposing of it, I certainly should have used more Expedition, and at all Events have taken care that mine had been the first Publication. — Never would it have been brought into the World, had not the want of Cash (a disease, which as you once before observed to me,. the rich as well as the poor — the affluent as well as the needy, sometimes labor under; and which believe me Sir, in these times of uncertainty, is too heavily and severely experienced by the latter, for if Men in your superior station of life, have reason to complain, how much more, must those upon the same level with myself) had not the want of Cash I repeat, struck me with the thought of proffering it to the Booksellers. — I consulted my friends upon the Subject, some of whom were for, and others against it; the latter prevailed — it was for a time thrown aside, and I endeavoured to creep on two or three Months longer. — At length however, times began to afford but a dreary prospect, and I came to a resolution of delaying no longer a plan which might afford me a supply of money; the work (with twelve drawings) was therefore offered to a Bookseller for the Sum of Eighty Guineas, and in the course of a Week or Fortnight, I was to receive his Answer. — As this time (which was in July) I will honestly confess, that I was by no means easy in my own mind, with respect to your Opinion of my proceedings; and I had several times come to a resolution of informing you of them, but the fear of your disapprobation set it aside: because had you expressed a dislike, & intimated a desire that it might be suppressed, I must have given it up, and then my resource would have been entirely cut off; and I never could have applied to you again for supply, who had before so readily and generously granted it in a Circumstance which I never think of without great uneasiness and anxiety, for reasons Sir, which you well know.

The time at length arrived, which was to place me above want, at least for some short period, and full of Expectation, I called upon the Bookseller. But how great was my surprise, when he presented me with the following hard Conditions, viz: that in lieu of Eighty he offered me Forty Guineas, that I was to correct the press — and to put my Name in the Titlepage as Author of the Work. Or if I did not approve of this, he would be at the whole Expence of printing and engraving — free me from all risque, and share the profits with me. The latter probably w<sup>d</sup> have been the more eligible plan but the length of time before publication, and my want of present Cash, did by no means agree. I must confess, I was not a little chagrined, but hard as the conditions were, I accepted the former. — As I had (and now have) many drawings by me, he made choice of ten others, for which he paid me ten Guineas more; the whole Sum then which I received was fifty Guineas, — a Sum by no means adequate to the suffering of my mind, tho' perhaps more by far than the work is worth. — This Sir, is the true state of the case; but as I have forfeited whatever share I might have had in your Esteem. I have now very little to hope or expect from any one, and may truly say Spes et fortuna valete! — I have the honour to remain with the highest Esteem, Sir your most Obed: tho' unfort. Ser.<sup>y</sup> WW: Ellis

No. 11, Gough Square, Fleet Street, Dec.<sup>r</sup> 25<sup>th</sup>

Banks Correspondence (B.C. 1, 113),
Royal Botanic Gardens, Kew.

# APPENDIX 8

## Sir Joseph Banks's letter to William Ellis, 23 January 1782

Soho Square Jan 23, 1782

Sir,

I received yours, & am sorry you have engaged in so imprudent a business as the publication of your Observations.

From my situation & Connexions with the Board of Admiralty, from whence only I could have hop'd to have serv'd you, I fear it will not in future be in my power to do what it might have been, had you ask'd & followed my advice. Your note of hand, which is in my possession, I am ready to deliver up to you, & to pay you thirty pounds more on account of your drawings, which I value at 50 £, whenever you chuse to consent to give me a receipt for that sum as their price; as I do not think it proper to insist upon the right to them which I derive from you having made me a present of them, or while your circumstances are so much confin'd.

The only service you could do me would be by entering into a plan to revenge yourself of the bookseller for his Judaic treatment: if you would heartily join in, I would assist.

Your Hble Servant Jos. Banks
Mr. Ellis N.° 14 Gough Square.

Dawson Turner Copies, Banks Letters (D.C.T. 2.89),
British Museum (Natural History), London.